African Voices in the African American Heritage

# AFRICAN VOICES IN THE AFRICAN AMERICAN HERITAGE

Betty M. Kuyk

**INDIANA**
University Press
Bloomington & Indianapolis

Publication of this book is made possible in part with the assistance of a Challenge Grant from the National Endowment for the Humanities, a federal agency that supports research, education, and public programming in the humanities.

This book is a publication of

Indiana University Press
601 North Morton Street
Bloomington, IN 47404-3797 USA

http://iupress.indiana.edu

*Telephone orders*  800-842-6796
*Fax orders*  812-855-7931
*Orders by e-mail*  iuporder@indiana.edu

The paper used in this publication meets the minimum requirements of American National Standard for Information Sciences—Permanence of Paper for Printed Library Materials, ANSI Z39.48-1984.

Manufactured in the United States of America

**Library of Congress Cataloging-in-Publication Data**

Kuyk, Betty M., date
African voices in the African American heritage / Betty M. Kuyk.
p. cm.
Includes bibliographical references (p.  ) and index.
ISBN 0-253-34204-X (alk. paper) — ISBN 0-253-21576-5 (pbk. :
alk. paper)
1. United States—Civilization—African influences. 2. African
Americans—Social life and customs. 3. African American arts.
4. African Americans—Relations with Africans. 5. Africans—United
States—History. 6. Africans—United States—Social life and
customs. 7. Slavery—Social aspects—United States—History.
8. Slave trade—Social aspects—United States—History. 9. Sea
Islands—Civilization. 10. Southern States—Civilization. I. Title.
E185.K89 2003
973'.0496073—dc21

2002012902

1 2 3 4 5 08 07 06 05 04 03

For Tigger,
who never got lost and who
*never* came unbounced

# CONTENTS

# COLOR PLATES

# ILLUSTRATIONS

# DIAGRAMS

# FOREWORD

Several years back John Szwed, my colleague in African American studies at Yale, and I co-taught a graduate seminar on theory and method in the study of blacks in the Western Hemisphere. We had students read Betty Kuyk's important study of African continuities in religious social structure in Virginia. It was, and remains, a model of care and precision. Now, with this rich, dense, exciting book, we read her masterpiece.

Part of her power is knowing she works not alone. She salutes and absorbs the insights of black colleagues before her. Early on in this text she shows how historians as late as the seventies of the preceding century deemed it impossible to know the beliefs and attitudes of African Americans, especially slaves. So they concluded that writing African American history in fullness and depth was essentially impossible.

Say what? We read, fascinated, as step by step, case by case, Betty Kuyk dismantles forever that nonsense. She gathers the voices that take us on home. She brings to our attention the work of an African American historian, Luther Porter Jackson, who proved that a notably large population of free African Americans in Virginia made a significant contribution to the economy of the state. These were the kinds of currents, true, deep, and lasting, she learned to move in, carrying us through to history and presence.

She privileges the oral traditions. She stays on alert for their clues. She close-reads the memories of Sam Gadsden, African American of Edisto Island. Noting his mention of an African trade system, a style of cloth, and a Dutch trader, she traces his family back to a particular region of the motherland.

All this, especially her distinguished work on Igbo influences on Virginia, is basic training for the brilliant campaigns that unfold in this book. Savor how she handles Kongo philosophic influence in the work of two famous self-taught artists of the Black South, Bill Traylor of Montgomery, Alabama, and Sam Doyle of Frogmore, South Carolina.

Her pages on the deep meaning of the work of Bill Traylor are among the most moving I have read in the field of African American cultural history. Because she is looking not just at motifs but at aspects of thought that surround and enliven them. She's discovered how to plug directly into the firepower of memory. Proust be not proud! Read how she translates the lived experiences of the people as powerful self-theory and self-ideology. All this propels us into ultimate insight: "an art that shows the individual taking himself on a singular journey of preparation—a journey comparable to the stages of initiation in African American community organization—a journey that prepares one to join the spirit world in death." We know that initiatory art in Central Africa is hardy and intractable, always changing,

hence always alive. I think of Zoe Strother's book on Pende dance, masking, and creativity, which makes a wonderful methodological pendant to this work. We know that Central Africans don't just dance but form clubs around styles and new motions. That kind of social aura is the shining context in which Betty Kuyk placed what is happening in the art of Traylor and Doyle.

These men, and women like the late Bessie Jones, knew where we are coming from and where we are going. That's why they were able to line the road to glory with a beauty predictive of the glamour of the other world.

Robert Farris Thompson
*New Haven, Connecticut*

# INTERPENETRATING THEMES

*A Preface*

Sam Gadsden, grandson and great-grandson of African-born slaves, told the long story of his forebears' journey into slavery, a journey complete with trickery, smuggling, and separations. And yet, he concluded, they were able to keep the family together. They made it grow. And so, he said, they built "practically a whole nation."

Gadsden's words invite deep probing. His forebears, like all the Africans transported to the New World, brought their own traditions—their aesthetic values, their religious and philosophical beliefs, their concepts of how society should be organized and governed. They taught these to their children, who passed them on to theirs, transmitting African traditions into American communities. But how do we recognize these African voices speaking through the generations? The deepest values that came from Africa into African American and American culture may be the hardest to perceive.

About seventy years ago Melville Herskovits recognized the Africanness of this whole body of traits in the New World and devoted his life's work to studying them. By now anyone familiar with the field knows his classic *The Myth of the Negro Past*. Yet recognition of his contribution was a long time coming. While Herskovits made some interesting analogies, neither he nor anyone else could put together the factual documentation necessary to prove how the transmissions he pointed to could have occurred. Even thirty years after his book's publication, in the early- to mid-1970s, Black Studies programs in universities were merely in an embryonic stage. Historians still maintained that almost 250 years of slavery had left no primary sources from which to study truly African American points of view. Since slaves had been forbidden to read and write, historians asked, how could they have left written records? After emancipation the freed people were soon intimidated and again deprived of schooling; so, historians added, one shouldn't expect sources through the turn of the twentieth century, either. Deeming it impossible to know the beliefs and attitudes of African Americans, especially slaves, historians concluded that African American history couldn't be done in depth. As late as 1979, African American women meeting at the Association for the Study of Afro-American Life and History cautioned each other that their dissertation advisers were still white male professors whose attitudes kept the women from exploring their African backgrounds and their African American culture.

While this view prevailed, however, one African American historian had quietly and persistently been at work. Braving county and city courthouses controlled and staffed entirely by white officials in Southside Virginia during and following the worst era of lynching the country had ever known, Luther Porter Jackson, professor of history at Virginia State College, searched tax records, wills, deeds, and registers of "free Negroes and mulattoes" to prove ultimately that a notably large population of free African Americans in Virginia had made quite a significant contribution to the state's economy. In 1942 he published his findings in *Free Negro Labor and Property Holding in Virginia, 1830–1860*. His ability to find the sources became a catalyst to me. From the moment I met his work, I believed the sources were out there if one looked hard enough.

Searching in the Library of Virginia in Richmond, I found my first source, *The Planet*, a turn-of-the-century African American newspaper. Now these journals are taken for granted as sources; in 1975 they were either unknown or unacknowledged. In *The Planet* I found my first bit of evidence that one could indeed uncover the African American point of view from the earlier era. *The Planet* regularly ran a column called "Do You Know Them?" It was a column of letters written by people who had lost relatives—parents, siblings, children, nieces, nephews, all—in slave sales. Forty to sixty years after those sales their relatives still tried to reunite their families, and I defy anyone to read those letters without tears. Our tears respond to a penetrating value in African American culture—the community of family, a community that has held itself together for several centuries through intensely difficult separations—indeed, even through death.

In the Library of Virginia I also found my second source. This was the ritual of an African American fraternal order, the Independent Order of St. Luke. The Order was founded as soon as the Civil War ended and slaves were freed. Its ritual was codified by 1877. My strongest academic grounding was in precolonial African history, and as I read that handbook, close analogies between the structure of traditional West African societies and the Order became apparent. Extensive examination of societies on both sides of the Atlantic made it clear that the Africans who had come here had brought with them another deep value—their concept of how society should be organized.

Within this concept the power of community is intimately linked with the power of what Euro-American culture calls religious belief. The concept holds that no person can exist alone, apart from the community's members, both living and ancestral. This concept was so deeply ingrained that slaves from West Africa brought it with them. Its transmission into slavery America was ensured by the all-encompassing power that John Mason, a priest of Obatala and a teacher of Yoruba theology, says "cradles, caresses, chastises and praises." In joining the community through its belief system, one gains knowledge, "making sense out of nonsense . . . giving shape to

shapelessness," he says, and one becomes "part of the universal community forever."[1] Community buttresses survival. Community provides recognition of its members and guides them. In its traditional backgrounds the African community included all of its members living on earth and all of its members living in the spirit world. In the New World environment the African American community maintains its universality, uniting the living and the spirit worlds. The African American community did and does preserve values which save humanity in the midst of inhumanity.

This book shows how the newly forming African American community organized itself through a specific structure as its members became free to build their own societal institutions. Together we shall examine a specific West African concept of the proper structure of social organization and discover how African Americans put the concept to use in organizing their new communities in the United States. New adaptations grew in both formal and informal manifestations, but in whatever direction they grew, an African mindset remained. It holds that all facets of life are intertwined: the realm of religious and philosophical belief cannot be separated from, say, community government. The African system of thought holds that if one facet is removed, all will collapse. We shall see how religious and philosophical beliefs inhere on both sides of the Atlantic in the whole structure of community; and we shall see how both sides came together, how the ideas, beliefs, and ways of expressing them crossed the Atlantic and survived to grow in new ways in the United States.

While references to "the Middle Passage" usually describe foul slave ships or estimate how many slaves were taken from Africa, "Crossing the Middle Passage," the title of Chapter 1, refers to bringing living cultures to the New World in people's minds. Chapter 1 explains the research method I use throughout the book. In addition to the usual printed documentation I draw on less traditional sources for writing history. Here African Americans speak for themselves through oral history and oral interviews, through folklore and song lyrics. More surprising, perhaps, they also speak visually, giving historical and cultural information in painting and sculpture. In particular, I focus on oral historian Sam Gadsden and on two artists, Sam Doyle and Bill Traylor. All three record their societies' history, thus speaking as African griots. In calling on these seldom-used sources for writing history, I have applied theories developed by Jan Vansina in both *Oral Tradition as History* and *Art History in Africa: An Introduction to Method.*

Using oral sources is no longer uncommon. But the notion of visual art as a source for historical study is still surprising. For many, if not all, traditional societies in Africa, the entire cosmos was sacred. The structure of life revolved around the sacred, and aesthetic expression served ritual. Aesthetic traditions, although they differed from people to people, were extremely conservative, changing within societies only very slowly after Europeans took Christianity into Africa. Herbert Cole and Chike Aniakor estimate

that for the Igbo of Nigeria, for example, European-influenced changes oc-
curred only in the late nineteenth and early twentieth centuries.[2] Aesthetic
traditions, then, remained virtually intact during the long period when slaves
were brought into the United States. Normal behavior dictates that along
with concepts of social organization and religious beliefs, these Africans
brought their aesthetic values. One art critic has commented on the "iconic
power" of Bill Traylor's figures.[3] In fact, we shall ultimately see that the
iconographic, symbolic relationship with art comes directly from the Afri-
can aesthetic tradition to inform African American art. Investigating that
African tradition, then, enables African American art to inform us.

Chapter 2, "Into the American Community," gives the historical ground-
ing to show that the transmission of ideas from African peoples continued
through the nineteenth and into the twentieth centuries. If all the slaves had
been brought into the United States by the early eighteenth century, and if
they had lived in close communication with many European Americans,
one might expect that their original ideas would have eroded and blended
pretty thoroughly with the European-derived cultures. The U.S. Congress
outlawed direct import of slaves from Africa as of January 1, 1808. Histo-
rians have thought that this effectively ended that trade. But the trade sim-
ply became secret. Slaves from Africa were smuggled into hidey-holes in the
southern coastal areas along the Atlantic Ocean and the Gulf of Mexico
right up until the Civil War. The history of this smuggling has not been
written. Documentary evidence exists, but it is scanty—smugglers did not
publicize their exploits.

Chapter 2 is the story of Sam Gadsden's large family that was smuggled
into Wadmalaw Island, near Charleston, South Carolina, about 1818.
Gadsden's story gave clues to his family's African origin. He spoke of a
specific African trade system, a kind of cloth, and a Dutch trader. These
details enabled me not only to trace his family back to a particular region
but also to cast light on the system of piracy and illegal import. He recorded
his story twice—once with Nick Lindsay on Edisto Island and once with
African American students. I have used both versions, applying to them
Vansina's principles for using oral history.

Gadsden's story gives the factual basis to prove both how the transmis-
sion of traits from African societies occurred and that they did in fact occur.
Smuggling such as his family experienced kept the African impulse alive for
more than a century after 1808: in the early decades of the twentieth cen-
tury there were still people living in the United States who had been born in
Africa. Gadsden's story exemplifies the origins of thousands of African
American families. His story validates not just Herskovits's observations
but the work of many historians who have found analogies between Afri-
can and African American arts, crafts, and religious practices but could not
explain how African influences actually got here. Gadsden's story provides
the foundation for understanding how the cultural practices—the African

traditions—that I describe in subsequent parts of this book came into the American community and continue to be influential.

Chapter 3, "Voices of Survival," builds on Gadsden's story. Those Africans newly arrived in the Sea Islands had survived the "middle passage." Their beliefs, customs, and attitudes had also survived; and the people held on to them despite owners' vigorous attempts to erase every trait. Unbeknownst to their owners, the people kept African names. They retained African concepts of the relationship between people and land and of relationships among family members. They kept traditional storytelling forms that preserved the concepts within these relationships.

On these bases the surviving people built institutions for living. Two of these—the secret-association form of organization and the African system of religious belief—are central to this book because they are central to the development of African American culture in the United States. We shall examine the structure and functions of a secret title association, the Agbalanze of the Onitsha Igbo of Nigeria, as an example of an African society. We shall then compare these with the structure and functions of an African American society, the Independent Order of St. Luke. How the structure and functions serve each other and how the religious system interpenetrates the societies form a basis for understanding the African American practices that we shall examine in Chapters 4 and 5. We shall see how patterns of preparation, initiation, and induction into higher levels of spiritual involvement occur in both formal and informal institutions and in people's daily lives. Patterning of activity, says Robert Plant Armstrong, shows that the activity has become cultural. Patterns are specific to the culture.[4] When such a pattern of stages of spiritual preparation shows up in the new African American environment, we know that the pattern is African.

Chapters 4 and 5 examine how those African patterns were intermingled and varied by the next generations of African Americans. Using St. Helena Island, South Carolina, as the primary example, in Chapter 4 we shall examine Sea Island culture and its relationship to its Kongo origins. Kongo, once a vast kingdom, is a civilization that has endured for over 700 years. It encompassed many different groupings of peoples who shared fundamentals of language and belief. Between 1733 and 1807 two-fifths of the slaves imported to South Carolina came from peoples of Kongo-related culture; in the same period one-fifth came from the Senegambia region and one-sixth from the Windward Coast. It is estimated that one-fourth of the total number of slaves brought into the United States during the entire slaving period came from Kongo peoples.[5] Consequently, while several historians have discussed Gullah culture in relation to backgrounds from the upper west coast of Africa, I draw parallels with Kongo backgrounds. During the era when Sea Island cotton was grown, when fortunes were made fast, the demand for slaves was great; and this demand coincided with a concentration of export from Kongo regions. While Kongo people were being taken in open

trade to other parts of the New World, they were being smuggled into the United States. Thus the descendants of settled West Africans in the United States were joined by large numbers of Kongo peoples.

And they were not just numerous; they were influential. The paintings of Sam Doyle illustrate Kongo influence. On St. Helena Island, which was Doyle's home, I was given access to a collection of tape-recorded interviews with local elders speaking with African American students in the 1970s. I also interviewed Doyle several times. Here Sea Islanders speak for themselves, describing customs and beliefs that prevailed in the Islands in the early part of this century when few white people lived there. During this period Sea Island culture remained close to that of its African forebears, in large measure unchanged by the Euro-American customs of plantation owners and overseers. Here we will see structural themes interpenetrating a system of admission to church membership. We will find that principles of the structure resemble principles of the organizations described in Chapter 3, while individual details differ according to the Kongo backgrounds of the Sea Island participants.

Chapter 5 follows the movement of slaves to the inland Deep South, where people of many different African origins blended their beliefs to construct a new African American culture. In this region interpenetrating themes resonate with the influence of the underlying secret-association structure and the blend of religious beliefs. We will look closely at the life and works of the folk artist Bill Traylor. In his paintings the same motifs recur repeatedly. Robert Farris Thompson, who has studied the art of Kongo peoples extensively and has been educated in its meanings by Bakongo teachers, has noted that "wherever in the history of Kongo art a motif . . . occurs with formalized insistence, there is every reason to suggest deep iconic import."[6] The Belgian scholar François Neyt gave an example: a figure sitting with crossed legs signified "respect and courtesy."[7] In Chapter 4 we will see several instances of the Kongo use of motif in Doyle's work. Traylor's work will take us much more deeply into the world of "iconic import." His motifs are repeated with such "formalized insistence" that, once discerned, they impel us into an understanding both of his individual life and of his African American community.

Westerners are so imbued with the concept of individualism that they impose it on other cultures, Eli Bentor has said, while Africans are "bound in a web of relationships with one another, as well as with invisible entities and objects, to such an extent that they can be said to permeate each other. The boundary between an individual and society, between man and nature, is blurred."[8] Traylor's work requires us to see it from this African perspective. As art serves the structure of the secret association among African peoples, it also served the process of Traylor's journey through his examination of his life and his approaching death. His art reveals how deeply these

patterns of African culture, which became institutions of African American culture, affected an individual member of the community.

Traylor's art shows the individual taking himself on a singular journey of preparation—a journey comparable to the stages of initiation in African American community organization—a journey that prepares one to join the spirit world in death. Dominique Zahan explains the African's philosophical, or theoretical, basis for the development of the stage structure in these manifestations in the African background. People, Zahan says, are intricately and centrally involved in the cycle of life; but the African view, unlike the European view, does not center on God. The African view unites "an individual and the social ethic" culminating in the "supreme goal" of achieving both moral life and mystical life. This, he says, is "the objective towards which the individual strives with all his energy because he feels his perfection can only be completed and consummated if he masters and surpasses himself through divinity, indeed through the mastery of divinity itself."[9] And this definition explains the relationship between the structure of Traylor's journey and the structures of the social organizations—the fraternal order of Chapter 3 and the church organization of Chapter 4. We shall see how it all works out.

The book concludes with an epilogue. Having followed an intricate path, we shall have arrived at our destination—a new understanding of basic, interpenetrating themes in African American culture in the United States. The epilogue tells the brief story of how Sam Gadsden's grandfather, Thomas Gadsden, fought for freedom and for the unity that would bind the nation together. His story highlights the gift that Africans have woven into the fabric of our culture.

Several terms that I've used can be potholes in the road of interdisciplinary study, and I ask that the reader bump through them to get on down the road. The worst:

*African.* Here it never refers to all the peoples of Africa. Since slaves brought to the United States came mainly from West and Central Africa, the word refers to peoples from those regions, although slaves occasionally came from peoples farther to the east. *African* here also refers to philosophical characteristics prevalent enough in West and Central African thinking to have been transmitted to the United States.

*Peoples, grouping.* More than twenty years ago anthropologists and historians acknowledged that Africans found the designation "tribe" offensive. It also proved inaccurate. It implied fixed boundaries, static "ethnic groups." But people and customs flowed across so-called "tribal" boundaries as people intermarried and exchanged ideas. Vansina has shown that even names of groups can be erroneous.[10] I have used "peoples" to refer to

groups with a nucleus of language, customs, and relationships. I have also used "grouping" because a man from Senegal told me it was preferred by African people.

*White*, as applied to a group of people. This term defines those people in the southern United States who were of European descent and who in many ways dominated the political and economic lives of African Americans until well into the twentieth century. I have referred to their culture as European American or Euro-American. The dominant group did not call themselves European Americans—they referred to themselves as *white*, and the term retains this use today in African American culture as well as in general American culture.

*Culture*. Use of the word "culture" is much debated in anthropology and sociology. Here I ask the reader not to dwell on that debate but to use Webster's "behavior typical of a group."

*Folk art* and *folk artist*. No one studying artists who have no formal training has come up with an adequate title. Some are using "outsider art," a label I find unacceptable. These artists are in no way outsiders.

*Cunjuring*. The dictionary spells the word *conjure*. In my determination that African American people must speak for themselves whenever possible, I have used the very old pronunciation given to Harry M. Hyatt by an informant from St. Petersburg, Florida. Born about 1858, this man said the word was pronounced *cunjuring* before emancipation.[11] In addition, the dictionary's word seems to suggest sleight-of-hand tricks on stage. Cunjuring, as we shall see, is much more than that.

*Hand*. A traditional term used throughout the southern United States to refer to the charms made by root doctors for curing problems. In all probability it derived from the Kikongo word *handa*, which John Janzen translates as "to initiate or consecrate a medicine."[12] With this translation, *hand* is infinitely more accurate in African American usage than *charm*. Another word used for hand is *seal*.

*Bakongo, Kikongo, Mukongo*. Bantu languages use prefixes to define people, language, individual, land, and so on. Kongo refers to the culture group; *ba-* designates the people of the Kongo group; *ki-* designates the language of the Kongo group; *mu-* designates the individual.

Some writers have "corrected" the spelling in transcriptions of dialect because they feel the transcriptions reflect badly on the speakers. I have used them as they were originally written down. Most of the transcriptions I have used are old, and I have repeated them as written primarily because they are the only clue we have to the rhythm and intonation of the language. The sound of the language is another link to its African background. In doing my own transcriptions from the Penn Center collection of tape-recorded interviews, I transcribed words as they were spoken: for example, if a verb was omitted in the speech, I did not add it. In the interviews the people spoke Gullah, now recognized as a creolized language, not a

corruption of English. Since intonation is lacking on the printed page, I sometimes italicize to show the emphasis that the speaker made. I hope this will help the reader who does not know Gullah supply verbs or other parts of speech that seem lacking during the reading. Sometimes I have also inserted translations in parentheses for Gullah expressions that the reader might not know.

# ACKNOWLEDGMENTS

Without Emory Campbell, director of Penn Community Services on St. Helena Island, this project would never have begun. A Sea Islander with an unlimited devotion to his home and its history, he suggested that I study— no, he *challenged* me to study—the Penn collection of oral history. When my father donated listening equipment and my husband went with me to help set it up and take notes, Emory Campbell asked St. Helena people to help us understand the Gullah language on the tapes. And so I thank Mrs. Eula Skinner, who sat with us to translate, located still-existing prayer houses for us, and then taught me to do the "shout" step she learned as a child. *In memoriam* I thank Deacon Tom Brown, who taught us about being "in harmony with the church and with our neighbors." His kind and gentle spirit has traveled the journey of this book. Also *in memoriam* I thank Sam Doyle, who always had time to tell St. Helena stories and share laughter.

On neighboring Edisto Island, multitudinous thanks to Nick and DuBose Lindsay for their hospitality; their introductions to Sam and Rachel Gadsden's daughter and to the Murrays at Cypress Trees and Jack Daw Hall plantations; their guided tours of the island and the convoluted path to Hollywood, South Carolina; and—not to be forgotten—their introduction to shrimp and grits at the Old Post Office Restaurant!

In Montgomery it was our great pleasure to meet David Ross Jr., heir to management of the Ross-Clayton Funeral Home, which had taken Bill Traylor in during the Depression. Mr. Ross very kindly called people who might remember Traylor or his daughter Sarah and arranged for us to meet his own father, who did remember Traylor. Their interest in our project was a great gift.

Thanks to the Lila M. Terry Trust for providing funds to support the reproduction of art works in color, and appreciation *in memoriam* of Miss Terry's interest in and support for college education for African American women. It came at a time in the South when African Americans were disenfranchised and education for the most part denied them.

Support for research came through the Southern Studies Research Project at Trinity College, Hartford, and Trinity's Mellon Grant for interdisciplinary research. I thank former deans Borden Painter and Andrew DeRocco for backing the Project. Without the help of research librarians, no scholarly work would get done, and in that sphere I am especially indebted to Wylma A. Wates of the South Carolina Department of Archives and History for her help with Edisto Island history, to Mimi Jones of the Alabama Department of Archives and History for her help with Traylor plantation documents, to Peter Knapp of Trinity College for his expertise on naval history, and to the amazing staff at the National Archives branch in Pittsfield,

Massachusetts. I am indebted to Patricia Bunker of Trinity College for the entire work; she can find anything and everything.

Sections of Chapters 1 and 3 are from my article "The African Derivation of Black Fraternal Orders in the United States," previously published in *Comparative Studies in Society and History* 25, no. 4 (1983): 559–592, and are reprinted with the permission of Cambridge University Press.

Amanda Lember and Shelley Farmer of Hirschl & Adler Gallery found the majority of Traylor's art works and helped secure permission to use them. I owe much to them, to Alice Carter of the Montgomery Museum, to Janey Fire of the American Museum of Folk Art, and to Luise Ross, without whom Bill Traylor would never have been so well known as he is today. And thanks to many members of the Traylor family—Mrs. J. Bryant Traylor, Ms. Sally Traylor, Mrs. David G. Traylor, and Dennis Quarles, a descendant of Margaret Getsen Traylor.

For the special details of the end of Bill Traylor's life I am indebted to Mary Stanford of St. Jude's Church, Montgomery, Alabama. And for biblical consultation I am indebted to Reverend Susan Boone. For direction and bibliography concerning the ladder and other nsibidi symbols, I thank Professors Herbert Cole and Eli Bentor. Thanks also to Bob Sloan, editor at Indiana University Press, who combines the uncommon abilities of clearing the way with staying out of it. And so much gratitude to Larry Becker, who kept me "trabellin' on. . . ."

To Robert Farris Thompson, whose exuberant encouragement of those who follow his teaching has been responsible for so much fine scholarship and is only matched by the depth and breadth of his own research, writing, and lecturing:

Oonah studdy gib we toko cyahr fo all-two we tass o' wuds. An dis be fo trutru. Weuns gib oonah tanks clean out ob we heart.

Through all, thanks to Dutch, who after he "spat upon me" (said the grownups) at age three, came around at seventeen to devote himself to the whole shebang—perfecting pancakes, raising a child, team-teaching, helping with research. It was he who found the Leopards in Louis Armstrong's "Didn't He Ramble"; he who found a lost news article showing us that Traylor had not died in 1947; he who got Sam Doyle to tell stories no one else had heard; he who spent hours listening to Gullah with me, translating together; he who for over fifteen years believed in the project's value. But then, spitting on a child is, in some traditional African societies, a gesture of endearment, belonging, and hope.

African Voices in the African American Heritage

# 1

# Crossing the Middle Passage

## A Method

For generations, Sea Islanders have said that the last slaves brought into the United States straight from Africa were smuggled into the Sea Islands.[1] The story was treated as a mere African American folktale, possibly because after the Civil War, Americans, courting reconciliation, did not wish to call prominent southerners smugglers. Now, however, it is possible to verify the story, to turn it from folklore into a chapter in American history and to uncover a tapestry of African origins, developments, and migrations woven into the fabric of American culture.

In the Sea Islands, two griots help to tell the story. One is Sam Gadsden, whose family lived on Edisto Island. In 1972, at the age of 91, Gadsden recorded his family's oral tradition, once in an interview for the Penn Community Services Oral History Project and again with his friend Nick Lindsay on Edisto Island.[2] The second griot is the painter Thomas Doyle, known to the public as "Sam." His paintings recorded the history of his community on St. Helena Island—its vocations, crafts, notable people, pets, stories, beliefs. Beyond reportage, however, Sam Doyle inhabited the world he painted and lived its beliefs. He opens the way for us to understand elements of our cultural heritage that we have not yet fathomed. He will enable us to see a direct connection with an African cosmological structure.

Importation of slaves rose and fell in response to economic demand. So when the invention of the cotton gin in 1793 spurred the vast expansion of cotton lands, the demand for slaves far exceeded supply. Congress prohibited legal import directly from Africa in 1808, but that did not stop smugglers. Philip Curtin has estimated that 1,000 slaves each year were smuggled into the United States and the Texas territory between 1808 and 1861. While Curtin called his estimate a "shot in the dark," he saw it as conservative.[3] But the total—about 54,000 people of purely African culture—is not inconsequential, and their spread was pervasive. Right up until the outbreak of the Civil War, incoming Africans renewed the cultural knowledge both of those of African birth and of those of African descent who were already here. Many people from Africa lived into the twentieth century and so carried their African traditions into our contemporary generations.

As this illegal importation was bringing new Africans into the country, the first half of the nineteenth century also saw the opening of new territories between the "Old South" and the Mississippi River as the United States wrested lands from the Creek Indians. Mississippi became a state in 1817, Alabama in 1819. By 1835, roads, river steamboats, and new methods of cotton farming had brought large numbers of Euro-American planters to the inland South. Their arrival combined with the 1808 prohibition to foster a burgeoning interstate trade in slaves.

Planters were moving from their frontier homes on the Atlantic seaboard into virgin territory, taking some slaves with them and buying more slaves, mostly from interstate markets along inland trade routes. On the Atlantic seaboard the importation process and the preferences of slaveowners had often resulted in slave communities with a fair degree of cultural homogeneity. For example, during the period of smuggling, large communities in the Sea Islands were composed mostly of Kongo peoples simply because the Kongo was the major export region at the time. The inland trade markets, on the other hand, brought together slaves from many peoples. Consequently, cultural traits from many African peoples were intermixed in slave communities in the new inland states—and even in individuals—producing, in essence, a "melting pot" of African cultures.

A third griot, who exemplifies this mixing of cultures, helps to tell this part of the story. William Traylor, also known as Bill, was also a painter of folk art. He, too, is a pictorial griot. His mother, Sally, a slave on a plantation near Benton in west central Alabama, came from Virginia; his father came from Georgia.[4] His parents' owner was establishing a cotton plantation in the 1830s.

These three griots will show us an evolution of cultural patterns in African American life in the United States. But I shall not follow the usual chronological approach to historical narrative. We shall look first at the "purer" example of how African culture came into the country. That is not to say that any single African people reestablished their traditional culture in the anthropological sense of *pure*. In the United States the closest we can get to this sense is to examine the culture established by a new aggregate of African people who had almost no contact with white American culture or with a broad mixture of African backgrounds for their first generation here, if not longer. In the Sea Islands, Kongo peoples came late and in large numbers and remained mostly isolated from white cultural influence until well into the twentieth century.

Gadsden will show how the Kongo people came after 1808. His family came about 1818 or 1819, but Kongo people kept on coming into the country until 1860. Doyle, who was not born until 1906 and lived until 1985, will illustrate the comparatively isolated island culture. Traylor, born a half century earlier, about 1854, to parents from different cultural backgrounds, will then show how different forms of culture from various African backgrounds blended.

Narrative histories of the United States typically follow the chronological order of settlements as they move westward, but the narrative of African and African American settlement cannot follow the same chronological order. Since the Sea Islands example occurred sometimes concurrently with and sometimes later than the blending process in Alabama, times will be juxtaposed here. I shall also depart from the usual method of constructing narrative history exclusively from written documents. To fathom the history that these griots tell, we must use two unusual kinds of sources. Sam Gadsden's account calls on oral tradition, folklore, and language to uncover our past. Sam Doyle and Bill Traylor provide art as historical document. Fortunately, Jan Vansina has published helpful treatises on using both oral accounts and art to construct history.[5]

Oral traditions, Vansina says, contain the present within the telling of the past: Sam Gadsden reflects contemporary attitudes while he tells his family's history. Because we can compare two versions of Gadsden's history, we can sometimes tell what is past and what is present. Luckily, both of Gadsden's versions were done with interviewers who had his trust. Although Nick Lindsay is white, he worked side by side with Gadsden and other African American men in the Edisto Island community for many years, and his children went to school with the children of the African American community. The interviews held for the Penn Center oral history project were conducted by African American college students whom Gadsden trusted as members of his own race. Thus, the interviewers in this situation filled primary requirements from Vansina's code of necessary qualifications: they were well-known or local or were from a common culture.[6]

In discussing how the teller interprets experience, Vansina notes that where a person develops a public self-image, as opposed to his private view of himself, his public image is what Vansina calls "the noble mask" of himself. The teller's "noble mask" is based on his value system—his ideas regarding status and moral principle. It sets aside his interior doubts and contradictions. Gadsden did develop a noble mask of himself. He was a leader in his community. Born in 1882, he completed the fifth grade, the highest level allowed to African American children on Edisto in his time. He owned a small store, co-owned a dance hall, and grew cotton until the boll weevil "came along and wiped that all out." Then he successfully switched to cash crops of potatoes and beans. He became a trustee in the Allen African Methodist Episcopal Church.[7]

The two versions of Gadsden's story do not vary a great deal from each other, but the points of variance are significant. In the printed version, Gadsden said his great-grandfather brought only one wife from Africa. Gadsden's noble mask as a Christian and trustee in his church required that he uphold Christian morality. In this instance, the mask required monogamy.

He was an adult in the early- to mid-twentieth century. At that time, the ideal for southern African Americans who wanted to improve their status was to be acceptable by white standards. These were white Anglo-Saxon Protestant standards, and they reinforced the status of monogamy.

Even when the times changed, when the back-to-Africa movement arrived in the 1970s, Gadsden, by then in his 90s, did not change his public self-image. "Right now today," he told Nick Lindsay, "there might be a man who says he has more than one wife and that it is all right since he is following an African custom. No . . . those women are not joined to him in any true way." When speaking to the African American students, however, Gadsden revealed that his great-grandfather brought three wives from Africa. And when his friend Bubberson Brown talked about slavery times, Gadsden told a story that located one of his great-grandfather's wives: people "would say . . . 'we got a brother over at Middleton's.' He actually was a brother to all Jane, Charles, Dara and them, since their father, Kwibo Tom, had a wife there and it was her son."[8] Gadsden knew this custom would be understood in the African American community. I have accepted the version which gives three wives, because it accords with African custom and with Gadsden's great-grandfather's status within his community and because his statement that there were three wives served only one purpose: factual accuracy.

In telling his story, Gadsden saw himself as an educator. Both forums—what Vansina calls "performance"—gave Gadsden an opportunity to educate. Although one version was to be written and the other was oral, both were recorded. In this situation, Vansina tells us, the teller, or performer, "acts in a different arena, one linking his community or encapsulated society with a wider world, and often with the national state." Gadsden made Lindsay do many revisions so that the printed version would present a story that Gadsden found acceptable according to his own values. This was the story of a people. It must not be seen as "a curiosity" or "some kind of monkey talk." Criticizing a book about the African Americans on Edisto, Gadsden said, "It tells a true story, but it is not the complete story. There was no Christian in that book. . . . It was an incomplete picture and it held the people up to ridicule."[9] As a spokesman for his people, Gadsden insists upon the dignity that is rightfully theirs.

In speaking with the African American college students, Gadsden taught his vision of global importance. Lindsay noted the "lively and humorous interest" in current events in the Gadsden household. Speaking of an Edisto man who made a career in Washington, Gadsden observed: "When he died they printed it in the papers all around the world. When the news got to New York, they sent it on to London. When it got to London, they sent it on to Paris—all around the world." Gadsden's account to the students placed his family's story within the broader spectrum of African American history in the United States. And in concluding, he did "link his encapsulated

society with the national state." "Out of that family of people has come," he said, "practically a whole nation."[10]

Bearing in mind Gadsden's desire to establish his people within the global spectrum, we must look closely at the reliability of his story. Vansina cautions us to look for both "unconscious distortions" and "obvious alterations." He advises us to be suspicious "as soon as characters conform to ideal types." On the other hand, if "traits or anecdotes run counter to fashion, they should be seen as reliable." Reliability is also influenced by what Vansina calls the "dynamics of accounts." If the story has become "fused" from several generations of accounts and has become a fixed recitation, Vansina feels we won't be able to learn where the blending process occurred.[11]

Gadsden's story was probably beginning to be fused out of several accounts. He was of the fourth generation of his family in this country. However, since he learned the story from his grandmother and her sister, who came from Africa with their parents, Gadsden is only the second generation beyond the actual participants. His story had not become a fixed recitation when the two versions were recorded. Nor does his story present the stereotypical situations of slaves coming to this country. Throughout the body of narratives from former slaves, there are innumerable repetitions of the tale of trickery with red cloth luring slaves to boats. Gadsden gave no such simple tale. He described an intricately constructed trade system. While it did involve cloth, he described a particular type of cloth that we now know was preferred in a specific region of the Kongo coast at the time his people came here. Furthermore, Gadsden insisted that his people were not brought by Englishmen, the slave traders known to all of us, but by a Dutchman. We will see that this was possible, that there were still Dutch traders in the region where this type of cloth was preferred. Gadsden's tale is rich with specific detail.

His two versions differ as to his family's place of origin. Lindsay's version records the origin as Nigeria; the taped oral version records the origin as the Kongo. The second version is the more reliable for three reasons. The most compelling is the coincidence of evidence. Details of Gadsden's account mesh closely with the economic and political situation among coastal peoples of Loango Bay at the time, and at this time by far the largest percentage of Africans coming into the Sea Islands were from the region of the Kongo. Second, as we have seen, the oral version is the more spontaneous. Third, Gadsden knew that Lindsay knew much about Nigeria and had consulted an Ibibio scholar from Nigeria about the story. Following Vansina's advice, we are obliged to suspect that Gadsden could have had another motive for giving Nigeria in this version.[12]

In judging between versions we can never know that our choice is correct. Much of historical writing is inference. But reconstructing the African American past often requires taking a leap—not of faith, but of rational probability. Where the ultimate fact cannot be documented, we must, if we hope ever

to understand, apply logic, buttressed by a large accumulation of supporting details. Actually, the leap we take in Gadsden's case is not great. When Melville Herskovits set out to validate the "Negro Past," he found that one must begin by establishing "tribal origins" as accurately as possible.[13] Since his time, the study of slaving operations has given a fuller picture of origins, so that where scholars once would have been bothered because they did not know a region of origin, we are now examining origins from specific peoples. Our tale is more tightly woven than it could have been even a few years ago.

The passages that follow are iconic: they stand for the many similar stories we can never know. But how does one read such icons? Understanding Gadsden's narratives is easy: we are used to hearing and reading stories. However, understanding symbols in visual art presents a different problem. To understand the icons given us by Doyle and Traylor, we must read their pictures. But how do we do this?

Again, Vansina has provided both a penetrating raison d'être and guidelines for use. Art, he says, "acts as a total proof." It confronts the historian with a concrete, tangible statement from the past. "Art is the past coming to us," he says, "without simplification, without generalization and it comes to us at a glance. It is an ideal mode of expression to render a situation directly rather than to describe it with all the selectivity description entails." Historians work with data to reconstruct the past as fully as possible. We build structures of progressions, causes, effects. When we then look at a work of art from our chosen time and place, our construction must stand up to its statement. It challenges our accuracy. And, as Vansina notes, "It is because of this power to challenge, to uncover precisely what remains unknown and what is known, that art works are important to historians."[14]

Art can be a record of historical events. Let Sam Doyle show us how this works. On a spring day in 1983, I stood in "Sam's Gallery," the front yard of his home in Wallace plantation on St. Helena Island, contemplating a painting. Across the top I read, "America. L 1893." What did it mean? Doyle wasn't at home. I came back later and asked. "Oh," he said, "that was the storm." *The* Storm. . . .

On September 20, 1989, the governor of South Carolina ordered all residents of the South Carolina Sea Islands to evacuate. "Hugo" was approaching. It promised to be the most devastating hurricane the twentieth century had yet seen. Residents paid attention, and although "Hugo" came ashore with enough force to level almost every tree for fifty miles and do significant damage all the way to the mountains of Virginia, only a handful of lives were lost.

Ninety-six years earlier, however, on Saturday, August 26, 1893, heavy rain and wind also pelted the South Atlantic coastal states. The telegraph service wired warning of an approaching storm. In Port Royal Sound, those

seamen who got the warning ignored it and went about their phosphate-mining business even as currents picked up and boats strained at their moorings.

On the Sea Islands, there were no warnings. Almost no white people lived here—only African Americans, freed slaves and their children and grandchildren. Many of them were small landowners, trying to support themselves independently with their own farms. There were no telegraph wires here. The only communication was by boat.

By Sunday, the dirt roads—the only roads—were so awash that getting to church was virtually impossible. From Beaufort, a traveling insurance agent found the sky so ugly he was afraid to leave his family alone. The winds picked up and hit full-storm force in mid-afternoon. "The first effect," he reported, was "the fall of the great oak in front of the Sea Island House." By four o'clock, he said, the gale "was blowing so hard that every house here was shaken." By midnight, "great trees all around us as far as the eye could see were being uprooted or snapped off."[15]

By ten o'clock on Sunday morning, the tide was due to peak in Beaufort at eight feet. Two hours later, it had not begun to ebb. At one o'clock in the afternoon, it was two and a half feet above its high-water mark, and the sea was smashing Port Royal and Beaufort with 20-foot-high waves. But the real peak of the storm was yet to come. Some time before dawn on Monday morning, the wind shifted, water rose to nine feet above any recorded height, and hundreds of houses washed away. In Beaufort, large warehouses were crushed. On the railroad line near Charleston, twenty "great refrigerator cars" were picked up by the wind, "their couplings snapped," and they were "hurled from 30 to 50 feet over into the adjoining marshes."[16]

Traveling up the coast, the storm reached Maryland and Delaware on Monday night, hit Long Island, and lashed the Battery on Manhattan early Tuesday morning. Inland, it reached as far west as Pittsburgh and Chicago. To the north, it tore apple trees up from their roots on the Massachusetts–New Hampshire border. It knocked out all telegraph communications, first from Savannah to Richmond, then from Chicago to New York. In many areas, railroad service was washed out, tracks ripped out of their beds. But in these places, most of the people survived.[17]

In Beaufort, a week later, someone spoke to a middle-aged African American man from St. Helena. On August 26th, he had had a wife and sixteen children. On August 28th, he had no one left. The *New York Times* correspondent commented that it "was in the outlying districts, where the poor plantation hands, wood choppers, and factory hands live, that death found her harvest." From Little Edisto Island, a descendant of plantation owners wrote that when the storm broke there were twenty-one people on his farm, and when it was over there were five left. Sixteen African Americans had drowned. By noon on Monday, the *Times* reported, "every one on the chain of islands about here had become a grave digger." By September 4th, the

count of the dead was given as a minimum of 1,000. But a week after the storm, bodies were still being found, and with contamination rampant, they were buried as quickly as possible.[18] We will never know how many hundreds of people vanished in the water, but we know that they were almost all African American. And in the islands to this day, each African American family still has a story of the 1893 storm.

In the 1970s, when the students gathered oral histories, they heard the stories. On St. Helena, they heard them from Amanda Bradley, who was 4 years old in 1893; from Rachel Holmes, who marked her husband's birth year in African fashion as "the year after the storm came"; and from Ben Mack, who told them "twenty-six people drowned right there." Edward Milton, born on Independence Day in 1879, identified his maternal grandparents, Rentie and Lydie Capers, as the ones who "slip off in that storm." Flowers Polite described the darkness and the plight of the farm animals and told about her uncle who carried his six-month-old baby up in a tree to escape the rising water. He lost both the baby and his wife.[19]

On Edisto Island, Nick Lindsay heard Sam Gadsden's tale of the storm. Gadsden was 12 years old and never forgot the day. He was out with two friends, who went off in other directions. He was alone when suddenly "it began to fog-rain." The wind began to howl. Frightened, he ran across fields and through woods where trees were bending to the ground until he came to Peter Wright's house. He sat on a step; the stairs began to break up. He panicked and ran out into water up to his waist and rising. He didn't remember how he got to his own house. There were so many people crowded on the stairs there that he "climbed up on the underneath side of the stairs, like you climb the back side of a ladder when it's up against the house, hanging upside down like a squirrel." The next day he heard that Peter Wright, his wife, their son, and James Wright and his daughter were all drowned. All the people on Joe Island and Whooping Island drowned. Then he added, "More people died after the storm than died in it. There was nothing to eat, the whole island stank with dead cattle. . . . All the crops for that year were wiped out and the land was too salty and wasn't fit to plant the next spring, 1894. . . . The next two years sickness broke out and killed almost all the old people."[20] Nobody forgets such a milestone.

Sam Doyle was not born until thirteen years later, in 1906. But he painted a story of the storm (Plate 1). It was not "America. L," but "a miracle." In a yard near Doyle's house stood a great live oak. All of his life, his family told a story of the family who lived near it. Those people also lost a baby in the raging waters. They grieved for their baby. Then, three or four days after the storm subsided, the father happened to walk near the tree and heard a faint whimper. Looking up, he saw his baby Dianne lodged in the branches, alive.[21] It was "A. MERICAL." Doyle painted the swirling waters and the baby lodged in the tree, her clothing ripped but her face animated and limbs flailing—alive.

Because Doyle painted the miracle of Dianne's life, the story was not lost. He brought the past to our attention, giving us, indeed, a work of art that acts as Vansina specified, "as a total proof." The painting is proof of the event in time, in emotion, in faith, and in the oral tradition of a people—proof in one immediate visual statement, a "concrete and tangible statement from the past." Our construction of the event stands up to Doyle's statement. Our accuracy holds up to his challenge. In addition, the artist adds another dimension to understanding the history we are reconstructing. With the impact of the concrete and tangible visual statement, we are forced to feel the union of pain and joy. The artist makes us at once know history and care about it. That is the reason for using art as historical document.

In addition to letting us respond to historical events, art can reveal society's activities, structures, and values. Society, says Vansina, is "the mother of art." Its activities can be revealed by objects that show up in art—tools, clothing, food, houses, furniture, vehicles. Objects can be symbols of government, social status, rites of passage, religious beliefs. Objects provide clues to the society that has mothered them. The historian's job is to find the context from which the object came into the piece, and the context can be obscure. From African art, Vansina offers the example of a fly whisk, an object for shooing and swatting flies. But it is also a ruler's symbol of office. It designates his status. When we see a representation of a man holding a fly whisk, what we see depends upon what we know. If we merely know the culture's tools, we see a man with a fly swatter; but if we know the culture's government, we see a man of authority. Vansina draws the distinction between "the immediate use," swatting, and "the main use," which designates placement in the social structure.[22] The historian elucidates the context that enables us to understand what the work of art can tell us about the society it comes from.

But let's look next at a more complex example. Among some of the Igbo of Nigeria, when a man dies, his oldest son performs the ceremony of "bringing his father into the house." He gathers together a set of symbols of the dead which include ancestral symbols, among them his father's ikenga. The meaning of the word *ikenga* encompasses the individual's spirituality, his achievements through his personal abilities and good fortune, his strength and fearlessness, and his status in the community. It has a relationship with his father's spirit, transmitting continuity and ancestral spirituality to his personal god.

Ikenga is symbolized by a wooden piece. Documents from the precolonial era in Africa may refer to the symbol of ikenga as a "stick." One might then imagine the symbol to be any sort of stick, maybe a tree branch, a walking stick, or even a drumstick. From an exhibit of art objects, however, we see

ikenga symbolized by a length of sculpted wood. Usually it is an elongated abstract figure with a carved head and horns and with decoration incised or in relief.[23] Adding its own cultural context, we find that ikenga has less to do with aesthetic beauty and much to do with individual human personality. If we can read its carvings, it will tell us of its owner—his morality, strength, achievement, prosperity, ancestral heritage, spirituality, social rank. When the Igbo man joins the Ozo title association, a secret society, the first ceremony of his initiation process is the same inyedo mmuo: "bringing in the father." The sculpted ikenga symbol and the other ancestral symbols represent the man's own personality and fortune.

Another work by Sam Doyle will further illustrate what a work can teach us about society if we pay attention. Doyle painted two African American boxers fighting. They appear to be contemporary with us. Wearing boxing gloves and shorts, they are fighting in a ring. Doyle painted "ABE.," the word and the period, in the upper left corner and "KANE" in the upper right corner.[24] The painting was exhibited as Abe Kane. But titling it that way ignores both Doyle's period and the wide space he left between the words. His painting is a metaphor for the biblical story of Cain and Abel. Here they are African Americans, contemporary men fighting. Doyle's pictorial statement blending Christian with African heritages proclaims the immediacy of African American faith.

These two examples illustrate the difficulty of actually seeing what we're looking at. In A. MERICAL, the colors of the letters—the brown "A" versus the "MERICAL" in red—and the brown period separate words. In Abe. Kane, Doyle intended the separation that the period and the space between the two names imposed. The separation indicates the cultural reference for this painting. Although their subjects appear to be secular, both of these paintings are clues to how all-permeating religion is in Doyle's society. The cultural reference eluded viewers, but it was there for discovering. Doyle's words, his punctuation marks, and his coloration of the words are details which must be seen together with the objects in his paintings in order to catch the clues they provide to his society. If we overlook some clues, the context becomes more deceptive than it need be.

With art work as stimulus, the historian can look for a deeper cultural statement than written documents often reveal. Sometimes this is relatively easy. In Doyle's two paintings, most of the clues were accessible to Eurocentric viewers who paid attention to every pictorial detail and to Doyle's use of words and punctuation marks, elements understood by all who read English. Sometimes, however, the deeper cultural statement may depend on evidence that even African American viewers can't readily recognize. For example, in a drawing by William Traylor, a woman is wearing a skirt decorated with figures that look like an nsibidi symbol for leopard. (Nsibidi is the ideographic writing devised by secret societies of the Ejagham grouping of people in Nigeria and Cameroon.) But how could Traylor, an Alabama

country man, have had any contact with a Leopard Society? Even a histo-rian searching for a chronological and geographic path of transmission might fail to trace it. Thus, while lecturing on African American quilts, the histo-rian Maude Wahlman showed a slide of the drawing, pointed out the re-semblance to nsibidi, but said that there was no evidence that Traylor could have known of it as a symbol.[25]

An obscure bit of evidence, however, suggests that there was in fact a Leopard Society in the African American community in New Orleans. In a recording, Louis Armstrong gives the evidence in a recitative explanation of a funeral procession's transition from the slow march to the cemetery to the lively march afterwards: "And the snare drum player, he takes the handker-chief out of the snare and roll up so the Leopards can form a line to swing back to the hall playing 'Didn't He Ramble?'"[26] Just as the Leopard Society had reached African Americans in New Orleans, it could have reached Traylor either by way of New Orleans or from the African-born people in his community of Benton. Wahlman's reaction to the figures on the skirt as nsibidi is more justifiable than she thought.

Another piece of Traylor's illustrates the deeper cultural statement in more detail. A Traylor painting was exhibited with the title *Black Dandy* (Illus. 1.1). But Traylor never gave his pictures titles. A street person, he sat on sidewalks in downtown Montgomery where African Americans gathered in the late 1930s and drew what he wanted to draw on papers that other people would call trash. Sometimes he hung a few pictures on a board fence beside where he sat. Mostly he carried his stuff around in a bag. Occasion-ally someone would pay him five or ten cents for a piece.[27] He did not draw to be an artist. *Black Dandy* was his picture, but not his title.

This painting presents the figure of a man dressed in dark clothes from top to toe except for what appears to be a white shirtfront—a vertical rect-angle with triangulated top and bottom, dotted with what seem to be three buttons. He wears a hat with a broad brim. His eye is a large white circle around a black pin-dot. The left hand holds a cane with a crook-shaped handle; the right elbow is bent, the hand on the hip. The head is in profile—so is the body below the waist—but the torso is fully frontal. The left knee is slightly bent, the foot raised.

The clothes of this figure have been interpreted as evening clothes, the white shirtfront as fancy shirt with studs. But is it really a shirtfront? Coats do not generally cover shirts at angles at the neck and waist ends in triangu-lar fashion. Odd details spur investigation. In *Voodoo in Haiti*, Alfred Métraux included an illustration of Baron Samedi, member of the Guédé family of spirits. Baron Samedi is Lord of the Cemetery, a spirit with great power. In this portrait he wears dark clothing; his center front is lighter, with a row of buttons; he wears a dark, broad-brimmed hat; he carries a cane with a crook-shaped handle. Métraux also gave another illustration of a Guédé death spirit. This one also wears dark clothing and broad-brimmed

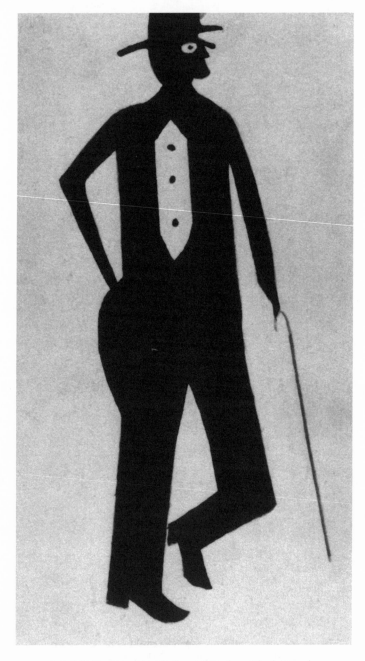

1.1. Bill Traylor, Untitled, exhibited as *Black Dandy*.
Poster paint, pencil on cardboard; 12" x 7¼".
*Private Collection.*

hat; its chest is a white rectangle. Here, however, the shirtfront with buttons has become an open chest, revealing spine and ribs—clearly a body of the dead.[28] In contemporary Haiti, Baron Samedi continues. He is depicted on a sequined flag (Plate 2), where he is identified with his brother, Zaka or Mazaka, a god of agriculture. (The gods, or lwa, have many manifestations.) Such flags, decorated with symbols, originally were made to signal the ritual opening of Vodou ceremony. On this flag, the Baron wears dark pants and a broad-brimmed hat, and his shirtfront is marked with a vertical black line, probably representing the narrow tie he sometimes wears. Here his clothing blends characteristics of Zaka and Samedi. Often his clothing is like Black Dandy's, resembling an undertaker's outfit worn with a top hat. Like Traylor's figure, the figure on the flag carries a cane with a crook-shaped handle. And like Traylor's figure, his eyes are wide, light circles with black pin-dots. Both are like the eyes of the skull on the Vodou flag.

Did the death spirit cross the oceans? In New Orleans in about 1930, another Baron Samedi figure was found in an African American barber's shop. This sculpture, made of wood and having articulated joints, has an upper torso—or an abstract chest—with a flat metal plate. Down the center of the plate—the mid-line of the body—is a line of circular squiggles with dotted centers. Placement of the line renders it analogous to the spine or to buttons on a shirtfront. On the plate are several concentric circles surrounding the heads of some of the nails which attach the plate to the torso. We cannot know whether the figure was dressed in black clothes or broad-brimmed hat; for if it wore clothes, they are gone.[29]

The cane held by Traylor's figure is another clue. Like the fly whisk described by Vansina, the canes carried by Traylor's figure and the Baron Samedi figures seem to be mere "objects of social activity." However, for Kongo people, the cane symbolized fearlessness. It allowed an elder to walk upright, so it functioned metaphorically as a bridge across the water between the worlds of the living and the dead. With it, the elder could cross into the realm of the dead without fear.[30] Black Dandy seems to be a Baron Samedi, holding his cane and walking upright, fearless. Perhaps he, too, guards the houses of the dead in the New World.

By looking at this group of similar works of art, we can begin to reread what Traylor was saying. There are other signs that indicate what beliefs informed this work. Referring to the Haitian artist André Pierre, Sheldon Williams noted that Pierre painted Baron Samedi "in cheerful vein. His skull-and-crossbones tricorne is worn jauntily. His black undertaker's suit (chief undertaker) is decorated like a Cockney Pearly King's." Baron Samedi is not a somber spirit. In Haiti, where Baron Samedi is head of the Guédé group of spirits, the dance of the Guédés is erotic, and their songs have obscene verses. On the *Mazaka Guede* flag, as in Métraux's and Pierre's illustrations, Baron Samedi also wears some decoration on his suit, and his position—the torso frontal and legs turned sideways—is jaunty, perhaps

indicating a dance. In New Orleans, Baron Samedi wears exuberant decoration on his chest. And in Traylor's work, Samedi's counterpart stands with chin lifted, one hand on his hip, and his left foot slightly raised—all combining to lighten his movement, to give him a rather cheerful stance. Traylor did a number of versions of the Samedi figure. One version, a figure virtually identical to the one called Black Dandy, has kicked one foot up in the air and grabbed it with one hand, while the other knee is bent as the figure balances on his toe and his cane. Another figure is done with a hollow, or blank, chest similar to Métraux's figure but without the spine and ribcage. This figure also wears black and a top hat, is jaunty, and holds up in one hand another symbol of Baron Samedi, a bunch of leaves.[31]

Clothing like Baron Samedi's and Black Dandy's shows up in folklore and in cunjuring. There, too, the clothing symbolizes elements in the same underlying system of beliefs. George Young, born in 1846 outside of Livingston, Alabama, saw a spirit one day when he was working a cotton field. It was, he said, "a man all dressed in black, wid a white shirt bosom, his hat a-sittin' on one side, ridin' a black hoss." This spirit, with his hat cocked to the side, apparently carried Samedi's jaunty attitude as well as his clothing. Young saw the spirit so clearly he at first thought he'd seen a real person. Then he realized that no horse could have maneuvered where he saw it, and he found that his wife, who was working with him, did not see the figure. Liza White, from Lee County, Alabama, also saw a "haint" riding "on a mule or horseback, wearing big hat." Jake Dawkins was walking to church and stepped aside to let a spirit pass him. He said it had "a white bosom." A woman from Algiers, Louisiana, who was born soon after the Civil War, became a specialist in cunjuring. Giving instructions on how to connect with the spirit who controls the fork of the road, she said he will appear dressed in black. And she emphasized the seriousness: "When yo' git in touch wit de fo'k of de road, yo' gittin' in touch wit a whole lot." You will be fearless.[32]

In reading these works of art, it is much easier to identify the Baron Samedi figures with their cultures than to identify Traylor's *Dandy*. Haitian culture knows itself, and its conventions for representing Samedi are well known. In New Orleans, the situation is comparable. The New Orleans Baron Samedi was found with a coating of chicken feathers and blood. Even if the collector of the figure had not been told that it had been used in sacrificial rituals, this knowledge is easily available. However, when we look at a piece from central Alabama, the context is more obscure. To use it to interpret African American culture in central Alabama in any depth, we must follow Vansina's advice to use the work of art as a document for history and to use it as the stimulus for the questions we hope to answer. The work then leads us to a broader search—into folklore, in the case of *Black Dandy*—and to a deeper examination and understanding of the culture.

Fly whisk, ikenga, *Abe. Kane,* nsibidi, *Black Dandy*—all these bits of evidence have suggested how art can reveal African influences in aspects of African American culture. And other evidence is visible around us every day in small traits that appear odd in a culture dominated by European systems of values. For example: hair is divided into little blocks with a pigtail in the middle of each block; house yards are swept to bare dirt with no grass allowed to grow; church "mothers," dressed all in white, take care of individuals who fall out (faint) during church services; glass bottles are impaled upside down on bare tree branches; clocks are placed in graveyards. Even historians may see these practices as mere oddities peppering American culture with African remnants. But perhaps the bits cohere on deeper, broader levels. If so, where might we discover evidence of that coherence? We will be guided by the words of Phyllis Biggs, who was brought from the Kongo in 1818 when she was 12 or 13 years old and sold into Talbot County, Georgia:

> They stripped me of everything but my thoughts. But one day I balled up my fists and held up both my arms. With my left arm I held my freedom to think and my freedom to pray. With my right arm I held on to my religion, my art, and my music.[33]

As we further examine African American oral histories and works of art, we will look for ideas that have carried African principles of social organization into African American culture. But first, we need to identify principles from the African cultures whose people were brought to America as slaves.

Most African people brought to the United States came from regions of the continent with access to the western coast south of the Sahara desert and north of Namibia. Through many centuries—long before people were brought to the Americas—varying degrees of contact took place among peoples there. They influenced each other's customs and languages. Many groupings share a basic concept of social organization, although the degree to which it dominates varies across groups. Among the most complex, formalized institutions are those sometimes called title associations. Some examples include the Ogboni society of the Yoruba people, Ozo among the Igbo, Poro and Sandogo of the Senufo, and Lemba among the Kongo. Many of these societies spread among peoples and now cross national boundaries. Poro may be the best-known example; Tyi Wara, of the Bambara, is another. Whether relaxed or formal, the groups have common characteristics: initiations, public and private ceremonies, social celebration, a degree of control over the community, a stabilizing influence in the community, and secrecy.

One example illustrates both how extensively one of these societies could influence various aspects of a community and how powerful the institution was in African society. In southeastern Nigeria and Cameroon, the Ejagham,

or Ekoi, people developed a society called Ngbe, meaning leopard. Before the colonial era, Ngbe was extremely strong, and scholars believe that related peoples throughout the Cross River basin adopted it. In Old Calabar at the Cross River estuary, the Efik people, a related group, called the society Ekpe, their word for leopard.[34]

In the eighteenth century, at the height of the slave trade through the Bight of Biafra, the Efik controlled Old Calabar through their Ekpe association. Through time, the number of levels in Ekpe varied from five to twelve. Members paid high fees and went through initiation ordeals at each level. They learned secret identification signals which then afforded them safety as they traveled and made themselves known to other members where they were strangers. Fees were pooled and donations made to members in need. Ekpe was also a social group. Members gathered for feasting and drinking, and Ekpe was related to another society that met to gossip and sing. It also was related to a mortuary society, which regulated burials of members. In the community, Ekpe made laws and enforced them. Its powers derived from the Ekpe spirit, giving the force of religious belief to the association's mandates. The association was the interpreter of the spirit's wishes. The community was made up of several lineages which held belief in the Ekpe spirit in common. The association, as the spirit's representative, therefore unified the lineages. From this position, it was able to arbitrate disputes between lineages. As the slave trade grew, the Efik gained a monopoly over trade by developing a complex credit system and enforcing it. Ekpe thus operated in every facet of the community's life—religious, legislative, judicial, social, and commercial.[35]

Secrecy permeated every facet. Well into the twentieth century, nonmembers were killed for witnessing secret ceremonies, and members were killed for revealing secrets. Ekpe owned land and a "palaver house," where it held secret ceremonies and meetings and kept its costumes. One day of the Efik eight-day week was designated as Ekpe meeting day. On this day, Ekpe's messenger dressed in a knitted bodysuit patterned with horizontal stripes of red, white, and yellow or bands of triangles and a hood covering the head. At the waist, he wore bells which warned the community that Ekpe was coming. In Cameroon, the bells hung from a red sash and a white one. The people there said that these showed that the wearer was a messenger from the realm of spirits of the dead. Often the costume's pattern represented the leopard's pelt. In early times, there were two messengers. One carried a long, narrow, tapered rod, and the other carried branches of green leaves. The rod was for punishment and the leaves were for salutations, either actually or symbolically.[36]

The messengers chased all uninitiated people, especially women, indoors and patrolled to keep them in. The recalcitrant were whipped; the persistent, beheaded. On October 14, 1786, Antera Duke, an Efik senior member of Ekpe in Duke Town, Old Calabar, was working at the palaver house and

heard that "Egbosherry Sam Ambo had caught seven men." "So," Antera Duke said, "we sent the Ekpe drum to blow, forbidding everyone in the town to come or go to market." Ekpe thus affected even how ordinary daily living could occur. Antera Duke himself worried about whether his own "cabin boy" had been captured on this slaving expedition. He sent "one good canoe" to see about the boy and the next day wrote in his diary that he wasn't able to eat all day "for fear [the boy] should be caught."[37]

Ekpe had a sacred mechanism with which members produced a leopard-like noise behind a screen of blue and white cloth, called ukara, which was printed with nsibidi, Ekpe's secret writing. Nsibidi was inscribed on the society's drums, which also functioned as messengers. Drums told people to stay inside and gave permission to come out. Traditionally, Efik houses had no windows so that secrets could not get out. Later, when senior Ekpe members began to build windows into their houses, slaves still could not have windows lest they witness secrets.[38]

If debts were not paid, Ekpe forced collection. On May 10, 1785, Antera Duke wrote that he "saw Sam Ambo carrying the Ekpe drum to Dick Ephraim." Dick Ephraim owed a debt that he had not paid. Sam Ambo was probably taking a small drum with nsibidi signs which would tell Dick Ephraim that he was in serious trouble and must appear before the society's judges in the palaver house.[39] Ekpe therefore extended its control even over the Efik system of writing, mandating its use and keeping its meaning secret. When an Ekoi informant was asked to teach nsibidi to an ethnologist, he said he would not, because "if I taught him Nsibidi, he would know all the Egbo signs and the secrets of the animals."[40] Secrets must be kept.

This basic secret-association concept of how to organize society permeated West Africa so broadly, in terms of numbers of peoples affected by it, and so deeply, in terms of intricacy in the social structure, that Africans carried it with them to all parts of the Americas. Wherever and whenever they were able to construct their own social systems, they built from this concept. In Haiti, secret societies began, it is believed, among the maroons during slavery. When freedom came, the secret societies proliferated, formed by local farmers to protect their lands from government takeovers and redistribution. Today the concept perseveres in the Bizango society, which walks the streets at night. Members are preceded by a sentinelle who warns them of approaching vehicles. When the sentinelle blows his whistle, those in the procession lie down to escape recognition. Bizango sings a song of warning to neighbors who might overhear their meetings:

Be careful about what you might say.
When we organize a Bizango rally,
We don't wish for you to start talking about our
   songs and dances, the morning after.[41]

The compulsion to secrecy is so strong, in fact, that one American ethnologist who gained access to Bizango's inner workings has elected to keep his information confidential to preserve the custom of the people who trusted him.[42]

Many other examples of forms of these societies have been seen in the Caribbean and South America since Africans were first brought there. In the eighteenth century, a Benedictine prior found secret societies formed by Africans in São Tomé and its environs. In Cuba, cabildos took care of the elderly, gave mutual aid, held dance celebrations, bought slaves' freedom, and arranged the proper funerals for their members. In the 1930s Zora Neale Hurston observed vestiges of ceremonies in Accompong, Jamaica. More recently, Seth and Ruth Leacock, anthropologist and historian, studied the Batuque organization in Belém, Brazil.[43] Among African Americans in the United States, vestiges of secret-society organization and ceremony have also occurred in many contexts. Vestiges appear in the "mysterious" practices variously called witchcraft, voodoo, hoodoo, conjure, and whatever other terms Hollywood has devised. Vestiges show up, too, in the rich body of folklore and in the narratives of oral history.

But one context—the beneficial society—became thoroughly formalized. It probably flourished because it seemed to be copying white fraternal organizations, so white society left it alone. For many years it was dismissed as a mere parody or exaggeration of such white groups as the Freemasons or Elks. Yet close examination reveals that African American orders differed radically from their so-called counterparts and have close structural and philosophical ties with African concepts of social organization. All of these strands of social organization as Africans knew it are woven into the works of Sam Doyle and William Traylor. We have but to recognize them. The fabric of African American culture is a complex interweaving of strands that forms a whole cloth.

# 2

## Into the American Community

It was "*not* the English," Sam Gadsden emphasized. "It was the *Dutch.*" Those were the people who brought his great-grandfather's family to this country. He reported the story as it was given to him by his grandaunt, his grandmother Rebecca's sister. The girls were daughters of Gadsden's great-grandfather, Kwibo Tom. They all came to the Sea Islands together.

Gadsden said that Kwibo Tom's father, whose name also was Tom, was a "chief" among his people in the Kongo. They knew "all about where to find elephants" and how to get the tusks. At the same time "they didn't know much about cloth." Tom's family lived "in the Kongo," where the Dutch wanted to buy "elephant teeth . . . and elephant bones and things," so they went into the area to trade "nice flowered cloth . . . and pretty things . . . and trinkets" for tusks.

In the Sea Islands, Gadsden said, "the Dutch" found people who needed "plenty of labor" to work their "rich place," and they figured out how to "get some of these tribal people" who were "good workers." "They can outwork these white people. They can stand there and *mow* a yard!" So the Dutch fooled "these people who wanted to get the nice things" by promising to take the Kongo people to the place where they could get the cloth for themselves. And so young Tom's father "sent a whole family, expecting to get them back." He sent Kwibo Tom with his three wives and all of their children and Tom's brother, Wali, with his wife and children.

The Dutch ship sailed to the coast of South Carolina, Sam Gadsden continued. "My grandaunt said that the way they come to this country. They land some place they call Bohicket—over there to Wadmalaw, and a white man bought them from the Dutch. . . . And the man who bought them there—Mr. Clark . . . had places on Wadmalaw and on Edisto." Clark kept members of Tom's family on both islands, but, as Gadsden explained, "they were a family, were sisters and brothers right on, because they could row across the river and work on the Clark place and could row back." Later, when Clark's daughter Lydia was married to Major Murray, some of the people moved to the Murray place on Edisto Island; some other members of the family were taken to Fenwick Island. Those on Fenwick Island raised "a whole lot of children," and so did those on Edisto Island. But still they were able to row back and forth between islands, and so they remained one family.[1]

Sam Gadsden's story probably gives the particulars of the tradition recorded by Nell Graydon, which held that many of Edisto Island's African

American people were "descended from an African king."[2] With an examination of the history of the slave trade on both sides of the Atlantic at the time when Gadsden's forebears were brought to South Carolina, we will be able to watch legend change into reality.

Gadsden thought that his family was brought to Bohicket Creek about 1820. The Mr. Clark who bought the family was James Clark III, who owned plantation land on the tip of Edisto Island at Botany Bay. At that time it was called Clark's Bay. Clark died there on October 4, 1819, and Gadsden's people are listed in Clark's estate inventory of 1820.[3] They must, therefore, have come shortly before 1820. By this time direct importation of slaves from Africa had been illegal for a dozen years, so Gadsden's forebears were victims of smuggling, sneaked into an obscure creek long after the congressional prohibition of January 1, 1808, banned the importation of slaves from Africa.

The story of the smuggling traffic in slaves from 1808 until the Civil War has yet to be told. But for at least two reasons the story is not easy to tell. Obviously, most smugglers prefer not to keep records of their operations. And this phase of the slave trade found the young nation struggling in a churned-up world which erupted into the War of 1812, pitting Britain and the seventeen new United States against each other. Britain, which had the power on the seas, began to follow her impulse to abolish slave trading. During the Napoleonic Wars her seamen boarded and searched ships of other nations. This technique could help combat the slave trade if she could continue to use it; and by 1818 her foreign minister, Castlereagh, had concluded limited visit-and-search treaties with Spain, Portugal, and the Netherlands. The United States, still smarting from resentments of the War of 1812, adamantly refused to agree. The American states were now involved in heated contests over extending slavery into new territories. Sugar cane cultivation was increasing. The invention of the cotton gin and new techniques in manufacturing textiles spawned expansions in cotton farming. The luxuriant long-staple cotton of the coastal islands was making planters' fortunes in a single year, and in 1819 planters did not see that their cotton culture was already declining. They felt they needed more slaves, and more, and more.

Geographically, no shoreline could have been better laid out for smuggling than the coasts of South Carolina and Georgia. Tidal streams, rivers, and inlets led to uncountable islands. Almost all are accessible to others by rowboat and many, at low tide, by foot. Beaufort County, at the southern tip of South Carolina, counts over ninety islands that have names.[4] No amount of patrolling by land or sea could have stopped smuggling. Pirates found their havens here more than a century before Kwibo Tom's smuggler brought him to the United States. Place names still attest to their presence. A little way into the North Edisto River from the Atlantic Ocean, Kwibo Tom's Dutch sea captain passed a tip of land called Privateer Point, the

entrance to Privateer Creek. Privateer Point lay on the north side of the river, opposite Clark's Bay. Legend tells that Clark's Bay and its surroundings were well-known landing spots for smugglers and pirates.[5]

Between 1808 and 1820 federal authorities, who were encumbered by bureaucracy, made little headway against slave smuggling. There was no workable enforcement mechanism. Because the Treasury Department handled collection of customs duties, it was first assigned to enforce the law. But because the navy soon had to send cruisers after slaving ships, enforcement ultimately devolved to the Navy Department, sometimes passing through the State Department or the War Department on the way. Confusion over who was in charge was the result.

To try to curb smuggling, law enforcers on the East Coast focused most of their attention on the mouth of the St. Mary's River, which formed the boundary between Georgia and Florida. Since this area was under the command of the port of Charleston, the sailing ships patrolled coastal waters for a distance of roughly 200 miles. In January 1811 Secretary of the Navy Paul Hamilton directed Commodore Campbell at Charleston to hurry up and get gunboats down to St. Mary's, as he had heard that slaves were frequently being taken ashore there.[6]

A man who wanted to deal in smuggling first had to find one or more backers and make arrangements for a safe landing spot. He had to find space on a ship, or command one himself, and have the slaves transported and secretly landed at the spot previously settled on. Charles G. Cox was one of these men. His story was told through the records of the Florida Supreme Court after he and his associates were so unlucky as to be caught. After at least two of his proposals for financing were refused, Cox received money from a Frenchman, Paul de Malherbe, and a Floridian, Farquhar Macrae.

Cox bought slaves in Havana and became master of the *Emperor,* a schooner supposedly owned by Anthony G. Richards of Savannah. The *Emperor* sailed from Havana with Cox in command and Paul de Malherbe on board as a passenger. On the afternoon of February 6, 1837, the *Emperor* was sighted off St. Joseph Peninsula on the northern Gulf coast of Florida. That night Cox transferred his slave cargo to a boat in charge of de Malherbe. De Malherbe landed his cargo somewhere near Port St. Joseph and immediately paid with his life. His boat went down, and he drowned.

Cox, however, did not suffer. The slaves were collected as planned by Joseph R. Croskey, who later became the American consul in Cowes, England. Croskey took the slaves to his plantation in Washington County, Florida. Eight of them were identified by the overseer, who called them Milo, Peter, Coogar, Jim, Tony, Larkin, Sam, and Harper. They were all African. Only Milo spoke English; the rest spoke African languages and understood no English. Milo said he came from Africa. Two of the men were cicatrized, and two had filed teeth.[7] Only slaves born in Africa would

have had these characteristics. These were customs belonging to traditional peoples; in some areas the marks signified initiation into secret societies.

Peter died at the plantation. Three months after their arrival there U. S. Marshal Samuel DuVal took the remaining seven into custody. In 1838 they were declared free, but in 1839 DuVal still had them. No more of their lives is known. Milo, Peter, Coogar, Jim, Tony, Larkin, Sam, and Harper retain this much identity only because Cox was caught when he sailed the *Emperor* on another voyage from Havana into Pensacola against her owners' directions. In Pensacola he was arrested by the customs collector and jailed, but he was released on bail and never convicted. The *Emperor* was ordered sold, and DuVal was to deposit the money to the court registry. He did not do so, but held on to it for two years until the sheriff forced him to pay.[8]

While the government considered returning recaptured slaves to Africa, it did not activate a plan to do so. At least one marshal was told to "dispose of them in such a manner as to cause least expense." They theoretically were to be held over on plantations until they could be sent back to Africa. Mostly they disappeared into slavery.[9] Thus, DuVal probably held onto Milo, Coogar, Jim, Tony, Larkin, Sam, and Harper.

Off the St. Mary's River, Commodore Campbell's gunboats could not be effective. With the navy's attention diverted by the War of 1812, Amelia Island, just at the mouth of the river, became a hive for slave smugglers. Smuggling was profitable. In 1812 Philip Drake, a supposed slave smuggler, wrote in his diary that he expected to make $8,000 for 100 captives—"a tolerable setup," he said. He expected the sale to provide the capital to start his own trade business.[10] Amelia Island was such a choice location that the notorious pirate Luis Aury moved his headquarters there from Galveston, Texas, in 1817. Within two months he sent 1,000 African slaves inland. Captain John Henley of the USS *John Adams* told the secretary of the navy that he was sure Aury was sending the slaves into Georgia. Henley found Georgia residents "too much inclined to afford every facility to this species of illicit trade."[11]

Other U.S. government officers bore him out. The customs collector in Savannah wrote to the secretary of the treasury in November 1817 to tell him that a schooner with Spanish papers had been brought in by the USS *Saranac*, commanded by Lt. John H. Elton. There were 128 Africans on board. Four years later Judge William Johnson of Charleston told the secretary of state that these were bought by a citizen of Georgia who lived on the Savannah River. Such illegal import and sale was confirmed by the district attorney of Savannah at the same time.[12]

In March 1818 W. I. McIntosh, the customs collector at Darien, near Brunswick, Georgia, wrote the secretary of the treasury regarding eighty-eight smuggled Africans and commented that they were sold into Georgia or transported through Georgia to other states almost every day. "These facts are notorious," he said, "and it is not unusual to see such negroes in

the streets of St. Mary's." And, he continued, they were "illegally bartered by hundreds" in Savannah. He explained how the governor and other state officials managed to get the slaves returned to themselves after they were taken from smugglers by federal officials. In July McIntosh delivered ninety-one more Africans to the governor of Georgia.[13] Indeed, slave smuggling in Georgia was so rampant that David B. Mitchell gave up the governorship of Georgia to pursue the more lucrative illegal trade under cover of serving as the U.S. agent to the Creek Indians.

The same smuggling process operated in South Carolina. In March 1822 a pirate was captured while trying to sneak Africans into St. Luke's Parish, just south of St. Helena Island.[14] Earlier, in 1819, Thomas Parker, district attorney for Charleston, had alluded to the ease of smuggling. His job required him to find placement for Africans who were found on board captured slavers when these ships were taken into Charleston. On July 18, 1819, he addressed the issue of what to do with a group of over 100 Africans, describing thievery among those receiving smuggled slaves:

> I have received information from a person who will not be seen in the business, that upwards of 100 of the same parcel . . . were offered to him to be conveyed into the country on certain conditions. I have been well informed of one or two cases, in which the first party imported Africans contrary to law and hid them in the woods, the second party robbed the first, and the third the second, and the negroes could not be traced.[15]

Four of the smuggled Africans were held in jail under the supervision of the marshal of South Carolina. A year later the secretary of the navy directed the marshal to put them "at service, where they will be treated with kindness and humanity, and safely kept, until they can be removed."[16] The marshal tried to find paid employment for them but could not. However, District Attorney Parker contacted him in May with an offer to take them to his own plantation, sixteen miles outside Charleston. There he would keep them on the same status as his own slaves:

> I will house, clothe and feed them as I do my own, but I will not agree to pay the physician's bill, nor be answerable for them, should they run away, or be *stolen*. As to running away, it is not probable they will do so, as none of my own have ever run from me. As to their being stolen, there is some risk of its being done, in case the importer should find out where they are, as such things have already been done in Charleston, and therefore the place to which they may be sent, must remain a secret.[17]

They must work and be satisfied, he said, or he would send them back. So after at least ten months in jail, the four Africans were allowed to live as slaves and had to accept it. Although they were perhaps lucky enough to be sent to Africa later that year, the rest of the group disappeared from the records. So it was easy in South Carolina, as in Georgia, to lose even recaptured Africans into slavery!

How much easier, then, to smuggle slaves past the few navy patrols and into the islands. And this is what happened to Tom, Wali, their wives, and their children some time before October 4, 1819, when James Clark III died. He bought them at the landing on Wadmalaw Island. They may have been kept for a while on his Wadmalaw plantation, but before long they were rowed across to Edisto Island and walked "first to Legare's," then to Clark's plantations. Thus the family came as Gadsden said: into the creek "about 1820."

It was "*not* the English," Gadsden said. "It was the *Dutch*." But could they really have been smuggled by a Dutch trader? And about 1820?

At first the likelihood looks low. In the preceding thirty years the Dutch slave trade appeared to have collapsed.[18] The Netherlands' West India Company expired in 1791. By 1795 the Dutch Republic had been overrun by the French army. The major private company ceased slaving in 1803. In 1814 the Dutch outlawed slaving, and in 1818 they joined Great Britain in setting up courts in Sierra Leone and Dutch Guiana to try ships seized in the trade. Of the twenty-two ships captured with Dutch papers and brought to Freetown, Sierra Leone, for trial, all proved to be American or French ships with fraudulent documents.[19]

Nevertheless, despite all this evidence of collapse, the Dutch slave trade continued because for well over a century the Dutch had found smuggling lucrative. They had smuggled goods to and from Spanish colonies in the New World; they had smuggled tea, brandy, and tobacco to England; they had smuggled goods to Iceland. As the historian C. R. Boxer said, Dutch smuggling "helped to provide the livelihood of thousands." In 1780 there were up to 40,000 seamen in the Dutch sea trades as well as captains, mates, cooks, doctors, ship fitters, brokers, shipping agents, merchants, and ship-owners. So even though the trade had ostensibly collapsed, it was continued by so-called free traders. They dealt directly with African slavers, gathered smaller numbers of slaves quickly, and carried them on ships swift enough to evade capture by British and U.S. naval vessels.[20] And the free traders had huge markets to supply. Cuba and Brazil were importing slaves by the thousands; and although the United States had abolished importation directly from Africa, slaves could be brought in from ports in the Americas. British naval officers on the West African coast reported large exports of slaves in 1819 and 1820.[21]

The Dutch free traders did not always elude the navies. In 1820 the USS *Cyane* reported from her West African patrol that there were at least 300 slaving ships on the African coast, each with papers of two or three nationalities. HMS *Thistle* captured the Dutch ship *Eliza* in October 1819. In February 1820 the *Thistle* and HMS *Tartar* caught two ships in the Rio

Pongas north of the Isles de Los on the Windward Coast. One of these was a Dutch brig with slaves on board.[22]

A year later the USS *Alligator* was on patrol off Sierra Leone and Liberia. On May 24th she took a schooner, *La Daphnée*. At the moment of capture *La Daphnée*'s mainmast flag proclaimed her to be French, and her foremast flag said she was Dutch. Her captain at the time was a Mr. Gouy. She was equipped for slaving: she had slave decking, exceptional amounts of rice and water, too many crew members for regular trade, and slave-trading papers on board. The *Alligator* put an American crew on *La Daphnée*, planning to send her to the United States for adjudication. Once at sea, however, her foreign crew recaptured her, returned to the African coast, and took on more slaves. *La Daphnée* then sailed for her home port in Guadeloupe, where her slave cargo was put ashore. Because of *La Daphnée*'s provenance it was quite easy to mix up her identity. Guadeloupe was settled by both French and Dutch people. The most conclusive proof of ownership found on board were cargo permits that said she was a Dutch vessel.[23] In February 1822 two Dutch ships left Freetown with full cargoes of slaves shortly before a British navy ship put in to search for slavers. While the Freetown newspaper reported these sailings, it said it could not begin to give the names and destinations of all such vessels. The job would be endless.[24]

The following October yet another Dutch schooner, the *Aurora*, was caught off the Gallinas River by HMS *Cyrene*. The *Aurora* carried slaving equipment, and the *Cyrene*'s captain found slaves being held for her at a warehouse up the river. More ships might have been caught but for the legal stipulation that slaves had to be on board, not just slaving equipment. An item in a Sierra Leone newspaper stated that "so long as this clause remains in force, we must expect numerous Spanish, Portuguese, and *Dutch* vessels on the coast."[25] There is no doubt that Dutch smugglers were actively involved in slaving when Sam Gadsden's family was brought to South Carolina.

Having seen Dutch smugglers on the West African coast and in the Caribbean, though, we still have to ask whether they could have been trading into South Carolina. Without actually nailing the perpetrator, we cannot prove that Dutch vessel X was at spot Y on day Z. However, if we examine the structure of trade through the Caribbean to the Gulf of Mexico and off the coast of the southern United States, we can know what is plausible.

In the Caribbean the Netherlands held St. Eustatius in the Leeward Islands and, with France, St. Martin. On the north coast of South America she held Surinam, the seat of her large plantations. In the Lesser Antilles she held the islands of Curaçao, Aruba, and Bonaire. Across three centuries trade went back and forth between the Caribbean and North America. By the end of the eighteenth century Cuba's economic base had evolved from somewhat diversified farms into large plantations growing coffee and sugar. By the 1820s Cuba had become the greatest producer of sugar and the

"world's richest colony." Her production of sugar soon grew to be twice the size of Brazil's output. To support her new system, Cuba encouraged slave importation from Africa. British monopoly of slave transport gave way to free trade. Cuba lies between Surinam and Florida, between the island possessions and the Gulf and Atlantic coasts of the United States. To the south of Cuba lay the infamous Spanish Main, which took in both the mainland of South America that bordered the Caribbean and the islands nearby. Cuba was, in the words of W. E. B. DuBois, a "nursery for slave breeders," and she was surrounded by pirate lairs: Matanzas and Cape Antonio on her own coast, the Bahama keys, and Florida.[26]

In 1817 the U.S. Navy beefed up the patrol in the Gulf of Mexico, sending out the USS *John Adams* with the brigs *Prometheus* and *Enterprise* and the schooner *Lynx* to protect trade from pirates and stop slaving into U.S. territory.[27] In 1821 the *Enterprise* destroyed vessels belonging to a total of seventy pirates, who then set up forts on Cape Antonio. One naval commander told of a pirate hideout at New Malaga. From there, he said, "the pirates had direct and uninterrupted intercourse with Havana, by means of small coasting vessels that ran regularly to the ports on the coast, and always touched at New Malaga. Frequently some of them would go up to the Havana, and others of the gang come down." He spoke of meeting an English sailor who had seen the rest of his crew slaughtered. Pirates had kept him prisoner for two months, during which he had witnessed the capture of nine ships and the butchering of most crew members. When he got away from the pirates, they held a slaver with a cargo of 200 people and much ivory on board. Between 1820 and 1830 there were an estimated 2,000 pirates terrorizing Caribbean waters at any given time.[28] Pirates who did not slaughter merchant crews immediately often asked them to join their pirate crews. Many did. Some wanted to; some hoped to save their own skins by joining. Most pirates brought to trial argued that they had to become pirates to avoid death.

In the fall of 1821 the USS *Spark* sailed for the Caribbean under the command of John H. Elton. She was on patrol to catch slave smugglers. Elton was experienced at the job. It was he who had brought the 128 Africans into Savannah on the USS *Saranac* in 1817. The *Spark* cruised off Matanzas and into the Spanish Main. On December 23rd she was docked at the Dutch island of Curaçao. She carried on board the ensigns and pennants of France, Spain, the United States, Portugal, and Buenos Aires. Her charts included the Gulf of Mexico, the coast of Africa, and the coast of America.[29] Clearly, she was prepared to assume many identities and sail many waters in her quest for slavers.

On January 9, 1822, near Aruba, she captured a Dutch sloop. The sloop's master and mate were on board, supposedly in the hands of seven pirates. The *Spark* took the sloop to Charleston, South Carolina, and turned the seven pirates in for trial. Six of these men were "colored"; one was white.

Their names were Phillip Munois, Louis Morica, Francisco Peris, Francisco Powzales, Antonio Fuento, Juan Escandale, and Louis Escarine. The six "colored" men with Spanish names undoubtedly began their pirate lives as slaves who had been given Spanish names after their arrival from Africa.[30]

Apparently the Americans believed that the Dutch master and mate were held against their will, for the sloop was returned to them. But it is quite possible that they had joined the pirates and even that they were in command and found a way out of capture by disclaiming association. The nagging question is whether this Dutchman was the very one who took Sam Gadsden's great-grandfather Tom and his family to South Carolina. The only answer is that he *could* have been. It's a frustrating answer because we probably can't ever know for sure exactly who brought these Africans. But we do know that those who went into smuggling or piracy could spend a lifetime at it and that this Dutchman was captured within three or four years of the time Gadsden's family came. Though we cannot name Kwibo Tom's Dutchman, we can conclude that his existence was likely.

On the African side of the Atlantic the trade situation after the Napoleonic Wars also supports Sam Gadsden's story. (In this story "chief" and "prince" are both translations of a title for one who holds a position of authority over at least a small group of people.) Gadsden located his family in the Kongo region: "My grandaunt told me that her father come from Africa and he was the young chief . . . known as Kwibo [pronounced so that *Kwi* rhymes with *eye*] Tom, the chief of the Ibo [also with a long *i*] tribe in Africa—in the Kongo." He described a fairly complex economic arrangement between Kwibo Tom, Prince Tom in the Kongo, and the Dutch trader:

> And the tribe know all about where to find elephant where they're dead and get the teeth—the elephant tush and elephant bones and things. And the Dutch goes over there—trades with Tom. See. Tom get his tribe—his people—to go get these things to sell to the Dutch, and they're doing business with the Dutch that way. . . . After a while the Dutch bring all kinds of nice flowered cloth like that and all pretty things, you know, and trinkets and all kind of things and give them for that—that's the way they trade for the tush. . . . They didn't know much about cloth at that time, and the Dutch come back from America and trade these things. . . . Prince Tom, their old grandfather, sent a whole family expecting to get them back. . . . The Dutch said they'd bring them here where they could get plenty of clothes.[31]

The trade between the Dutchman and Prince Tom was a recurring arrangement. Gadsden explained that "the Dutchman had been dealing regularly with the old man. Old Tom would lead the Dutchman in to find . . . whatever it was he wanted. In return for this, the Dutchman would bring the people clothes. This trade had been going on for years, for many years." Then Prince Tom's son, Gadsden's great-grandfather, decided, "Why

shouldn't I be going out there and trading? We could be trading out there on our own account." So Kwibo Tom got together with his brother and their father and held a conference with the Dutchman that resulted in a contract:

> He would bring them here to the place where those trinkets came from; and if they would bring a cargo of trade goods and trade for themselves for these things, they could gather up a boat load and take them back to their tribe. Yes, he said he would bring them *back*, in his own boat. And they could give him a proportion of their trade goods to pay him for his trouble and the use of his boat. Tom and Wallie could then bring that cloth and those trinkets back to their daddy and their tribe and they would receive a laurel. . . . They all agreed to that and Tom and Wallie went aboard with their trade goods and their families.[32]

Gadsden's account contains a remarkable set of clues to the African identity of his people. Family names reinforce the claim of a Kongo origin. His descriptions of the specific trade in ivory and cloth and of an aesthetic preference for flowered cloth buttress his claim of trade with the Dutch. He also adds that the Dutchman brought in clothes. In the oral version this word almost slips past the ear, because he is emphasizing the cloth trade. But in the printed version he made a point of the word "clothes." Finally, Gadsden tells how the trust between Prince Tom and the Dutchman had evolved over years of visits. Now, to learn something of value to their people, Prince Tom and his sons Kwibo Tom and Wali trusted this trader with their lives and their dependents' lives.

This whole set of clues points to the region behind the Loango coast as the family's origin. In the Loango region Dutch traders, an abundant supply of ivory, and a preference for the particular flowered cloth all occur together in the period when Gadsden's family came out. In addition, because they trusted the Dutchman to take them and to bring them back, we know they did not expect to be enslaved. Possibly they had not seen people tricked into slavery for export from their area. Possibly they expected to occupy a superior position. Both may be true.

By 1820 the maloango, the head of the Vili people living near Loango Bay, was following a long-established policy of free trade. Although the French then dominated trade there, the policy encouraged Portuguese, English, and Dutch traders to visit the Loango coast. The maloango particularly trusted the Dutch, having dealt with them for well over 200 years in trade in ivory, cloth, and slaves; so the Loango coast remained profitable for the Dutch even after its trade had declined in the late 1700s. In the early 1800s—Prince Tom's era—the Dutch traders were buying and selling as free agents, reporting to no one and sailing straight to the Americas. Although few slaves were available in Loango, the traders yearned for the profits of slaving; and thus the conditions favored their snatching Tom and Wali away.[33] To understand why Tom and Wali would want to go, we must look more closely at the Vili people and their trade system.

Now known as Vili, this group has been known to Europeans by various names and spellings: Bavili, Vidi, Mubire; Fiote, Fioti, Fiotte; Bafiote, Mfioti; Fjort; Chiloango. They seem to be related to the other Kongo peoples living in regions around the lower Zaire River: they understand other Kongo languages, and they traditionally had similar systems of law and custom. Their tradition of origin holds that the founding fathers of the Vili, the Tio, the Woyo, and the Kongo people were brothers—sons of the same mother. Her name was Nguunu. By the end of the fifteenth century her "kingdom" had evolved into the Tio. Their land, Makoko, was located on the north bank of the Zaire near Malebo Pool. As their body of descendants multiplied and needed more land to farm, groups moved away to begin new communities.[34]

All of the groups that settled coastal areas north of the Zaire River moved out from this kingdom. The Vili then moved from Kakongo to settle the Loango area from the Chiloango River northward past the Kouilou River toward Banda Point and Sette-Cama. Theirs was a traditional African reason for movement: economic betterment. Relatively peaceful, the Vili seemed to have moved into the coastal lands by pushing out a few previous inhabitants without fighting. Once settled, they were in a geographic position to become middlemen in trade relationships. They capitalized on it, developing institutions to buttress their position. By the seventeenth century they had evolved a strong, centralized, thoroughly hierarchical structure for governing Vili land. At the apex was the maloango, whose titles included those meaning "Supreme Ruler" and "Guardian of the Spirits." He held the land and all of his power in trust from the Creator God, Nzambi.

The hierarchy established a rigid class structure based on division of the land into provinces, each with a governor. One of them, the maboma, was the chief judge of the land and the next most powerful official to the maloango. Also at the apex was a woman who was related to the maloango. Called makunda, she was responsible for women. She was extremely powerful. In the early eighteenth century one makunda was the maloango's sister, who actually ruled during an interregnum. The makunda may always have been the sister of the maloango, and she may have been the mother of the future maloango. Inheritance in this society was matrilineal.[35]

Four men held titles as heirs to the maloango, and below these officials was an aristocracy of princes and princesses. Because of matrilineal inheritance the princesses were important and had a political voice. A wide gap separated the aristocratic class from ordinary people. The aristocracy controlled all the wealth; their ideas of status were based on amassed wealth; and Europeans dealt only with them, not with common freemen.

In the eighteenth century the complex Vili hierarchy included a structure for controlling an equally complex trade system. The maloango appointed a mafouk as top administrator of trade in each of three regions: Loango Bay, Malemba, and Cabinda. The mafouk had to be wealthy enough to pay high fees for his office, but he was not a prince. He was economically pow-

erful, able to trade privately with Europeans and appoint Vili men as brokers. While the maloango lived several miles inland from the coast, each mafouk lived in the primary trading center village. There he fixed prices, judged disputes, collected fees, and meted out punishments. He sat on the royal council, and only the maboma could intervene between the mafouk and the maloango—so important was trade to this society.

Inland, along rivers and on lakes, there were smaller trade villages. The mafouk appointed lesser mafouks to manage trade at these centers. Europeans also got to these villages to trade, although far less often than to the coast. In addition to these mafouks a network of other officials—the royal treasurer, the royal messenger, and so on—whose duties crossed local boundaries, kept the hierarchy intact.

Through the course of the slave trade in the eighteenth century the office of broker evolved into an extremely important position. The broker was the middleman. He acquired the sole right to deal directly with the European trader. He lived in or near the trade village and guarded the rules of the maloango and mafouk. He made sure that people who were not legally slaves were not sold—an extremely important distinction, as Vili law forbade selling Vili people into slavery. The slave trade gave brokers the chance to become rich and important to both Europeans and Africans. By the end of the eighteenth century Europeans accorded them "more respect than any others," and Africans saw them as just as important as the aristocracy. In fact, princes could also be brokers.[36]

Several pieces of Sam Gadsden's history fit into the Vili hierarchical structures for both government and trade. First, in light of the class system, Tom's title, "Prince," is significant. Europeans referred to "kings" and "princes" among the Vili at least as early as the seventeenth century. Since the Europeans dealt only with this class, the Vili people would have known these terms as translated into English through their own discourse with English-speaking Europeans. Prince Tom's title places him in the class of princes just as Gadsden's description of him as the son of a "chief" places him in this class.

Gadsden tells a story of his grandmother's sister, Jane, that also places the family in this class. It shows her filling a position similar to a governing makunda within the structure of her slave community on Edisto Island. The story also involves Major Murray's overseer, J. M. Muirhead.[37] Gadsden identified him as "Moosehead," saying, "the people didn't like Mr. Moosehead very well; they called him 'Mule Head.'" Muirhead told the driver, a slave named York Scott, to whip any slave who didn't get his task for the day finished. Gadsden's great-uncle Charles normally worked for "Miss Liddy" in her garden; but while Major Murray and his family were away, the driver sent Charles to do field work. Charles couldn't finish one day's field task and received extreme punishment, said Sam:

The next day the driver got rough. He took his men and caught up with Charles; his men tied Brother Charles on to a barrel and they gave him fifty lashes, and Maussa wasn't even there. . . . If a hundred lashes would kill a man, fifty was likely to leave him half dead.

"Sister Jane" stepped in to control her brother's treatment.

That night Jane went to the yard to see Maussa about what had happened, but Maussa hadn't come home yet. She slept on the steps all that night. Late in the night Maussa came home, but she didn't bother him then. In the morning she went in and told him the whole story. She said, "Mister Murray, sir, I want to tell you, that Mister Moosehead have he driver to lick my brother, Charles. But I just want you to know, sir, that before you allow that driver to put any hand on my brother again, must make arrangements: there will sure be a funeral."

Maussa said, "How come will there be a funeral, Jane?"

"That driver will be dead. I kill him myself."

Major Murray bowed to Jane's demand:

Maussa went out and told Mister Mule Head, "Don't lick those niggers no more. If you do, you are going to get killed. Jane will kill the driver her own self. If they don't do their tasks, go to Jane. Jane can make them work."[38]

Gadsden describes Jane's power over the production system on the plantation. She controlled workers, driver, and white overseer alike:

After that, Jane would bid them go, and they got. . . . But Mule Head nor Scott must not lick any of those people [her family], or Jane would commit murder. She would have killed him the first time, only she just waited until Maussa came. If they had not known Maussa to be a good man, they would have killed that driver sure.

If Jane was driver, York Scott was not out of work. He stayed to carry out the agent's orders and give them their tasks and help them to get tools and things, but he had no more anything to do with whether they finished their tasks or not. They always did.

Mule Head would surely have tried to abuse those people and increase the tasks they had to do just because he saw they would always finish them. But he was afraid to, for he knew Jane would cry out. She would go to Maussa and he would welcome her. We had a chief. Jane was a chief of chiefs. She was queen of the whole works.[39]

Jane thus functioned as the governor, head of her people—a makunda in her community.

Prince Tom also fits into Vili history both in time and in place. In the early 1800s he was one of the wealthy brokers to whom the Europeans accorded great respect. As a broker he had the right to deal directly with the Dutchman. Prince Tom probably lived on one of the rivers somewhat inland, possibly on the Kouilou River, where there is known to have been a Dutch factory during the nineteenth century. By this time there had been no

maloango for more than a generation. Government had devolved into de-centralized control by petty chiefs, as the old maloango died in 1787 and no successor could afford to pay the fees incumbent on taking office. In the Kouilou River villages Europeans now rented land from the mafouks and established factories there. In consequence, the local mafouk developed more loyalty to the European who was renting from him than he had to a ruler.[40] Prince Tom would have known his Dutchman well: Tom rented land to the Dutchman, and the Dutchman repeatedly returned to his factory in Tom's village. This relationship as well as the mafouk's role in enforcing the law against selling Vili people into slavery helps to explain why Prince Tom trusted the Dutchman to take his family and why Prince Tom expected to get them back.

Prince Tom was but one middleman in the system, but the middleman was the focal point of a vast geographic network in this trade. Between the early sixteenth and late eighteenth centuries trade routes developed through-out the regions around the lower Zaire River and its tributaries. European desires for ivory and slaves nurtured African desires for cloth, guns, gun-powder, and ornaments so that by the nineteenth century trade reached at least as far as the Ubangi River. Trade routes involved contact between many peoples, and profit necessitated communication. Complex systems for peace-ful interchange evolved.

When Gadsden said that Prince Tom "knew all about where to find el-ephant tush" and how to "get his tribe—his people—to go get these things," he gave insight into a tightly woven system. Slave trade routes of the late eighteenth and early nineteenth centuries developed over the same routes followed by the ivory, iron, and copper trades in earlier centuries. In the seventeenth century slaves owned by the Vili were sent to bring ivory from the interior country. When Loango rose to prominence, its kingdom con-trolled a large hinterland with routes crossing Mayombe. They soon ex-panded into southern Gabon, into the regions of the upper Ogowe River, and to Malebo Pool. Chief Tom's village was located on these routes and in the 1800s was a focus of a regenerating ivory trade. G. A. Robertson noted an increase in the ivory trade north of the Zaire River between 1811 and 1817. He found almost no slave trading at Malemba but a greater trade in "elephant teeth" than "on any other part of the coasts of south-west or north-west Africa." Capt. John Adams, trading with Loango about 1820, commented that ivory and camwood of "superior quality" were the exports of the area.[41]

The ivory sold in Loango Bay villages often came from the area con-trolled by Mayumba town. Prince Tom's people lived close to the rough mountainous region of the Mayombe. Geography accounts for both the absence of a large supply of slaves and the presence of ivory. The terrain

made slave raiding unprofitable while being hospitable to elephants. Across the Kouilou River to the north the province of Chilongo was a rich source of tusks. To the east Vili trade would cross the thirty to forty miles of Mayombe to connect with various Bateke peoples who traded with other peoples in regions surrounding Malebo Pool, where the Tio group of Bateke controlled the markets. Malebo Pool became a major source of ivory for Loango.[42]

To reach the Dutchman at Prince Tom's village on the Kouilou, a pair of ivory tusks might have followed this scenario: a Jinju man found a dead elephant in the forest near his village, which lay between the Teke-Laadi people and the Zaire River, north of the Pool. The man took the tusks to the political chief of his village. The chief paid two or three men to go out and sell the tusks. With their payment they bought cloth in the Nsundi market. The rest of the profit was shared by the finder, the political chief, and the chief of the land.

The Jinju men could have sold the tusks to Teke-Laadi traders, or they might have sold them to Kukuya neighbors to their north or to Sese to their south. Either of these neighbors would also have traded them on to the Teke-Laadi. When men reached the Laadi territory with tusks to sell, they sent one man to the house of the political chief, where this agent opened the trading by giving the chief a gift of cloth. The Jinju probably traded their tusks for salt that the Vili made and for cloth. Both were brought up-country by Vili and Kongo traders following the system that would now carry their tusks down.[43]

Some time between May and October, when the weather was dry, the Teke-Laadi formed a caravan that would take the Jinju tusks to the Vili. In the caravan, porters and slaves under guards carried the tusks, which could run to ten feet or more and weigh over 200 pounds.[44] One Vili man who had been a porter described the job:

> We went up and down mountain after mountain; valleys, water courses, savannas with sharp-edged grasses and a stifling atmosphere, were traversed in turn. Huge, shadowy, terrifying, the hostile forests of the Mayombe waylaid us; and once under their canopy we were soaked by a continuous deluge of rain. In the semi-darkness of the undergrowth we slid over the soft and muddy ground; we tripped on enormous tree trunks blown down by the hurricanes. At every turn we had to unload our burdens to release a comrade bogged down and to help another, slipping in the mud, to replace his load on his shoulder or head.[45]

The caravan leader filled a highly skilled role. He organized men, trade goods, and food supplies. If cassava wasn't stored en route for the return journey, his men could starve. He was a disciplinarian and negotiator. He had to know the customs of each locality he crossed so that he could discuss, bargain, compromise, and pay tolls to cross "foreign" lands. He had to avoid ambushes, funeral processions, and leopard hunters, for all might

cause him to forfeit half or more of his trade goods. And to avoid these pitfalls, he had to be, mentally, a cartographer; for he had to be able to choose alternate routes or negotiate the rain forest by night when these dangers loomed.

He could not afford to lose his ivory tusks to marauders, for the tusks were particularly valuable cargo. When he reached the Mayombe, he held a palaver with the Mayombe ruler who controlled the path here. The palaver could go on for several days before the Teke man was allowed to move his caravan on. As he crossed the Niari River valley, he paid tolls to Bakongo rulers; if he crossed the north bank of the Chiloango, he paid tolls to the Solongo. As he led his troupe out of the Mayombe to the eastern boundary of Loango, he met a wooden fence that protected Vili land from the Kouilou River to the Loeme. The fence had only three gates. When the Teke caravan leader reached this point, he again negotiated with the Vili man in charge. Gates were fortified by guards well-armed with guns and ammunition. However, relations here were probably as peaceful as possible for men of differing cultures. By the nineteenth century the slave trade had caused a surge in the value placed on wealth. Wealth was now the hallmark of status throughout the trade network. In Vili land this value went hand in hand with the decline in the maloango's centralized power and the consequent shift of power to local mafouks. Accumulating wealth and rising in status made peaceful relations mandatory.[46]

Ritual patterns, therefore, also protected the trade network. A missionary to Zaire River peoples, John Weeks, described rituals for protecting a trading caravan as it prepared to depart: the chief who sponsored the caravan paid a priest a high price—one slave or the equivalent. When the porters assembled with their baggage tied up and ready to travel, they formed a circle; and the priest came and sat there. He brought an image that contained bits of skin from leopard, hyena, and lion to transmit strength and power. The priest placed it in front of himself in the circle and spoke to it, "telling it to give the traders good luck on the road, and at the trading factory."[47]

A blood sacrifice followed this admonition. The priest cut off the head of a fowl and dripped its blood onto the image. As the liquid of life the blood brought the image to life. It was now empowered to protect the caravan. During the ceremony the focus of the people of the caravan was totally directed toward the road they were to take. Next they cooked and ate the fowl and so received sustenance for their own vital energy to enable them to prosper on the journey. At this point they could neither enter a house nor refuse to go down the road. The priest then put a shell, with contents identical to that of the image, in the road. "Every person in the caravan," Weeks continued, "must step over this shell, and if anyone touches it with his foot he is not allowed to proceed, for according to the omen he will die on the journey; and after stepping over the shell no member of the party must look back or he will destroy his luck."[48]

Along the route the caravan crossed territorial boundaries protected at toll points by shrines as well as by armed guards. In each territory the ruler had an official who escorted caravans by ringing a double iron bell. In the nineteenth century the explorer Monteiro saw these bells in use when he traveled the region south of the Zaire River. Called *engongui* in Kikongo, they were "held in the left hand whilst being beaten with a short stick. There is a regular code of signals, and as each bell has a different note, a great number of variations can be produced . . . ; a curious effect is also produced by the performer striking the mouths of the bells against his naked stomach whilst they are reverberating from the blows with the stick."[49] One group of people specialized in making the bells and sold them to other peoples throughout the trade area. They were of great value, Monteiro indicated. Each town would allow just one engongui there. The king owned it, and each successor inherited it. The engongui held much power. To sell it or to give it away was unthinkable.[50]

The caravan leader tried to establish a friendship with a local ruler in each area he had to cross. Leader and ruler performed the blood brotherhood ritual together. Then the ruler hosted the trader, giving him lodging, selling him food supplies, and receiving the right to broker his goods in return.[51] Robert Harms noted the depth of the tie of blood brotherhood when he studied peoples of the Ubangi River. Blood brothers regarded each other as kinsmen. Harms described how the relationship worked in trade:

> Contacts in neighboring spheres of influence conferred enormous benefits on traders who possessed them. These traders not only increased their own profits but also established themselves as brokers for traders who lacked such contacts. Traders from villages near the limits of one sphere of influence tried to monopolize contacts with the neighboring sphere. The traders of Tchumbiri, near the downstream limits of the Bobangi sphere, were the best-known brokers in the entire system. They made enormous profits by utilizing their contacts with the Tio at the Pool. Upriver informants noted that their own ancestors seldom went to the Pool because they had no "kinsmen" there, while the Tchumbiri traders did. The word "kinsmen" must be taken in its largest sense to mean Tio traders with whom they had long-standing relationships.[52]

Intermarriage often reinforced ties of blood brotherhood in forming friendly relationships between trade groups. A trader might marry a partner's daughter or give his own daughters to be married to partners in other "spheres." Teke-Laadi remembered both Vili and Kongo traders staying with their chiefs and knew of their close trading contacts. The Vili name actually meant "caravaneer" and only later came into use as an ethnic designation. Thus, they too participated in blood brotherhood and intermarriage to further their trade profits and in some areas came to prefer marriage as a trade strategy.[53]

❁

When the tusks were finally delivered to Chief Tom, he had them stored in his ivory warehouse to await the Dutchman's arrival with goods to trade. Sam Gadsden tells several things about these goods. He emphasizes the desire not just for cloth, but for "flowered" cloth. He says the African people "didn't know much about cloth at that time." He mentions "clothes," and he lists a general category of "all pretty things, you know, and trinkets and all kind of things."[54] Clearly, through its transmission process Gadsden's history maintained the importance of flowered cloth as its dominant motivating factor.

The word "clothes" is a clue because it seems an odd trade item. In fact, this clue reinforces our belief that the family lived somewhere near the coastal or river areas where Europeans rented land from the mafouks. Here Europeans gave clothing as a special present, often called a "dash," to Africans in charge. While travelers mentioned the clothing, they didn't include it in their list of goods that made up a "bundle," the unit price for trade, thus giving further evidence that clothing was lagniappe. Otherwise, Africans charged payment in such goods as brokerage fees.

At the beginning of the nineteenth century clothing items were described as red or blue coats with large collars and cocked hats, all with gold embroidery—that is, the European styles of the time. About 1820 the trader John Adams wrote: "Besides the cargoes sent in vessels to Africa, the captains generally take with them a few presents for those chiefs with whom they mean to trade, and whose favour and interest it is important for them to obtain. These presents chiefly consist of gold-laced hats, silver-headed canes, pieces of rich silk, and embroidered coats and waistcoats."[55]

Received by king Don André "in his state attire" at Ambriz in 1841, Georg Tams wrote that the king's "scarlet silk cloak trimmed in ermine" was about fifty years old. When Tams visited Luanda, he found that many men from Cabinda—these would be Vili men—went to Luanda to work for months at a time in order to buy European clothing for their families. "For this purpose," he said, "the head of a family will willingly submit to the most laborious employment and miserable fare for months together."[56] So far had the status symbol become entrenched twenty years after Gadsden's forebears came out. The clue of clothing thus further places Tom's family both geographically—near the water source of contact with the European—and socially—firmly within the upper class.

The specific list of other goods has been forgotten by Gadsden's time and so lumped into the category of "pretty things" and "trinkets." These concerned only his African family, not his Edisto family. He gave them a general category possibly either because they were subsidiary in his tradition or because he had read about trade "trinkets" in the broader scope of African history and used them to embellish his telling. They were subsidiary in the African trade, useful only to trade for small supply items, as Captain Tuckey, a British explorer, reported in 1816: "Beads are only taken in

exchange for fowls, eggs, manioc and fruits, which seem all to belong to the women, the men never disposing of them without first consulting their wives, to whom the beads are given."[57]

Each of these items coincides with the Vili trade structure both as an individual item and as to the relative importance of each item within the structure. Flowered cloth is paramount. By this time European trade cloth had become the sine qua non for status among all the African peoples along the Zaire River and its tributaries, the coastal peoples to the north and south of its mouth, and the peoples on the connecting inland trade routes. Zaire River peoples were once known for making exquisite raffia cloth, but by the early nineteenth century Loango Bay people had shifted their preference to European-made cloth. And it was early Dutch traders there who sparked that interest.[58] At the time of Sam Gadsden's story, about 1818–1820, European cloth (cottons such as baft and guinea) had totally replaced raffia as the cloth of the upper class. Tuckey also saw this trend in 1816: "The price paid here, by a native, for a wife of the first class, the Chenoo's daughter, for instance, is four pieces of baft, one piece of guinea, and a certain quantity of palm wine." Needing a guide, he secretly offered a piece of baft and immediately acquired not only the guide but five carriers as well.[59]

For more than aesthetic reasons the upper class preferred cloth. Since before the sixteenth century access to sources of cloth gave power to Loango people. At that time the Vili controlled raffia sources. As preference shifted, the Vili shifted to control trade sources of European cloth. Thus, while aesthetic preference changed, the value of cloth—cloth as access to power—persisted. Through the first half of the nineteenth century, until the colonial period, cloth remained a basic unit in determining monetary value.[60]

This estimation of worth coincided in the Loango and Zaire areas with an increasing desire to accumulate larger and larger amounts of cloth to show off a person's status at his burial. W. Holman Bentley, a British missionary to Zaire River peoples in the 1870s, commented that before his time, almost all of the European cloth was collected for funerals. His point of view is not sympathetic, but through his description we can feel cloth's enormous value:

> It is the great desire of a Congo man to be buried in a great quantity of cotton cloth, and to have a grand funeral. For *this* he trades, and works, and sins, sparing no pains, not that he may wear fine cloths, and have a comfortable home. He shivers with cold in the dry season, but will not put on his back the coat or blanket which is reserved for his shroud. . . . It is not even the love of hoarding that prompts this, only the desire for display at the funeral. When a friend dies, it is the proper thing to take a present of cloth for his shroud. . . . Public opinion forces them to use the cloth to the end for which it was given, and it is done with a light heart. . . . So a great man is often buried in hundreds of yards of cloth.[61]

Use in the funeral indicated that cloth was valued above all other posses-
sions in these societies. Its value transcended earthly worth. The intensity of
its value explains its survival in Gadsden's family's story.

Peoples of different regions preferred different colorations and patterns
in the cloth they would accept for trade. Aesthetic preference is therefore a
clue to a person's cultural origin. In the middle of the eighteenth century, for
example, a Dutchman found that he had to supply cloth with one narrow
white stripe on two wide blue stripes to buy the Kongo people he wanted.
Without this cloth he could only buy Mayombe people.[62] Gadsden specified
that his family was interested in flowered cloth, thus telling us their aes-
thetic preference and giving another clue to their origin.

The Vili preferred flowered cloth, and that preference prevailed during
the era of Prince Tom's family's departure. In 1826 the British government
sent William F. W. Owen on a surveying expedition to the Kongo coast. On
January 5th he anchored in Cabinda Bay, met the local mafouk, Prince Jack,
and was introduced to six of Prince Jack's daughters. They were, he noted,
"dressed in gaudy-coloured cloths of English manufacture, secured round
the waist, and hanging down to their ankles; a piece of the same stuff was
also thrown carelessly over the shoulders, so as to cover the bosom."[63] The
coastal region was ahead of the up-river areas in wearing the cloth by
this time, and the amount worn by each princess shows that it was impor-
tant to have lots of it. Captain Adams listed English chintz of "patterns
various, and generally large" in red, blue, and white in his catalog of trade
cloth. A helmet mask shows the "gaudy" flowered cloth traded into Tio
country, where the cloth was used to wrap projections on the headdress of
the mask.[64]

For at least two centuries Vili traders covered the breadth of regions
throughout the area known as Angola to Europeans in the nineteenth cen-
tury. Their trade was known in San Salvador through the seventeenth cen-
tury. Their import in guns and ammunition lent strength to the expansion
of the Lunda empire. And in the eighteenth century their trade connections
extended as far as the Ndembu a couple of hundred miles inland from
Luanda. The Vili also established "colonies" in distant lands: in 1693 about
200 Vili were settled at Lemba, near today's Matadi; a settlement which
existed in San Salvador in 1707 was extant in 1857; in the mid-eighteenth
century there were Vili farming communities on the upper Dande River; in
1863 Burton found Vili monopolizing the blacksmith trade at Calumbo,
near Luanda. Everywhere, they were influential and respected. The Vili man
was known to have supernatural power: one did not mess with him.[65]

As Gadsden reported, "the tribe know all about where to find elephant
where they're dead and get the teeth—the elephant tush and elephant bones
and things. . . . Tom get his tribe—his people—to go get these things." This
is no idle tale. Tom's was a highly structured, sophisticated society having
intricately developed governmental and economic systems which always kept

in contact with home base in Loango. Sam Gadsden's family's persistence in keeping their history alive is but further evidence of this contact.

In summary, then, why did Tom and Wali leave Africa? Why did they put themselves, their wives, and their children into the hands of the Dutchman?

Their culture valued leaders who became wealthy through trade. Cloth was the basis of their trade; their people historically controlled the supply of cloth. Resettlement for purposes of trade was part of their economic system. For several centuries groups of their people had traveled great distances to settle among other peoples for trading. Vili in these settlements always stayed in contact with their Loango base. They had a word for "friend" which had come to apply to men who traded together.[66] Tom and Wali regarded the Dutchman as their friend and expected to maintain contact with their home. In fact, if their colony operated as other Vili colonies did, they could expect others of their people to join them. Their plan to leave was probably regarded as necessary, certainly adventuresome, but neither unusual nor scary.

Although there was slave trading, Tom and Wali would not expect to be enslaved. At the time they left, slave trading was in the doldrums in Loango Bay for two reasons. Control over the trade had shifted away from Loango Bay to the Cabinda/Mboma axis. Then, for the first few years after the Napoleonic Wars ended in 1815, there was no demand for slaves in Loango Bay. African brokers complained that they couldn't sell the ones they had gathered in their factories to await ships. On his arrival off Malemba Point in July 1816 Captain Tuckey was met by a mafouk whose name, incidentally, was almost "Tom": Tamme Gomma. Tuckey recorded that the mafouk was angry with "all the sovereigns of Europe" because they weren't coming in to get the slaves and he was overstocked. He complained that a French ship that had come the year before was the only vessel into Malemba for five years.[67] Tom and Wali would not expect to be tricked into slavery where brokers could not even sell the slaves they had available.

Finally, among the African upper class there was a practice of sending its sons to Europe to be educated. This happened much more frequently than we may realize. In the 1760s Prince Will, the mafouk of Cabinda who regulated the slave trade there, sent his son to France in care of merchants for his education. When their company sent a trader to Cabinda in 1766, they sent a portrait of the boy to his father. In 1816 Captain Tuckey returned a son to a prince of Mboma. The prince had sent his son with a captain from Liverpool to be educated in England, but the captain had sold him to a sugar planter in the West Indies instead. Richard Dennett, a trader who lived among the Vili, told of a prince's son whose father sent him from their inland town to work for a European "who was to teach him sense, or in other words to educate him." He was taught to read and write and then was

able to gain political power in the service of another prince.[68] So for men of the Vili upper class to send a part of the family out into the world to expand their knowledge as well as to further their business operations was a familiar thing to do. And for Chief Tom to allow a segment of his family to go away with the white man is no surprise.

The surprise came only when Tom's group arrived on the opposite side of the ocean and were landed secretly in Bohicket Creek and turned over to a white landowner on Wadmalaw Island who now claimed to possess them. Yet Tom and Wali refused to live as slaves but, according to their family's account, always moved around as free men. Tom established an additional family on at least one plantation other than Clark's. Nevertheless, the families of Tom and Wali were settled by their Clark and Murray owners on Wadmalaw and Fenwick Islands and on the several Clark and Murray plantations on Edisto. Two of Tom's daughters were given to the church, as it were, and established families at the Presbyterian parsonage plantation. Yet as Gadsden reported, "They were a family, were sisters and brothers right on . . . and out of that family has come practically a whole nation."

Here on these islands, among other peoples of African heritage but South Carolina birth, Tom's and Wali's people joined the estimated 54,000 Africans who were smuggled into South Carolina, Georgia, Florida, and the Gulf coastal region between 1808 and 1860 and who continually injected fresh infusions of African customs, beliefs, and values into their new neighborhoods. We shall examine just how deeply these African mores penetrated. And our examination will lead us to understand how these Africans did indeed "found a nation."

# 3

# Voices of Survival

With my left arm I held my freedom to think
and my freedom to pray. With my right arm I held on
to my religion, my art, and my music.

—Phyllis Biggs

The Africans, every one of them, brought with them their whole experience of living in their own African culture. "Americanization" could not erase that experience. It inhered in each person; it *was* the person. To work as a slave, an African needed only to modify some external practices. The beliefs, values, customs, and rituals that lay at the heart of each person's culture remained. Heeding the voice of Phyllis Biggs, when I discuss survival here, I include both the people and their beliefs and customs, all of which survived capture, slavery, and peonage. We will begin with a small, quite specific instance—naming practices—and will proceed to broader and more complex instances. Slaveowners tried to make newly imported Africans adapt not only to the work of slaves but also to American customs and culture. To communicate, owners needed a way to identify the people. The first step was to assign them names. James Clark's estate inventory shows that he, like other owners, tried to give slaves English names. But it also shows that he, like others, did not succeed.

Two of Clark's slaves bore names which obviously were African: "Aubah" and "Quackqu." Another was called "Sawdy-Key," a name with Kongo provenance. When traveling on the Zaire River, W. Holman Bentley met a man named Sadi-kia-mbanza. "Mbanza" referred to the location of the chief and center of his government.[1] "Kia" (or "kya") is a linking word in Kikongo meaning "of" or "from" in the sense of belonging to or being derived from. Thus, the Sadi whom Bentley met came from such an mbanza. The Sawdy-Key who was owned by James Clark retained a remnant of Kongo naming practice, a name which almost said "Sawdy—who came from—" and then lost his place of origin: a statement in poetic irony.

Clark's inventory appears to list most of his slaves in family groups, and Gadsden says that the brothers Wali and Tom each came with African wives. Clark's list names on one line together:
"Wharley 600. Flora 500. B. Tom 900. Sary 500 . . . 2500."[2]
The values assigned tell us that these are adults at their most useful stage of maturity. B. Tom, at $900, is Clark's most valuable slave. This accords with

Gadsden's family's reports about his importance. The "B." may refer to "Big," a designation common throughout southern naming practices which signifies the oldest of that name in the family, usually a father with a son named for him. This line in the inventory undoubtedly refers to Wali with his African wife and to Tom with one of his.

The name "Flora" easily derives from early names of the Vili people, which included "Fjort," "Fiote," "Mfioti"—all heard as "Flora" when the need to transliterate the name into a familiar English name comes into play. Likewise, Tom's wife, Sary, bears a name similar to the word "ndzali" or to "nzadi"; the first is the Tio name and the second the Kongo name for the Zaire River. "Sary" is also like "Zarry," the name of a people with whom the Vili traded. As we have seen, marriage among trading partners commonly formed bonds, and we know that Tom's role in his family was to trade. One of Wali's descendants was called "Benjie," a name also similar to the Vili trading partners, the Jinju.[3] In our utter ignorance of African names it is far too easy to assume that names recorded in plantation or census records are English words. Names such as Zarry and Jinju, which have been transmitted on so-called ethnic or tribal maps of Africa as names of separate peoples, did not necessarily designate peoples who were culturally different from each other. The names designated geographical locations of peoples who often had similar, even sometimes identical, cultures.[4] This would explain the ease with which intermarriage of trading peoples in Africa could occur, and it helps to explain the appearance of place names as the names of individuals in the United States.

The names Wali and Tom fit a Kongo provenance. "Wali" is not unlike "Vili" itself and is especially close to the form designating the Vili people, Bavili. It is also like Buali, the name of the early city of the royal court in Loango, where in the nineteenth century there were still some trading houses.[5] On Edisto Island, where a family named Whaley was prominent, the transliteration from Bavili, Vili, or Buali to Wali—or, as the inventory listed it, "Wharley"—would be simple. The derivation of Tom is clearer: the title "Dom" went to west central Africa with the Portuguese and proliferated as a name among Africans. Clark's inventory list includes four Toms. Since Clark obviously did not assign names that would avoid confusion, I infer that Gadsden's great-grandfather Tom kept the phonic version of the name he told Clark was his, and it was written down as the English name "Tom."

Significance in African names went far deeper, however, than just designating one's home place. It was totally identified with the self, with being human. The Dogon elder Ogotemmêli explained that humans are above every other animal because their intellect is creative and they alone have speech. The spoken word translates their creativity into action. Word empowers living. Amma, the high god who created the universe and life, sent the seventh of the original ancestors to give speech to people. The word, Ogotemmêli said, was the seed from which the world grew.[6] The person—

the controller of the word—begins at birth only at the time the name is given.

Among the Bakongo the name first given the child would have some relation to a family situation. The name would begin a phrase, but the rest of the phrase was kept quiet. Among other peoples of the lower Zaire River region the first name given was a "spirit name," the name of a member of the group who has died. This name was kept secret from strangers. No single name would be known to everyone, yet all of them together identify the whole person. The child was born to the family, the "clan," the line of ancestors, and had to be cared for and protected by them. The child's later names would refer to this family membership.[7]

The depth of the power of naming is illustrated by a story told by the anthropologist Wyatt MacGaffey. A Bakongo man called Na Kunka chose, though born in a matrilineal culture, to live with his father's people and expected the support of their spirits through their charms, called minkisi in Kikongo. His father's people pooh-poohed his expectation, saying he was properly a member of his mother's family. His wife told him he must go to his own people. To do that, he and his wife went to a river, descended into it, and traveled past many villages under the water until they came to their place of ceremonies. As they passed these villages, they named their ancestors there. To return from the water, Na Kunka and his wife were called out of the river by their own names through the talking, drumming, and singing of members of Na Kunka's proper family. Both sets of names with the adjunct ceremonies united Na Kunka and his wife with his matrilineal set of ancestors and family and restored his power to live.[8]

Bakongo people did not inhabit geography as Euro-Americans think of it. Rather, they inhabited cosmography, a world of the living and the dead, separated but united. This is why Na Kunka traveled through the underwater world, the world of the dead, to reach his goal. Once his relationship with the spirit world was reestablished, he was able to call names correctly. The historian Robin Horton explained the power thus acquired: "In traditional African custom, to know the name of a being or thing is to have some degree of control over it. In the invocation of spirits, it is essential to call their names correctly; and the control which such correct calling gives is one reason why the true or 'deep' names of gods are often withheld from strangers, and their utterance forbidden to all but a few whose business it is to use them in ritual."[9]

Africans transplanted to the United States brought with them the custom of giving many names, of being known by one name to some and by another to others, and of keeping names relatively secret. The man called "Archibelle" by the Oaks plantation community on St. Helena enlisted in General Hunter's regiment of freedmen as "Baltimore Chaplin." To work for freedom was surely the most important circumstance of Chaplin's life, particularly because the slaves at Oaks were treated notoriously badly. He

chose the name to mark his ascent to dignity. In 1863, when Elizabeth Botume tried to organize her classroom to teach freed slave children in Beaufort, South Carolina, she found herself in a muddle of names. Each child gave one name one day and a different name the next. Quash became Bryan, Middleton became Drayton, and Lucy Barnwell said she was Fanny Osborne when she thought she'd rather have her mother's name.[10] When interviewing on Edisto, I was told to look for Nancy Mack Fludd, who was 104 years old and knew some of the people I was researching. Once I found her, she insisted that she must be entered in my book as Evelina Fludd. When I showed surprise, her daughter explained that "Nancy Mack" was "just another name she was called by—kind of a nickname."[11] "Evelina Fludd" obviously was a more private name. My first informant was a younger relative and may not have known anything but the familiar "Nancy Mack." In any case, she thought that name was all I needed. But Fludd was quite definite. As an elder she was beyond the power of human control. A book is a formal situation, and for this she was determined to be known by her private, formal name, Evelina Fludd.

The African custom of keeping names secret was often well hidden in the United States. On St. Helena early in the twentieth century a woman explained that a baby must have a basket name "so the evil one can't know the real name."[12] Control came through knowing the name. Lavinia Fields revealed only in 1985 that her mother called her Pessy. In Kimbundu, an Angolan language, "pessy" means "pipe." Fields said this was her basket name, a name given her as a new baby. It conformed to the Gullah custom of naming babies for objects in daily use.[13] On Edisto, African Americans knew Bella Brown as Beuw; her sister was Baw. Beuw's name was not transliterated until her grandson gave it to Nick Lindsay in the mid-1970s. Vansina identifies a people of the name Aboõ, the inhabitants of Boõ, in Tio country between two rivers which drain into the Zaire north of Malebo Pool. Beuw was born in Africa and came with her father, April Frazier; her mother, Nancy; and "all their children." Her family said that when Beuw died in 1927 or 1928, she was 105. This would mean she was born about 1822. Her family was therefore smuggled into the islands after Sam Gadsden's. And, although Beuw gave her American name, "Bella," to the census-taker as early as 1870, her family still used African names toward the end of the twentieth century.[14] In the Sea Islands, as long as there were people alive who were born in Africa, or whose parents were born in Africa, there were people with African names such as Beuw, Baw, and Pessy, names that local white people never knew. These examples of the permeation of African naming patterns are but tiny examples of how African culture traits came to be part of the fabric of American culture.

Much more than the naming practices survived. Once the new African Americans were located on the Sea Island plantations, African concepts continued to inform their behavior as they built the institutions of their

daily living. They lived close together in settlements of small houses, called "the street." Although the owner's home was not so far removed as, say, the manor house of an English village, it was separated by a little geographic distance, a great distance in lifestyle, and an unfathomable distance in culture. The owner was also often absent for long periods, especially in the summer, the season when people are outside and more likely to observe each other's mores. Since there were no bridges between islands or to the mainland, transportation and communication depended on boats, tides, and weather. The combination promoted isolation, and so African Americans saw white people only infrequently. In fact, a photograph shows two small children on St. Helena laughing as they saw their first white people ever—as late as 1904.[15]

In the plantation street settlement Africans began to develop community with the new grouping of peoples, calling on mutual beliefs and histories to, as John Mason wrote, make "sense out of nonsense," give "shape to shapelessness," and to establish members as "part of the universal community forever." The patterns of thinking and of organizing, which were preserved and adapted in this new community, enabled the survivors to survive.

Beginning with their concept of their relationship to the very earth they now occupied, they preserved traditional beliefs that differed radically from those of their new owners. Euro-Americans measure land according to precise systems, record those measurements on maps and deeds, and believe it can be owned by those who pay for it. In African thinking only God owns the land. Territory is not a measurement but a concept. People's right to inhabit it derives from ancestral settlement as recorded in traditions of origin, and both the land boundaries and the traditions are indefinite. MacGaffey cites an example from the Manteke group of Bakongo. The oldest man was called to testify to boundaries because he "had with his own eyes seen the land dispositions taken by elders long since gone."[16] Other Kongo peoples observe similar systems. Lineages have the right to use land; but if the lineage dies out, the right to use its land moves to related lineages. This value system extends still more broadly among African peoples. According to Paul Bohannon, the Tiv, for instance, define Tivland with reference to lineage names but do not even have names for the natural characteristics of the place.[17]

In the Sea Islands slaves identified their location by the names of the landowners, and the places retain these names today. Gadsden said that Tom's family came first to Legare's on Edisto, then to Clark's. Anyone from Edisto today knows those locations, though the people of those names are long gone. On St. Helena, where Sam Doyle lived "on Wallace," the name referred to Reverend Joseph Wallace, absentee owner of a plantation with twenty-two slaves in 1830. There has been no Wallace there since his widow

left when the Union army invaded in 1861. Deacon Tom Brown explained that the plantation boundaries were not fixed; but, he said, "We know where one ends and the next begins."[18]

A Bakongo tradition of origin reveals the deep spiritual connection between the individual and the place. The tradition is recited according to a formula. MacGaffey finds two major parts to its structure. The first part is a "praise name," which has four subparts: the clan's names, the attributes of the clan's founder, the clan's place of origin, and the course of the clan's departure from its place. The clans leave because they need food. Eventually they reach a river they must cross; this river, usually the Zaire, has both actual and mythical attributes. The crossing ends the praise name, the first part of the formula. Once the river is crossed, part two of the formula becomes more historical as the people approach their present location. MacGaffey defines the tradition as "the story of the origin and adventures of each descent group."[19] Gadsden's story certainly fits this definition. His story also fits the structure of the tradition's formula.

In the Bakongo tradition the founding ancestors, who comprise a major component of Bakongo cosmology, as we shall see in more detail further on, arrived at their location through a process which began with their farthest-back ancestress in a perfect place, a mythical Mbanza Kongo, from which their clan moved out and regrouped through time until the present. Their tradition includes listing villages, chiefs' names, branches of the clan that did not move—down to the chief who built the present village and the place of his grave. Only parts of this account are historically accurate, but this is relatively unimportant. What counts is the recitation that spiritually connects the individuals to the place. Without this connection the individual has no identity.[20]

Gadsden's recitation shows that African Americans in the Sea Islands retained both this recitation formula and its expression of their belief in their spiritual connection with the land they lived on and worked. His "praise name" lists his "clan's names" as clearly as possible. He names his great-grandfather Kwibo Tom, Tom's younger brother Wali, and all of the children of both men who came to South Carolina. We know nothing of the origin of the title "Kwibo." All we have is the remnant of sound that was passed through four generations before it was both transliterated and taped orally. But the sound survived as a title identifying Tom. Is it a remnant of clan section name included in a praise-name? (Oddly enough, MacGaffey's example from oral tradition includes in a clan name the title "Ntambu," yet another Kikongo word which could easily transliterate to "Tom.") Gadsden's great-grandfather carried the same name as his own father, also "Kwibo Tom." In the Bakongo formula the title would be passed on in order to transmit identity. The Mukongo scholar A. Fu-Kiau kia Bunseki-Lumanisa explains, "The use of two names to designate a person . . . has a very rich significance for those who wish to know Bakongo history and origin. If . . .

a person . . . has two names, that shows that this pair of names belongs to two people."[21] Gadsden's great-grandfather was named according to the Bakongo custom.

The second part of the praise-name formula occurs in Gadsden's recitation as he describes attributes of the founder Kwibo Tom, for Tom and Wali had a status above slavery: "Tom and Wallie never did work as slaves, but they came and went freely about these islands; there may have been some special arrangement about them." Major Murray thought Tom's child-making superior and gave him a special dispensation: "You go ahead: get as many wives as you want. We need the same kind of people as your children are."[22]

In the Bakongo tradition the chief's sisters would be named with the clans of their husbands and their children as founders of new houses. Tradition here coincided with historical fact. For at least 250 years Bakongo moved in small groups of relatives, grouping and regrouping. Although Kwibo Tom's sisters are not on Edisto, Gadsden characterizes his daughters, Gadsden's great-aunts, as major figures, founders of new groups of relatives. We've seen the attributes of his great-aunt Jane as a makunda in her community. Jane is not remembered as having children of her own, which may be why Gadsden did not tell her last name. She was in fact married to Joshua Joseph and was given her sister Kate's grandchild, Evelina Fludd, to raise. Fludd commented, "Jane was tough."[23]

Two of Kwibo Tom's other daughters were given to the Presbyterian parsonage plantation: "Major Murray gave my grandmother's sisters Alice and Grace to be slaves on that plantation. I knew them both; they were my grand-aunts." They founded their own lineages: "Those two sisters married two brothers. Alice married James Gadsden and Grace married Joe Gadsden. They had plenty of children." And they, too, "were practically free. . . . They were slaves, but they didn't work like slaves. They worked more like free people." Slaves at "Parson Lee" constituted a special group who were allowed to farm for themselves and take their produce to market.[24] Although Gadsden's grandmother was one of thirteen children, and Gadsden named ten of them, he only revealed spouses and last names of these two who went into service for the church.

Gadsden's recitation continues into the third part of the praise-name section of the Bakongo tradition with a reference to his family's place of origin. Gadsden's farthest-back place in Africa, he says in the taped version, is the Kongo. This is his "perfect place" where Chief Kwibo Tom took care of his people. Is Gadsden's Kongo, then, a remnant paralleling the Mbanza Kongo of Bakongo myth? The people of Gadsden's generation on Edisto themselves had a farthest-back place as an ideal. They saw themselves as rooted in the plantations to which their African ancestors had been brought. Although the plantation names such as Rabbit Point, Cypress Trees, and Sunnyside are known on Edisto today, the African Americans there still

designate them by the owners' names from slavery times. As Bubberson Brown explained, "The place name you. You related from there. 'Who is that?' 'That is Thomas Brown, he a Konkey,' that mean his place is McKonkeys."[25] The owners' names are used like Bakongo praise-names: as titles of founders refer to chiefs who built villages, former owners' names are remembered as builders of today's communities.

Those of Gadsden's generation saw those plantations as their farthest-back place although they knew that their ancestors had been forced to work those plantations for whole mornings without food, had seen their babies sold away, and had had their backs lashed and ears cut off. Despite knowing the brutality of slavery the people turned the old plantations into a mythical place, their own Mbanza Kongo. "The old days and the old ways were better than the days and ways we see now," one of Edisto's African American elders, Tony Deas, told Nick Lindsay. In his tradition-gathering project Lindsay found that a "paradisal time is hinted in the narrative of each person who has undertaken a segment of the history of the old days and the old ways." Four of his informants actually said of the old time, "It is paradise."[26]

The fourth part of the praise-name formula tells of the clan's departure from Mbanza Kongo. The clans did not leave their ideal Mbanza Kongo until they needed food and had to leave to search out a place to produce it. Tom and Wali left with their families to find a new source of cloth. As we have seen, the Vili people historically moved out to find and control cloth supplies. Thus, the mythological economic situation has its parallel in the historically real economic situation.

As the clans left their farthest-back place, they reached a river they had to cross, and the crossing concluded part one, the praise-name section of the tradition. This river of tradition varied as mythological circumstance fluctuated. It might be large—as the Zaire—or very small. Gadsden's people first crossed the largest body of water, the Atlantic Ocean, then the North Edisto River to get from Wadmalaw Island to Edisto. After moving there, some of the family crossed the South Edisto River to be settled on Fenwick Island.

In the Bakongo tradition, once the clans reached the river, they could not cross until their chief performed some heroic act to get them across. In the tradition, MacGaffey specifies, the chief would use the implements of his office—his "staff, sword, or knife, a raphia-fiber mat, or certain trees"—to perform this feat. Slaves brought to the United States were not allowed to carry artifacts, so Gadsden's tradition could not contain them. Gadsden, however, used knowledge—the mind—as an artifact of miraculous power. Chief Tom "know all about" where to get the ivory needed to trade. His knowledge, and Tom's and Wali's, enabled the segment of his lineage to cross the water to better the family's economic base. Gadsden's estimation of rowing skill elevated the boat to a chief's implement. For he explained

that after the people were taken to different islands, "They could row a boat—go to Fenwick Island—backwards and forwards—just like they could row from Wadmalaw backwards and forwards." Their rowing skill kept the family in contact with who they were. And so on each island, Gadsden emphasized, "They raise a whole lot of children there, and they raise a whole lot of children here"; until he can say with cosmic significance, "Out that family of people has come practically a whole nation of them."[27]

Gadsden's account of his own family's tradition was conservatively earthbound. But he preserved the heroic-act part of the Bakongo tradition by telling a tale of another Edisto family's crossing the mythical river to return to Africa. The founding father, the slave Caesar, and his brother didn't complete work assigned them, and they were to be whipped. But Caesar "threw his hoe up into the air, climbed up and sat cross-legged on the hoe, up high where the driver couldn't reach him." He and his brother were not whipped that day. The next day the same thing happened again. And on the next, said Gadsden:

> Maussa went himself to see where Ceasar [*sic*] was working. He saw where Ceasar had a big fire and him and his brother and their wives and children were all dancing and making a celebration around the fire, kick up their heels and all. While Maussa watched, the fire began to make a smoke, make a big smoke. Smoke, smoke, smoke, and when the smoke was gone, come to find out, Ceasar and his whole family had gone up in that smoke. Fly out across the ocean, gone home to Africa. No more see, no more hear: two brothers, their wives and children—the whole tribe.

This family, too, had originally been brought from Africa. Caesar was its "chief," who wielded his hoe as a tool of chiefship to achieve heroic power. Gadsden notes that versions of this "Flying Affiky Mans" story come "from Wadmalaw, from Saint Helena—all about."[28] The form of the Bakongo tradition thus came to the Sea Islands. Its threads appear scattered throughout the islands. But the whole cloth is there.

In the second part of the Bakongo tradition the clans separate into sections, and the account moves toward present time. Gadsden, too, told of his family's separating into sections: some people were left on Wadmalaw, some settled on Edisto, and some moved to Fenwick Island. In the Bakongo tradition each clan section begins to record its own journeys and settlement, including its chiefs and their sisters as the major figures. Gadsden's account follows much the same course. He tells us that Wali's family settled at "Clark's" on Edisto, and Gadsden's account of the activities of that branch of the family ends there. When his memory was triggered by repeated meetings with Lindsay, he listed a few names for a genealogy of Wali's family, but his taped interview revealed nothing else of the history of Wali's family.[29]

For his own direct lineage, however, he traced the path of movement and settlement for each generation down to himself. He gave details of his family's move from Wadmalaw: "My grandmother and her brothers and sisters and their father, Tom, came first to a place they call Legree's [Legare's], over near Oak Island Plantation on this island [Edisto], then from there they went to Murray's place, when her father gave all that family—Tom's family, not Wallie's [*sic*]—to his daughter, Liddy, as a wedding portion when she got married. That was in 1825." His grandfather, Thomas Gadsden, settled on land he thought he had bought, located on a parcel of the Wescott plantation, which "lies on both sides of the road which leads out to Point of Pines—Jabez Wescott on the left and John Wescott on the right." Then his father, Charles Gadsden, "built a house on land from the John Wescott place in 1886." It turned out, though, that they had been tricked out of ownership, and "about the year 1915, we were run off from that house and my father bought land over here."[30] Since he is talking to people who know where they are, he doesn't identify Charles Gadsden's new location in this text.

References to the chiefs' burial places were also included in the Bakongo recitation. Gadsden established a relationship with this phase of the tradition when he talked about where his grandfather and his father lived and died. He spoke with awe of his father's having built the house on Thomas Gadsden's land, saying, "That gallant old man did that. I remember." Then, twelve years later, he said, "My grandfather died in 1898, . . . died right there in the house my father had built. Then . . . about the year 1915, we . . . moved into a big house which used to stand up north of the yard. My father died there and we weathered the 1940 storm in that house." And bringing the tradition to a close with the present generation in the present place, he said, "but a couple of years later it burned and I built this one."[31] Building, living in, and dying in houses anchored people to their land, their families, and their founding ancestors on the Sea Islands.

On St. Helena, as well, remnants of the second part of the Bakongo tradition form survived. There, too, people told of the journeys and settling of their progenitors on the land. Robert Grant reported that his grandparents told him that their people were "created from Africa," and his great-uncle told him they were brought on a boat named *Santianna* to Pinckney Island, near Hilton Head, where they were sold and then resold and came to St. Helena. Edward and Annie Milton both said their "parents come from Africa." Edward Milton said, "They sailed them." And Annie Milton explained, "Great Britain had a boatload of our people and then our parents were carried from one place to the other. They had to dig a hole in the earth and make tent to live in. . . . My grandmother tell me that. And they didn't have nothing to eat. They didn't have anything. They knew how to get feed out of the woods—and cook different bushes—and that's what they were living on." Edward Milton added that his grandfather talked about that, too. Amanda Bradley told about her great-grandmother, Molly, who was brought

with her brother and their mother, Ginny. They were settled on St. Helena, but their children were sold. Her grandfather "was sold to Walterboro—then after peace declared he come back to his people." The family lived together then on Frogmore plantation.[32]

Sam Doyle's paintings chronicle this part of the tradition, envisioning the community of the whole island. His tradition records securing all of St. Helena Island as a free community of African Americans. Again he shows "in one immediate visual statement" the truth of the experience of the people: he shows where the African people were brought—to the pain of slavery—in one graphic painting of a slave with feet chained, hands bound, and back cut open and bloody from the whip. In his large painting of freedom he then makes us understand the overwhelming relief that begins a new life, proclaiming "NO MORE we hear" as he points to the master and says "the driver horn the whip we fear."[33]

Doyle shows how members of his family helped to establish St. Helena as an African American community. He painted *Ma Cinda*, a portrait of his great-grandmother, who was St. Helena's first African American midwife. Her name was Cinda Ladson. She was born a slave, owned by Gabriel Capers, who had a plantation just south of Wallace plantation where Doyle's family settled later. Capers sent Cinda to Charleston to learn to be a midwife. Doyle also painted her daughter, Adelaide, who was well-known to the Penn School teacher Rossa Cooley. Cooley wrote of her, "Suddenly, through a break in the hedge we had our first sight of Aunt Adelaide. She poised a large basket on her head, her skirts were above her ankles, tied below the hips by a stout cord. . . . She held a pipe tightly in her teeth, and carried the heavy Island hoe on one shoulder. . . . [She] swung down the road, tall, straight, strong." Doyle remarked that Adelaide worked for herself and came from people who didn't have much education but were "smart-working." He painted his brother James, "the first Black man to drive an automobile on the island," and his brothers Fortion, John, and Frank, who went to war for their country.[34]

Then he broadened his approach to reveal the record of his community with paintings of St. Helena's first African American professionals—policeman, doctor, embalmer, dry cleaner, taxi driver. The community was thus established on the land. Doyle secured this tradition by putting high prices or "SOLD" on the pictures he wanted to stay on the island. He didn't want people to buy these. He wanted St. Helena people to know and remember their history. The last time I saw him, he was loading a sheet of plywood into his truck to go home and paint Adelaide and Cinda again. He was annoyed because his last pictures of them had been sold. "This time," he said, "they're going no place. They stay right *here*."[35] Doyle clearly saw himself as the chronicler of his people's tradition.

The Bakongo tradition ends with the present generation in its present location. Information about living people and their place in the tradition of

origin belongs to their "pedigree," not to this tradition. Nor does this kind of information find a place in either Gadsden's or Doyle's history. Doyle refused to put the name of the baby who survived the storm of 1893 on her picture because she had relatives still living, but he emphasized that the baby's family's location was near his home.[36] Likewise, as Sam Gadsden and Bubberson Brown tossed stories around, they identified the participants as "cousin" or "sister-in-law" or "aunt," locating them within the family. Always, always, the tradition—with its entire panoply of facts, tales, descriptions, myths—serves to pinpoint the identity of the teller, merging the identity of the individual with location on the land. It serves the same function both for Kongo peoples and for Sea Island people. And in preserving and adapting the Bakongo pattern of thinking, the recitation of traditions of origin maintained Sea Islanders as part of their centuries-old "universal community."

Embedded in the patterns of thinking that Africans brought to their plantation street settlements is the underlying but highly structured concept of how society should be organized. Surrounding and interpenetrating that concept is the equally highly structured system of African religious belief. When we glanced at the Igbo secret title association, Ozo, we saw the interpenetration of religious belief in concepts attached to the symbolic ikenga sculpture. We looked at the extensive power wielded by the Efik in the name of the Ekpe spirit. We've now seen the interpenetration of religious beliefs in both naming and land-holding customs in African American communities. A system of thought so pervasive and so complex was bound to accompany African peoples to the New World.

Where African Americans were free, formal societies were known to exist. In South Carolina the Brown Fellowship Society existed in 1790, the Humane and Friendly Society in 1802, and the Minors Moralist Society in 1803. In Virginia free African Americans had formed societies by 1815. But oral tradition has also reported that societies existed even among slaves. A Hampton Negro Conference recorded that societies to take care of the sick and provide acceptable funerals existed in Virginia's cities. Most of these societies were secret. They had secretaries who kept records with number codes. Members would drift in, state their numbers, and make payment without telling their names. Societies usually had a "privileged" slave as president. This slave could move freely and so keep in current communication with members. Members of a Richmond society surreptitiously sat together during funeral services. Afterward, once they were far enough away from white surveillance, they formed a column of march. The conference reported that members reputedly "were faithful to each other and . . . every obligation was faithfully carried out." The system had developed to this rather complex stage by the early nineteenth century.[37]

To understand just how pervasive, complex, and powerfully influential these structures of thought were in evolving African American communities, we will compare details in the organization of the Ozo association of the Igbo of Nigeria with the structure of an American counterpart, the Independent Order of St. Luke, a purely African American fraternal order whose center was in Richmond, Virginia. By 1866, merely one year after the end of the Civil War, there were already about thirty beneficial societies in Richmond. Although the Independent Order of St. Luke began in Baltimore, it soon moved its center to Richmond and by 1877 had codified and printed its ritual. While some of these societies shared names with white organizations—Free and Accepted Masons and Knights of Pythias, for example—when W. E. B. DuBois analyzed them in detail, he found that only these two and the Odd Fellows contained any internal similarities to the white organizations. The others had "curious" differences which he could not fully define.[38]

St. Luke itself exhibits several of these differences. The Euro-American fraternal orders were men's organizations with subsidiaries for women. St. Luke, in contrast, was founded by a woman, and its outstanding leader in Richmond was Maggie Lena Walker. Both men and women belonged to St. Luke—and belonged on equal footing. Their equality contrasts with African associations, whose membership was generally confined to men or to women. Their equality may, nevertheless, preserve an African value: women and men are of equal worth.

The early date of St. Luke allows us to study a purely African American society before much of the intermingling with Euro-American cultural habits occurred. But we need to determine where to look for an African association with which we can appropriately compare St. Luke. A predominance of peoples in Virginia came from the Bight of Biafra. Through the mid-eighteenth century increasing numbers of slaves came into Virginia directly from Africa. Concurrently, slaving along the Bight of Biafra increased, so that area produced higher percentages of the slaves going into Virginia than did other regions of Africa. People from a complex interior slave-trade system passed through the Biafra ports. They included Ibibio, Cross River peoples, Tiv, and a few Efik; but by far the largest number were Igbo.[39] In Virginia major landing places for delivering slaves imported directly from Africa included the Bermuda Hundred community on the upper James River and the ports at Yorktown and West Point on the upper York River. Both areas linked with Richmond; Bermuda Hundred was a gate into what became Chesterfield and Dinwiddie counties. The logical conclusion is that the amalgamation of Africans in and around Richmond and the counties southeast of it included large numbers with Biafran, especially Igbo, heritage.

Furthermore, Virginia acquired large numbers of Igbo from South Carolina, the second major destination for Biafran slaves. South Carolinian

planters avoided buying Igbo and shipped them on to Virginia when possible.[40] Thus, cultural values of the Igbo, who were sold to Virginia in great numbers, and of their neighbors, the Efik, whose control of slave trade assured their contact with Igbo, were the values of large numbers of Virginia's African slaves. Just as Kongo cultural values operated among African Americans in the Sea Islands, Igbo and Efik values and customs were passed on to Virginia's African American children in the natural course of upbringing. They profoundly influenced developing institutions. We will therefore compare the values embodied in St. Luke with those of the Igbo and Efik title associations.

Structurally Ozo and St. Luke are alike. Each had a number of degrees, or levels, of membership; each degree had a set of symbols. Ozo and St. Luke each required an initiation before a member could rise to a higher level. Within each society's organization many small points appear similar. Taken singly, each might seem meaningless; together they suggest that both the whole structure and individual characteristics came from an African form like Ozo into St. Luke. Charts 1 and 2 show these similarities as they appear in the structure of St. Luke and in the Agbalanze, which was the Onitsha Igbo division of the Ozo title association. Variation in numbers of stages is not significant. For example, Ekpe, the Efik title association, had from seven to twelve stages.[41] Within the stages of both African and African American associations, however, similar acts occur in similar order. The two cultures thus had similar concepts of how to arrange action.

Charts 1 and 2 show similar structures of fee payment. At stage two of Agbalanze the process of haggling, paying money, reevaluating the candidate, and demanding more money is repeated over several years; at each degree in St. Luke the candidate pays a fee to the Degree Chief. In Agbalanze fee payment precedes an evaluation of the candidate in which he is found lacking but is allowed to continue if he pays more money; in St. Luke fee payment precedes ordeals and instruction, after which the candidate pays another fee to go on to the next stage. In both organizations, then, candidates pay fees, endure ritual ordeals, and pay more to continue.

Symbols are parallel. The first set of symbols the Agbalanze initiate deals with are his "god emblems." Among these are five "sticks."[42] Four are okposi, representing his ancestors; one is ikenga. Representing his father's fortune, whether good or bad, ikenga has associations with wealth and with the age-group, a formally constituted peer group. The initiate has a wooden bowl, his okwachi, to hold the god sticks, and an altar, a sacred place, where the emblems remain. In the Council Chamber of St. Luke we find "god emblems" too: a Bible and a cross placed on an altar are obvious ones. We also find five "sticks"—candles—representing Matthew, Mark, Luke, John, and Peter. While these apostles are not ancestral blood relatives of the St. Luke

## Chart 1

### Independent Order of St. Luke

Degree Council Chamber contained: desk with three candles
altar with Bible, cross, five candles

| Stages | Symbols | Initiation |
|---|---|---|
| Basic | White satin collars, white aprons<br>Emblem of the Order<br>Men: red cross; women: white<br>    cross on red ribbon | |
| 1 | White satin rosette<br>Silver star | Fee payment to Degree Chief<br>Oath at altar<br>Degree Chief's address to initiate<br>Signs and passwords taught |
| 2 | White and purple rosette<br>Silver star | Fee payment to Degree Chief<br>Alarm play; wandering pilgrim play<br>Oath<br>Ceremonial bread and water: fellowship<br>Signs and password taught |
| 3 | White, purple, red, and blue<br>    rosette<br>Silver star | Fee payment to Degree Chief<br>Alarm; continue pilgrimage to cross<br>Oath at altar<br>Instructions on history of degree,<br>    financial card, and travel certificate<br>Signs and password taught |
| 4 | Black and scarlet rosette<br>Silver star | Fee payment to Degree Chief<br>Alarm; commitment to principles of the<br>    order with oath at altar<br>Ordeal: seizure in semidarkness;<br>    moral lesson<br>Signs and password taught |
| 5 | Purple and pink rosette<br>Silver star<br>Purple collar<br>Purple apron | Fee payment to Degree Chief<br>Alarm; oath at altar<br>Explanation of emblems<br>Signs and password taught |
| 6 | Purple, black, scarlet rosette<br>Silver star; purple collar with yel-<br>    low trim; white or gold cross<br>Degree Chief: crown, robe<br>    with scarlet and yellow trim<br>Past Worthy Chiefs: purple<br>    rosette, gold star, gold cross<br>    on purple ribbon | Fee payment to Degree Chief<br>Ordeal: an intruder play; initiates sent<br>    out, alarm to re-enter<br>Oath; explanation of principles<br>Sign and password taught |

Goal   Love, charity, purity: to be worthy of the brotherhood.

SOURCE: William M. T. Forrester, comp., *Degree Ritual of the Independent Order of Saint Luke* (Richmond, Virginia, 1894).

## Chart 2

### *Agbalanze*

| Stages | Symbols | Initiation |
|---|---|---|
| **1A** | | |
| *Inyedo mmuo*— "Bringing in the father" | Altar<br>4 *okposi* sticks<br>1 *ikenga* stick<br>(= 5 carved emblems of gods)<br>*Okwachi* (wooden bowl) | Consecration of symbols |
| **1B** | | |
| "Rubbing the ears of the kinsmen" | | Notification: of whole siblings (the "kitchen"), of patrilineal siblings (the "ancestral house"), the extended patrilineage, the clan's senior Agbalanze member<br>Meetings; reparations; prayers |
| **2** | | |
| *Igo mmuo*— "Carrying money for ghosts" | Money | Haggling over price of fee payment; pressure on relatives to donate; money given to Ozo; candidate reevaluated and found lacking; more money demanded; process repeated for several years |
| | Palm wine | Ozo receive 100 or more pots of wine |
| **3** | | |
| *Mkpalo*—"Consorting with the ghosts" | *Okposi* sticks<br>Goat skin<br>Corn wine<br>Father's *ofo* stick<br>Crown | Fee payment to Ozo<br>Ordination<br>Oath at altar; goat sacrifice; sitting on goat skin: too pure to sit on earth<br>Ceremonial corn wine: priestliness |
| **4** | | |
| *Mmacha* | Treasure box<br>2 *osisi*<br>White chalk<br>White clothing<br>2 eagle feathers: truth<br>Ivory trumpet<br>Money | Fee payment to Ozo<br>Notification of kin<br>Isolation from women<br>Ceremonial purification and dedication to *nze*; oath at treasure box<br>"Has money" procession<br>Fee payment<br>Ceremonies of reunion with wives<br>Mock market |

**Goal** Purification: to be worthy of the brotherhood.

Sources: Richard N. Henderson, *The King in Every Man* (New Haven, 1972): 111–113, 249–264; Onuora Nzekwu, "Initiation into the Agbalanze Society," *Nigeria Magazine* 82 (September 1964): 173–187; Adebiyi Tepowa, "The Titles of Ozor and Ndichie at Onitsha," *Journal of the African Society* 9:34 (1910): 189–192; and Tony Amugbanite, "Iboland's Sleeping Customs," *West African Review* 30 (October 1959): 649–651.

initiate, both the candles and the okposi sticks represent distant, historical donors of the candidate's religion. St. Luke's hall also contained three other candles, representing the Worthy Chief, the Vice-Chief, and the Secretary of the order.[43] These candles are comparable to ikenga in that they symbolize the peers most responsible for the St. Luke initiate's induction into the order, just as the Agbalanze initiate's father, or peer group, as embodied in the ikenga representation, was most responsible for his candidacy: in the eighteenth century the Agbalanze father's death precipitated initiation of his senior son.

Color symbolism permeated both organizations. White symbolized purity to both Igbo and St. Luke. The Agbalanze initiate proceeded through stages of increasing purification until in the final ceremonies he was bathed in white chalk, was dressed in white clothing, and had earned the right to "bathe" his god emblems in white chalk. In St. Luke purity was a prime goal; the regulation for basic regalia specified white collars and white aprons. The rosette for the first degree was entirely white; those for the second and third degrees contained white. The order's regalia designating degrees also contained a color pattern prevalent in West Africa: the trio of white, red, and black. In African cultures these colors are common; their appearance here might seem meaningless. As Chart 3 shows, however, there was a vertical progression in their use and a horizontal coincidence between symbol and rite. St. Luke followed an African pattern, progressing from white to black, whereas the usual pattern in European color symbolism progresses from black to white. The white-red-black triad appears in the sixth degree in a powerful combination of color symbolism and emblems. While red and black occur in the rosette, white occurs in two ways. One is in the water used as a symbol of the principle of purity. For the African, white, water, and purity were equivalent. The Onitsha Igbo "bathed" his emblems in white chalk; he also called his clothes white after they were washed, no matter what their color. In parts of central Africa clear water is called white water. St. Luke represented purity with a "flowing fountain gushing forth its crystal streams." The second occurrence of white is in a white cross worn with regalia. A pattern thus appears here which Victor Turner notes time and again among African peoples: the conjunction of the white-red-black triad with water and with a cross motif. Further, he notes, "the critical situation in which these appear together is initiation."[44]

Within initiation rituals the American and African groups include similar patterns of action—of notification, of payment, and of ceremonies of oath-taking, self-improvement, "having money," and dedication. Looking at the Agbalanze ritual in Chart 2, we see much of stage 1B—"Rubbing the ears of the kinsmen"—devoted to notification.[45] At the beginning of stage 4, before the ceremonies of ultimate purification can begin, ritual notification of the kin occurs again. In St. Luke, as Chart 1 shows, "alarm" recurs at the beginning of degree initiation meetings. Alarm signals the

Chart 3

| Color | Meanings of color symbols[a] | Degrees | Corresponding rosette color symbols | Ritual traits paralleling color symbolism |
|---|---|---|---|---|
| White | Purity, cleanliness, harmony, peace Light: daylight Widespread knowledge | 1 | White | Most public degree Lecture: no fear of danger |
| | | 2 | White Purple (a red variant) | Pilgrimage begins: possibility of danger implied |
| Red | Blood: therefore sometimes dangerous power Power Sometimes wealth | 3 | White Purple, Red Blue (a black variant) | Pilgrimage continues; warning of danger Wealth introduced via financial card |
| Black | Darkness, danger | 4 | Black Scarlet | Seizure ordeal in semidarkness |
| | | 5 | Purple Pink | Wealth: promise to employ brothers |
| | Secret knowledge | | | Symbols of power taught |
| | Ritual death: regeneration | 6 | Purple Black Scarlet | Intruder ordeal: initiate ousted, then allowed to re-enter |

[a]Meanings derived by Victor Turner from the Ndembu and observed by others elsewhere in Africa. See Turner, "Colour Classification," 72–74, 77–79.

Sources: Victor W. Turner, "Colour Classification in Ndembu Ritual," in *Anthropological Approaches to the Study of Religion,* ed. Michael Banton (London, 1966), 64–67, 58–61; and Forrester, *Degree Ritual of the Independent Order of St. Luke* (1894).

notification ritual. The Senior Conductor officiates: he informs the Degree Chief and membership that there is a candidate; he challenges the candidate's willingness to conform; and, when satisfied, he knocks on the chamber door. "Alarm" ritually notifies the assembly that an initiation will begin. This pattern of notification occurs at every degree stage except the first, which in this respect, as in the use of color symbolism, is the most public degree.

Since ceremonies of oath-taking occur in all societies, they are not especially significant here except for a consistency in their pattern: both St. Luke and Agbalanze initiates took oaths in kneeling position at a revered spot, usually an altar. In St. Luke the ceremony of self-improvement instructed candidates—first in degree history, then increasingly in fellowship and morality as they were taught the significance of emblems and principles.

Instruction was always linked to the candidate's promises to "become a better man (or woman)."[46] In Agbalanze the ceremony of self-improvement occurred in each purification ritual as the candidates moved toward becoming pure enough to assume a full priestly role in their community.

Patterns of fee payment were followed by ceremonies of "having money" at the higher stages in both organizations. They are more obvious in Agbalanze: having paid huge sums of money and come through his most secret purification rite, the candidate walked from the nze shrine to the village, accompanied by the Agbalanze members repeating "has money, has money." Later, at the end of all the ceremonies, the village held a mock market, which closed when the newly titled Agbalanze member threw a shower of coins for children to gather.[47]

Ceremonies of "having money" were more subtle in St. Luke. The first occurred in the third degree along with a stepping up of the danger motif in the initiation ritual: candidates were cautioned, adamantly, that any member in distress to whom they wished to give aid must be in good financial standing with the order. Distressed members could confirm their standing by producing their "financial cards" and backing them up with the "travelling password and certificate" and the addresses of their council's Worthy Chief and Recording Secretary. In other words, St. Luke members needed to "have money" to receive help from others in the Order. The second ceremony of "having money" occurred in the fifth degree. Within the oath-taking ceremony, while promising to help and shelter fellow members, the candidate said, "I also promise to give him or her employment and employ him or her in preference to all other males or females." In order to give employment, one must "have money." A third ceremony was couched in less materialistic terms: in the sixth-degree oath candidates promised to be charitable and to use their "influence for the promotion of the members of this Order, both morally and socially." And in a fourth ceremony in the same degree the Degree Chief, ritually explaining the purity principle, linked purity with benevolent deeds: "So let our acts of benevolence be actuated by the purest motives, . . . setting an example for our brothers and sisters of lesser degrees and the uninitiated to gaze on our good works with admiration."[48] To perform good works, one must "have money." When we discuss the functional structure of these organizations, we shall see that this seemingly materialistic attribute is a deeply African conception.

Ceremonies in the highest stages follow parallel patterns of dedication to symbols that stand for concepts. Once sworn to keeping secrets, the St. Luke candidate for the fifth degree was taught the meaning of symbols of power in the order: an all-seeing eye, a figure of "Justice" with scales, a St. Luke monument, a cross with clasped hands below its base. In Agbalanze this ceremony of dedication happened at the climax of the mmacha stage. At night the initiate was led to a shrine where the nze objects were kept. These symbols of the clan's "sacred mystery" were relics associated with its

founding patrilineal ancestor. Kneeling there, the initiate took his final oaths to purity and began his final ritual. There he acquired his title, agbala-nze. He had achieved the ultimate purification necessary to serve nze.[49]

The final element in organizational structure of both the Agbalanze and St. Luke was a social gathering, a relaxed and secular event. On the day after the nze ceremony the new priest's oldest son and daughter and his senior wife rejoined him by participating in a public ritual dance. After that his entire community celebrated into the night. In the Virginia environment celebrations after ritual services were more subdued, but members shared refreshments, and, as noted by Richmond's African American newspaper, "all highly enjoyed themselves."[50]

The functional structures of West African and American associations may seem less similar than the organizational but only because they are so complex. Within single West African communities several title associations could exist and have overlapping functions. Ozo, for example, was an association of wealthy men who acted as councilors who influenced political decisions and kept order when people broke religious and social rules. Among the Onitsha Igbo, another title association, the Ndichie, held still tighter political control, with two groups of Ndichie representing the people while a third supported the chief. The Ndichie thus formed a check-and-balance system. Men who wanted to join Ndichie had to belong to the Ozo first. Ozo members also belonged to a secret mortuary society, the Mmuo, which performed rites both to satisfy ancestral spirits by ensuring proper burials and to enforce Ndichie laws.[51] In this example we see functions intertwined. From legislating to enforcing laws, from conferring status to forming priesthoods, title associations combined political, social, religious, and psychological functions that operated to stabilize the community.

More striking to Western thought, however, is the inclusion of an economic function. We have seen that the Efik Ekpe controlled trade at Old Calabar through a credit system enforced with backing from the spirit world. The system was so forceful that it ultimately gained complete control over the Efik economic structure. By standing between the spirit and the community, by interpreting and enforcing the spirit's will, Ekpe members filled administrative, executive, and judicial as well as religious functions. Like the Ozo, Ekpe members met for sociability, feasting, and drinking. Ekpe, too, was related to a society for gossip and singing. And like Ozo, Ekpe was related to a society that dealt with death—and so closely related as to be called a "brother."[52] Thus, as in Ozo, we see all facets of community organization—governmental, social, economic, and spiritual—combined in Ekpe. The same unifying force appeared in Virginia, where the African concept of the interrelatedness of all facets of life became embodied in the beneficial-fraternal society. Within that society African Americans acted out the

unified complexity of life's aspects and did it with emphases characteristic of African thinking rather than European.

During transmission, changes within functions occurred as the new environment demanded. The most obvious shift is in governmental functions. Ozo, Ndichie, and Ekpe were dominant law-making and law-enforcing title associations. The Virginia environment normally precluded any political participation. Slaves obviously could have no dominant political role. Nor could free African Americans. And in the half-century after emancipation African Americans in Virginia moved from participating in government to being politically repressed. Finally, in 1902, white rule disfranchised virtually all of them.

Nevertheless, the benevolent society performed a governmental function by creating a complex set of procedural rules. They governed the order of business, the opening and closing of council meetings, the installation of officers. Rules established procedures for opening, organizing, and consecrating a new council and for conducting initiation ceremonies. St. Luke's "Burial Ceremony" prescribed dress, mode of transportation, order of march, the council service to be held before and after the church service and burial, and the procedure for behavior at the grave. The society also legislated moral standards, delineating values through ritual, rules, and peer-group behavior. St. Luke's basic goals were love, purity, and charity. They appear throughout the ceremonies of initiation into the six stages of membership, and they are embellished by others. In the primary initiation rite the Recording Secretary instructed new candidates for membership: "Strangers, allow me to inform you that the virtues which should characterize a true St. Luke, are honor, temperance, faithfulness, obedience, meekness, charity, and brotherly and sisterly kindness."[53]

The first instruction of the first stage of initiation explained the symbols of St. Luke's principles—flowers for love, water for purity, and alms for charity. In the second stage the candidates swore "to administer aid and relief to the sick and distressed wherever I may find them, but particularly to a brother or sister of this Order." After the oath the candidates ceremonially ate a piece of bread and drank from a cup of water. The Degree Chief explained that this ceremony commemorated the difficulties and persecutions suffered by Christians traveling to the Holy Land and that it should remind the candidates of their oath of charity to those in trouble and especially to their brothers and sisters in the order. Instructions for initiation into the third through the sixth degrees emphasized obedience and faithfulness to the laws of the order. At the fourth level initiates underwent a ritual ordeal to impress them with the need for charity: "The lights are all lowered, and as the candidate attempts to re-enter he is seized by several members and charged with being an enemy; his hands are chained or tied, and he is carried before the Degree Chief as an intruder, who has gained admission without the pass-word. Some will attempt to order him out."[54]

The Degree Chief then taught the initiates the moral of the ordeal: "This should be a lesson for you. The scene of this occasion is a representation of what often follows misunderstanding or the want of proper instruction or training. How many of our fellow-men perish as victims for the want of some friendly advice and hand in the time of danger and distress. . . . Remember in future never be harsh to the unfortunate, the poor, or to those afflicted with the trials of life." In the fifth degree the vocabulary of the oath to charity became more vigorous: "I solemnly swear to be in no plots or conspiracies against a brother or sister of this Council, or against the Order in general. . . . In case of any sad accident, I will fly to his or her relief." Peer-group pressure to conform to the moral laws established by the order emerged forcefully in the initiation ordeal of the sixth degree: "The members will form two lines, faces inward, and through this line the Assistant Degree Chief and the candidates must pass. On their way through, the members must seize the candidates, some charging them with intrusion, some with being an enemy, some with being a traitor, while others will express themselves as to the punishment such action deserves." Initiates there endured confrontation and bodily threats from every member of the sixth degree. Next they were charged with intruding into the council without proper signs and passwords. The Degree Chief admonished the Senior Conductor to "please see that the laws of this Council are enforced and that the penalty for the offense is inflicted."[55]

Candidates were then expelled from the council chamber. After a time each asked to be readmitted and was brought back by the Senior Conductor, who said, "Respected Degree Chief, I present you this pilgrim, who was a short while ago charged with being an intruder. In attempting to carry out our laws, I found that his . . . motives were pure, and that he comes to enlist with this Council for the promotion of love, purity, and charity." The candidates having been found worthy, the Degree Chief then accepted them, but only for as long as they would conform to the order's standards: "Senior Conductor, if [these persons] are really pilgrims, and their desires true and their motives sincere, we shall be pleased to enlist [them as] our members. We want only true and faithful followers; those who are not afraid to face the hardships and the scorns of the world."[56]

Apart from these two channels—the body of regulations and the legislation of moral standards—a symbol appeared which seems almost a vestige of the African title association's original purpose of assuring law and order. It is the figure of "Justice," placed on the right side of the St. Luke emblem. It reminded the member to be objective and rational in a dispute, to leave punishment to the "office of Justice."[57] Though the society could not control how Justice performed her offices in Virginia or the nation, this brief instruction directed members to obey her and so buttressed the preservation of law and order.

❀

While governmental functions shifted toward subtle fulfillment, religious functions remained dominant and were expressed openly. We have already seen evidence that religious traits permeated both St. Luke and the African title association. We shall now examine parallel religious functions in leadership, in the purposes of rites, and in attitudes toward death.

First, the organizations have parallel components in their leadership—in chief, priest, and father roles. The Igbo initiation ceremony ordained a priest. All of the extended family's Agbalanze members gathered in the home of the candidate's family's chief priest for a major part of the ceremony. All of the chief priests of his extended family officiated. The priests made offerings to the candidate's personal god, asking blessings on their candidate; they held prayers among themselves and for the whole family. The chief priest concept has several layers. The one who earned the Ozo title reached the highest level of achievement and the ultimate purification. Through his purity the priest gained access to the ancestors, thereby linking the living with the dead.

A third interpretation, found at Onitsha, included a kingship institution with "chieftaincy" concepts. It is believed that nine clans founded Onitsha. Kings of eight of them were chief priests of the lineage. Their title included "eze," designating them as custodians of their clan's nze. The kings were also called "ńnà-ányi," meaning "our father."[58] Thus, they linked paternal with priestly roles. These religious functions were also present in St. Luke, although it was not an organization of priests and although priests, as such, did not officiate at its rites. Still, the functions of top-ranking officers—leading prayers and hymns, administering oaths, teaching morality—were priestly, and "Chief" is repeated in officers' titles. Founders and high-ranking officers of fraternal orders were often also ministers.

Along with this "chief priest" role the Virginia society also contained a paternal role, which a woman could fill. In Virginia, however, the two roles were not embodied in one person. Though called "Worthy Father," the paternal role might be taken by a woman: "Brother (or sister) _____, you have been elected Worthy Father of this Council. . . . You are called upon to exercise a parental care over this Council." Mrs. Dorothy Turner, Right Worthy Grand Secretary of the Independent Order of St. Luke, described this officer as an "older, respected person, one who would fill a fatherly, advisory role."[59] The religious functions of chief, priest, and father are thus combined in the leaders of the American society as they were in the African.

Both Ozo and St. Luke endured initiation in order to be prepared to enter the spirit world when the time came. In a Christian context St. Luke members swore oaths, promised study and faithfulness, and sang hymns. The final instruction for the highest degree explained the Order's three guiding principles in terms of Christian principles. The St. Luke must "love thy neighbor as thyself," strive for purity, and follow St. Paul's command: "Above all these things put on charity, which is the bond of perfectedness."[60]

Purity was a principal goal for the Ozo of Onitsha as well. They did not incorporate love and charity as basic principles, but all three may have been components of the Ozo title association in Awka. The organization there once had ten stages. The ninth, ozo, is now the final stage, but in earlier generations, the tenth stage was whum. A titled man defined it as "asking for general love, between man and the gods, because this is measured in the amount of alms and good turns you can do to humanity. It is a final sacrifice of life." So the relationship between love, charity, and purity is clearly at work in the Igbo title association. With the religious force of its love and caring for mankind built on a foundation of purity, the relationship is the same as the one that Dorothy Turner described in St. Luke.[61] Could it be that sixth-degree St. Luke members have preserved a custom in the United States that has died out among Awka Igbo in Nigeria since their forebears were brought here? Could it be that sixth-degree St. Luke members have achieved whum? With the vast choice of virtues available as guiding principles, and the even greater choice of combinations of them, the occurrence of the same triad—love, charity, and purity—in both societies seems more than coincidental.

The third set of religious parallels occurs in concepts of how to deal with death, both in basic attitudes toward death and in rituals surrounding it. The African mortuary society, constituted separately but closely related to the title association, expressed attitudes toward death and burial which are identifiable in slaves' behavior. Death was not a finality to the African. It was merely a passage between stages of life. The good dead went into worlds beyond this one; the bad dead stayed in this one, wandering restlessly and causing trouble. The good dead were buried with elaborate funerals which helped settle them properly in the worlds beyond. From there they would help with the upbringing of future generations, contributing good fortune, judgment, longevity, and physical and behavioral characteristics. It was therefore of paramount importance to send the dead into other worlds with correct observance of the ritual of passage.[62]

Slaves could perform only limited rituals for their dead. Shortly after emancipation, however, burial ritual became complex. Merely twelve years after the Civil War, St. Luke published its prescribed burial form. Part of the church service for the dead, it contained religious elements. Slaves had formed surreptitious funeral marches; the St. Luke ritual prescribed a highly elaborated march. The St. Luke burial form included a council service within the procession. This pattern of behavior appears to revert from the adapted and simplified version of slavery time to the more detailed format of an African burial society. Efik Ekpe members belonged to a secret burial society, the Obon. Like St. Luke's council service Obon held its own ritual within the larger scope of the funeral observances.[63]

A number of traits of the St. Luke service procession had parallel traits in traditional Igbo funerals. Once St. Luke had formed its procession, it marched to the home of the deceased before going to church or cemetery. Ozo members marched to the gate of the deceased's home, then inside to his shrine and to the door of his house, shouting his name through their ivory Ozo trumpets. When an Igbo woman died, her relatives took her body home. Awka Igbo carried the body first to the front door of her father's house before taking it out to the farm for burial.[64] Positioning of mourners at the grave was also similar. At the St. Luke grave the council formed "a circle around the grave, as near as possible." The ritual placed officers at the head and sides of the grave; mourners were to stand at the foot. Members took these positions before the body was lowered into the grave. In Asaba, Okpala title members also formed a circle walking clockwise around the grave, also before lowering the body.[65]

Behavior initiating participation of the organizations in funerals shows two sets of characteristics in common. First, wealth and standing were required in both African American and African forms. The St. Luke ritual began: "At the death of any member of this Order, who is at the time financial and in good standing in his (or her) Council, the Worthy Chief, after being satisfied that all necessary arrangements have been made for the interment of the deceased member, shall appoint an hour agreeable with the time appointed for the funeral, for the members to meet at their Council chamber to attend the funeral of the deceased member." Like the deceased St. Luke who had to be "financial," members of title associations also had to be well-to-do. When an Igbo Ozo member from Ogwashi died, women relatives threw cowry-shell money in their market. Okpala title members of Ubuluku Igbo received cowries at the death of a fellow member before his grave was dug. In Asaba cowries were placed on the wrists of a deceased Eze title holder. As the St. Luke must also have been "in good standing," so an Igbo Eze from Asaba was dressed in his title association regalia—his red cap with two eagle feathers—to show his "good standing." While his body remained in his home, any stranger who came in paid respect to his "good standing" by saluting him. Second, the organizations began to join funeral rites only after initial preparations for acceptable burial were made. Among the Igbo the body was prepared before title association members convened. At Amo-Imo village, elders consulted a diviner about burial to satisfy themselves that the method was proper.[66] St. Luke's *Ritual* specified that the Worthy Chief must ascertain that "all necessary arrangements" for burial had been completed before convening the council members.

The ritual gestures of St. Luke and Igbo mourners also bore striking resemblances. Dress regulation specified that both St. Luke brothers and sisters wear "a sprig of evergreen" on the left breast. In Awka, Igbo women who belonged to the Ekwe title association carried "branches of a strong

smelling tree" in their procession for a fellow member. This parallel might be even closer: St. Luke had many women members, and Ekwe was a women's organization. St. Luke mourners wore the evergreen throughout the procession until near the end of the service read by the Senior Past Worthy Chief. Then all St. Luke members together threw their branches into the grave at the end of the lines: "As St. Lukes, we now deposit this sprig of evergreen in the grave of our deceased brother (or sister) as a token, that while we bury his (or her) foibles in the grave with his (or her) body, that his (or her) virtues shall dwell green in our memory." Ozo title members of Isu village gathered before the burial; the senior Ozo held a piece of vine to his neck while he said a prayer that the deceased might prosper "in the spirit world"; the vine was then passed to each Ozo, who repeated the prayer; then the vine, like the St. Lukes' evergreen, was buried in the ground. Likewise, Awka Igbo frequently used palm leaves ceremonially in burial. They were placed in the grave, cut up and planted in the ground by the body, or laid under the body. If the body of a family member could not be brought home for burial, a palm leaf might be buried as a substitute. The act of hitting the ground with the palm leaf occurred repeatedly among Awka Igbo. The act echoes the St. Luke members' throwing a branch into the ground at burial. A variation of the act occurred among Asaba Igbo. When a man of Nkpalo title died at Okpanam, his associates came to his house. Each held an isikeli leaf between his left thumb and forefinger, then clapped his right hand on it and dropped it on the ground. The next gestures in the St. Luke ceremony also reflected parallel attitudes. After casting the evergreen into the grave, the Past Worthy Chief noted that members would "depart and shake from our feet the dust of this City of the Dead." In the same spirit the Nkpalo turned away immediately after dropping his isikeli leaf and went home "without turning to look back."[67] In the ceremony of dropping the green both the St. Luke and the Nkpalo separated themselves from death.

Death was not final for either the Igbo or the member of St. Luke, however. The dead were buried with a piece of green plant, the symbol of life placed in the realm of the dead. For the African the spirit of the dead lived as long as the person was remembered. The St. Luke's "virtues" were to continue "green in our memory." Continuity of life through the spirit was expressed forcefully with a comment on Christ's resurrection:

WORTHY CHIEF.—Shall my brother (or sister) rise again?
RESPONSE.—If the dead rise not, then is not Christ raised.[68]

This apparently innocent Christian response reveals the African origin of this African American thought pattern. Christianity holds that since Christ rose from the dead, humankind shall therefore rise. The St. Luke response reversed the logic: Christ rose because all the dead rise to the spirit world. Although the terms are Christian, the belief system is African. Final gestures in both societies—raising arms over the head, then letting them fall toward

earth—severed the life bond with the dead, leaving them to join the ancestral spirits.

St. Luke contrasts most sharply with Euro-American fraternal orders in having an extensive economic function. The white orders, of course, offered life insurance, established homes for the elderly, and donated to charities. African American fraternals, however, had far more elaborate economic functions and integrated them more intricately into the whole of African American society. Just as Ekpe had a vertical monopoly controlling trade through the Bight of Biafra, so, despite being confined within white culture, the African American fraternals developed intertwined economic institutions that themselves tended toward vertical monopoly. The fraternals' economic function manifests the African belief in a vitally integral relationship between property and being human, as described by the African philosopher Vincent Mulago: the "totality of being includes all that belongs to it: inheritance, family or group capital, etc. Indeed, for the Muntu [person], the human personality cannot be thought of without its belongings." And Igbo titled men prayed for the success of trade, saying, "We shall get life in exchange!"[69]

The economic function of both African and African American societies was integrated into the idea of caring for members of the community. Title association funds served as capital, a savings fund against which members could draw in cases of infirmity or death. If a titled man died leaving an orphan, his child collected shares from his father's title regularly. If a titled man had no children to support him when he could not work anymore, the shares from his titles supported him. New members' fees were divided and paid to older members as interest on the capital they had invested to join the association. Some associations allowed their members to use their titles as security for loans, and Ekpe members invested in "shares" of entrance fees, increasing profit according to the number of shares owned. People of Igboland discouraged hoarding while they encouraged lending any money saved. As late as 1947 E. P. Oyeoka Offodile, an Awka Igbo, commented that investment by "modern means" was "purely selfish," while investing in a title helped the whole society "by the communal works which are performed."[70]

African Americans implemented the mutual-care aspect of the economic function even during slavery time, when they collected money through their secret societies to help with sickness and death insurance. With political emancipation African Americans gained freedom to develop other economic institutions. Richmond became the home of many African Americans who were no more than one or two generations removed from those Africans who knew Igbo and Efik trade systems. When emancipation came, Virginia's newly freed African Americans built an economic system that was based on

their inherited economic, social, and philosophical concepts and adapted to the environment of the United States in the second half of the nineteenth century. A pattern similar to the Ekpe vertical monopoly emerged. Its most nearly complete form occurred in the Grand United Order of True Reformers. On April 3, 1889, the True Reformers, led by Reverend W. W. Browne, opened the first bank owned by African Americans in the United States. In the depression of 1893 this bank paid in dollars while other Richmond banks issued scrip, and this bank advanced the money that enabled Richmond's school system to make its payroll. Its assets were estimated at over $500,000. The True Reformers also bought Westham Farm, an area of about 635 acres, where it established an African American community with its own railroad station. The farms there produced goods to be sold in stores run by the Reformers' Mercantile and Industrial Association in Washington, D.C., and in Richmond, Manchester, Roanoke, and Portsmouth, Virginia. The Association was also established to manufacture products and to run a newspaper, hotels, a building-and-loan company, and any other necessary business. The Reformers began a system of housing for the elderly and in 1901 paid death claims in twenty-three states and Washington, D.C. With these institutions the True Reformers built a structure for a self-sufficient and far-flung community. Like their Igbo forebears they linked spiritual with material facets: the True Reformer bank held a prayer meeting before beginning business every day.[71]

Other orders repeated the pattern, though less completely. In 1900 St. Luke also seemed headed toward a vertical monopoly. Reaching beyond the order's original concern with sickness and burial payments, by 1901 Right Worthy Grand Secretary Maggie Walker called for a bank, a factory, and a newspaper. In an address to the thirty-fourth annual session of the Right Worthy Grand Council of Virginia, she made her appeal in religious terms: "First we need a savings bank. . . . Let us put our money out at usury among ourselves, and reap the benefit ourselves. Shall we continue to bury our talent, which the Lord has given us, wrapped in a napkin and hidden away, where it ought to be gaining us still other talents?" The St. Luke Penny Savings Bank opened on November 2, 1903. Walker continued: "We need . . . a newspaper, a trumpet to sound the orders, so that the St. Luke upon the mountain top, and the St. Luke dwelling by the side of the sea, can hear the same order, keep step to the same music, march in union to the same command, although miles and miles intervene." The order got its "trumpet," the *St. Luke Herald,* and bought its own printing plant. Between 1900 and 1910 the St. Luke Association was established to acquire and manage real estate, and the St. Luke Emporium became acknowledged as the most advanced department store in the South.[72]

The Grand United Order of Galilean Fishermen, organized as early as 1854, also developed a vertical structure. This order bought a farm in Nottoway County, Virginia, where it established homes for disabled and

elderly members and for orphans. It bought land in Alabama, where it planned to build industries necessary to become self-sufficient: brickyards, cotton gins, dairies, sawmills. Its newspaper, *The Ship,* was based in Bristol, Virginia, and the order ran a regalia business. This order, too, had its own bank, as did the People's Relief Association and the Knights of Pythias in Richmond, the Gideons in Norfolk, and the Sons and Daughters of Peace in Newport News.[73]

Similar fraternal orders developed in many African American communities. The Independent Order of Good Samaritans, begun in 1847, well before slaves were freed, was chartered in Virginia in 1872, established in Georgia in 1875 by a minister from Mobile, Alabama, and begun in South Carolina in 1878 by Rev. E. W. Williams of Norfolk, Virginia. By 1883 Beaufort had at least twelve societies, and Charleston had twenty.[74] On St. Helena the Rome of Victory society building, which was rebuilt in 1981, is marked with its founding date of September 26, 1896. Sam Doyle painted several versions of St. Helena societies marching.

We can conclude that almost on the instant that African Americans were able to form their own communities, they followed their traditions and constructed institutions based on the dominant form they had known in Africa. Thus, these societies with stages of membership—each stage requiring initiation to rise to the next higher level and each stage aspiring to a higher spiritual relationship—began almost immediately upon Africans' arrival in this country, grew with African American freedom, and proliferated.

During the Union occupation of St. Helena Island in the early 1860s William Gannett, one of the first northern teachers to go to the island and a recent graduate of Harvard Divinity School, visited an old woman whose whole family had died and who lived in a house he described as a cabin "full of all dirt and wretchedness." He asked, "You live here all alone, Aunt Phillis?" And she answered, "Me and Jesus."

Her response overwhelmed him. It revealed to him how religion permeated her life. He even saw that she spoke for her culture, for he wrote, "They literally have lived by faith, for by it alone they have had a sense of what other men call life. . . . God is never far from their lips or thoughts."[75] Of course, he must have thought that she had spoken in purely Christian terms, for he could not hear her African voice. He had no way to comprehend what we have come to know: her culture had grafted Christian elements onto sturdy roots transplanted from African soil to America. From those roots African Americans had grown a new culture adapted to a new land, but in that new culture their religious, spiritual, economic, social, and governmental values and practices remained intertwined as they had been in Africa. We will now see how these African voices manifested themselves in the very different communities of Sam Doyle and Bill Traylor.

# 4

## Sea Islands Voices

*From "My daddy's daddy daddy. . . ."*

One night during the Passover before Christ's crucifixion Nicodemus, an elder in the Jewish community and a member of the Sanhedrin, went to Jesus and asked how a man could be born again. Jesus answered, "No one can enter the kingdom of God unless he is born from water and spirit. It is spirit that gives birth to spirit." After Jesus was crucified, Nicodemus and Joseph of Arimathaea prepared the body, wrapping it with myrrh and aloe in a linen shroud. Nicodemus and Joseph then laid the body in the tomb. Nicodemus learned the ritual of baptism from Jesus Christ, and he participated in Christ's burial. That is all we know of the biblical Nicodemus.

On April 17, 1933, about ten o'clock in the deep dark, one could hear many quiet voices beginning a night of spiritual singing from a little house on St. Helena Island. It was the home of the Reverend D. C. Washington. He had "passed" that day. A dim lantern lit the mourners' way up the steps to the porch and center hall. His body washed and dressed, he lay in the front bedroom to the left of the hall. In the sitting room to the right, only about twelve feet square, plank benches had been set as closely together as possible. Nearly fifty people crowded into the room; others hovered on the porch; still more kept watch in the yard.[1]

They came from all parts of the island, for Reverend Washington was an honored elder and highly ranked minister. When he was born, he was named, as was another elder who preceded him on the island by seventy-odd years, for the biblical Nicodemus. On St. Helena the name "Nicodemus" was shortened to "Demus"—hence the initial "D" in Reverend Washington's name—although for official records it was given as "Nicodemus." Like Nicodemus in the Bible, Reverend Washington's primary role in his church was to understand regeneration through "the water and the spirit," to administer baptism to his church community. Sam Doyle, speaking of his painting *Baptism of Rev. Midlton* (Plate 3), pointed to the figure in the upper right and said, "That is Reverend D. C. Washington. *He* baptized us." Doyle was identifying him by his title, his priestly stature, and his most important function. In the painting Doyle appears in the lower right: it is his own baptism. The candidate in the middle is a contemporary of Doyle's who grew up to become a minister on St. Helena. Doyle titled the painting:

BAPTISM of REV. MIDLTON
1920
and Sam Doyle

His large capital letters emphasize both the ritual itself and the ritual stage toward his friend's attaining priestly status. Doyle usually signed his paintings "S. D.," but this one he signed with his full name. It was important to him. He pointed it out, saying, "You got my whole name on that one."[2]

Doyle's painting documents the significance of baptism on several levels, all of which join to emphasize its importance in his community. With its emphasis on titles, ritual, and steps in the initiation process, the painting links St. Helena Island with its African cultural heritage. It brings the Christian tradition together with secret association structure and with African religious tradition in a way that is both subtle and startling.

This painting was made flat on the ground. Doyle's footprints are on it, and not by accident. They are near the edge; he could easily have reached areas of the painting without standing on it. They are not soiled, as they would be if he had accidentally stepped in blobs of wet paint. The soles of his shoes are used like woodblocks. They inscribe a design of inverted V's on the edge of the river. They show faintly under the water where Doyle and Middleton are immersed. The footsteps come out of the water, cross the shore, and go upward to the bridge and onto the white gown of the spiritual assistant to Reverend Washington.

In the 1930s Henry Middleton Hyatt interviewed an elderly man in Brunswick, Georgia, who explained the significance of the water of baptism: "Yo' take [a cockle-shell] up an' place it tuh yore ear an' yo'll hear a great roaring from de sea where de watah done gone obeyed God—at God's own word. . . . De whole earth is de Word of God. . . . De earth is got words. . . . All dust is de Word of God. . . . Cuz God spoke de dust from undah de waters." This is the relationship that Doyle explains in painting. Doyle's footsteps in his baptism portrait bring the dust which is the "Word of God" upward "from undah de waters."

Throughout his long session with Hyatt the Brunswick informant emphasized the secrecy of his procedures, saying that Hyatt must not tell this to anyone: "Course ah'm learnin' tuh yo' dat an' 'splainin' to yo' dat ah nevah has learnt nor spoke to nobody since ah been a man." He agreed to give his information to Hyatt because he felt that Hyatt wanted to learn the work to enhance his knowledge, not to use the information for any harmful purpose. Since we have no name for this man who was confessing his faith for purposes of teaching, I will call him the "Brunswick Confessor." The Confessor added still more detail and complexity to his explanation.

Drawing an analogy with a dirt dauber's nest and reproduction, he explained the entire structure of the relationship between African philosophies and their transference into Christianity. He then described their

transfer into cunjuring as well. Just as the meaning of proverbs eludes listeners, the meaning of the Brunswick Confessor's tale would elude us without a frame of reference. First we shall see what he said; then we shall examine the philosophical basis of his cosmogony.

Daubers' nests have doors, he said. They "have ridge lak mah fingah dere an' in each ridge dey make a do'." Then they bring the mud in their mouths. He comments, "He's Second Person tuh God—dat [that's] Wisdom. An' then he gits his nest done, he seals up de do' wit mud an'—places one aig way back in de back of dat mud nest an' seals it up. No dew can't git to it—no rain can't git to it—no fog can't git to it. Dat dry aig an' dat daub dat de thing made in dere hit's tomb dust dry—hit don't nevah git moist." And the Confessor calls on his own longevity to validate his knowledge:

> Ah have twelve—fo'teen yeahs experience of . . . dat de dirt dauber aig of being a live sustaining, breathing of insects without no watah . . . —without anything atall—nuthin. Yo' don't know where dat aig come from. Ah don't know where dat aig come from. . . . But ah do know whut it brings out. It brings out a livin' dirt dauber.

The dirt dauber teaches a lesson of a peaceful relationship with the creator god: "It don't harm nobody," the Confessor emphasizes. "It go to de mudhole, gits a batch of mud in its mouth, comes in an' goes to de nest an' put it on his nest. He ain't fightin' against nobody, but his own aig he leave. He does lay in dat nest an' seals it up an' goes on 'bout his business—flies on away by de order of Almighty God. De wisdom an' birth an' life of de Almighty God, de dirt dauber is movin' onto it."

Then the Confessor describes where the dauber's dirt comes from, speaking in what appear on first reading to be Christian terms. He refers to the biblical story of Joseph and Mary searching for young Jesus and finding him teaching by answering questions "in the lawyers' an' doctors' office." He specifies that Jesus was young—"nuthin but a twelve year ole boy." He refers to Christ's crucifixion, death, and burial; and he emphasizes that when Christ appeared to his mother Mary, he told her not to touch him because he had not yet ascended to sit beside God. The Confessor repeats for emphasis, "He wouldn't let his maw tech him." This is the background he gives for gathering dust from a grave, saying,

> Yo' kin go to any tomb. . . . So it look like less'n [less than] a twelve year ole boy . . . by de length of de tomb. . . . Ah go dere after de sun go down. Ah gits down on mah knees, *Our Father who art in heaven* . . . an' not moving none of dat dust 'cuz dat dust is de Word of God. Yo' know Jesus wus de Son of God, doesn't yo'? Well, dat whole tomb is de baby tomb—de *Babe of Bethlehem*. Praying de *Father's Prayer,* ah does git a handful, an' ah makes addition to it a wisdom of one part . . . a dirt dauber's *hut.*

He continues, comparing the "hut" with Christ's tomb. Just as the hut contained only the egg that would become the adult dirt dauber, he

emphasizes that only Christ's body was in the tomb, that no one else could have "slipped into Christ's sepulchre," because "de king men cement an' sealed it around de stone dat nobody could git dere. . . . No soul—body—nuthin in dere but Jesus' dead body." And, just as the "living dirt dauber" emerged from its "hut" and has "got his life in him, his wings an' he's goin' out in de summer an' build him a nest an' raise him some young uns," so Christ "from Friday evenin' until Monday mawnin' sunrise . . . got up out of dat eart' bed which wus de tomb. . . . He got up a livin' body." On this basis the Brunswick Confessor founds his root-doctoring practice.

He describes how he compounds the ingredients of the hands that will solve problems:

> Dat dust from the *Babe of Bethlehem's tomb* . . . it not ready fo' service until ah do mah wisdom. Ah . . . crush dat ole dirt dauber nestses up into three tablespoonfuls, put in one "In Name of de Father"—second one "an' of de Son," dat's Jesus—de third of de three dirt dauber nests . . . hit brings forth an Angel from God's Kingdom. Hit rules yore home—it rules anybody's home. It brings love where confusion would be. . . . [To the grave dust and the powdered dirt dauber's nest] take de same tablespoon . . . an' measure three spoonful of sugah . . . an' mix an' stir it good . . . sugah sweeten anything it go into.

Each time a tablespoon is added the litany is repeated:

> "In de Name of de Father . . . of de Son" [and then] de third an' las' tablespoonful—of sugah—represent de faith dat chew'll pray de Father's Prayer wit to git a angel tuh go everywhere in every business . . . even in de skin game—or even in church—if yo' pray de Father's Prayer yo'll win every time. Dat's de necessity an' de goodness of—an' de evidence of dat wise aig laid by de dirt dauber. . . . Ah nevah has tried tuh git none of it till ah git down on mah knees among tombstones an' pray, "Our Father who are in heaven. . . ."

Adding, "Ah don't give it no money," he then confesses to Hyatt his means of paying for the child's grave dust, which he calls a "handful of de Lord God's Word." "De way ah pays," he says, "Ah take a little clean white scrubbed cloth representing de pure white linen of dat Joseph an' Nicodemus purchase when dey buried de body of Christ. Yo' always known dat, heard dat, how dey purchased pure white linen an' swathed de body of Christ." Here we have returned through the symbol of water, the rituals of regeneration, to Nicodemus and learn that the white cloth—like the color white in the Order of St. Luke ritual—symbolizes purity.

The Brunswick Confessor goes on, delving further into how the white cloth of purity relates to cunjuring:

> Well, dis little white scrap dat ah use into dis represents dat . . . nevah will be forgotten. . . . Hit all wus from de Almighty Word of God 'cause dat brings a angel from heaven—into church, in a skin game, in de home place, or in any business yo' go into, if yo' prays de *Father of God's Prayer* first, yo' will win every time. . . . An' call—yo' gotta call three calls, "Little Baby, Little Baby,

Little Baby." Don't wait to hear nuthin. See, ah didn't hear nuthin when ah called it out now. "In de Name of de Father an' of de Son an' of de Holy Ghost, ah want chew tuh help me right heah. . . ." Dat prayer go on back to de wise God in heaven, an' de angel comes on down wherevah yo' at.

He emphasizes further that without the prayer no attempts will succeed, but with it "yo' kin go to New York wit it—yo' kin go to New Jersey wit it—yo' go to anywhere in de world tuh make money—de dust from de *Tomb of de Babe of Bethlehem* will be with yo'. . . . Go dere an' pray de *Father's Prayer* an' take dat package an' put it where yo' wanta do business . . . an' no man can't beat nuthin about de Word of God."[3]

Both Sam Doyle and the Brunswick Confessor reveal Kongo heritage in their works. To clarify this body of detail, it is probably easiest to begin with the tangible and move to the ideological. The Brunswick Confessor has just described making a tangible thing—a "package"—to hold onto and use. To understand this, we return to the minkisi of MacGaffey's tale of the Bakongo man, Na Kunka, where we referred to minkisi as charms. In reality minkisi are much more complex than that translation allows. MacGaffey refers to the nkisi (singular) as an "institution." Through the story of Na Kunka we saw that the Bakongo live within their cosmography, "a world of the living and the dead, separated but united." The nkisi is a tool that comes from the world of the dead to be used in the world of the living; therefore, as MacGaffey shows, it has attributes of the abstract philosophical, the ritual, and the concrete. He defines these attributes as follows:

—the philosophical—it is "a personalised force from the invisible land of the dead";

—the ritual—its purpose is to produce "some degree of human control" over the force, but the force has actually "chosen, or been induced" to agree to this control; its activity may be short or may take years: it may involve "the participation of from one person to perhaps a whole village or more; it usually includes songs, dances, behavioral restrictions, special enclosures and prepared spaces, and a material apparatus"; it must have an "initiated expert," a nganga, to conduct it;

—the concrete—this is the material apparatus and may have a number of forms: "musical instruments, the bodies of the [initiated expert] and the initiate . . . , articles of costume, cosmetics, and [sometimes] a focal object."

The "focal object," as the tangible manifestation of the nkisi, is "the embodiment of the spiritual entity. The potency or sacredness of this focal object extends, however, to the rest of the material apparatus and beyond it to the persons and places required by the ritual, all of which are part of the nkisi."[4]

In the terms of that Bakongo belief the Brunswick Confessor's "package" contains all three elements. Philosophically, the "force from the invisible land of the dead" comes spiritually in two ways—through the crucified Christ and through the baby that has died. The Confessor is the nganga who has performed the ritual, going to the prescribed spot "among tombstones" after sundown, kneeling, praying while he follows a formula for his mixture and reciting a litany with each addition, calling the three calls, "Little Baby, Little Baby, Little Baby." He does all this in the name of the Christian Trinity, explaining that his prayer will "go on back" to God on high and bring the angel down.

MacGaffey tells us that the tangible nkisi will include "medicines" such as "grave dirt, kaolin (white clay) or stones, taken from the place where the spirit in question abides." This is precisely what the Brunswick Confessor describes in gathering grave dust from the child's grave. This substance, MacGaffey says, "metonymically incorporates the spirit in the nkisi,"[5] and this is precisely the Confessor's purpose in using the grave dust. MacGaffey lists items that are used metaphorically. They vary from one nkisi to another according to the specific need. Among them will be something white, usually chalk or clay, for seeing more clearly—or purely—and this is the first ingredient to be prepared. The Confessor is not clear about what he uses as a carrier for his ingredients, but he seems to say that the scrap of white cloth is to go into the package rather than to be the carrier, for he refers to "dis little white scrap dat ah use *into* dis" [my italics]. He thus introduces into his package the primary metaphoric agent, the white, pure item to produce clairvoyance. The dirt dauber's nest used by the Confessor is his second metaphoric ingredient. He is describing a universally powerful nkisi rather than making a specific one for Hyatt's use. The dirt dauber's nest is the Confessor's metaphor for nature's creature's universal, generative power, the power that he, as nganga, calls on to perform the desired deed.

The package is the "material apparatus," the concrete element. In Kikongo the word "handa" means "to initiate or consecrate a medicine." It is used with nkisi—handa nkisi—to mean "to enter a cure in the consecration of medicine."[6] Throughout the southern United States African Americans who have either composed or used packages such as the Confessor's have referred to them as "hands." Contrary to the derogatory image of "hoodoo" or "witchcraft" they are objects for regeneration put together by priests who have been initiated into the traditional knowledge necessary to bring together spiritual and physical healing.

The tangible is relatively easy to analyze, because it is easy to envision. Now we must move from the tangible to the ideological. To make that easier to envision, I shall return to Na Kunka's story, which demonstrates that the Bakongo live within their cosmography. We must look further into their

conception of the world as comprising the living and the dead, separated but united.

The Bakongo developed their science of the structure of the universe from the sun's rising and setting. Its course forms a circle. By analogy the life of mankind also forms a circle: as the sun rises, so the person is born; and as the sun sets, so the person dies. The circle is therefore the basic shape of the cosmographic structure. Then, the Bakongo observe, "The origin of everything is water. Water is life. As all comes from water, all will live from water."[7] Water divides the circle; when the sun sets, it goes beneath the water, and when it rises, it comes up from beneath the water. So the circle representing the cosmogram is halved by a horizontal line representing water.

The Bakongo also halve the circle with a vertical line which marks the sun at its apex in the world of the living at the top of the circle and at the nadir of night, midnight, at the bottom of the circle. The basic shape is now a circle with a cross in it. Throughout the arts of the Bakongo this shape can be found in many manifestations and variations—sometimes in two concentric circles, sometimes with small circles at each point of the cross, sometimes with the cross modified into a diamond shape—but always the concept of the circle with the cross will be basic.[8]

Within the upper half of this circle, people live life, as Euro-Americans think of living it. The Bakongo see the earth as a mound, or mountain, arising in the upper half of the circle. The mountain is surrounded by the water that divides the circle. The upper half is day, when one is awake and going about one's tasks. In this half the sun is up. However, in Bakongo cosmography, when the sun sets on the living, it *rises* in the world of the dead.

The lower half of the circle, the half beneath the water, is mpemba, the land of the dead. But the dead are not dead as Euro-Americans think of them—finished, buried in the cemetery. For the Bakongo, people do not die. With "death" their bodies undergo a transference into mpemba. The sun lives under the water; people live under the water. Life under the water is much as it is above the water—people live on a mountain that mirrors the one above the water; they live in communities in which they produce their necessities the same as above the water. These are the communities that Na Kunka and his wife passed as they traveled under the water to find Na Kunka's matrilineal minkisi.

Death for the Bakongo, then, is not an end. It is a rite of passage—a door, or a crossroad—to a stage of life. For the Bakongo the structure of the universe is also informed by a second shape: the spiral, which is given concrete expression in the shell. According to MacGaffey, the shell symbolizes longevity, because it controls the structure of the living organism inside it rather than the organism's giving shape to the shell. The spiral, he says, therefore "reconciles vitality and permanence." A. Fu-Kiau kia Bunseki-

Lumanisa discusses the spiral shape in terms of Bakongo history: on the map of Kongo territory the people's movement in time formed a spiral shape. The long history of the people is longevity.[9]

Whereas Fu-Kiau finds an analogy between the spiral shape and Bakongo history, MacGaffey finds the source of the spiral symbol in social structure. During the nineteenth century society was organized in a hierarchical structure in which one clan might gain power and dominate a collection of local groups of increasingly less importance. The source of power in each locality derived from the spirit world. Therefore, the chief of the dominant clan was "the principal ritual object," and subordinate chiefs were identified with correspondingly subordinate spirits. As the number of localities in a hierarchy increased, the power of the chief at the top became more remote. The hierarchy in mpemba corresponded to this. Thus, MacGaffey tells us, there was a "sense of the dead as moving, by a series of transformations in the after life, through a hierarchy of increasingly remote but also more powerful and functionally less specific positions in the otherworld." Before the social structure began to change in the 1870s, he concludes, the cosmography "included a nonreversible time dimension." This is known in Kongo philosophy as "the spiral universe."[10] And it was the Kongo cosmography in its pre-1870s conception, based on the ideals depicted in these two shapes—the quartered circle and the spiral—that was brought to the United States in the slave trade.

Among the Bakongo the spiral and the shell took many forms because the concept so penetrated their philosophy. The missionary John Weeks discovered this pattern symbolically worked out in the approach to the Bakongo king when he was taken into the king's enclosure in 1882. To enter, he had to go through a maze, turning to left, right, right again into another opening, then right, left, and left again to return almost to the beginning and so on—a generally spiraling path into the king's presence. I had a similar experience in South Carolina when I asked directions to the home of Evelina Fludd. I could have been sent around a rectangular block. Instead, I was directed along a curving track behind, between, and around fenced yards. Neither Weeks, in Africa in 1882, nor I, in America a hundred years later, understood what was happening. But Robert Farris Thompson disclosed the analogy: "The circling corridors between the fences portray the world of a man who has made a revolution through this world and the next and who has come back spiritually armed with extraordinary vision."[11] The king must have knowledge of the spirit world in order to lead and care for the people properly. Through the continual circling of the sun and of humanity—through the water, through the spirit world, through the living world—the shell, showing this continuity, symbolizes communication: each world communicates, and so lives, with the other.

❀

These two concepts—the circling and the spiraling forms—bring us back into the world of Sam Doyle. One of the modifications of the encircled cross that Thompson gives us is an arrow inscribed on a burial figure. Thompson explains that this is a symbol for bringing knowledge from the spirit world, the world below the water.[12] In Doyle's *Baptism* the footprints, those inverted V's from the soles of his shoes, are *arrows* emerging from the water, implanting themselves in the earth, and curving upward in an only slightly abbreviated spiral onto the bridge and into the white gown. Those inverted V's, now seen in the Kongo context, are the medium for bringing messages from below the water, from the spirit world. They cross the bridge, symbolically crossing between the worlds of the spirit and of the living, and bring knowledge to those "priests" responsible for giving spiritual guidance. In fact, the bridge is startlingly focalized in this painting. It does exist on St. Helena where Doyle was baptized, but it is not in a location to be crossed during the baptism. The whole ceremony would take place beyond the bridge. A bridge was not necessary to African American baptism rituals. But it is necessary to Doyle's message: it serves as kalunga, the horizontal line dividing the two worlds of the universe.

The world beneath kalunga was as immediate on St. Helena as the world above it. The circularity of man's passage through the universe was inevitable. Robert Grant, an elder of 85 years, repeated, "The old people said they'll come a time when the bottom will come to the top." And the universe enveloped man. Franklin Holmes explained: "The dead . . . haven't gone nowhere. The spiritual world is immediately around our world. . . . The dead tell you everything. All the time. That body died but your spirit and your mind lives." Rebecca Mattis reported that as a child she had been "told not to be out at night because ghosts were walking around."[13]

When the sun shone under the water, the people who lived there were out and about. Holmes said, "Anybody dies—if you are spiritualized enough, you can see them." Mariah Perry, an elder of 92 years, said she could see spirits because "My mama say I born with a caul and I can see em. . . . When you walk by yourself they roll like a paper. They roll like a paper—then—they grow and grow and grow." Doyle told a story of a kinsman known for his ability to see spirits. After a bus wreck near a chapel's ruins his kinsman saw "spirits of these people all through the woods around the chapel. They were trying to get up in the trees, climbing hand to foot."[14]

Doyle also saw spirits. His oldest sister told of a time when he looked out the window, saw a man lying in the road, and went out to help, thinking the man had been hit by a car. But there was no one there when he got outside. It was clearly, she said, a spirit. Doyle said their mother saw spirits, and his two sisters confirmed this. She would suddenly stare at someone she was talking to because she saw spirits hovering around them. Doyle explained that spirits always used to be of specific people but that now those have become general spirits.[15] Apparently they have now moved, as MacGaffey

described, "through a hierarchy of increasingly remote but also more powerful and functionally less specific positions in the otherworld."
Doyle painted one of these spirits. Called *Jack. O Lanton,* it appears all white but for black hair, mustache, and beard and red tongue, nostril, and ring around its eye (Plate 4). Doyle told about seeing this apparition when he was a boy out with two friends near an inlet one evening. Rosa Johnson and Victoria Polite, who were interviewed by African American students, talked about the Jack O Lanton. It was night, Polite said, and

> you'd have to walk all through corn with the pond full of water. And, honey, when you had to cross where the cemetery's at, you seen the Jack O Lanton—I don't know if you all heard about the Jack O Lanton with a big fire coming to burn you up, and some night that Jack O Lanton run on so fast, and if it catch you now, it'll burn you now sure enough. They will. My step-daddy take a stick just before I got to the door to go in—Jack O Lanton run behind me so that I like to fall in. It been a big ditch of water and then he knowed the Jack O Lanton was coming and when he seed the Jack O Lanton he had a big stick by here, and I hear across my head a pheeeee-a-chung! That Jack O Lanton out there—whang—gone back in that cemetery. That's right.[16]

The Jack O Lanton is a spirit and represents those who live beneath kalunga. Doyle's Jack stands on a background of blue—the spirit-protection color used to trim house doors and windows throughout the coastal islands and the water color of the *Baptism of Rev. Midlton 1920 and Sam Doyle.* The Jack has its head on backward and fishes with a red pole by a light that shines from what Doyle said was "its back." The "n" within the word "Lanton" is reversed. Bakongo peoples use ritual reversals to deal with death. Death is chaotic, abnormal; therefore reversals are used as coping mechanisms. Anything may be turned around—clothes, furniture, people, the corpse. On St. Helena, Mariah Perry described reversals in dead spirits, "E ain't look natural. . . . You don't watch em frontwards. They see you backwards."[17] The reversals in Doyle's *Jack* indicate that Jack and his light are in mpemba. Doyle, Johnson, and Polite all agreed that the Jack was associated with water: "They're in them pond, along them pond edge, them crick edge along there. They catch, eat fish. They got a torch light. They come out on rainy or foggy nights." Doyle's Jack has a white body with red markings, and he fishes.

The story of Na Kunka and his wife contains a parallel with Jack's colors and his fishing. Under the waters, searching for the minkisi of his mother's people, when Na Kunka came to the right village, he first gathered the correct herbs. Then he and his wife were "marked all over their bodies with white and red clays." The priest then performed a ritual during which he sang a song which translates as "Don't trifle with the catfish." Another story collected far up the Zaire on the Ubangi River told also of a young woman who traveled under the river. She met Sangu, the great water spirit, and saw his meal of fish bones. Polite said the Jack would "burn you up,"

and Johnson said, "they'll loss you, loss you" [Gullah for "kill you"]. Sangu, also, could lure one to death by drowning. Doyle, however, said Jacks were "No, not mean. You just see them there."[18]

These differing points of view illustrate the change of the spirit's position within the hierarchy of the spirit world. Both Johnson and Polite were closer to the source of the story. Rosa Johnson, born in 1889, was much older than Doyle, and Victoria Polite said her people talked about Africa when she was a child. For Doyle the Jack O Lanton spirit was becoming more remote and less specific while retaining great power. Within the interpretations lies the lesson of Na Kunka's priest: this spirit under the water needs fish for his life; disturbing him will bring out his anger, and the peaceful balance in life may be upset.

Doyle has also given us a document of the communication between worlds as symbolized by the shell. This is in one of his most famous subjects, his paintings of Doctor Buzzard. There were several Doctor Buzzards in the South, but St. Helena's Doctor Buzzard was a famous root doctor among African Americans. One still hears epic tales of his feats. Actually, St. Helena's Doctor Buzzard was not a single person; there was a family of Doctor Buzzards. The family name was Robinson, and the title "Doctor Buzzard" descended through several generations. Possibly the most renowned was Stephney Robinson, the "Dr. Buz" Doyle painted in several versions. He explained the meaning of the shell in his story of the painting: a man Doyle worked with in a warehouse in Beaufort had stolen seven bags of sugar to make moonshine with. He thought he was going to be caught, and he asked Doyle to go to town with him. He didn't say where or why. Because they were friends, Doyle said,

I didn't ask—we just went. And we went to Doctor Buzzard! Doctor Buzzard said, 'I know who you are and why you're here.' He picked up his telephone [Doyle pointed to the conch shell]—had a long conversation—Couldn't hear what the other person said, but he talked a long time. He hung up and said to the guy, 'You're gonna be arrested tomorrow morning at 9:00.' Doctor Buzzard gave him a stick with a red rag wrapped around it—dipped in one thing and then another and told him to chew it when he saw the policeman coming across the street. The next day we went to work. All of us boys in the warehouse knew what was going to happen. We were watching. The police captain . . . coming down Bay St. with the handcuffs in his hand—ready to put those handcuffs on—stepped off the sidewalk into the street—lifted his foot back up out of the street—he stepped down again and then back up on the sidewalk again—blinked his eyes and he turned and went away. We knew what had happened. My friend put the end of the stick in his mouth when he saw the policeman step off the curb. He chewed on it. After that the people in the warehouse never said a word about the sugar—he never got arrested or lost job time, and the warehouse people loved him even bet-

ter than before. And that's how I know Doctor Buzzard knew his work! I seen it.[19]

Plate 5 shows Dr. Buzzard saying "Halo" [Hello] into his conch-shell telephone. The man who dwells in the upper half of the Kongo cosmogram uses the shell to communicate with those from the lower half of the cosmogram who will tell him what Doyle's friend needs.

Doctor Buzzard then wrapped the protection device, the "hand," in the Kongo color of communication with the spirit world—red—and dipped it in substances to give it power and life. When the friend put the "hand" into his mouth to chew on it, he connected it with his own body fluid, thus connecting its power, the power of the total universe, with his own life force. The policeman didn't stand a chance. The missionary John Weeks had seen an identical use of the shell among Kongo peoples and described it as the doctor's "stock-in-trade." It was elaborately prepared, having ingredients applied inside and out. Weeks reported: "He puts the shell to his ear, and it tells him the disease [or problem] of his patient and the best means of curing it."[20]

Doctor Buzzard's gestures in Doyle's paintings tell us still more of the Kongo system of belief as it survived in coastal South Carolina. Gestures in Kongo art are used iconographically. Robert Farris Thompson describes a pose in which a foot is lifted. This, he shows, is a gesture meaning to kill. He then describes a classic pose: the right hand is extended while the left is placed on the hip. He explains that "it is one of the key climactic gestures of the intermingled world of Kongo art and law." It shows that when someone upsets the balance in the community—"veers from substance or ethical expectation"—another person will assert leadership to restore the balance. He emphasizes that "it is imperative to have at all times alert, seasoned men and women who can tear such matters down." The left hand is placed on the hip to "anchor evil," while the extended right hand is "simultaneously releasing positive powers." He translates a Kongo proverb which says, "The one who foresaw the argument / Is the person who blocked its coming into being."[21]

As Doyle's story tells us, Doctor Buzzard "foresaw the argument": "I know who you are and why you're here." Doctor Buzzard "blocked" the argument between the "law" and Doyle's friend from happening. Doyle's versions of Doctor Buzzard usually have the left foot raised. Although the view of Doctor Buzzard in Plate 5 does not have the foot raised, Doctor Eagle demonstrates this trait in Plate 6. The problem must be "killed." Although gestures with left and right are reversed from the Kongo in "Dr. Buz" paintings, the figure always has one arm extended, usually with one finger pointing upward. His right hand, rather than being on his hip, holds the conch shell that is necessary for his communication with the spirits whose powers will be released by the other upraised hand. This difference is due to the particular circumstance of this story. In other paintings people in

positions of authority and power—Doctor Crow, Doctor Eagle, Abraham Lincoln—are depicted in the Kongo pose. With left hand on hip and right hand extended they stand ready to "kill" problems so as to restore balance in the community.

The Kongo cosmogram appeared in the daily life of Beaufort, South Carolina, in an unexpected place—where the races crossed paths. Ed McTeer was sheriff of Beaufort County across the middle of the twentieth century. McTeer witnessed a use of the cosmogram when he was a young man. Two African American trusties had a habit of leaving the jail at times. McTeer saw a deputy pour white powder on the ground in the shape of a cross so that it "stood out stark against the dark earth, right in the center of the gateway." Then the deputy told the men, "If you want to go again, just walk across this . . . but if you do, you'll never walk again."[22] He did not know that he was describing the Kongo universe to them, or that he was saying, in effect, that they would pass into the spirit world if they crossed it. But in Beaufort in the early twentieth century African Americans so outnumbered whites that whites could easily adopt and even absorb the traits of African American culture. Undoubtedly the deputy had seen these rites and knew how to use the fears to his own ends.

McTeer became sheriff in 1926 and crossed paths with Stephney Robinson. McTeer claimed to know that Robinson had acquired his knowledge from his father, who, McTeer said, "was a witch doctor in Africa." That seems possible, since Robinson's father was born about 1835, and census-takers recorded his name once as "Toom" and possibly another time as "Nktun." These probably were versions of his African name, which might have come from a Kikongo word, ntumwa, translated as meaning one who is an "apostle" of nkisi.[23] Like the Brunswick Confessor, Toom was sent on a spiritual mission to compose hands to cure social or personal problems. His son Stephney is the Doctor Buzzard whom white people in the South came across or have written about.[24] Before Stephney's time, however, African Americans knew Doctor Buzzard's work widely across the South, identified his location accurately in Beaufort, and made distinctions between him and others who also used that name. This Doctor Buzzard was Toom.

Several years after Toom died, Hyatt interviewed the grandson of another doctor from Beaufort, Doctor Jones, who was born a slave. He described a set-to between Doctor Buzzard and Doctor Jones: each had a walking cane, and they disagreed over who was the better man. "So Doctor Buzzard, he'd taken his walkin' cane an' chunked it out dere in de yard an' it turnt to a snake. So mah grandfather chunked his'n out dere an' it turned to a snake, an' mah grandfather's snake killed Doctor Buzzard's snake. An' so after den dey shook han's an' come tuh be friends." Like Doctor Buzzard, who knew Doyle and his friend were coming and what they wanted

with him, Doctor Jones also fulfilled the Kongo proverb as the one who "foresaw the argument." He, too, predicted when clients would arrive to get help. His grandson asked him how he could see someone coming from two or three hundred miles, and Doctor Jones answered, "Well, ah sees de individual. . . . Dat was gived tuh me. . . . Dat's de secret part of a man." He wants to teach his grandson but insists that the boy *must* keep all the teachings secret. One teaching places Doctor Jones within the Kongo universe. He told his grandson to find a certain flowering shrub and dig down at its tap root. There he would find a piece of the root shaped like a ball. He must cut that off, quarter it, and then extract an oil from the meat of it.[25] This root ball, a sphere, is the circle of the Kongo cosmogram, and in quartering it, he places the cross within it. By drawing the oil out of the root he extracts the sacramental fluid—the water of kalunga that divides the universe.

As we have learned of Bakongo belief, "the origin of everything is water. Water is life. As all comes from water, all will live from water." This we have also learned from Na Kunka's journey. One must travel under the water, absorbing the lessons to be learned there first. Then one will be prepared to live life properly. The necessity for this preparation is the same on both sides of the Atlantic. Thus, where the African American community turned to Christianity, the church's rite of baptism became the medium for preparation. It is the initiation for the moral life, just as the initiations of the stages of title associations or other secret societies prepared participants for the ultimate role of priest.

In the Sea Islands, however, preparation for the baptism ritual was unlike preparation for baptism in any Christian context other than African American. It involved two stages, the first called "seeking," and the second a course of instruction with community elders. We will examine the elements of the structure of this preparation and the process of the baptism ritual. Then we will find its origin in a Kongo secret society and thus see how the structure of ritual in the Islands, even though it is Christian, relates to the cosmographic structure of Bakongo belief.

Coming out of slavery, the freedmen on St. Helena brought the custom of "seeking." Harold Loundes, who was 70 when interviewed in 1974, told about the custom as it came "all the way from way back yonder—that comes from the old land-mark." His brother Richard explained that originally seeking was done outdoors and out loud: "We call God from one end of the world to the other—anybody outdoors can hear you. The devil even can hear you." The brothers explained that they prayed to God, calling him the "master," and "ask him to teach you how to pray." Harold emphasized, "Talk to the man," and Richard added, "Plead, plead." The child who was ready for seeking must go into isolation, and Richard explained that this

was necessary to "get the younger ones away out the *racket*." Originally children didn't go to school while seeking; and later, although they attended, they didn't participate in school or work responsibilities.[26]

Young children did not seek. At age 12, children were thought mature enough to take on the responsibility and at that point were regarded as "old children." They had to stop playing the ring games of small children. Julia Peterkin found a belief that at this age an angel in heaven began recording a child's every "sin." To be cleansed of these sins, the child must fast, pray, and do no playing, laughing, or even talking until it found peace.[27] Thus, those who went into seeking were adults and "old children."

The place outdoors could be a cornfield or the woods some distance from home, or it could be under a big tree in the yard. In the 1930s several seekers said they had gone to a graveyard to pray, and four others said that it was a "*secret* place." Even if close to home, the place was referred to as the "wilderness." Although "wilderness" has a biblical connotation, it is also a translation for the widespread African practice of initiation in seclusion from the village in an area where rituals occur in utmost secrecy. These African areas are often referred to as being "in the bush." And on St. Helena, Jeremiah Alston articulated the closer link with the African practice, saying that the seeking custom was "one of the old time. . . . Go out and seek for your soul . . . in the *bush*."[28]

The time in the wilderness is, in fact, an ordeal. It may involve abstaining from food or water, especially for adults who were seeking. In the early 1930s many people told Samuel Lawton about fasting: "Cain't tell me wunner [you] can pray with de belly full. Yes suh, I fast. I just eat nuff to keep gwine"; "I didn't eat much when I bin prayin'. I too sorry for my sins and too full ob religion"; and "Cain't t'ink ob religion and eatin' all to same time." Lawton's informants reported going without food or drink for up to two weeks.[29] Concentration must deepen; distractions are not allowed.

The ordeal does not end until one reaches the "right" spiritual place. As Fred Chaplin said, "Oh you have to *be* out there—got to go out and stay out." Reverend David Grant said you "better stay out there two and three weeks with your head tie up and get religion," and Sam Doyle said, "You may be out there two months, but until you give up for the right thing," you'll have to stay with it. Edward Milton, baptized in 1890, explained that the seeker must "be out there til your mind made up. You go out there and you got to see all the bad before you get to the good. You work the bad out of the way." This principle was still central in 1919, when an informant told the anthropologist Elsie Clews Parsons that the "first dreams should be bad. 'You have to have dem to get yer way clear . . . befo' yer kyan get on a level, mus' explain all de bad dreams. After dat not'in' come to you but good.'" The seeker prayed and prayed until the dreams came. They first revealed "all the bad." Lawton's interviews reported black things—feathers, a bag, hogs, the devil, a black man, bull dogs, bad things inscribed in a

Bible. These things, he said, symbolized evil. While they were seeking, people wore head ties. Doyle explained that girls wore cloths and boys wore strings around their foreheads. Lawton was told that the ties "takes up de sin which come out de head," and he commented that "this is considered sufficient explanation for the soiled condition . . . at the conclusion of the seekin' experience."[30] Thus the bad things get tangibly worked out of the head until they dirty the string or cloth.

Richard Loundes and Fred Chaplin specified that the proper position was to face the east, and Gertrude Green agreed as she described the ordeal that gave her much trouble: "Mama would make up bed on they floor. Go in the summertime—wake you up, and she put a quilt and a pillow right side of the bed and wake me up before day in the morning. And I was 'fraid, you know. Time for me to get up she wake me. And I bet ya I ain't going outdoors—too scared to go out there—I go some way in that yard—turn my face to sunrise and say my prayers and when I get through then I go back in the house." Green was "turned back" twice before she passed the ordeal. The wilderness was scary, and Green succeeded only when she conquered her fear of it. Robert Grant also emphasized how frightening it was: "Them old people was hard. You had to go out three times—4AM, 5 in day and 12 that night. You had to go outside in the woods . . . *by yourself, man!*" Those who went to the graveyard to pray were proud of having been strong enough to go there alone and declared, "Nothin' won't hurt you while you bin seekin'." And those who stayed out all night also felt this proved their strength, and one bragged, "My head bin wet wid de midnight dew and de Mornin' Star my witness."[31]

Once committed to beginning to pray, the seeker had to find a teacher. This could be done simply by choice, but apparently it was more common in earlier generations for the teacher to appear to the seeker in a dream. Mariah Perry, at 92 years, described hearing her teacher's voice in the wilderness:

> I went in the wilderness, and I ask the Lord to send me a teacher. . . . And I went back into the wilderness that evening, and I went and my teacher said he teach me. I heard—I heard a voice calling me three times—said, "Marayah, Marayah, Marayah, I powered to forgive you for the sinning of your soul. And this teacher said, "Darling," say, "I had finished three or four nights before you come to me—I done for you. You go home and tell your mama that I coming up there to have a talk with her."[32]

Minnie Jenkins also explained that you had to go into the wilderness to find your teacher, and she told of dreaming of hers:

> This man appeared there. . . . But he appeared to me, and he took me into a room, and he was trying to show me different things. And I got up—wake up next morning and didn't say nothing to my mother, but my mother look— and I went back, and I got the same dream again. And I tell my mother, and

she tell me that was for me to go to someone to show me to pray—teach me.[33]

Called a "spiritual mother" or "spiritual father," the teacher would interpret the seeker's dreams and determine when the preparation for church membership was complete. Florence Rivers explained that you "cannot be a spiritual mother until you reach a certain age—not young." They are "older women who lead particular lives; live very Christian lives."[34] The same qualification would apply to spiritual fathers. Being a spiritual leader was such an extremely important responsibility that Amanda Bradley, when asked how she became a spiritual mother, dropped her voice and spoke in deep Gullah—as Gullah people do when the subject is close to the heart.

Richard Loundes explained the teacher's responsibility: "He watch your dream every night, and he got to pray along with you; and he know exactly when you come through." Sam Doyle commented on the teacher's perception: "As long as you're on the wrong road, that teacher knows. You can't fool 'em." Doyle and Gertrude Green both had the same spiritual mother, Nancy Newton, a very old woman who had been a slave and whose husband, Marshall Newton, had served with the United States Colored Troops in the Union army. Doyle painted several versions of "Nanny" Newton with children she had "saved," claiming she had saved 2,000 souls. Gertrude Green elaborated on Nanny Newton's perceptive ability: "I went to the old lady, Nanny Newton, the first time, and she come—told my mother I ain't praying. And when Mama saw her that day, Mama said—she said maybe she come to tell her something about me. But I didn't have nothing to tell her because I hadn't been praying. So I prayed about three months, and I turned back. . . . That means stop praying. . . . They know when you ain't doing nothing. So she tell my mother that I was doing nothing. It was true. They could *see*."[35]

The earliest account of an acceptable dream may be the one that Harold and Richard Loundes said their mother told them about. Susannah Loundes was born about 1882 and probably was seeking in about 1895. Susannah told her sons, "A young girl come to her and two nights—and three nights." At first she didn't "come through," but then she "had dream—caught the pigeon that night or caught the baby. . . . Dream of a baby: that's the soul that they catch. Either a baby or something *white*." Harold emphasized that white meant clean, and Fred Chaplin repeated the principle: "May not have to be something white all the time—but has to be something that you are cleaning up." Then he explained further that this meant the dream must be about "something you—have some trouble with . . . til you get to the place where you belong." Ellic Smalls told about his dream that came to him one day when his mother had gone to a distant funeral. Ellic would nap under a big oak tree in his yard "in the cool, you know." And his mother told him, "Don't sleep yourself to death cause look like the time to pray you gone sleep more than you usual does." Then, Ellic said:

I go on to my prayers; and I love that oak tree, . . . cause that's my section. My land runs for the oak tree. . . . I get on my knees and start to pray, and a host of people come from that corner of the woods—come over to me on the oak tree and was sing', "How beautiful are the feet who stand on Zion Hill / That's assured me to Heaven" and they sing that—see—over in the east—and they sat a while over me; and the singers are gone down to the east corner. Then I feel that words. I was praying then. . . . I didn't have the kind of sense I be have all the time, but I can remember this . . . and I give these words as I go on through living.

Later that day he went to his spiritual mother and told her his dream and the song in it; and, he said, "I didn't know what kind of word it is til I had to go tell the old lady. [She] say, 'You go right back to that same spot where you get that word and you ask Christ to make you send someone out that word,' and . . . I pray right on—cause she say, 'Don't stop praying.'" And his spiritual mother called him, "'Kelley'—That's—'Kelley'. . . . She say 'so long I been workin on you, you gone put on the clothes and shoes of the world.'" Then she admonished him: "Go back and pray . . . because you know we be have to pray like that til we dead."[36] And he passed the test and was sent on to prepare for admission to the church.

Intensity of the ordeal increased as prayers multiplied. In examining the reports of eighty-six people who had been seeking, Lawton found that all had strange sensory experiences—sensing bodily motion, losing one's balance, or touching. One person was swung about on a chain; another's hand was taken by an angel. One was pulled around by a silver hook in his nose, one had to uncoil a spring, and another was handed a "little box with a white chicken in it." Some sensed odors or tastes, and many heard messages such as being given church assignments or forgiveness of sins. One reported that "angels sang sweet songs." Some saw written messages, and a man who could not read said, "When I looked at the Bible it flew open. Although I can't read, I could see written on that page everything that I had ever done since the time I cried into this world and I see that it all had been scratched out. An' I could tell in de Spirit dat it wuz my prayers dat scratch 'em out." Symbolic objects in visions flashed brightly—a gold basket with silver handles, a golden ladder, cement with colored lights glowing through pieces of glass in it. And there was glaring whiteness—of people, sheep, a crane, horses, clothes, feathers, sails, sand, and a skeleton. Both water and circles were prominent. Visions included pools and rivers, vessels to hold water, and the act of washing with it; and one informant described an elaborate vision of a white fruit tree across the Jordan River. One man drew a circle on the ground; another put a chicken in a circle.[37]

Although most people interviewed during the Penn Center project did tell their dreams to the students asking questions, Ezekiel Green revealed that the system originally required secrecy. He emphatically refused to tell his dream, saying, "That's a *secret not to be told to no one* unless you coulda

prove that that person have been a Christian."[38] In other words, you may tell that dream only to *someone who has already been initiated* into full church membership.

Coming out of the wilderness must have originally involved a procession with singing, a ritual which has gone unreported. Florence Rivers said that when they came out of the wilderness, they sang, "Didn't I shout when I come out the wilderness, come out the wilderness, come out the wilderness?" And she commented, "They used to sing those because they had to go out in the wilderness. So when they got converted and come out, they were out of the wilderness, they sang."[39]

After seeking, the second stage of preparation for baptism was to be instructed and then tested by the community's religious leaders. The initiate had to learn more of the rules of the church. As Josephine Green described it, she was sent "to another old man to learn the sipnin [Gullah for "discipline"] of the church, and he taught me the sipnin." And after Ellic Smalls told of dreaming of the people who sang to him, he was sent to Chester Capers—"old man Chester Capers who lived over on the road there for teach me for the church." Edward Milton explained that the preachers and deacons constituted an examining committee for the church.[40]

This committee functioned through another institution indigenous to the African American community in the Sea Islands. Each plantation had a meeting place where the people gathered on Tuesday, Thursday, and Sunday (or sometimes Saturday) nights to pray and sing. These traditionally were located, as Lawton described, "at the focal point of many well-beaten paths leading from the different homes in the community." Commonly known as "praise houses," Lawton thought this term derived from the Gullah pronunciation of "prayers house." The speaker of Gullah would say, "One pray. Den anudder lead a pray'. Dat mak' two pray's"—thus dropping the last syllable of "prayer." Emanuel Alston actually refers to the so-called praise house as the "prayer house": "From that [seeking] I joined the church and gave the preacher my hand and was taught catechism and went on to prayer house."[41]

Where there was not a prayer house on a plantation, several former slaves told Lawton, they would meet in the house belonging to "the oldes' head and most 'ligious man on de plantation." This might also be a woman's house, for the prayer house leader, at least by the early twentieth century, could be either man or woman. The leader commanded great respect in the community. The leader's job was to arrive at dusk and light the lantern or, in earlier times, the candle and begin the service by lining out the first hymn. Mary Ames, a teacher from Springfield, Massachusetts, described a prayer meeting at the house where she lived on Edisto Island in July 1865:

Jim asked permission to have it on the back piazza. . . . An Elder who could read, led the singing. George held for him a lighted candle. . . . The leader read one or two lines from the hymnbook; then they all sang, each man for himself. He asked the blessed Lord to raise the window curtains this blessed night and let the poor sinners look in, and if it was the blessed Lord's will, would he this blessed evening send down his angels with a hammer and knife and knock at every sinner's heart, for many there are this blessed evening, weeping and tearing their hair and searching for religion, and not knowing how to get it.[42]

Before freedom the elders of the community constituted the leadership, and after freedom they became the deacons of the church and sometimes were joined by the preachers. These elders also became leaders after going through an intense visionary experience. One of them told of having seen a silver chain with links about a foot long hanging down from heaven:

When I wanted to visit a fr'en' I jes' reach up and graff de chain and push off. Den I swings t'ru de air and land right in front ob de fr'en's house. My gran'mudder who been a speeritual teacher 'terpret dis to mean I com t'ru and my wuk in life gwiner be dat I bin goin' 'bout from place to place apreachin'.[43]

Emanuel Alston was urged by a preacher to assist in the church but refused, saying he was not "sufficient." After some urging, he said, he had the following dream:

A man and a woman come to my house. Man said, "Be an officer in the work of the Lord; and if you don't do it, I'm going to whip you." All right. I went fishing. I threw my line out toward the east, and there I hooked something and—pullin', pullin', pullin'—and it was so heavy—and began coming to the top of the water—and I saw the water light up—and the whole water lit up. When it came up to the top of the water, I said, "Oh yes! This is the blessing of the Lord!" Yeah—And he got up out of the water with a big glow—look like gold! Like *that.*

Then, he said, "That's the foundation that I'm standing on in the line of the church work."[44]

One of Lawton's informants described a possession experience that happened to him while visiting in Philadelphia:

Den one day I settin' in de church wid my back to the side doo'. Whilse de Reverence was a-preachin', de Speerit come in de doo' behime me an' he com' jes like a man and strike me on de head an' knock me out ob my seat an' I ketch on de back ob de seat in front ob me and den de Speerit went on cross the odders and knock my mudder down. She bin settin' 'bout twenty foot 'cross on de udder side ob de pulpit wid de wimmen. As I ketch on de back ob de seat in front ob me an' see my mudder knock down on de floo', I say, "Oh, Lawd, I'll do it. I'll do whatebber yo' wants me to do." F'om dat day to dis, I bin tryin' to preach."[45]

These, then, were the leaders to whom the initiates had to answer in order to be admitted into the community of the church. Emanuel Alston outlined the process: "I was examined by the leaders, and from the leaders I was turned over to the church to be baptized. . . . [They] took me to the conference and voted me in, and preachers and deacons took me aside and questioned me—about my faith."[46] Questions specifically addressed the initiates' frame of mind about their own status as a sinner. Each in turn was asked, "Do you know you were a sinner?" All but one replied, "Yes sir." When one said, "No sir," another deacon broke in: "I don't think you understood. What de deacon wanted to know was, do you realize that you have not been doing right, that you were a sinner before Christ saved you?" The answer this time was "Yes sir."

Leaders then moved on to emphasize that the initiates must feel responsible for themselves if they are not truly saved. Questions included:

> "If the church takes you in and you find in about a year or two you were mistaken when you tho't you were saved, and you should die and be lost, whose fault would it be?"

> "Who will be to blame if you are mistaken and are lost?"

And the answer must always be "I will blame myself"; "It will be my fault." Candidates must declare that their sins have been forgiven, that they have been saved, and that they have come to the deacons to ask to be baptized and to join the church. They are badgered about giving up sinful practices. One candidate was asked about giving up sin and answered, "I am willing to sacrifice pleasure." But the next, a girl, was asked, "I understand you have been smoking cigarettes, are you going to stop?" At that point a deacon interjected, "No deacon, that little girl hasn't. She ain't more'n ten years old." But the accusing deacon persisted: "Well, are you going to stop?" To which the girl answered, "Yes sir," but "then in an undertone, 'But I ain't been smokin'.'" Others went through the same process of accusation.[47]

Another set of questions underlined the importance of the religious leadership as the governing body in the community. One must obey the deacons and abide by the rules of the church. The examination concluded with a statement of spiritual growth: "Now since you has a changed heart, you must live different from how you been living. Your playmates goner watch you to see if you is different from what you used to be. You must be manoresable [have good manners], and kind, and helpful. Now you must attend the church services so you will grow in your spiritual life." Amanda Bradley gave insight into how deeply the examination impressed children: "Those men there had voice heavy as thunder, and they cross-questioned me."[48] After passing through the examination, the initiates are ready for the paramount ritual. They are ready to join with the spirit of Nicodemus to enter the water to be born again into the kingdom of God.

On the day set for baptism all met at the prayer house, and, Minnie Jenkins said, "They would tell us what we would have to do. We had to do the things what was right: no fighting, no cursing, no nothing." And there was to be *no* courting in the prayer house! Whereas seeking was an individual ritual, this gathering for baptism began a group ritual. Virginia Daise Anderson, who was born in 1887 on Pollawana Island next to St. Helena, said, "The string sometimes they had was thirty head to baptize." In January 1863 Harriet Ware, one of the northern teachers, reported that the number baptized on one Sunday reached 149. The participants, dressed in white gowns and head cloths, all lined up and marched to the river, singing as they went. On Hilton Head Island in 1919 Pinky Murray described the candidates as completely swathed, with "whole body cover, head cover, only eyes out," and the marching and singing went very slowly—"so pitiful, jus' like a funeral, march down wid de candidate."[49] In the river the actual baptism was done by the pastor, just as Reverend D. C. Washington was shown doing in Plate 3. The pastor was assisted by a deacon and a man called the "waterman" who provided a towel and helped the candidates out of the water when their clothes had become soaked and heavy and, often, cold.

Amanda Bradley, who later became a spiritual mother, said that there was a black frost on the morning of her baptism, and her mother didn't want her to go for fear she'd catch cold. But Bradley told her mother, "The water will be warm for me," and, she said to her interviewer, "That water was *hot!*" In 1932 Lawton observed a service that he regarded as typical. He described its structure—march, singing, officiating, test ordeal, baptism—and judged the baptism services to be "dramatic occasions":

> The congregation formed in line of march two abreast, led by the officiating minister and the investigator. Next came the deacons, then the five candidates, afterwards the men followed by the women and children. A swinging spiritual was begun and continued until all had reached the water's edge some quarter of a mile distant. Two of the deacons accompanied the minister into the water. One deacon went first with a stick measuring the depth, then the minister and the other deacon. After the minister quoted a few verses of scripture concerning baptism, the investigator, in response to a request from the minister, led in prayer. Then one of the deacons in the water who was to act as usher walked to the shore for the first candidate. Taking the young boy by the hand, he said to the audience: "Any ob you folks hear anything 'bout dis candidate dat would keep him from bein' baptize?" After a period of silence, the deacon continued, "It bin reported to me dat dis same candidate was in a fishin' boat yodder day and w'en he mash he finger wid de o', he blaspheme." To this two men in the audience replied that they had not heard anything about that at all. The deacon continued, "I dun talk to de candidate an' he say it ain't fur true. I glad dat it ain't so, 'cause effen it wuz, I'd snatch dis candidate outten de water 'fore he bin in it. Whoever staart dat lie on dis

candidate sho' bes' fo' mind out w'at he bin doin'." Forthwith, in stately dignity, he led the candidate to the minister who with raised hand said, "I baptize you in the name of the Father, and of the Son and of the Holy Ghost." The candidate was then immersed by the minister assisted by the other deacon. A general "Amen" ensued. A spiritual was begun as the ushering deacon led the newly baptized to the shore where there awaited a man from the church selected to be his personal attendant. This attendant threw a blanket around the dripping white-robed form, lifted him bodily into a waiting two wheeled chaise, sprang to the seat beside him, whipped the mule into a run across the sandy beach to "de ante-room ob de church" where the young man dressed for the next service.

This process was repeated for each candidate in turn until all had been immersed. Pinky Murray reported that when the minister "say 'Holy Ghos',' you is down, when say 'Amen,' you is up." Then the minister led a prayer to close the ritual, and the people of the church community "walked leisurely back to the church yard."[50]

The next stage included two ceremonies. One, called "giving the right hand of fellowship," welcomed initiates into the church community. Then the deacons prepared the second, Holy Communion. At this time the entire congregation *and* the minister left the church to wait in the churchyard, even on a cold rainy day. The window shutters were closed. No one could watch. The deacons—not the pastor, as is usual in Christian practice—prepared the sacraments. The new church members now received communion together. In the words of Pinky Murray, "Dey give dem de right han' o' fellowship, an' den give dem wine. Call dat initiate. Become a whole member jus' like de res'."[51] The ritual of baptism is complete. Now they belong. That night they will observe a final ritual of full acceptance when they attend their first prayer house meeting as members.

The prayer house meeting began with a formal service, after which the new members led the opening of a "shout." The "shout"—sometimes referred to as the "ring-shout"—has been documented often, by missionaries, teachers, and administrators in the nineteenth century and by film, television, folklorists, and analytical scholars in the twentieth. Its African roots have been readily acknowledged, but they may never be fully understood. We can, however, increase our understanding by looking at minute details. Lawton described a shout led by three newly initiated boys. At the end of the prayer service the leader directed that "After givin' de right han' of fellowship to dese t'ree boy what joined de church dis mornin' we'll . . . gib dese boys de opportunity to exercise deyselbes wid de shout." Then, Lawton continued,

There was a great deal of boisterous laughter as the people pushed back the benches against the walls and the three boys began to stamp the smooth worn

floor, to clap their hands rhythmically, and to move round and round the open space in the center of the floor, which was walled in by encouraging older people and other young people, all singing "De bell dun rung."

Others joined to form a circle. The three boys began to lead the singing. All chimed in, and momentum grew until the boys could be heard singing "with a note of frenzy in their shrill clear voices as they screamed the shout song, 'De bell dun rung, de bell dun rung, de bell dun rung.'" And Lawton described the effect: "Just as a whirling dynamo generates a magnetic field, so this vibrant circle varying in diameter according to the endurance of the participants turning on, and on, and on seemed to create a desire which could not be satisfied until each one yielded to the irresistable [*sic*] urge [to get into the circle]."[52]

Close reading of other accounts of the shout reveals surprising details. On Edisto, Sam Gadsden criticized a book by Chalmers Murray, grandson of Major William Murray. Gadsden objected to the book for holding "the people up to ridicule." But, he said, "it tells a true story." In other words, although Murray's attitude toward the people was wrong, the details of his account were accurate. Murray describes a shout which he saw on the Murray plantation in the early twentieth century. This shout began with the song, "Limping Jesus, Simeon." As the meeting began to heat up, a "weazen-faced woman" rose, admonished the participants for not being involved enough in their prayer, and "began singing in a high shrill voice, 'Oh, limping Jesus, Simeon, limping Jesus, Simeon,' shuffling her feet and clapping her hands." The circle was formed, and the beat increased while "the celebrants were circling the room swaying as they moved, dipping their hands at each handclap." As they circled, they sang, "Limp, limp, that the way, that how you come to Jesus. Limp and sing, sing out, Brother, sing out, Sister." The pace picked up, and the words of the song changed to "Jumping, Jesus, Simeon" while participants were urged to "hit the floor hard" and told, "Jesus Christ is waiting for you, right here in this room. He knows the inside of your heart; he knows it's softer now. The limp has gone out of your step." Tension built up, and the words changed to "Leaping, Jesus, Simeon . . . Leap up, leap up high. Leap up and crack your feet in the air. Almost in His arms, almost there."[53]

In 1862 Harriet Ware told of a prayer meeting that she and William Gannett were invited to attend on Pine Grove plantation on St. Helena, where the leader, Old Peter, prayed for the two of them that they should be "boun' up in de belly-band of faith." Cuffy, who had invited them, ended the meeting with a prayer that included the phrase "when we done chawing all de hard bones and swallow all de bitter pills." Following this, "one of the young girls struck up one of their wild songs," and the shout began. Ware and Gannett stayed only a short time longer and talked with Cuffy on their way home, asking him about the shout. He told them that he composed his own songs, "praying to de Lord Jesus to teach him as he in de

woods—jine one word 'ginst toder." They talked about how the older people felt about the shout and noted that Old Binah thought they must be held within the prayer house: "She did not like the shout 'out in de world,' i.e. before they joined the Church or came to 'strive behind the Elders.'" In other words, Binah felt that only the initiated should participate and that the ritual should be held where it could be kept private, if not wholly secret. As Binah was a leader in the church—one "whom all that came into the Church had to come through"⁵⁴—her opinion undoubtedly had tradition behind it and carried great influence.

Charlotte Forten, on St. Helena in 1864, noted that at the beginning of a shout, all the people shook hands with each other "in the most solemn manner." Then the elder, Maurice, who was blind, began the shout by starting a song. Forten described the room as dark with "blackened walls" and the circle of "wild, whirling" shouters lit by "the red glare of the burning pine-knot, which shed a circle of light around it, but only seemed to deepen and darken the shadows in the other parts of the room." An 1867 description of the shout also noted the centrality of the light or fire: "a light-wood fire burns red before the door . . . and on the hearth." Harriet Ware noted that two candles were lit to begin the service she visited. In the fall of 1862, as Dr. Esther Hawks set up a household in Beaufort, she found her helpers, Joshua and Eve, organizing a meeting "down in Aunt Chloes cabin." Joshua was the leader, so Dr. Hawks asked if she might go. She was allowed to stand "outside the band of *shouters.*" Joshua started the meeting "as soon as the pitch knots were lighted." Singing began with "Sister Mary's sitting on the tree of life . . . Roll Jordin, roll." All those attending repeated the chorus with variations until, Dr. Hawks wrote, "Joshua makes a new start, with 'Brudder Tony's sitting on the tree of life'—and so on until the names of all the members have been called—and every one is on their feet shuffling and swaing [*sic*] from side to side keeping time with their whole bodies, and putting in the emphasis with an occasional unexpected screach—followed by a groan from the whole company. This is kept up until they were all to [*sic*] exhausted to keep on their feet."⁵⁵

In his 1931 study of the shout Robert Gordon gave many variations from Darien, Georgia. He found two body movements that were unacceptable. One was to place the arms akimbo: hands on hips, elbows pointed out. This was a gesture of challenge which expressed disrespect or could start an argument. The other unacceptable movement was to cross the feet while moving in the shout circle. To this the older members would chant, "Watch out, sister [or brother], how you walk on de cross! Yer foot might slip an' yer soul got los'." Gordon described body movements accompanying two other shout songs as well. For one which began "Oh, Eve, where is Adam?" he included references to vocal pitch along with movement: "The heavy sonorous call of God is answered by the higher-pitched, quicker reply of Eve, while at the proper places the shouters stoop to the ground to pick up

the leaves or go through the motions of pinning them on."[56]

The other song, "Down to the Mire," was "very ancient." This one was performed by women. They circle one woman who lowers herself slowly to the ground until her head touches while they sing, "You shall go down to de mire." In coastal Georgia south of Darien the same song was described as a man's activity by participant Alec Anderson: "We calls it 'Come Down tuh duh Myuh.' We dance roun an shake duh han an fiddle duh foot. One ub us kneel down in duh middle uh duh succle." Lydia Parrish, a folklorist collecting in the Georgia Sea Islands as early as 1909, gave both men's and women's versions of this shout ritual. The men formed a ring with one man in the center on his knees with his head at the floor. As the ring circled around him, each man pushed his head "down to the mire." Giving the lyrics, she showed that the song summoned each person by name as they sang:

Oh, you mus' come down to de mire . . .
Jesus been down
                    to de mire . . .
You must bow low
                    to de mire . . .
Honor Jesus
                    to de mire . . .
Lowrah lowrah
                    to de mire.[57]

Seeking, examination by the elders of the prayer house, baptism into church membership, communion, and the prayer house shout constitute the structure of initiation into the religious community in the Sea Islands. If we are to fully understand the unity of this structure and the purpose of the institution, we must look again into cultural practices in the Bakongo background.

From the Atlantic coast of Africa, along the north bank of the Zaire River to Malebo Pool and as far north as the valleys of the Kouilou and Niari Rivers and south of the Zaire in Nsundi territory, one society dominated all others. Although it varied from region to region, it was known by one name, Lemba. This large area encompassed the Vili people, from whom Sam Gadsden's forebears came. It included the Yombe, Teke, Laadi, and Kongo peoples with whom the Vili traded. It covered an enormous area from which Kongo peoples were brought into slavery in the United States, especially in the Sea Islands. We have examined the trade system of Loango largely from a secular point of view, mentioning only a few rituals that were performed along the trade routes. Now we will see how religious facets intertwined with secular in true African fashion within Lemba as well, for

Lemba ruled the trade system here just as Ekpe ruled the trade system in southeastern Nigeria.

We have seen the Igbo title association structure as a concept for organizing society in Virginia. Here we can see the Lemba society as a concept for organizing communities in the Sea Islands. Lemba was so dominant among Central African peoples that it would be illogical not to expect its transference to the New World. On the other hand, it was so secret that through the 200-odd years since its transference, much unifying detail has been lost, making it harder to identify. To try to make its identification easier, we will look first at its major principles and then at details of its rituals while examining how these principles and details were manifested in the Sea Islands.

Lemba existed among Bakongo peoples for at least 300 years, dying out only under the onslaughts of colonial administrations in the early twentieth century. When we looked at the Vili background of Sam Gadsden's forebears, we saw that early trade in ivory, iron, and copper gave way as the slave trade grew. While exports of slaves to the United States declined in the mid-nineteenth century, export to Cuba and Brazil increased. The slave trade brought a surge in the value of wealth as the hallmark of status. As the centralized power of the maloango declined, local mafouks needed peaceful relationships to ensure that their own villages survived as well as to protect their own status and wealth. Consequently, the slave trade also brought a surge in the power of Lemba. It focused on wealth and trade. Since fees to join were extremely high, it became a secret society of the elite—chiefs, merchants, judges, doctors. Protecting trade required a strong kinship structure and peaceful relationships within and between communities. Because it sought harmony at all levels of social structure, Janzen calls Lemba a "therapeutic association."[58] Its very name referred to bringing peace or healing to an individual, situation, or community.

The name chosen for the Lemba society raises a characteristic in Bakongo language usage that we will find informing the meaning of cultural practices as we look into them. This is the use of punning and metaphor. Puns and metaphors permeate Kongo thinking patterns. John Weeks, the missionary, gave the example of the Kikongo word that applied both to hunger and to fingernails: the sentence "They gave me a good knife to cut my nails" meant "They gave me nice food to cut (satisfy) my hunger." On St. Helena an elder expressed himself through the same device. He referred to a bad harvest season by saying, "I has two or three buttons on my coat, but some men I see has but one."[59] The speaker in both cases makes the analogy through the figure of speech but leaves interpretation to the listener. The Brunswick Confessor's dirt dauber is an elaborate metaphor in the Bakongo tradition.

Using metaphor and playing on words bring layers of meaning into whatever activity or subject is at hand. Robert Farris Thompson gives a range of

examples from the Kongo. A metaphor can seem elementary. A band of abstract pattern on a pot actually is a fish-scale pattern implying passage through mpemba and can refer to the sun's passage or the passage of the dead as well as the obvious reference to the fish. Or a metaphor can be as complex as a nkondi image that symbolizes coming to agreement in an argument, lawsuit, or contract. In this case, an iron blade will be hammered into the image. That much is apparent. But before the blade is inserted, two opponents who now wish peace with each other may have licked the blade so that their saliva also enters the image. Then, "should they break the vow," Thompson points out, "the spirit in the image knows . . . exactly whom to annihilate or punish."[60] These images are the familiar Kongo so-called nail fetish sculptures, figures of humans or animals shot through with nails or wedges. With one or more blades driven in, they look ferocious, but each has now become a tangible metaphor signifying harmony. In this same way, the Lemba society, which controlled governing, trading, and family relationships with a ferocious power in an extensive geographic region, carried both a name and an intent which mean "peace."

The values of the Lemba society are thus expressed through metaphors and symbols rather than being stated directly and literally. Elementary metaphors and symbols are embodied in rituals, and the rituals may themselves become higher-level metaphors and symbols for Lemba's deepest values. The Lemba society valued wealth and trade, the solidity of the family, and governing the community; all of these took root from the need to maintain balance. The society employed rituals of marriage to symbolize the family and employed rituals of healing to promote harmony. These, in sum, are its basic principles, and we must see how these values were manifested in the Sea Islands. Because the people there were not free to establish the institutions of their lives as they could in Africa, emphases among principles were different. Relationships among elements of the African structure might therefore seem askew, some receding while others grow in prominence.

Let's begin with the all-permeating principle—healing, curing, maintaining balance, bringing peace. The starting point for joining Lemba began with the individual's affliction. Janzen lists an assortment of types of affliction: "as possession by Lemba's ancestors . . . ; as any illness affecting head, heart, abdomen, and sides, that is, the key organs of the person; as difficulty breathing . . . ; as miraculous recovery from a deadly disease."[61] The individual's affliction worked both as his reason for joining and as a metaphor for the social ills needing cure.

In the Sea Islands, until the liberation by Union forces began in November 1861, all life was an affliction. Those thousands from Kongo lands who were brought into slavery traveled from the direction of the rising sun and,

crossing the vast ocean, traveled across the line of kalunga. Following the sun westward, they were put down at its point of decline into the world of the dead, and there their lives became torment: beatings, hunger, sickness, damp cold, and emotional wrenchings. Lizzie Davis from Marion, South Carolina, spoke of her family's pain:

> I hear my father tell bout dat his mammy was sold right here to dis court-house, on dat big public square up dere, en say dat de man set her up in de wagon en took her to Georgetown wid him. Sold her right dere on de block. Oh, I hear dem talkin bout de sellin block plenty times. Pa say, when he see dem carry his mammy off from dere, it make he heart swell in his breast.[62]

One can understand the need for healing.

But the people also reveal to us the relationship between their individual afflictions and their ritual paths toward healing. Charlotte Forten spoke of Maurice, the elder who had been blinded. His owner had beaten him on the head with a loaded whip—a whip weighted to make it into a bludgeon. Maurice told Forten: "I feel great distress when I become blind, but den I went to seek de Lord; and eber since I know I see in de next world, I always hab great satisfaction." After his affliction Maurice went into the seeking ritual, and this was long before freedom. Almost 100 years later Isabella Glen "put a headband on" and began seeking after she burned her arm so badly that her mother fainted. Glen said she began seeking because "every-one was telling me to join the church. They all convinced me that it was a warning from God." And on St. Helena, Rebecca Mattis said that once when she was sick, she dreamt that a man came along and told her to put her hand across her breast and repeat the Twenty-fifth Psalm. She said, "Who is you?" And he replied, "I'm Deacon Grant." She answered, "Well, I know one Deacon Grant, but that is not the one." Then he replied, "No, that is not the one. . . . I'm talkin about the Lord Jesus Christ." Her illness coupled with her dream prompted her desire for baptism. Likewise, Ezekiel Cohen said he had gotten sick after he disobeyed his mother and went out-side after a hot bath, and the sickness was part of the sign to him.[63]

The concept of individual pain as part of the ritual is clear in a shout song that Lydia Parrish recorded in the early twentieth century. The song begins:

> Pain in the head—Shout—Shout!

And the verses continue with "Pain in the back . . . neck . . . hip . . . toe . . . leg . . . heel." And another song—"If you want to find Jesus, go in the wilderness"—reveals the link between pain and belonging to a group. Later stanzas begin with "O weepin' Mary," "'Flicted [afflicted] sister," and "Say, ain't you a member?"[64] The structure for working out this underlying prin-ciple of Lemba membership, putting the need for healing individuals' afflic-tions together with rituals to find healing, was clearly brought to the Sea Islands and established there.

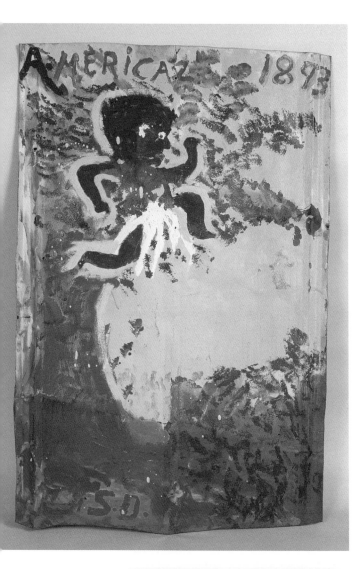

1. Sam Doyle,
*A. MERICAL 1893.*
House paint on metal;
39½" x 26".
*Private Collection.*

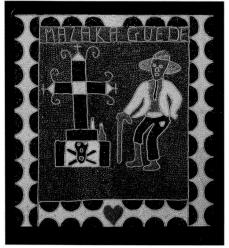

2. Haiti, Vodou Flag,
*MAZAKA GUEDE.*
Sequins and beads on
fabric; 29¼" x 29".
*Collection of
Barbara J. Frey and
Ralph V. Katz.*

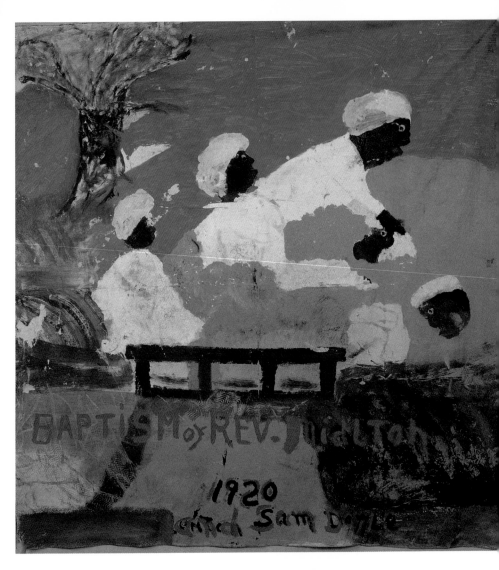

3. Sam Doyle, *Baptism of Rev. Midlton 1920 and Sam Doyle.*
House paint on vinyl tablecloth; 52" x 51½".
*Private Collection.*

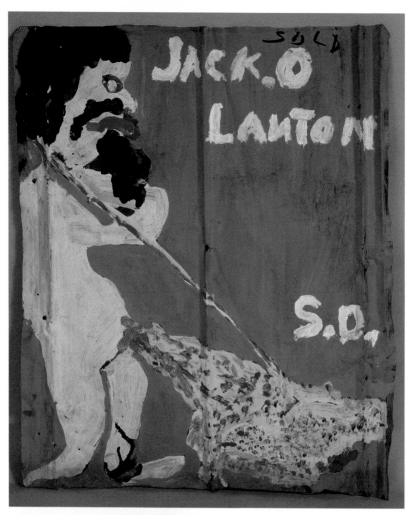

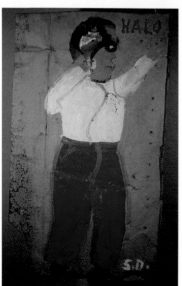

4. ABOVE: Sam Doyle,
*Jack. O Lanton.*
House paint on metal;
33" x 27".
*Private Collection.*

5. LEFT: Sam Doyle,
*Halo* (Doctor Buzzard).
House paint on metal.
*Collection of South Carolina
State Museum.*

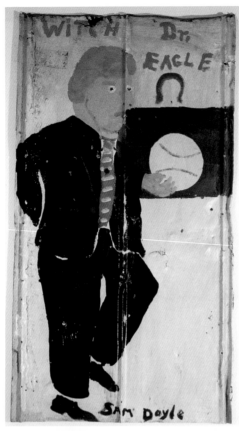

6. Sam Doyle,
*Witch Dr. Eagle.*
House paint on metal;
45" x 25".
*Collection of
Dr. Robert Dickens.*

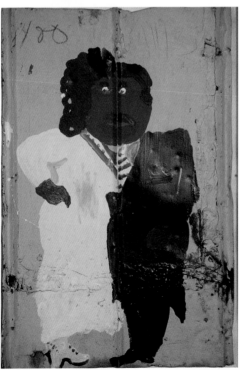

7. Sam Doyle,
*He/She in Wedding Outfit.*
House paint on metal;
38½" x 25½".
*Collection of Gary Davenport.
Photograph courtesy of the
American Folk Art Museum,
New York.*

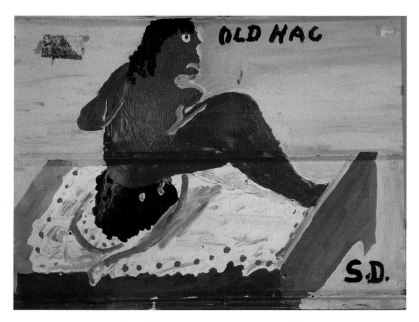

8. Sam Doyle, *Old Hag.* House paint on metal; 26" x 35".
*Private Collection.*

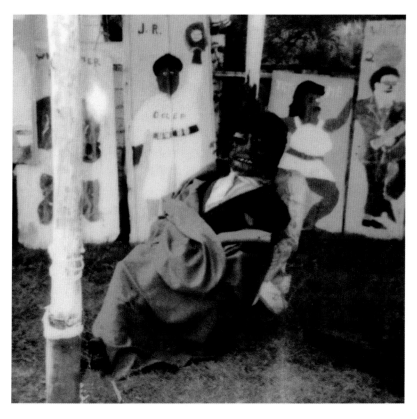

9. Sam Doyle, *Uncle Remus* in "Sam's Gallery."
St. Helena Island, South Carolina.

10. Ralph Griffin,
*Spanish Dog.*
Spray paint on root
and branch; length 21".
*Author's Collection.*

11. BELOW: Ralph Griffin,
*Evil Boy* [facing road].
Spray paint on tree
stump; 26" h.
*Author's Collection.*

12. Ralph Griffin,
*Mermaid on a Ski.*
Spray paint on root;
24" h.
*Author's Collection.*

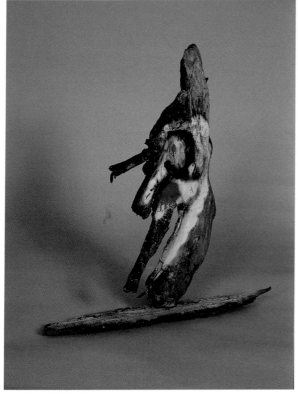

13. Ralph Griffin,
*Mermaid on a Ski*
[spirit side].

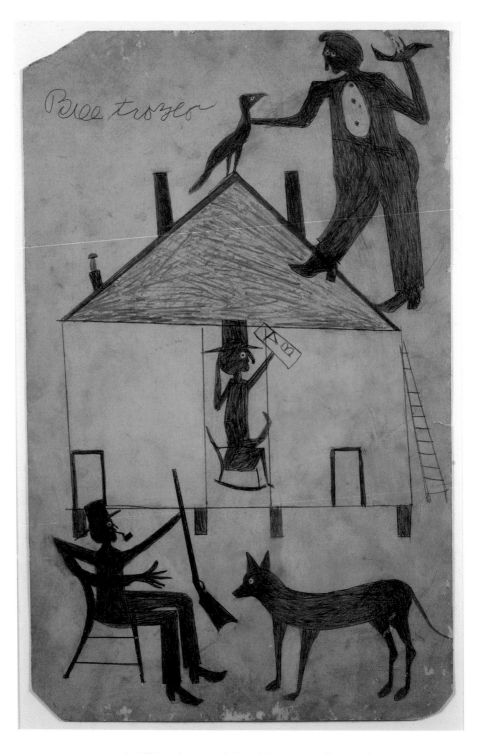

14. Bill Traylor, Untitled, exhibited as *Yellow and
Blue House with Figures and Dog.*
Pencil and colored pencil on cardboard; 22" x 14".
*Collection of Judy Saslow.*

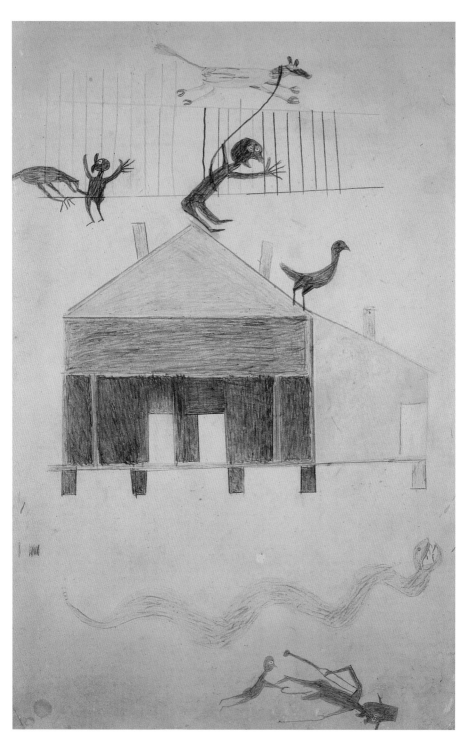

15. Bill Traylor, Untitled, exhibited as *House with Figures*.
Pencil and colored pencil on cardboard; 22" x 13½".
*Luise Ross Gallery, New York.*

16. Bill Traylor, Untitled, exhibited as *Woman in Black Dress with Blue Purse and Shoes.* Pencil, charcoal, and gouache on cardboard 13³/₈" x 7³/₈". *Private Collection. Photograph courtesy of Sotheby's, New York.*

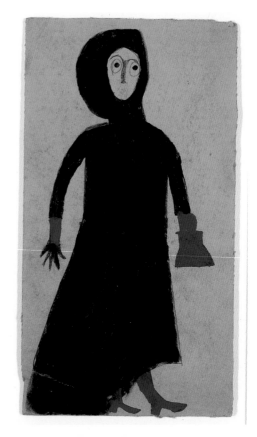

17. Bill Traylor, Untitled woman in red shirt. Colored pencil on cardboard. *Collection of Micki Beth Stiller, Montgomery, Alabama.*

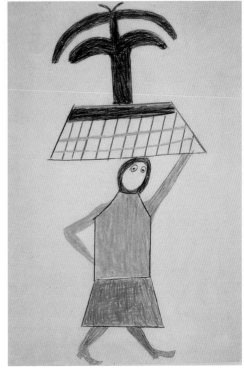

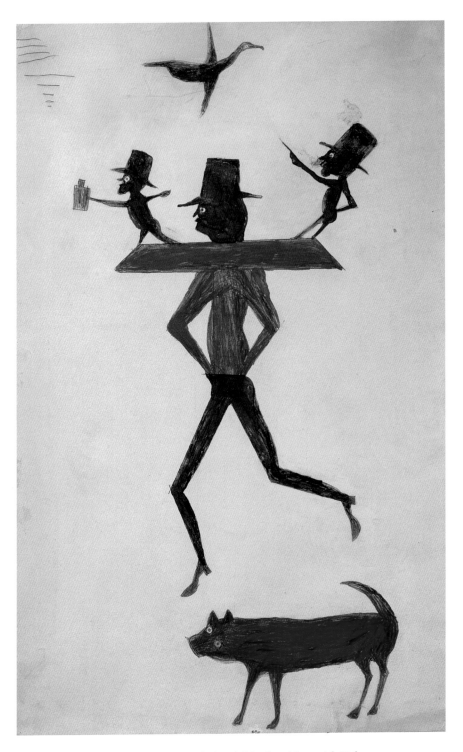

18. Bill Traylor, Untitled, exhibited as *Man with Yoke*.
Poster paint and pencil on cardboard; 22" x 14".
*Collection of the American Folk Art Museum, New York.*
*Photograph courtesy of Sotheby's, New York, and Joseph Wilkinson.*

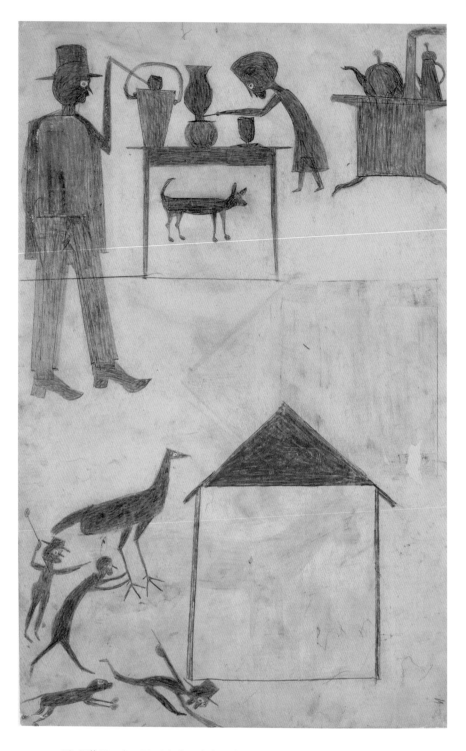

19. Bill Traylor, Untitled, exhibited as *Kitchen Scene, Yellow House*.
Pencil and colored pencil on cardboard; 22" x 14".
*The Metropolitan Museum of Art, Purchase, Anonymous Gift (1992.48).*
*Photograph © 1992 The Metropolitan Museum of Art.*

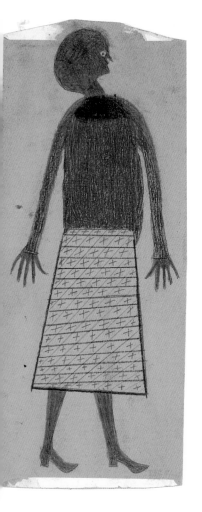
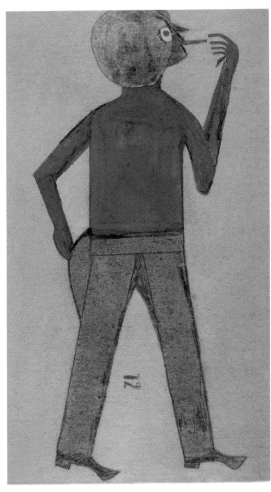

20. LEFT: Bill Traylor, Untitled, exhibited
as *Woman in Blue Blouse*.
Pencil and crayon on cardboard;
16¼" x 7".
*Private Collection.*

21. RIGHT: Bill Traylor, Untitled, exhibited
as *Red Eyed Man Smoking*.
Poster paint and pencil on cardboard;
13¾" x 8¾".
*Private Collection.*

22. LEFT: Bill Traylor, Untitled,
exhibited as *Basket in Blue*, recto.
Pencil and poster paint on show card;
10³/₄" x 7".
*Private Collection.*

23. RIGHT: *Basket in Blue*, verso.
Show card.

24. Bill Traylor, Untitled, exhibited as *Figures, Construction*.
Watercolor and pencil on cardboard; 12$^{11}$/$_{16}$" x 11$^{5}$/$_{8}$".
*Montgomery Museum of Fine Arts, Montgomery, Alabama.*
*Gift of Charles and Eugenia Shannon.*

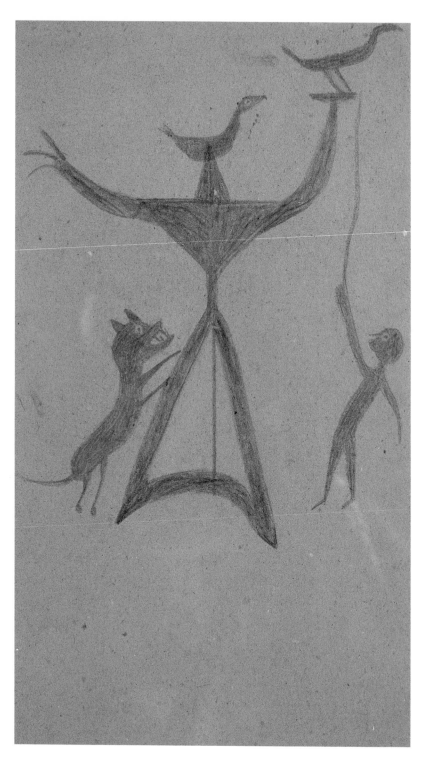

25. Bill Traylor, Untitled figure with birds, dog, and man.
Pencil and colored pencil on cardboard; 13³/₄" x 8".
*Private Collection.*

The need to keep balance in the community is equally important. Descriptions of the plantation "street" are common. After freedom, people stayed in the vicinity when they could and moved their houses to their own plots of land. When they had to move, they lived near other African Americans, not in racially integrated communities. On Edisto quite a few freed families moved houses to a central spot that others referred to as "Freedman's Village" but that they themselves called "shay-go." Winifred Vass, in her work on Bantu language in the United States, points out that African Americans often called their area of town "Shakerag." She suggests that "shakerag" came from the Bantu "tshiakalaka," which meant gathering for conversation. Her theory may be reinforced by the traditional "hello" from the Luba-Kasai: "anyishaku."[65] In short, African Americans both in slavery and afterward did in fact live in their own communities, as they had in Africa. Bakongo recognized the tensions created within and among communities, and Lemba worked to moderate these tensions at all levels. In the Sea Islands, where African Americans established their own communities, they also formed social institutions to maintain balance.

Whereas Lemba governed relations both within villages and between them in Kongo regions, African Americans in the Sea Islands first developed the prayer house structure as the focus of community coherence. To that end, people in a plantation community established a prayer house. The oldest man (or, eventually, woman) who had joined through initiation was the leader. Other elders also were leaders. These leaders dealt with tensions in the community. By the early twentieth century a more formal structure had developed. Each prayer house had a leader, four deacons, and two committees. A committee board met on the first Thursday of each month to hold a conference and on the first Saturday of each month to adjudicate arguments. This system governed relationships within the community. When freedom came, relationships among communities expanded; and people from several plantations were able to attend church together. At this point, governance of the church was grafted onto governance through the prayer house. It then broadened the system to apply across plantations. Through its whole existence this structure governed in a community that was decentralized, without hierarchy. Although its texture is certainly different from that of the Kongo, this lack of focus on an apical ruler directly parallels the governing situation in the Kongo region during the height of the slave trade when, in Loango, the power of the maloango had declined.

Likewise, the primary responsibility of the prayer house/church system was to keep peace. Emanuel Alston described the system as it worked before the prayer house institution declined later in the twentieth century. Arguments, he said, would be reported to the committee, which would call a prayer service and hear complaints. If the dispute was not settled at that point, the disputants and committee would meet with the prayer house leader.

If not settled there, the dispute would be taken in turn to the deacons of the church and the church conference. If not settled at all, the disputants would be excluded from church. After prayer houses declined, church membership was divided into wards, which also coincided with plantation locations. Again, in case of argument, the dispute would be taken to the ward leader, then to the leader and his committee, then to the church officers, each in turn. The adjudicating group seemed to be enlarged as much as necessary to try to get a peaceful settlement.[66]

If negotiation failed, the disputant was "back benched." Originally, this literally meant sitting on the back bench in the prayer house. The custom evolved to mean that the person cannot voice opinions or participate in any way. A choir member may not sing, for instance, because, as Deacon Tom Brown said, "A person cannot sing if they're not in harmony with the church." The ultimate punishment still is exclusion from the church. But Deacon Brown explained that they use every possible means to avoid this because it hurts the person who is excluded, and "if you hurt someone else, you hurt yourself." When Isabella Glen was describing her own church, she gave the facts—the meeting times, who the minister was, the membership. Then she commented, "but we are all at peace." Her remark reveals the importance of the value. For African Americans of the Sea Islands the church with its original prayer house buttress was, like Lemba for the Kongo people, the instrument to provide peace and harmony through governance. Janzen describes Lemba as having a "therapeutic ideology" that provided the archetype for the "fully-formed social state."[67] The premise on which the prayer house/church system was based was also an archetypal "therapeutic ideology," and the prayer house/church system moved as close as oppressed African Americans could come to achieving the "fully-formed social state."

Lemba's focus on wealth and trade, however, does not have so immediately parallel a focus in the Sea Islands. Since slaves there could not accumulate wealth or develop elaborate social and trade systems, that focus receded. Yet the concern with wealth was present and had a ritual connection. That connection gives the clue to Kongo heritage, the clue that distinguishes this idea from the simplistic notion that everybody likes to get rich. At the core of the concern with trade in the Kongo was a belief that trade began with the ancestors. Janzen gives an illustration of trade occurring at the entrance to a Kongo marketplace, explaining that this position for the interchange is a metaphor for the concept that trade begins with the ancestors because the ancestors give wealth.[68]

The belief in the relationship between the ancestral spirits and the exchange of money permeates ritual observances in the Sea Island region. In cunjuring rites the principle of paying the spirit whenever its "graveyard dirt" is taken for a hand is virtually a universal instruction. Hyatt interviewed

a man who was born in Beaufort and was practicing root doctoring in Florida by the 1930s. In answering Hyatt's questions about how he began, he combined his root-doctoring knowledge with his seeking experience into one unit. His Christian orientation, like the Brunswick Confessor's, informed his cunjuring rituals. Furthermore, an affliction started his seeking: "Ah was goin' long one morning and a great big pain hit me right roun' mah navel . . . an' ah jumped right on de mule an' ah went right on home and wit dat pain ah was so sick ah couldn't do any work." He also told how to get graveyard dirt to use in a hand: "Put chure hand down in grave six inches which represents six foot. . . . That's done at de high hour at night, twelve 'clock, an' den yo' pay off with three pennies—leave it dere and talk to him . . . 'I want chew—I'm paying de dead.' . . . Then yo' take dat little dust den an' yo' go on." Another informant in Waycross, Georgia, whose hand was not for protection but was to do harm, told Hyatt, "Yo' kin take a one-cent piece an' go to a wicked grave . . . an' git some dirt from de head of that wicked person an' pay them with one-cent."[69]

In all the areas Janzen studied, copper bracelets were given to initiates. Because the bracelets were expensive, they symbolized the wealth necessary to join Lemba and exemplified the trade relationship with the ancestors. The bracelets were minkisi, consecrated medicines, symbols of the healing aspect of Lemba as well as symbols of the initiate's priestly rank and authority. During rituals the bracelets jingled against each other, accompanying the ritual with chiming music, mediating between the wearer and the spirit world. Where ceremonial marriages were part of the rites, bracelets were given to couples as symbols of family unity. In the United States the concept of the healing ability of the copper bracelets lasted well into the twentieth century. In the Georgia Sea Islands in the 1930s Dye Williams wore copper bracelets on both wrists and explained that they helped the nerves when you worked hard or did a lot of washing. In Florida, Jim Myers, a large landowner, wore bracelets around each ankle to help cure pain in his legs. East of Savannah, George Boddison wore bracelets on his wrists and arms. His bracelets elaborated the Lemba practice further: they were embellished with "good luck charms." These kept evil spirits and sickness at bay. In the Kongo the bracelets held containers for medicines and were embellished with designs having symbolic meanings. Boddison also wore copper around his head with pieces of mirror reflecting out from his temples. The mayor of his community, Boddison was a living nkisi of Kongo heritage. He wore Kongo emblems of authority: the mirrors gave him mystic vision, communication with ancestral power.[70]

On St. Helena, Sam Doyle illustrated the value in acquiring wealth while at the same time applying a Kongo-like use of metaphor. He painted a portrait of a root doctor whom he had named *Dr. Eagle* (Plate 6). Doyle said Doctor Eagle wasn't really known by that name, but he liked to collect dollar bills so much that Doyle named him for the eagles on the bills. Doctor

Eagle may actually have been the Doctor Jones described by the grandson interviewed by Hyatt. A William Jones who was born a slave lived on Wallace near the Doyle family at the turn of the century. This put him quite close enough to have competed with Doctor Buzzard, whose main family compound was not far down the road toward Beaufort. Doctor Eagle is painted with a white face and stands in a bluish-white background. When I asked Doyle if Eagle was a white root doctor, he said, "I forget." This is not a thing he would have forgotten. His reluctance probably indicates that Doctor Eagle had died: so his skin was painted as a spirit's, and he stands in the spirit world. He also wore a black suit such as Victoria Polite had seen ghosts wearing: "Somebody got killed. . . . Then as I passin' by . . . I could see the man dressed up in the black and the woman have a black dress and a white face on." (Also see Plate 16.) Doctor Eagle carries a white ball in a black bag. Doctor Jones worked with a crystal ball covered with "somepin black dat he put ovah it." In one of Doyle's versions Doctor Eagle's ball is on top of his head, combining the seat of wisdom with clairvoyance. Doctor Jones told his grandson that his knowledge was "a gift from God" and that "it is wuth thousands an' thousands of dollahs." He continued, "When ah wus takin' mah first step in witchcraft, ah didn't have a dime. But now ah got aplenty. Ah gits mah powah from above."[71]

This concern for the acquisition of wealth, the presence of ancestral spirits, and the performance of ritual acts all appear together in the stories of money-searching which abound in the folklore of coastal South Carolina. Jim Horton was born in 1872 and lived up the Broad River a few miles from St. Helena. When he was a child, he learned root work on his plantation from "Old Lady Jane Horton." He told how money-searching worked. The tool is a rod with a string on it, and the rod will move up and down. It has the numbers "12" and "1" as if on a clock face, and these "show you how much gold or how much silver; between that, then, is where you get greenback money." He said that you stick the rod down in the ground where you think the money is and when you "hit that money that rod there goes to shoutin'." Then you slap the rod and speak to it: "You hit it three times and tell it to hold it and the rod stops right still and stands right dead on it." Then you begin digging; and while you dig, you must keep quiet: "You can't talk or nothin' cause you has to be diggin'. If you get ready to talk, you got to go off—do your talkin' and then come back and don't talk any more. Just do the motions." On Lady's Island, Ezekiel Green spoke of silence, too. The old people told him, "If they give you the money, and you go there to dig it up, you can't talk—not until you get it up. And drill a hole in the treasury that that air can get out it. Then the money cannot go. But if you talk before you do that, the money will sink right back down in the ground."[72] So in money-searching there is, first, the belief that the tool has the life force, the spirit, to make it react to the presence of money. Second, there is

the ritual activity of striking and speaking to the tool and of maintaining silence during the action.

Digging for money is analogous to the metaphorical use of burrowing or digging animals or insects—rats or ants—which Janzen found in the lessons of Lemba. These metaphors refer to digging out Lemba's wealth, power, and revelation of truth. They depict the contrast between successful and unsuccessful searchers: the successful are analogous to priests who know the secrets and "can handle truth"; the unsuccessful "lack truth and power" and actually destroy resources. Horton experienced a money-searching quest that was ruined by breaking the rule of silence. A lady told him and his fellow-searchers where some money was supposed to be, but she couldn't find it: she was the unsuccessful searcher. Horton and his group went to the spot, and "there was a big rattlesnake coiled up there. We killed it, and right where he was coiled up, we stuck the rod down and struck the money." It was about six feet down, and they had to cut out a big red oak stump. Then, he said, "we struck the clay, and we could tell the designs of the black dirt of the hole they dug for that thing to go in there." So they dug and dug for about three hours down one side and then the other, and then "that lady come up and—oh, she hollered out about that money and what she was gonna do." And he exclaimed, "People, then that money *left*—that whole big thing just left! It disappeared! And when it disappeared, we disappeared."[73] But they didn't want to give up, so they waited an hour and tried again, but to no avail. The lady broke the rule of the ritual, and the money vanished: she had destroyed resources.

Horton went on many money-searching trips. On one expedition the spirits chased him and some friends away. A man told where there was supposed to be a large amount of money, so the friends started digging. Horton continued, "As I started to dig I saw a very powerful light over the hill there—and heard horses coming down just quick like this—through the old dark thicket out there by the graveyard—and went on off. We went back and went digging again—a big poplar tree there, and a baby just cryin', like to squawlin'. We stopped—couldn't talk—stopped and looked—saw the light down the road again. I don't know—whooo!—who was the fastest!" Leaving that alone, they went on to someone else's house beside a swamp; and looking near the house, they moved two bricks and found a $10 bill. The next day they found more. To the students interviewing him, Horton repeatedly exclaimed, "There's money in heaven! . . . Plenty of it. . . . Money-diggin' is a secret. You can just bet on that."[74] He had taught the students three principles: money is an element in the cosmology; the ritual for achieving it is secret; and the acquisition of money is governed by the spirit world.

A third principle of Lemba emphasized the solidity of the family. Throughout Lemba's area, Janzen explains, marriage and kin relationships were highly structured and tied to Lemba's control. Lemba's insistence on family solidity, however, derived first from a belief about the creator God. Fu-Kiau tells how traditional Bakongo belief explains the origin of humankind: "The first man was neither man nor woman; he had within himself two creatures: the feminine and the masculine. . . . [He] was created with two different but complementary sexes." He was called "Mahungu," and Fu-Kiau diagrammed him as one being in which the two sexes are joined like those in Diagram 4-1. Fu-Kiau said Mahungu was "the Being of which one cannot know the true sex."[75]

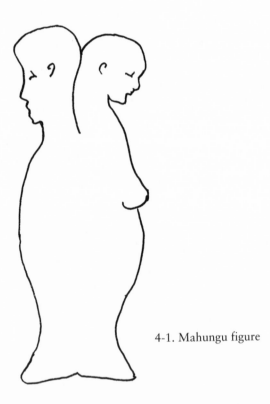

4-1. Mahungu figure

On St. Helena, Sam Doyle gave startling, powerful evidence that this belief survived. Here again Doyle challenges us, as Vansina said, "to uncover precisely what remains unknown." Doyle painted what he called a *He/She*. He/She, too, was a "Being of which one cannot know the true sex." This person, like Mahungu, was always half-man, half-woman. Doyle said it was a person who sometimes felt like a man and sometimes like a woman. Mahungu, said Fu-Kiau, "contains two opposing forces: that of creation

and that of destruction. He is then *creator* and *destroyer* for he is the *sign* of *force* and of *weakness,* as this person has at once the nature of man and the nature of woman. The person who gives life by his kindness and who destroys by his violence is Mahungu." Eventually Mahungu suffered a traumatic experience and became divided into man and woman. Each wished to have the qualities of the other. Each was afflicted by loneliness, and they tried but failed to become one again. Each continued to search for the other, and "the man reflected deeply, and finally he reached the solution of marriage."[76] And Sam Doyle painted a He/She wearing wedding dress (Plate 7).

Fu-Kiau commented that he received the story of Mahungu from "numbers of old men" and that it was "the most curious story" that he heard. On St. Helena, Sam Doyle probably also heard the story from the old people. When explaining how he knew what to paint, he said, "I think about it . . . at night . . . just like—people I've known a long time ago—and stories that I've been told—I can go right from the story. . . . I know what it's all about, you see. Yeah, that's how it is. Mmm-hmm." His oldest sister, Susan, who was born in 1892, noted that as a child Doyle "kept apart" from the other children's games and that he spent much time with the older people. His friend Emory Campbell, a son of the Islands himself, explained, "Many of the things he painted were things he could only have learned from [the old people], because they were before his time."[77] And so Mahungu came from the Kongo to St. Helena bringing the concept of strength of the marriage bond.

For Lemba this concept worked to establish relationships among localities to protect its trade system and all other phases of its influence, and so its ideal marriage was ritualized in Lemba ceremonies. We must look, then, at ritual observances in the Sea Islands to find evidence that the complexity of the connection between the cosmology of the society and the structure of the society's organization survived. Kinship structure as conceived among the Bakongo in Africa was of course completely disrupted by the slave system in the United States. Marriage, although sometimes performed by owners, was not truly recognized by them. Families were broken up for sale whenever it suited the owners. But the value system that determined attitudes toward family structure could not be obliterated. Within the African American community, marriages were sacred. On St. Helena, Rossa Cooley reported that Aunt Rina told her their marriages were performed in the prayer houses by the elders: "De ol' leader ob de praise house would pray ober dem." In Darien, Georgia, there was a very old custom of slaves offering a "shout" to honor the wedding of their owners' daughters. This ritual was a gift of a magnitude never understood by the recipients. Herbert Gutman has shown the extent to which family solidity endured. Erskine Clarke found that African Americans in the churches of Charleston brought cases of marital infidelity up for adjudication frequently and with unwavering insistence on

discipline. He found that marital fidelity was a value of major concern to the African American community.[78]

Surviving details indicate that the Lemba value in strong family relationship as symbolized by marriage came to the United States. In Lemba's ritual husbands and wives participated together. Among the Lari people, at one stage of initiation a fire was lit at the entrance to the village. The candidate's in-laws, wives, and priests gathered, feasted, and then danced, each dancing "out with his wife." In South Carolina, Julia Peterkin, born in Georgetown on the coast and raised by an African American woman, wrote a similar description in her novel *Black April*:

> The Quarter houses were all solid darkness but one, and its doorway was choked with people pushing in and out; its front yard hidden by a great ring of marching couples, that wheeled slowly around a high-reaching fire. These were holding hands, laughing into one another's faces, their feet plumping down with flat-footed steps that raised the dust, or cutting little extra fancy hops beside the steady tramping bidden by the drum.[79]

This is a description Peterkin could not have made up. Here are the couples dancing in the circle, the Kongo cosmogram, circling with the fire at their center. And here is the drum, the voice of the ancestors, determining their footfalls on the earth. Moreover, the celebration is in the front yard of the one lit-up house, just as part of the Lemba initiation also occurred in the yard of the candidate's house.

The philosophic union of man and woman as portrayed in Doyle's *He/She* is the source of the use of Adam-and-Eve root in cunjuring practices. Its shape combines man and woman. A root doctor in Florence, South Carolina, a few miles upriver from Pawleys Island and Georgetown, described the root's sex-determined behavior when it was dressed for use in a hand. "If yo' wanta see if it's a man an' woman," he said, you must put the root into water in a glass. Then "de man an' woman will go to de bottom, an' de man will come to de top, jes' lak yore doin' yo' . . . a man supposed tuh be on de top. . . . Den yo' know yo' got 'em a couple."[80]

Among the Yaa people Janzen found a Lemba marriage ritual that cleansed husband and wife together to purify them. This was done by priests who washed them with water. In South Carolina this purifying ritual was translated into the baptism ritual by Eliza Hasty, who said of her first marriage, "I love Solomon [Dixon] and went down under de water to be buried wid him in baptism, I sho' did, and I come up out of dat water to be united wid him in wedlock." Her statement thus joins the purification ritual with the marriage ritual on the western side of the Atlantic. But their marriage ceremony also had visible traits from Kongo ritual. Dixon, dressed most formally in tailcoat and striped trousers, "wore a long red lead pencil over his ear." Hasty emphasized the red pencil when she talked to interviewers. In the Kongo, people colored their bodies with red camwood powder or red

clay on ritual occasions. Na Kunka and his wife were painted with red and white clays while they were under water. Dixon's red pencil was comparable. Hasty also emphasized that she wore red and white—a red underskirt, a white petticoat, red stockings, and a red velvet hat with white satin streamers, an ostrich feather in front, and two big turkey feathers. She commented that her hat "was 'stonishment to everybody.'" These were the colors of purification, important to their marriage ritual. Janzen found among the Kamba that the stringent laws of purity in marriage applied only to those initiated into Lemba, to priests and priestesses. Solomon Dixon was also a pastor. On St. Helena, Ezekiel Cohen translated the same principle literally when he applied it to pastors of the church. Criticizing a local minister for not being married, he exclaimed, "All ministers *should* be married. They can't be a *clean* minister if they're not married. They'll run around. . . . Sure!"[81] By saying that sexual relations without marriage are impure and improper in a minister, he expressed a Lemba value.

Kamba wives of both the candidate and the chief priest initiating him were bound through intricate ceremonies that united all of them both physically and symbolically. The priests told the candidate that he would have intercourse with the wife of his chief priest and likewise the chief priest with the candidate's wife. "In doing this," the priests explained, "your eyes will be opened to ways of requesting goods from those who profane and transgress the laws of Lemba that give the priest his power." The priests then prepared minkisi. Ingredients were mixed together, wrapped in raffia cloth, and placed in a box holding the candidate's Lemba symbols. His wives tied statues together in a bundle and placed them in the box. All of these symbols protected the purity of the marriage; they symbolized Lemba's rules, and any changes in the character of the symbols revealed broken rules. Those who broke a rule were fined lest they cause Lemba's power to dissipate. The tied statues joining man and woman are analogous to the Mahungu figure and to Doyle's *He/She*. On Edisto, Hester Milligan saw such a bundle symbolic of family in her seeking vision. In the bundle, her family, a young man, and a girl were all wrapped together. Then she saw a white man who took her through a golden house and told her to throw the bundle as far as she could. She threw it way across a river. Then the man told her her soul was now set free.[82] Her initiation both incorporated the Lemba image—the bundle symbolizing the family—and used it toward the Lemba end—purification.

In the Sea Islands and in coastal South Carolina and Georgia prescriptions abound for maintaining faithfulness between spouses through cunjuring. These prescriptions for healing relationships derive from the ritual focus on the union between man and woman, a focus brought by Bakongo peoples. The totality of belonging to Lemba was symbolized in ritual medicines by combining elements of bodily fluids and excrement, hair, nails, and used clothing into minkisi. In philosophical terms, the profane elements of life, or what was considered dirty, would be absorbed by what was sacred

and so become purified. The union of husband and wife symbolized unity of the family, unity between neighborhoods, and unity within society and within Lemba. Janzen translates one scholar's description of the significance of all these initiation rites as "the key to the indissolubility of the Lemba order." They stress that the members comprise "one body whose trust they may not betray."[83] I stress the point too. Only by understanding the binding force of Lemba can we escape the Euro-American notion that cunjuring is nonsense.

Once the Lemba initiate had been consecrated, the society's rule dictated that he must ask for money from his father's people so that he might "learn healing and initiating and the initiation and the medicine before the appropriate high priest, whence all this comes."[84] Doctor Jones worked only for good purposes. When he needed ingredients from the spirit world, he visited only the graves of people he knew who also had done root work. The spirits of these root doctors were analogous to the priests of Lemba who had been initiated into the secrets of healing and had additional power which they brought from mpemba. Doctor Jones went to the grave, itself an nkisi of this power. He went at midnight, the nadir of night in the Kongo cosmogram. He knelt to the east, the point of the rising sun; and he said a prayer which was so secret his grandson would not repeat it to Hyatt.

Doctor Jones then counted out the money he would pay to the spirit and put his hand down into the grave "right to de haid on de left side, closest to his heart." He pulled the dirt out toward himself and then he took a small silver box "an' he'd drap it in dere, an' eve' time he drap it in dere why he'd say, 'De Father, de Son an' de Holy Ghost.'" He repeated this three times before putting the money in the grave and covering the hole he had made. Then, his grandson noted, "It don't make no diff'rent if he live in de west—when he'd leave he'd always go east."[85] He has now paid both through ritual and in money for the medicine from "the appropriate high priest, whence all this comes." Then he walked to the east toward the sun's rise, back to the world of the living. The ritual of preparation demonstrates the seriousness of the prescription for healing to follow it.

A woman's husband had left her. She wanted to bring him back to preserve her marriage. Doctor Jones asked for the last letter the husband had written to her. First Doctor Jones wrote on it; then he divided the two sheets of the letter into four quarters. This act created a metaphor for the quartered Kongo cosmogram just as he had done with the quartered sphere of root. She was to put two pieces in each of her shoes "in de sock in de hollow of de foot" and expect her husband to return in seven days. After he returned, she was to get the "last suit of underwear dat he pull off" and take that to Doctor Jones. When she did that, the grandson said, "He go tuh work an' take his scissors . . . an' he cut jes' a small little piece outa de seat

. . . jes' in his crotch. An' he dresses dat an' gives it back to her." She then took the hand home and fastened it over the front door to the house so that her husband would pass in and out under it. The result, said the grandson, would be that "jes' as long as he live wit her, he'll be a husband to her." His handwriting united his mind—his thoughts—with her life—her bodily fluid in the sweat in her shoes. They were joined; he would come home. The hand to keep him there combined a piece of his clothing—recently worn and thus containing his bodily fluid—with the doctor's purifying medicines. It was nailed over their door. With the nailing it became a nkondi nkisi: the issue was "tied." If the husband broke the agreement by straying, the spirit would know whom to bring back.[86] The hand, when attached to the house, also repeated the Kamba practice of hanging nkisi on the lodge during ritual wife exchange, a detail in rituals of unity between man and woman.

Another doctor from Beaufort also described hands activated by the body's fluids to preserve sexual faithfulness. The woman who wanted to keep her man faithful took to bed with her a dishrag she had used to dry dishes. It was therefore a container holding cleansing, or purifying, water. The doctor explained to Hyatt, "Well, when yo' have a little intercourse with her, she will use dat dishrag on yo', yo' know." Then she digs earthworms and fries them, "and she will wrap dat and she will grease it and she put dat dishrag all in dat grease, and she'll use dat de second time on him." Then after the third time she uses it, he said, "you'll become jest limber with another woman but you will be all right with her." He explains how a man can keep a woman faithful when he is going away for a few weeks. First he must cure a dove's tongue with salt. Then when he's ready to leave, he puts the dove's tongue under his own tongue, thus empowering it with saliva. And, he said, "When he go out to leave, he'll go kiss her three times . . . —dat turtledove there—and when he git right on out he kin put it in his pocket. An' she ain't got no feeling fer no other man— . . . it all in her head to see him." When a woman wanted a man to marry her, "she would take some of her chamber lye [urine] and kin set it in a pint bottle . . . wit de stopper jest slightly in it." When the man started away from her house, she would call his name suddenly, and when he said, "Huh?" she quickly "slam dat stopper right dere in dat bottle and she got yore spirit. . . . You'll come back."[87]

In one prescription Doctor Jones combined symbols of Christian belief and of Kongo cosmography with basic Lemba principles—balance, wealth, and the union of man and woman. The prescription was for a hand to gain success. The container was red flannel. He put in a pea-sized piece of lodestone, a piece of John the Conqueror root, and a piece of Sampson snakeroot. Then he enclosed words from Psalms written in yellow pencil and told his client to fold the package toward himself to make it as small as possible and wish for success with each fold. He instructed, "Wish wit confidence, faith in [me] an' de Almighty above." The client then must sew the package into a hidden pocket in his pants binding, and each time he drinks he must

"give hit a drink" from a "little bottle about lak dat wit some liquids in it tuh dress it." Into the liquid went the juice from the sphere of root that we saw him quarter. This plant produces a sweet-smelling magenta flower, and both the odor and the color contributed to the power of the root and, therefore, to the hand. He then added oil which he made from sheep fat because he said the sheep was "the commonest [calmest] beast we got." Doctor Jones said "De peoples would always figure dat de fellah dat transposed his business wit dat hand, was a calm fellah—had de protection powah." To increase the power of this hand, instead of wrapping and tying it he would put the ingredient into a bottle with Adam-and-Eve root and Hearts Cologne.[88] This increased the fee for the hand. The union of male and female therefore added strength to the power of balance, not to mention adding to the doctor's "acquisition of wealth."

Both in Lemba rituals and in the Sea Islands the home—the house itself—symbolized the centrality of marriage and family. Several steps in Lemba initiations occurred at the candidate's home. In the Sea Islands the custom of house blessing expressed this value before freedom, and it continues today. A South Carolina woman told of the ceremony from her grandmother's time before 1865. The house was simply log walls over a dirt floor with a door in the center front, the hearth in the center back, and no windows. She said:

> This house whenever it was completed they killed a calf. If they had sheep, they would kill a little lamb to let the blood go wherever it was killed, let the earth drink it up. This lamb was barbecued in front of the door. All of their friends and neighbors would come and have a feast there. They did that entering a new family to the house.

Then she told an additional custom that was current in the 1930s for protecting the family and bringing happiness to it in the house:

> In our neighborhood . . . in building a new house to live in, you always are supposed in one of the front pillows [pillars] of the house to fold the Holy Bible, wrap it carefully in oil cloth, that will protect it, put it in a stiff pasteboard, and lay it in the hollow of the front pillow of the house. This is supposed to be a protection sent from God on your home. And you are supposed to live happily there. This is one of the customs.

In 1919 Elsie Clews Parsons found a custom of having a "time [party] . . . christenin' de house" to be virtually universal. On St. Helena, Deacon Tom Brown said that people would gather for prayers, songs, and refreshments and that the custom is alive today.[89]

In the Mayombe region Janzen found that a marriage ceremony actually occurred within the Lemba rites. In the version that he cites, the ceremony occurs at the initiate's house, and Janzen found symbols of the house as a shrine used throughout the area. To the west, particularly in Loango, he

found that the shrine became a "fixed installation." On St. Helena, although we do not see couples initiated together or marriage performed as part of the initiation system, we know that marriages were performed by the elders in prayer houses during slavery time. Later, in the 1930s, Lawton observed a marriage performed during a church service with unusual ritual activity. At the end of the preaching session the preacher announced that there would be "another little service." At that point, a different man came forward to "direct the wedding." He took his place in front of the pulpit "and tapped twice a little bell." A portable organ had been brought to the church for the wedding, and after the bell was tapped, the organist began a march. There were six bridesmaids and six groomsmen. Each couple marched down the aisle to the front, and the bell was tapped again before the next couple came. When all were there, the bell was tapped again, and the bride and groom entered, also as a couple. All couples wore white, signifying purity. The preacher performed a ceremony, but the director of the wedding stepped forward to give the instruction for the ritual kiss.[90]

That curious use of the bell within the church ceremony points again to Kongo custom. Again, details are clues. Bell-tapping in the marriage ceremony is generally unheard of in Protestant weddings. This ritual use of the bell is African. We have seen its use along the trade route followed by the Vili in Loango. On St. Helena we have seen newly initiated boys at their inaugural shout leading the repeated singing of "De bell dun rung." In a version of the Mahungu myth which Janzen gathered in Cabinda, Mahungu received a bell that was to guide his journey, always telling him which direction to take. The bell avoided paths leading to temptations, and when it was obeyed, it guided Mahungu into healing and success.[91] The boys who sing that the bell has rung declare that they have followed its path through initiation into the healing and success of acceptance into the prayer house/church community. The couple who are guided down the aisle of the church by the ring of the bell are guided likewise into the healing security of marriage and family.

From the value in marriage and family relationship flows a value in children. It appears in Lemba as a major emphasis on what Janzen calls the "father-child dyad." Manifestations of the dyad show up in varying rituals or instructional stories in each of four geographic regions that he studies. Since people came to the Sea Islands from all these areas as well as others, there would be a mixture of traits. In all these areas the initiate was guided by a chief priest who became his Lemba Father. One example comes from the Kamba people. When a man was ready to begin Lemba and had caught an illness, he sent payment to a priest who sent back a medicine and became his Lemba Father while the man became the Lemba Child. This Father would instruct his Child and participate in rituals throughout the initiation. His

teachings were to lead the initiate on a search for truth through awareness of the powers of such oppositions as good/evil, male/female, learning/ignorance, success/failure.[92]

In the Sea Islands this parental guide became the spiritual father or spiritual mother. Spiritual mothers were as numerous and important as spiritual fathers. Nanny Newton, Sam Doyle's spiritual mother, is but one example. The essence of the nature of both spiritual parents in the Sea Islands coincided with the essence of the nature of Lemba parents and their teachings. Janzen notes that the virtues learned by both male and female initiates must be "patience, perseverance, persistence, and clarity." Initiates became priests and priestesses, and these virtues became part of their qualities as spiritual parents. In addition, Janzen says, the Lemba priest "was a judge who could perceive the inner nature of things and events."[93] This, too, was the function of spiritual parents in the Sea Islands. Through their perception of the "inner nature" of their charges, the spiritual parents interpreted each candidate's dreams and behavior while seeking.

The father-child dyad was a natural medium through which Sea Island African Americans could work out their interpretations of the Christian beliefs to which they were exposed by their masters. Christian masters here were Protestant. Protestant Christianity did not offer the pantheon of saints in which to subsume African divinities such as Catholic Christianity offered in the Caribbean and South America. However, the Protestant focus on God/ Christ, whom Protestants themselves called Father/Son, was perfectly reasonable to African Americans of Kongo heritage. Janzen makes this point about other areas of the New World. Further, unlike the relationships between saints and gods of other African peoples, he says, Zambi, the high god of the Kongo peoples, "is not made the object of a particular cult, nor does it become a possessing deity." While the Protestant God is analogous to Zambi and is not a cult object, Jesus, the Child of God, became the consummate Lemba priest. He lives close to the people—as William Gannet learned from Aunt Phillis when she told him "me and Jesus" lived in her lonely house. Jesus was the healer. His touch made the blind see and the lame walk. Evidence of this close analogy appeared in a ritual performed by Sea Islanders in a darkened building. One would call, "Where is Jesus?" and another would answer, "Here is Jesus." Then all would dash toward the voice of the answerer and say he wasn't there. Then another would call out, "Here is Jesus," and the dash would be repeated. The process would go on for hours, and the people "would become excited and frantic, would tear their hair, and scream and pray until the meeting was broken up in a religious frenzy."[94] Jesus was the source of healing, and he had to be sought through ritual.

These details indicate that the values constituting the core beliefs and concerns of Lemba survived in the Sea Islands. When we compare minute

details of Lemba initiation rituals with those in the Sea Islands, the picture will come still more clearly into focus. Whereas those values appeared in all the geographic areas of Janzen's study, the next details that we look at will come together in the Sea Islands from scattered backgrounds. As Vili people, for example, brought one observance, Nsundi people brought another. Together in new Sea Island communities, people blended details into a system which, although different, parallels the old.

The first detail we will look at is the use of space. Locations for seeking and for Lemba initiation were analogous. When Janzen examined the use of space in Lemba initiation, he found in all areas a movement from the initiate's village out to a savannah, stream, or forest and then back to the village. On St. Helena the initiate left home and village to go to the "wilderness"—cornfield, tree, forest, the "bush." These different locations represent various backgrounds of Kongo peoples. Those in the northern area went to the savannah, those in the eastern area went to savannah or stream, those in the south-central area went to a clearing in the bush, and those in the western area went to the forest. The St. Helena initiate returned "to the village" from the wilderness ritually when the spiritual parent went to talk to the birth parent at her home to prepare for the next phase of initiation.

Subsequent teaching occurred at the prayer house, situated at a crossroad, "the focal point of many well-beaten paths." The Nsundi candidate's first ceremony symbolized the "attachment" to the spiritual leader and occurred at a crossroad; after that his instruction occurred at a lodge located not at a crossroad but "in a clearing in the bush."[95] Thus, rituals for both St. Helena and Nsundi initiates occurred in "bush," lodge, and crossroad, although the spaces were not used in the same order. Janzen notes that the concept of moving from one place to another for parts of a ceremony is Central African. It transferred to Haiti, he says, where a similar "rhythm of spatial movement" endured, although there, as in the United States, the practice was forced into a "hidden forest setting" as a result of persecution. Variations in ritual traits from region to region in the Kongo and from Africa to Haiti ensured the vitality of the core concept.[96] This is undoubtedly true also of the transference of this and other core concepts to the United States.

Within initiations the use of song was another core concept transferred into Sea Island practice. Song lyrics provide clues to traits that survived and that were newly adapted in ritual behavior. In Kongo initiations, Janzen explains, songs gave meaning to the ingredients of minkisi while they were gathered and used during initiation rites. Songs, like dance and drumming, took "ritual action to another plane," describing the relationship between people and the spirit world. They served the same purpose in the Sea Islands, and we will see the use of song woven through rituals as we look further into them. We've already seen that those who were seeking saw

visions of people singing. And we've seen that initiates sang while coming out of the wilderness, going through baptism, and participating in the shout. In Beaufort Dr. Hawks had heard each person attending the shout sung onto the "tree of life"—"Brudder Tony's sitting on the tree of life"—while the refrain called on the water to maintain the kalunga divide—"roll, Jordan, roll." As Sea Islanders sang "De bell dun rung" for hours, Kamba people also repeated two or three phrases in songs that could last all night.[97]

In the first step of Nsundi initiation, called "tying of knees," songs communicated symbols of mediation between the initiate and God. "Tying of knees" celebrated the union of the candidate with his spiritual father. Symbols of mediation included masks, bracelets, and white and red colorings. On St. Helena the head tie symbolized the mediation that helped initiates learn "to 'see' the power of God." Reverend David Grant made this link between head tie as mediation for reaching God when he said "Stay out there two and three weeks with your head tie up and get religion." Lawton's informant also made the link when he explained that the head tie "takes up de sin which come out de head." In the western area of his study Janzen found that raffia was a plant symbolizing power. Turned into weavings, threads, or "strings" for head ties, it formed a route toward finding the power of God.[98]

Reverend Grant said with a chuckle that seekers put on the head tie because they "got to keep their brains together." This comment is not frivolous. In the western area of Janzen's study the head was revered as the "fount of wisdom" and protected by caps decorated with motifs of the Kongo cosmogram. Today on St. Helena deacons wear white caps made of a shiny material. In Fu-Kiau's exposition of Lemba raffia symbolized "the priest's ability to journey far without being interrupted."[99] And on St. Helena, when seekers donned the head tie, it took them, as Richard Loundes said, "away out the *racket.*" With the head tie they, too, would "journey far" spiritually "without being interrupted."

Dreams were another path of mediation. When the seekers began praying in the wilderness, they "talked to the man, . . . pleading," said Harold and Richard Loundes, until the dreams came. As Harold Loundes said, this custom came "from the old land-mark." Texts from Janzen's sources referred to dreams as having major roles in Lemba initiations. The bell that led Mahungu to make correct choices appeared in a dream. The Kamba spiritual father sang a ritual song which included the lines

What the sun gives, The sun takes away.
You may have dreamed of ancestors.[100]

From the Mayombe, Janzen gives this text:

Lemba itself is presented in a dream from the ancestors.
It is called an nkisi of the ancestors; it mediates the land of the dead and the village.

Thus it is activated by dreaming, by nightmares of suffocating by a curse, or through spirit possession.

This text includes the stipulation that the initiate must tell his spiritual leader everything seen in dreams or possession: "If a spirit has appeared or spoken, he will reveal it and make all known."[101] These rules from the Mayombe Lemba coincide with St. Helena, where they are revealed by informants, folklore, and art.

We've heard how Maria Perry and Minnie Jenkins chose their teachers from dreaming: "Marayah I powered to forgive you in the sinning of your soul"; and "This man appeared . . . trying to show me different things." We've heard how Ellic Smalls's dream of "a host of people" who sang to him at his oak tree sent him into deep prayer. Dreams that sent an initiate into preaching—like that of the man who dreamt of swinging through the air on a silver chain—show a close semantic link with Lemba, since each initiate to Lemba became a "priest." Dreams were the first requirement of seekers, and all of them must be told to the leader, who would decide, as Ezekiel Green said, "whether it was a finishing dream or it was not."[102] Without the dreams spiritual parents halted initiation.

Similarly, one of Hyatt's informants in coastal Florida clarified the link between dreams of suffocation and the spirit world: "Dey say if a person dies, . . . say his spirit will come back. Well, it comes den through a dream . . . dey jumps right up on yo' an' dey ketch yo' an' . . . yo' try to call but yo' can't call—yo' jes' [demonstrates] (gasp—gasp)." African American folklore has many versions of a tale of a hag who tries to suffocate a victim. An old root doctor in Savannah, Georgia, defined two kinds of hags for Hyatt. One was the spirit of a dead person; the other the spirit of a living person. Both caused suffocation during sleep.[103] And both have a relationship with Lemba: the first is a spirit from mpemba; the second activates mediation toward Lemba's core purpose, restoring balance.

On St. Helena, Sam Doyle painted *Old Hag,* showing a hag trying to suffocate his father (Plate 8). This one, he said, was the spirit of a living woman from about two miles away. His father caught her spirit in a bottle. Then, Doyle said, she had to walk from her house and "come and ask for a little sugar—or seasoning of salt—to get her spirit back." He said she seemed very old because his father had trapped her out of her skin, and the walk was like ten miles to her instead of two. Without her skin she appeared as what the Bakongo define as the inner body, which has blood in it, while the skin left behind is water. Doyle painted the hag in her inner body form—blood red. His father told his mother to give her the seasoning, which gave her back her youth, healing her pain and restoring her spirit. For the Bakongo salt was a "life-promising item."[104] Both the bottle in which the hag's spirit was trapped and the seasoning she received were minkisi, used to restore balance in the relationships among people in this community. Although they

operate outside initiation ritual on St. Helena, the hag-suffocation dream activated behavior to restore peace—the Lemba ideal.

Other specific details occurred during the instruction stage of initiation, the stage referred to in Gullah as learning the discipline—the "sipnin of the church." Janzen found that the Kamba initiate would be profaned in some way. The text tells that someone would drop an object on him from a palm tree; Janzen adds that he might be verbally assaulted. This ritual teaches perseverance. It was seen in the St. Helena initiation in the deacons' examination of the 10-year-old girl accused of smoking when all knew she had not been; and it was seen in their insisting on the candidates' awareness that up until then they had "not been doing right." The deacons' voices "heavy as thunder" were not their everyday voices. They spoke in ancestral voices from the spirit world. Spirits "got a heavy grossy voice," Annie Milton explained. "Don't talk like we talk." The verbal assault even occurred just before immersion in the Sea Island baptism. The deacon asked whether anything should prevent the candidate's baptism, then continued: "It bin reported to me dat dis same candidate was in a fishin' boat yodder day and w'en he mash he finger wid de o', he blaspheme." The deed was ascertained to be rumor or gossip, and the comment made that "whoever staart dat lie . . . sho' bes' fo' mind out w'at he bin doin'." Then the baptism continued. Reverend David Grant reported an incident near Hilton Head Island when a man hid in a tree above and threw something like a white ball down to scare a girl who was out seeking. Not only is the action in the incident parallel to the Kamba incident, but Grant specified that the object was white, thus emphasizing its ritual nature.[105] In the coastal islands initiates also had to learn to persevere.

Oath-taking rituals occurred in Lemba, Janzen says, to teach "how to relate ceremonially to the abstract reality of power and the beyond." Father and Child held staffs, and the Child swore:

> My father . . .
> Before this circle . . .
> We stand . . .
> If I hear . . .
> Rumors, gossip . . .
>   or evil reports . . .
> May death come.[106]

Both held their staffs in gestures confirming this agreement. MacGaffey showed that the Bakongo chief's staff was a symbol of his power. If he went to a village "to confer a title," the staff was "planted" in the center of the village until the end of the ceremony. MacGaffey explained that the chief could pray to the nkisi of the locality while "driving into the ground the point of his staff." This act was comparable to the action of "nailing" agreements which formed the essence of nkondi images. The Vili protected their community, for example, with a large two-headed dog studded with nails to

activate ingredients. The word nkondi means "hunter," and hunting in Kongo is a metaphor for healing: as the hunter brought food, the healer brought medicine. The nkisi nkondi hunted for the one who broke the contract and caused the pain of the nail wound. But, MacGaffey says, it is not necessary to drive the nail or wedge: "Nkondi can also be provoked by insults." The Nsundi rite with staffs was also comparable to the action invoking nkondi. The agreement was made with the staff-holding gesture and was given life by threats in the oaths—Lemba would punish the Father; the Child invited death—and by the Father and the Child each passing a knife blade under the Child's throat.[107]

On Edisto Island, Mary Ames heard a metaphoric reference to the nkisi nkondi at the prayer meeting when the elder asked God to "send down his angels with a hammer and knife and knock at every sinner's heart." It was a Lemba prayer using nkondi imagery to ask for the cure to those "weeping and tearing their hair" who could not find religion. On Port Royal Island, Higginson heard a song with a baffling, unrecognizable syllable which he called "Hoigh!" and described as "a sort of Irish yell." It occurred at the end of each verse of a song of entrance to the wilderness: "All true children gwine in de wilderness. . . . True believers gwine in de wilderness, To take away de sins ob de world." In Haitian ritual the sound was akin to the use of "ko!" which Janzen defines as an abbreviation of the Kongo word "koma," the word for driving in the nail. The sound described "the abstract idea of awakening in a person the mystical force of the spirits"[108]—exactly what was happening to the "true believer" in the wilderness. It confirmed the agreement between the seeker and the objective of purification. The Islander who was struck on the head by the spirit in Philadelphia was experiencing a nkondi blow, all the more forceful because it also struck his mother. He agreed to spend the rest of his life preaching.

Like the Lemba Father, on St. Helena the first deacon to go into the river at baptism carried a staff. White people recording this action assumed the deacon was measuring the water's depth, but African Americans in those islands knew every detail of the land and the water around it. They knew the depth at any moment of tidal activity. Driving the staff into the river bottom at baptism sealed the contract between the baptismal candidate and mpemba, or God. This staff, like the canes carried by Traylor's *Black Dandy* and by Baron Samedi, bridged the waters. In both Kongo and American cultures it signified power being manipulated for human good.

After the Kamba rite of profanation the priests assembled to construct a "lodge" of palm branch arches for the next rite. The Lari of the eastern region also built palm branch lodges for their final rite. Thomas Wentworth Higginson saw such a construction while he was in command of African American troops from the islands at an encampment at Beaufort in 1862. Higginson reported hearing in the night "mingled sounds of stir and glee. . . . A drum throbs far away. . . . And from a neighboring cook-fire comes

the monotonous sound of that strange festival . . . which they know only as a 'shout.'" He found it happening around a fire "enclosed in a little booth, made neatly of palm-leaves and covered in at top." This palm leaf lodge was "crammed with men" singing an "endless" song "at the top of their voices . . . with obscure syllables recurring constantly" while they drummed their feet and clapped their hands. As the intensity increased, men danced outside the lodge as well, forming a circle around one man in the center. This ceremony was repeated nightly. The palm leaf permeated Lemba ritual. Because palm was a source of trade products that brought wealth to Kongo peoples, it symbolized good fortune in rituals. Palm also grew on the Sea Islands, and so its ritual uses were not forgotten. Where Higginson saw it in nightly use, it probably symbolized the good fortune of liberation: when he asked an injured soldier if he'd gotten more than he bargained for, the man "promptly and stoutly" answered "I been a-tinking, Mas'r, *dat's jess what I went for.*"[109] The wealth of freedom was at hand. This combination of the shout phase of the prayer house service with the palm of Lemba ritual is graphic illustration of the connection between Kongo origins and Sea Islands community.

Having learned both the church's "sipnin" and how to persevere, St. Helena Islanders were told they now were different from before and must be "manoresable, kind, and helpful." Like their Bakongo counterparts they had been "especially consecrated" and were ready for the next stage. Bakongo priests then took their candidate to meet the ancestors in a "direct encounter with the forces of mpemba." In some regions this occurred at a stream; in some it occurred at a cemetery. Initiates had to face the ancestors, through whom they were linked to God. To bring them to this knowledge, the priests took them through sensory episodes of extreme terror, moving through phases of blackness into redness and on to whiteness, the "terrifying mpemba brilliance." In the whiteness phase the priests wore mask costumes and confronted the initiates with a "figure on a pole," making it superhumanly tall. It was masked in white, black, and red. While the figure loomed, the priests sang and drummed, making the initiates hear the ancestors' voices. The tall figure began to move; loud explosions burst nearby; intense fear made the initiates want to run away.[110] Can we, so far removed from this experience, even begin to sense what it was like?

From a recent Dagara initiation in Burkina Faso, comparable even though far away in space and time, Malidoma Somé described the feelings. His initiation was a ceremony of fire in a circle. "I lost the analytical part of my mind," he said. "Soon I experienced myself . . . as if I were invisible, yet all the more concrete, cogent, powerful, and inalienable. . . . Never before had I experienced something so real, so true, and so befitting a human being." He was drawn into the circle of fire, invited into it by "the Angels who

floated in it." The fire was unnatural but seemed "a vast natural place with trees that burned but were not consumed. The fire they burned with was as bright and pure as the purest gold in the world." He entered the fire and found "the grass was also in flames, golden and non-burning," and then he reached a river—"flowing golden liquid." There he said:

> The river made me experience an indescribable relief a thousand times more powerful than any earthly sensation. When I jumped into it in a moment of excess and foolishness, the effect produced by my contact with the water was so powerful that I blacked out.

Later he experienced hearing sensations produced by loud drumming accompanying an elder's voice increasing in pitch: "My hearing became confused and began to register strange noises. . . . I could not tell what I was hearing, but it sounded as if it were coming from underwater. It was the same thunderous rumbling sound I had heard earlier. . . . I tried to hold my breath in order to listen for more meaningful sounds and discovered that there was no breath to be held." All the while "the unearthly underwater sounds continued floating around me, sourceless. Soon they were followed by other noises coming from below. . . . The space beneath me was terrifying. . . . From the beginning . . . I had been experiencing a sense of hysteria that made me constantly want to scream." During the ordeal one of the Dagara elders explained the meaning of the fire: "We must merge with this fire, be one with it, to let our dreams come alive. For in the belly of the fire rests our ancestral lives, in it is who we have always been, who we truly are, and who we must be now."[111]

On St. Helena, when initiates went to baptism, they too went, as portrayed in Doyle's *Baptism,* to meet the ancestors in their own "direct encounter with the forces of mpemba." The approach to the ancestors had progressed as had the Bakongo, through phases of blackness, redness, and whiteness to the climax of cleansing in water. The St. Helena initiate's first dreams were filled with black objects—feathers, hogs, devil—symbolizing the bad that must be "worked out of the way." Head ties became soiled by sin. Redness was present in the centrality and symbolism of fire, as Charlotte Forten had noticed in the contrast between the "blackened walls" of the prayer meeting room and the "red glare of the burning pine-knot." It was enunciated in the lines of a shout song:

> Fiah in nuh Eas' and fiah in nuh Wes'
> Fiah goinah burn out tuh wilduhness

Another shout song articulated redness with a more dangerous symbol: "And de moon will turn to blood in dat day." Red was symbolic in head scarves worn by women during slavery. Reverend David Grant explained that his grandaunt told him that in the time when she was sold "most all of 'em head tied with red handkerchief." Later the custom was retained for going

to church.[112] In seeking, whiteness began with the bright shining objects in visions—silver and gold, lighted glass—and culminated in the white object appearing in the final "finishing" dream. Whiteness was terrifying in the figure of the Jack O Lanton, all white with red and black markings carrying a pole, the figure that came at you like a masked figure on a pole in the watery night.

In baptism, the apical experience in the Sea Islands, whiteness was awesome in the gowns and head-wraps worn by all the people surrounding the initiate at the time of immersion—"whole body cover, head cover, only eyes out," said Pinky Murray. All of these white clothes symbolized the world of the dead, for to the Bakongo the clothes were like the skin of the newly dead in mpemba, chalky white; and like skin they could be shed. Janzen shows that the blackness stage was equivalent to life above the kalunga line; redness signified the phase of communicating with the spirit world (hence one wore red on the head, the organ of communication, when going to church); and whiteness went below the kalunga line. Doctor Jones made a hand that miniaturized the transition of phases from black to white with a little figure of a man in a bottle of liquid. The hand turned from "black as sut" to "as bright as de mawnin' star." It brought protection and healing from the ancestral world just as in baptism pastor, deacons, and candidates ritually "participated in the world of the dead."[113]

Going under the water is the ritual death of the initiate's sin. St. Helena informants insisted that immersion be done in an ebbing tide, which would wash sins away and carry them out to sea. Informants in the Georgia Sea Islands added that the pastor always said a prayer to the river before immersing the initiate. The Kamba spiritual father sang that the initiate had made payment in

Pigs to assure
That the thing [causing illness] may fall into the water.

Sin equals affliction. Sins are to be washed—cleansed—away. It was an ancient rite, observed by the explorer, Olfert Dapper, in the seventeenth century when he saw priests anointed with consecrated water while songs were sung at the Vili court in Loango.[114] Emerging from the water is the initiate's rebirth into purity. It is to be well or whole, reborn in spirit.

Among the Bakongo ritual death at a stream was equivalent to ritual death in other areas. On their journey out of their "wilderness" Kamba priests stopped at a cemetery "to fetch a wise nkuyu spirit from amongst [the initiate's] ancestors by taking a clod of earth from the grave."[115] This too was an encounter with mpemba. St. Helena seekers who went to the graveyard for their "wilderness" made an analogous journey and encounter. Like immersion in water it was an occasion of "awe and fright," as could be seen in their pride in surviving it: "My head bin wet wid de midnight dew and de Mornin' Star my witness." The use of graveyard dirt in

composing hands is a direct descendant of this rite: the wisdom of the ancestral spirit world goes into the container.

In eastern-region ritual the initiate was struck during ritual consummation of marriage between the Lemba initiate and his favorite wife. At the propitious moment his genitalia were struck, causing him to faint. The priests described this as death, and this ritual death was followed by rebirth: "Then, they blow [in his ear] with wind, and when they have resurrected him they raise a shout of joy and fire a gun salute." In areas of the Mayombe, Janzen explains, Kongo words denoting blowing, which creates a breeze or wind, also have references to ritual rebirth.[116] Where blowing causes the initiate to come to life again, his spirit returns through breath or wind.

Bringing knowledge of this belief system, Kongo peoples in the Sea Islands received Christianity with an emphasis on New Testament scriptures and the teachings of Christ. They received Nicodemus as a priest at the crossroad in the cosmogram, for Nicodemus learned from Christ that to reach God people must be reborn through water and spirit, that people must come to the light in purity, and that what is done in the light is done through God. Christ was the quintessential Father from Lemba, and Nicodemus the quintessential Child.

The circle of the Kongo cosmogram informed minute ritual detail. Physical movements and song enacted the circling shape and the circling of life in the Kongo cosmogram. After taking their loyalty oath, Nsundi initiates and priests went again to their lodge, first circling it three times while singing a song which described their cosmogram, "comparing the endless circle of life to this circle." After taking communion, St. Helena Islanders went to their prayer house, where they sang, "Walk 'em easy round de heaven, dat all de people may join de band," repeating the walk-around-the-heaven line three times.[117] Their song describes circling the cosmogram, and repeating it three times signifies circling the lodge three times.

Nsundi then went into the lodge and cleared space for circling. St. Helena members cleared space in the prayer house "to move round and round." Janzen explains the significance of this space for circling, translating the Kongo words for it. One word implied bathing or anointing, referring to the encounter with mpemba. "Baptism" is almost an exact translation. Another implied "the center of a circling motion, or the hill around which one circles." Many accounts of the shout circle in the Islands have referred to a thing or a person at the center. The "hill" would refer to the hill or mountain of mirror images above and below the kalunga line in the Kongo cosmogram and likewise to the object or person in the center of the circle. Sea Islanders sang, "Dere's a hill on my leff, and he catch on my right." One of them explained to Thomas Wentworth Higginson [who did not understand the explanation] that it meant you'd go to destruction (meaning death,

which parallels mpenda or the hill beneath the kalunga line) if you went left, and you'd "go to God, for sure," if you went right. The verse was included with other verses describing the Kongo cosmogram: "I look to de East, and I look to de West," and "I wheel to de right, and I wheel to de left."[118]

In the center of the Nsundi's circling space a cross-shaped trench was prepared with a mud made from palm wine poured into dirt. Following the Child's oath abjuring gossip, he knelt and put his face into the sacramental mud, rubbing his mouth in it. Here is the source of the "very ancient" Sea Islands singing of "You must bow low to de mire . . . Lowrah lowrah to de mire . . ." while "one ub us kneel down in duh middle uh duh succle" as his head was pushed to the floor. On St. Helena, Isabella Glen linked the mire with Lemba's affliction when she explained symbolism of dreams and said that muddy water meant sickness. The Nsundi rite reinforced a teaching from early in the initiation which included a song with the line "Bow down; God passes." Lari people also sang "Bow down, for God is passing."[119] God was so great that he could not be looked at; so to understand God, the initiate "must bow down and cover himself 'with fear' lest he die." The lesson reached its apogee with the initiate lowering his face into the sacramental mud, an apt metaphor for fear.

Sickness, fear, sacramental mud—all were facets of a shout song heard by William Allen in 1864: "I hab a grandmother in de graveyard. Where d'you tink I fin' 'em? I fin' 'em in de boggy mire."[120] The mud's climactic importance ensured its endurance in the New World in the shout circle; and the Brunswick Confessor taught us the degree and nature of its importance. The dirt dauber went to the mudhole and brought the mud in its mouth to make the miraculous nest from which a living creature would emerge. A metaphor for rebirth as well as a metaphor for a Kongo initiation ritual, it partook of the peaceful essence of Lemba: "It don't harm nobody. . . . He ain't fightin' against nobody." Like the priests composing nkisi, the dirt dauber sang while it composed its nest. In making its nest from mud, in its wisdom it became like a Kongo priest, "Second Person tuh God," for "all dust is de Word of God. . . . Cuz God spoke de dust from undah de waters."

Song sung in the circling of the Sea Islands shout also reveals Lemba's value in marriage. At a point in Lari initiation the ritual specifies: "When the leaves have been brought out into the festive place then Lemba has been assembled (has arrived)." Then the wives participated in a celebration with drumming and clanging of the bracelets that symbolized marital union. In the Sea Islands people sang a litany of union: "Oh Eve, where is Adam?" was the question, and "Pickin' up leaves" the answer. The shouters bent to pick up the leaves from the ground. Here they were reenacting the rite of "leaves having been brought out into the festive place." Like the assembling of Lemba, members have assembled in the prayer house. Parrish found a version that used "pinnin' leaves" (not pinning *on*) rather than "pickin' up

leaves." She assumed that "pinning" was changed into "picking."[121] More likely, "picking" came from the Lemba origin and "pinning" joined the Adam-and-Eve metaphor when Christianity was applied.

Parrish's description of the shout step for this song reinforces this conclusion. Movement accelerated during the song so that it became more difficult to be sure that the feet did not rise off the floor or cross each other, a supreme test. In circling the room, shouters followed the Kongo cosmogram—"Watch out how you walk on de cross!" (Christians do not walk *on* the cross.)—and if the foot "slipped yer soul got los'." This Gullah phrase means that you died: if your foot slipped, you fell into mpemba! How the song was sung also shows Kongo origin. Parrish says, "'Adam' is turned into 'Ad-u-m,' with unusual tones and inflections all through the leading lines, which show surprising invention." Humming tones were also heard by William Allen on St. Helena in a version of "Bell da ring" when he heard "humbell-a-humbell" repeated in the song very fast. In the Lari song of God's passing are the lines "God has said: murmur hum, hum . . . Whoever would be strong." And later in the Lari initiation is another song described by Janzen as "lauding Lemba with its unique humming tone" and saying "God has said, hum, hum."[122]

When Chalmers Murray witnessed the circling shout performance of "Limping Jesus, Simeon," he translated the Gullah to mean, "Limping I'm coming to you, Jesus. See me here." In this song, he said, the people cried to Jesus to "see them coming to Him, blind, wretched, low in spirit, unworthy, limping with their load of sin, crawling even."[123] His interpretation is accurate as far as it goes. But the Gullah goes further, using phrases as the Kongo peoples did with multitudinous dimensions. "Simeon" both puns on the name and translates from Gullah to mean "See me on" in two senses: "See that I am coming" and "Watch over me as I come." "As they came," the shouters became transformed. They moved faster; they jumped; they "hit the floor hard"—another striking blow, a nkondi to awaken "the mystical force of the spirits." They neared Jesus "right here in this room." He was leading them to the cure: he was "seeing them on." They reached the ability to leap. No longer limping, they could "crack their feet in the air." Their affliction was cured. Jesus knew that their hearts grew "softer": they attained peacefulness, the Lemba ideal.

Again, Kongo application of a metaphor has supplied a mode for bringing the Lemba system of values into the New World, and it comes with a Christian cloak. Following Mary's purification after giving birth to Jesus, she and Joseph met Simeon the elder, who told them that their child Jesus would bring light and glory to all peoples; and Simeon gave thanks to God saying, "This day, Master, thou givest thy servant his discharge in *peace.*" Old Peter on Pine Grove plantation had prayed in 1862 for Harriet Ware and William Gannett to be "boun' up in de belly-band of faith." A bellyband was used to heal the navels of newborn babies. Old Peter's prayer was

a Lemba prayer for healing. Juno Washington on Scott plantation prayed in 1926, "Darlin' Jesus, please to bind us all together with a bandage of love."[124] Her prayer was a Lemba prayer for peace in the community. Today Christians sing the lines of the spiritual: "There is a balm in Gilead to heal the sinsick soul . . . to make the spirit whole." Lemba came from the Kongo, and Lemba continues.

Pastor Nicodemus Washington had "walked upright before the church." He had been born from water and spirit, and he had dedicated his life to helping others to be so reborn. On April 17, 1933, he reached the apogee of his life: he crossed the Jordan River into the kingdom of God—he crossed the kalunga line into mpemba.

The people came from all parts of St. Helena to sing their beloved pastor on his journey. They began softly, in a minor key. Each song was raised by a different person and joined by the others. When the song was "You better pray, de world da gwine, No man can hinder me! De Lord have mercy on my soul, No man can hinder me!" the singers substituted, "Reverence Washington, ef you don't go, don't hinder me." Other verses allowed comparison in song of Reverend Washington's good deeds with those of Jesus:

Jesus make de dumb to speak.
Jesus make de cripple walk.
Jesus do most anyting.
Satan ride an iron-gray horse.
King Jesus ride a milk-white horse.

The songs went on, and the substitutions went on: "Reverence Washington's bones goner rise again!" and "Reverence Washington dun cross ober Jordan."[125]

The songs praised Reverend Washington in the Kongo manner. "Reverence Washington dun cross ober Jordan" sang of him as a bridge into the spirit world. Fu-Kiau explained the meaning of funeral songs for an elder of the Bembe, a Bakongo people who live inland from the Vili people and the Mayombe forest. The elder was extolled as a "bridge" because he had "shaped their lives like an instrument of art, leaving grace and elegance behind him." Reverend Washington had baptized his people, shaping their healing processes, also "leaving grace and elegance behind him." MacGaffey explains that chiefs who became mediators between those alive and those in the spirit world would be "legitimated by tracing them through the line of initiates to the founder or discoverer of the power in question."[126] St. Helena people legitimated their pastor in two ways. By ascribing to Reverend Washington the deeds that Jesus had performed—he made the dumb speak, the crippled walk, and "do most anyting"—they linked him with Christ, the founder of the healing power as it existed in their community. And in the

metaphor of the milk-white horse, they sang of their pastor's passage into mpemba.

In the small room the volume rose; intensity grew. About fifty people began clapping their hands and stomping their feet. They took turns leading the songs, calling out "Catch it up! Don't let it stop!" and shouting approval of the most stimulating: "Good work, good work! . . . Sister you sho dun well dat time. I goner gib you a stick of candy fur dat!" Exhortation continued into the night: "Sing! Sing, chullun! Don't get sleepy!"—"Ef you on de back seats ain't gonna sing, den get out and let some udders in here what will sing." In the old days, Evelena Glover said, the people who came to sit up with the dead would "sing and clap and so forth" all night. Fu-Kiau gave the rationale for the stick of candy and the singing, clapping, foot-stomping, and increasing volume. Like the Bembe elder, Washington was now "a medium of ecstasy and joy," and so he must be sent with rejoicing into the world of the spirits. Islanders didn't have funerals in the church "because it was not in the action then." In Glover's experience the "body was displayed out in the yard," and the funeral took place there. Carrie Reynolds said the person was put into the coffin in the house, "and different ones came in and stayed with the dead person."[127]

Sam Doyle, Fred Chaplin, Evelena Glover, and Clarence Johnson all described the casket as a box made of boards and covered with black cloth. Chaplin gave further detail: "Take a whole lot of black and wrap the casket in it and get silver-looking handle and put it on it." Unlike a pall draping a casket this cloth was wrapped around it several times and was buried on the casket. This practice came to St. Helena with Kongo peoples. Where cloth was a coveted trade item among Kongo people and stores of it were built up by the wealthy, the dead were wrapped in as large a bundle of cloth as the family could afford. But still more closely parallel, as far back as the mid-seventeenth century a Capucin missionary found to the south in Mbanza Kongo that the coffin was covered with black cloth. Thompson notes that the custom of burying the dead in a cloth "envelope" is a very old custom indigenous to Kongo peoples.[128] It was so ingrained that it was resumed after slavery ended when people were able to procure the cloth once again.

In Sam Doyle's "Gallery" in his front yard sat *Uncle Remus* (Plate 9). He sat up in a chair. He had a large head made of wood and blackened with tar. His arms hung loosely at his sides, and his legs stretched out in front. He was dressed in "Sunday-best"—black suit, dress shirt, tie. When Doyle was working on him, you could see that an empty whiskey bottle rested between his left arm and his side. But when Doyle was not working on him, he was wrapped in a blanket carefully arranged so that a triangle of a red pocket handkerchief and the white shirtfront showed. Some time after an elder's burial Bembe people constructed doll-like figures called muzidi to hold exhumed relics. A muzidi honored the elder, as was shown by its sitting position. Its legs stretched out in front of the body. Its arms might hang down at

the sides, completing the attitude of repose, of resting peacefully.[129] So sat Uncle Remus.

Doyle said he was "loving, friendly. Sit right there; he don't hurt nobody." Uncle Remus sat with Sam Doyle for nearly twenty years, until Doyle himself passed the kalunga line. Muzidi were covered in red or dark blue cloth. Dark blue was traditional clothing for Bembe men. Uncle Remus wore the traditional clothing for St. Helena men. Muzidi figures were kept by their owners in special houses but brought out if a sticky problem came up. They might literally be asked a question and watched for movement in the direction of an answer. Thompson explains that as an elder was dying, he might assume the role he would have in the spirit world, "of conscious moral surveillance and intimidation," and that the muzidi, in passing judgment, carry further the concept that the spirit will "shape behavior by an unseen hand."[130] Uncle Remus, in his loving and friendly way, probably also sat with Doyle to give moral surveillance and guidance if not intimidation, for his literal "unseen hand" held close that empty whiskey bottle. And Doyle was known to be a bit fond of whiskey.

Other Kongo peoples made reliquary figures in other forms. In Cabinda on the coast and among the Teke inland, forms were wrapped in red blankets. Uncle Remus's blanket was not red, but he was always wrapped in it. The head of a reliquary figure was distinctive and important. Even the simple bundle shape had a head attached. The importance of Uncle Remus's head is shown by its large size and dominant face. The figures of niombo, huge figures made by the Bwende people who lived in the south-central region of Janzen's study, exhibited symbols of their beliefs. On the heads of these figures, as well as on some muzidi, the mouths were open, teeth prominently displayed, and lips formed in relief. Thompson explains that this rendering shows that the elder is speaking in the other world.[131] So spoke Uncle Remus: his mouth was identical.

Niombo figures bore symbolic designs such as the arrows that we studied in conjunction with the footprints in Doyle's *Baptism* painting. Uncle Remus, constructed as a more realistic portrait-like figure, did not exhibit such designs, but his clothing may provide one or two clues. While his covering was not red, his pocket handkerchief was. It was also carefully folded into a triangular shape which pointed down. Red, we know, is the color of communication; the spirit world, we know, lies downward, beneath the kalunga line; thus the handkerchief reinforces the message of the mouth, indicating that Uncle Remus communicated in the world of the dead.

Most important, Uncle Remus wore dark glasses. Doyle didn't remove them even when he unwrapped Uncle Remus to make adjustments. Throughout southern African American communities dark glasses are a sign of the root doctor. Doctor Buzzard was known for his purple ones: Doyle has depicted them in Plate 5 with white eyes shining through, and in other versions he has shown the eyes red. The eyes of muzidi and niombo figures

were shiny white, the color signifying mpemba. In Kongo sculpture eyes were often made of glass, the reflective quality indicating mystic vision. The root doctor's dark glasses imparted the ability to see without being seen; they communicated clairvoyance; their reflective quality also signified mystic vision. Uncle Remus sat in his chair, which the scholar Grey Gundaker has shown to be a classic African American symbol of communication with the spirit world;[132] and through his dark glasses Uncle Remus looked into the world of the ancestors.

Wrapped coffin and wrapped Uncle Remus both were composed minkisi. While the Uncle Remus nkisi stayed in the house yard, the coffin nkisi had to be taken to its grave in the cemetery. The procession that formed to accompany it also bore traits of Bakongo rituals. Doyle said the service preceding the procession was traditionally led by the "leader of the plantation" with the assistance of the deacons—thus, the community's elders officiated. The coffin was placed on an ox- or horse-drawn cart if one was available. Then Doyle said, "Most everybody in those days belonged to a society," and the society members, with a bearer of a "black flag leading," marched at the head of the procession. Doyle painted a version showing a large black flag unfurled behind the coffin ahead of a women's society marching. The black flag blown by the wind became a vehicle for the spirit of the dead, the wind connoting the spirit as in the ritual of rebirth through blowing into an initiate's ear. The flag unfurling referred to Kongo cloth blowing in the wind to open the entrance to mpemba.[133]

The spirit traveling in the wind was explained by an old woman who lived by the Combahee River between St. Helena and Edisto. It could "trabbel about all ober de world 'tween de hours of sunset and de second cock crow in de mornin'." This spirit, she said, is the one that "gib you worrimint. 'E come back to de 'tings 'e like. 'E try fur come right back in de same house." As the flag opened the entrance to mpemba, song called to the spirit to come with the people to its proper resting place. At Reverend Washington's house, in the night, with excitement from singing "I sees him in de Promis' Land!" crackling in the room, a voice suddenly called from the back of the crowd: "'E sees him now! Year, 'e do!" And Richard Loundes said the singing continued while "to the graveyard we went. Would sing a song—while call him or her up." And that custom, according to the Loundes brothers, was an extremely old one that "start from the old old parents—way back yonder." Harold added, "My daddy's daddy daddy daddy daddy daddy."[134]

Parsons described processions to the Beaufort cemetery in which two society members led carrying "gayly-painted staves." At each crossroad they made an arch of the staves for the members to pass through. When they processed to a church or to their hall as part of the service, they also made the arch with the painted staves for members to pass under as they entered the building. The painting on the staves and the use of them as an entrance device invite comparison with society lodges observed by John Weeks in the

lower Zaire River region. The entrance to the lodges was a gate painted red, blue, and yellow. Weeks observed that ritual death, regeneration, and acquiring knowledge of the spirit world were closely related to passing through these gates.[135] Parallel ritual connections to entering a church or society hall through these painted arches are obvious if one accepts the church and hall as institutions parallel to societies of Kongo peoples. However, the practice of stopping at the crossroads to go through the arch might need explanation.

Crossroads as ritual sites permeated root-doctoring practice. A doctor who probably was a nephew of Doctor Buzzard made connections between the Kongo cosmogram and the crossroads. In the low voice that Gullah-speakers use for serious subjects he explained making hands by using a circular pan or drawing a circle, making a cross in either one, and writing on the lines of the cross to quarter the circle, saying the form was "like a crossroad." Doctor Watson of Charleston described the crossroad as equivalent to the cemetery. It was the site of initiation where "you gotta stand de test," and he said few people could succeed. It was where, like Bakongo initiates, one came face to face with the spirit: "Dat's a-turning loose of de demon . . . an' nach'ly must look 'em. . . . He comes to meet cha thru de grave . . . he'll come up to you—unnatch'l but he look awful terrible. I'm telling you you won't see nuthin good. . . . Dat's what chew call standing de test. Dat test mean something." MacGaffey explains that crossroad and cemetery are the same in the sense that as a crossroad signifies a parting, it also signifies separating life from death. One Bakongo custom placed "medicated palm branches" at the crossroad; Lawton found palm branches on a grave near Beaufort.[136] Church, society lodge, crossroads, and cemetery all were places of communication with the ancestors, and passing through the painted gate was for a while a surviving method for meeting them properly.

Processions to cemeteries would not cover great distances. Cemeteries were located in conjunction with dwelling localities both in the Kongo regions and in the Sea Islands. Janzen describes the practice of land allocation into localities. In each locality a chief was descended from the dominant clan, which claimed ownership of the primary cemetery situated in a grove. The chief's office was consecrated to the spirits of the grove, and these spirits included ancestor and local spirits. Local spirits were called bisimbi; they were good spirits, particularly helping their living relatives toward good fortune. In the Islands each plantation had its own separate African American cemetery, usually also in a grove. Sam Doyle is buried "on Wallace." Missionary accounts have many references to the Coffin Point burial ground, which was also in a grove. On Edisto, Sam Gadsden is buried in the Murray grove with his relatives. Now overgrown, his small bronze marker disappears into brambles and vines. It is hard to see one relative's grave although it is outlined with plastic flowers, and a florist's cardboard clockface centering a wreath adorned with silver has deteriorated. But this grove used to be

tended by Edward Simmons, a relative who kept on working at the Murray plantation and who, in a tantalizing echo of bisimbi, was known as Big Sim.[137]

At burial the grave became the person's permanent home—as MacGaffey says, "the actual house." And the cemetery became the permanent village. Whether in the Kongo or in the Sea Islands, the function was the same, because life continued in mpemba. The dead had need of the same tools as the living, so the living took the deceased's belongings to the grave. Doyle said, "Everything that you used—plate, spoon, pipe. . . . You have what you have, and it's yours; they gave it to you." Richard Loundes said, "Old saucer, cup . . . your water glass . . . but all the medicine, they pull the cork out and pour it down in there." His brother Harold commented, "Ha, ha—it drink it—ha, ha." One of Lawton's informants reported that relatives poured "hamper baskets full of things right down on top of the coffin." By the late 1970s undertakers had asked families to take a more limited number of items in a shoebox to the mortuary to be placed inside the coffin.[138] Thus, although possessions are no longer visible on top of graves, balance and harmony between worlds of living and dead continue.

Balance and harmony bring peace—Lemba—the earthly goal that one hopes to fulfill eternally. Thompson describes the Bakongo grave as "a door to a glittering, pure world of aspiration and achievement." African Americans traditionally speak of *passing,* not of "dying." One passes through the door of death to live with the spirits of one's relatives in the permanent village. This village, in the words of a scholar from the Kongo, "possesses ordering power." From this village of ancestral spirits come aid and protection for the living family. Franklin Holmes lived in New York City for forty years and two months but came home to honor his parents by taking care of their house at Coffin Point. When he "passed," he was buried with his people in the cemetery in the grove there. Ezekiel Cohen's mother died in Florida, but "her body came home" to Cuffee plantation where she had given birth to him.[139] In the village of ancestral spirits the living become centered, for here with the ancestral lives the living find, as Malidoma Somé found, "who we have always been, who we truly are, and who we must be now."

# 5

## African Resonance

... yo' gittin' in touch wit a whole lot.
—Root Doctor, Algiers, Louisiana

Up the Savannah River lived Ralph Griffin, sculptor of water-washed tree roots and stumps and deacon in the church that stood within sight of his house. The son of a preacher, Griffin was deeply religious—when his church scheduled an important meeting at a time that conflicted with a rare Griffin family reunion in Savannah, he chose to be with his church. He said that even his brother from Philadelphia was going to the reunion but emphasized that it was more important to be with the church. His father had been the minister there.[1]

Gathering the wood for his sculpture was a spiritual communion for Griffin. A stream ran through his land to the river. He would walk in the water, searching among the sunken stumps until he found one that "spoke" to him. "The first thing," he said, "is to get the eyes. When you get the eyes, you get the spirit of the wood." The water was clear. "There's a miracle in that water," he had said, "running across them logs since the flood of Noah."[2]

Evidence of the power of water, the baptized roots spoke of the presence of God. They hearkened back to a Kongo belief that the first nkisi given to people by God was called Funza and was shaped like an oddly twisted root. Robert Farris Thompson recognized the link between this belief and the use of roots in individual cunjuring prescriptions such as those using the High John the Conqueror root.[3] Griffin's work gives evidence that Funza's basic philosophical principle permeates the translation of Bakongo civilization into its African American context. The root as the primary nkisi transmitted such great power that in the Kongo only a nganga might touch it.

In the United States it took strong religious conviction such as Griffin's to touch these roots and to interpret their power. "The spirits," he said, "work on me. In my head." He explained that the spirits dealt with him—not he with them—to make him bring out what was in the wood. His sculptures had been purchased by several white physicians. He felt that he dealt with them as a peer in a reciprocal arrangement: "I'm selling to those medicine doctors and a psychology doctor. All these doctors come down and ask me about things, and I'm making things with roots. I'm doing things, and it goes back the other way." He indicated that this was a somewhat different interpretation of the term "root doctor" and that this interpretation applied to him: his power went out to the medical doctors and helped them work.[4]

Communing with roots in the stream, Griffin would study until he saw a face in the wood. "Chinaberry and mulberry have the most faces. Those are people. When the person dies, the soul leaves. The body—the physical— goes into the tree." Once he found the face, he would take the wood home to transform it. He would paint the eyes first—"to put the vision on it," he said. He had a masterwork in progress, a sculpture of Moses on the mountain. He explained that he found Moses in a mulberry root where he "got the eyes." He decided to build the mountain and constructed it from many root sections piled up and nailed together. Moses held his tablet. It was outsized and painted stark white. Griffin pointed to it. "I won't put something on that." When I asked, "Because *God* did that?" the vigor of his nodding revealed the strength of the power of God in his relationship with the work. As nganga, Griffin might touch the root, but only God could write the words of the commandments.

My husband Dutch Kuyk and I talked with him and looked at his work for a couple of hours, and then I said, "Mr. Griffin, how long have you known I was coming to see you?" He looked a bit startled but admitted, "I knew *someone* was coming. I knew it would be *two* people. For a couple of days I thought someone was coming. I was working yesterday and came home and asked my wife had anybody been here, and she said, 'No.' I knew a man and a woman were coming." From beyond the room divider his wife Loretta called out to verify that this was true. Like Stephney Robinson and Doctor Jones, Griffin also had the gift of clairvoyance. This gift gave the power of communication to his works: the eyes he painted gave them vision. Their pupils are encircled by large, bright whites reflecting the same other-world communication that glass insertions in the eyes and torsos imparted to classical Kongo figures that were sculpted and prepared for healing, protection, or validating oaths.[5]

These are the eyes of Griffin's *Spanish Dog* (Plate 10). Fu-Kiau said that because dogs hunted unseen prey in secret hideaways below ground, they were able to see into the spirit world. They could therefore see the dead. Bakongo believed there was a village of dogs between the living and the dead and that everyone passed through it at death. Janzen quotes a Lemba initiation text: "It is that which dies, which laughs with the dogs." The song, he says, illustrates how Lemba deals with "ambiguity and contrast"— by turning the power that contains opposing effects—positive and negative, give and take, problem and protection—"from threat to beneficial ally."[6]

Griffin gave the *Spanish Dog* to Kuyk as a gift. The process of giving was a study in "ambiguity and contrast." Kuyk admired Griffin's sculpture and wanted to buy two pieces. When he asked the price, Griffin told him $25 each. Aware that Griffin was becoming known as an artist and that his work probably already commanded much higher prices in the folk art market, Kuyk felt it would be exploitation to pay only $50 for two pieces. Griffin did not agree. Finally after considerable discussion Kuyk said, "Would

you take $100 for the two pieces?" Griffin smiled and said, "Well, all right." Then he immediately gave each of us another piece—"as a gift to come back on," he said—thus managing to keep the price, if one were to consider all four as bought, at his original $25 each. In this thoroughly friendly interchange Griffin used the power of opposing effects—the arguments pro and con, our giving and his taking, his giving and our taking—to produce a result that he wanted and that addressed a situation of opposing movement: we were leaving, but we must come back.

The clairvoyant eyes of the dog are also the eyes of the piece Griffin called *Evil Boy* (Plate 11). Janus-headed, *Evil Boy* was placed up about chest-high at the front edge of his yard. One face looked fiercely toward the road; the other coolly toward the house. As we walked past it, Griffin commented, "No one will take me by surprise." This was the primary piece that Kuyk asked to buy, but Griffin was extremely reluctant, saying that he feared the piece would bring us harm. Even after deciding to let it go, he waited until we were both looking elsewhere, walked back to it, and spoke to it, saying, "You're going away with them. You behave yourself, you hear?" *Evil Boy* descended from the custom—as in the Kongo Bakhimba society—of guarding the home space with figures on posts.[7] He guarded Griffin's land, his home, his family, and Griffin himself. Sculpted from wood of the water-baptized primeval tree, *Evil Boy* was painted vibrant, spirit-protecting blue, his eyes seeing in all directions. His teeth prominent, like the teeth of the muzidi figures, he was prepared to speak in the spirit world. The face turned toward the road radiated fiery red, threatening dangerous communication with that world, while the face toward the house showed cool tan with the mouth red but closed and eyes almost sleepily peeping out from curls in the wood, maintaining peacefulness.

As we chatted with Griffin, I told him that I had learned of him through Thompson's work and asked if he knew him. He said he had talked with him—laughingly commenting, "That man sure can *talk*." Griffin lightheartedly brushed aside Thompson's conversation about African influence, referring to those ideas as "all that Africa stuff." Later, however, when we talked about pieces in his yard, he carefully chose the one I should take and just as carefully arranged that it be his gift, given to me *after* our visit had both acknowledged his clairvoyance and artistry and discussed the possibility of inferences from his African heritage. He called this piece *Mermaid on a Ski* (Plates 12, 13). It too is Janus-headed. The name of the piece seems obviously to apply to one side. But the other side is so frightening that my 32-year-old son would not sleep in the room with it facing him. What did it mean? Griffin acknowledged that it was a "spirit" aspect of the mermaid.

A text of a myth of origin from Cabinda analyzed by Janzen[8] gives the answer. Bunzi, a goddess in the mythology of the Vili people, had a daughter, the mermaid Tchi Kambizi, who was violently protective of her friends. At Ngoyo, her name was LuSunzi, and she lived in a river called the Tchi

Buanga. LuSunzi is described as having one black face and one white face. The *Mermaid on a Ski* has one brown face and one so pale-yellow as to be white. LuSunzi appeared fiery at a distance. *Mermaid on a Ski* is formed with an elongated knob coming from the top of her head. It is painted red and vibrant yellow-green, giving the appearance of flames arising from her head. Tchi Kambizi, at Loango, would destroy enemies and produce storms. LuSunzi, at Ngoyo, was lawgiver and judge who convicted or forgave. She was frightfully powerful. *Mermaid*'s white face expresses just that frightening power.

In some versions of the myth Bunzi descended from Funza, the first nkisi, shaped like a twisted root. *Mermaid* too is formed from a twisted root. Still more startling is the "Ski" in her name. Often in southern African American dialect the "sk" sound became "sh," so that "ski" might be pronounced with sounds very close to "Tchi"—as "shee." Sam Gadsden pronounced "tusk" as "tush," for example.[9] "Ski" is likely to be an unconsciously remembered syllable as well as an unconsciously remembered Kongo use of language—a cross-language pun on the name of the river goddess or of the river she inhabited, referring—as "mermaid" does—to the water in which she lived.

LuSunzi had primary responsibilities: she established the societies that defined families and that protected homes and marriages. She formed the institutions for healing, for discovering secrets, and for protecting from witchcraft.[10] These Kongo values, important in the Sea Islands, moved inland.

As people bearing Kongo values were being moved inland to the fast-developing cotton region, they were intermingled with people bearing values from many other African cultures. Slaveowners from Virginia, for example, took people from the Igbo culture into South Carolina, Georgia, and Mississippi. Cultural traits began to blend. Similarities between cultures sometimes reinforced traits; one culture's traits sometimes modified those from another; an appealing detail from any culture might be adopted or adapted by a new amalgam of people. These mixtures, which were surely diverse from place to place and even from family to family, could influence any aspect of life, from cooking practices to religious beliefs. Eliza Hasty's wedding hat that was a "'stonishment to everybody"—a red hat with ostrich and turkey feathers—was such an adaptation. Among the Igbo a red cap with two eagle feathers marked Ozo members of senior grade. Although Igbo women's organizations were separate from the men's Ozo, the mark apparently survived as a status symbol in itself. Thus Eliza Hasty could adapt Igbo features—cap, red color, feathers—as symbols appropriate for her own ritual, which took place in Kershaw County in central South Carolina.

Although U.S. law had forbidden importing slaves directly from Africa since 1808, slaves born in this country could readily meet people whose

parents came from Africa and even people born in Africa and smuggled in. Robert Kimbrough's mother, Sarah, was trekked from Richmond, Virginia, with a group of slaves; sold at auction in Columbus, Georgia; and taken north into Harris County to work on a plantation. Robert said that he knew many African-born Negroes who could speak no English. Sarah Virgil said her father's people were brought to Georgia from Africa. She remembered her father's African mother and said that no one could understand her language. Frank Ziegler's father was nicknamed "Ship Dan" because he came from "across the water." His mother came from Georgia, and his parents met on the slave block in Montgomery, Alabama. Benny Dillard's mother remembered her "trip on de water dat took nigh six months to make" and told him "de onliest name she had when she got to Georgy was Nancy." She must have been born about 1840; and so she, too, had to have been smuggled into the United States. Nancy was taken from Virginia to Georgia. The American "melting pot" had become a boiling cauldron. Sarah Byrd, born in Orange County, Virginia, summed it up. She told an interviewer: "Chile[,] in them days so many families were broke up and some went one way and der others went t'other way; you nebber seed them no more." Byrd and her siblings had been sold with their mother to Augusta, Georgia. Her father, whom they never saw again, had been sold into Tennessee.[11]

The artist Bill Traylor, born about 1854, grew up in this complex culture in Benton in central Alabama. Although Benton was a tiny community far from any coast, he was enveloped by these intermingled African influences. His mother and father, Sally and Bill, were owned by John Getson Traylor. John had followed his older brother George in moving from South Carolina to Alabama. George bought land in Benton in 1828. John bought land in Lowndes and Dallas Counties near Benton beginning in 1833. Sally was born in Virginia about 1820. Either she came to Alabama through the Traylor family or she came in a slave coffle. John did buy a "girl" at "the forte" on March 5, 1840. But Sally probably came with the Traylors. Family wills show that when deaths occurred, Traylor slaves were kept with family members, not sold; and by 1840 Sally was 20 years old and had children born in Alabama.[12]

John Getson Traylor came from an upper-class family established in Virginia since the mid-seventeenth century. Their family holdings were centered near Bermuda Hundred, where great numbers of Igbo people were landed and sold into communities along the James River. This influx occurred while the Traylors were buying more slaves. Consequently, Sally's birth background was probably Igbo, and her cultural background was heavily influenced by Igbo customs. Thus, through his mother Bill Traylor was immersed in Igbo culture.

He was also immersed in Kongo culture. It was dominant in Georgia where his father came from. And surrounding the child as he grew up in

Benton were many African Americans from South Carolina who brought concepts of cosmogony and social organization determined by Kongo Lemba-type beliefs. There were influences from other African groups as well. William Henry Towns, born in northwestern Alabama in the same year as Bill Traylor, spoke of Old Caleb, who came from New Orleans. Towns reported that Caleb said that "manny er day ship loades uv slaves was unloaded dere and sold ter de one awfferin de most money fer dem" and, further, that many of them were sent long distances out from New Orleans to farms. These would have included Yoruba peoples and slaves from the Caribbean trade as well as Kongo, Igbo, and others. In Bill Traylor's community while he was growing up, there were several people who were actually born in Africa and more whose parents had been born there.[13]

In 1861 the diarist William H. Russell described an African boy he met on a steamboat journey near Benton, Alabama. The child bore cicatrization marks on his face and chest, and his teeth were filed. His owner had trained him to say he was born in South Carolina, but Russell knew that the boy had been smuggled from Africa. He was about 12 years old. At that time Bill Traylor was 7. Africans smuggled into Alabama came late. In 1937 Dick Jones still remembered four who were brought from Africa together—his grandmother Judith Gist, Tom, Chany, and Daphne. They were allowed to visit one another on July Fourth and Christmas holidays when they all spoke "African" together. "When dey talk," said Jones, "nobody didn't know what dey was talking about. My granny never could speak good like I can. She talk half African, and all African when she get bothered."[14] These Africans continually refreshed the African American cultural memory. In Alabama, Lowndes County owners often hired or borrowed each others' slaves to get big jobs done and so reinforced contacts routinely made in the comings and goings of marketing, laundering, caregiving, and churchgoing. The climate in which African Americans would share cultural knowledge was established. African beliefs and customs would easily be kept alive.

About 1930 the sociologist Charles Johnson set out to interview a family in the Alabama countryside near Montgomery. He found himself following "a ragged and winding path half obscured by a field of growing cotton." Although hard to see, the path was much used, and he noted that "it does not trace a direct course, but meanders almost furtively through the field, down the side of a gulley, then over and around a tongue of thick-set trees and brush, all without apparent reason." Johnson followed a route of the same pattern that Weeks followed in 1882 to the court of the Bakongo king and that I followed in 1990 to the home of Evelina Fludd. He followed the spiraling path of the shell, the spiral of the Kongo cosmogram. Its "furtive" meandering in "obscurity" was intentional. It symbolized "the spiral universe" of Kongo belief, which by this time was well established in central

Alabama. Here too it symbolized the continual circling of the sun and of humanity through the water, through the spirit world, and through the living world, each world communicating with the other. Here too it "reconciled vitality and permanence" in a world especially filled with the insecurities of poverty, submission, abuse, and fear.[15]

The living world and the spirit world communicated actively with one another at a cemetery near Lowndesboro. There, Alfred Jones, born in 1833, reported that "folks say on dahk, rainy nights ef you pass dat grave yahd you could heah singin' an' prayin' an' see de sperrits movin' 'roun'." He repeated a story of a young man's seeing "a ball ob fire bout de size ob a nail kag" in the road near that cemetery on a stormy night. Edward Jones, born near Montgomery just a year after Bill Traylor's birth, told how children were most scared of ghosts: "You couldn't get us children out of doors after dark. My brother saw ghosts and he would tell us about them." Then he explained that the only one he saw was a spirit appearing as a light—"no feet, no body, just a light. It crossed the road and went back into the woods." The light spirit permeated the southern African American community. In Mississippi, Tom Floyd reported having seen "a big ball o' fire rised up outen de grave yard." His judgment of it was, "Dat wont bad but I aint askin' to see hit again." According to Sam Doyle, the ball-of-light spirit lived on St. Helena on the road near the water's edge. When automobiles came to the island, the sightings ended. Pete Williams, born near Montgomery, was just two years older than Bill Traylor. He said he was always told that "de dead come back atter dey die." He listed times when he'd seen spirits himself. His master's spirit always came "when its a-raining or bad weather," and it "jes' comes and talks to me lak. I kin' see him jes' as good as I sees you." Before she died, his wife promised she'd come back to get him, and she had appeared to him four times. Spirits of people he knew well were a normal part of Williams's everyday world.[16]

The road between Montgomery and Selma ran right through Benton. One "Uncle Zeke" met a Federal Writer's Project interviewer there and reported an entirely different sort of spirit communication. He told a story about his very smart son Ebenezer, who worked for a judge in Randolph County. Suddenly one day "'long 'bout dusk dark when Ebenezer wuz over at de court house . . . dey cum a clap o' thunder an' de devil apper'd in de office. De devil sit down jes' as cool as yo' please an' he say to de jedge:

> Jedge, suh, please, I'se jest got to have dat smart nigger whut yo' got heah. I ain't had no real pleasure in hell for a thousand years—too much hard work, too much remembering things to be done, too much bookkeeping. Why, jedge, I biled one lost soul jes' a week only las' month an de jedgement wuz to bile him a year. Jedge, suh, I'se jes' got t' have dat boy!

The judge flatly refused to hand over Ebenezer and told the Devil to go away.

The Devil retorted that he would put Ebenezer to the test; and the first time Ebenezer forgot something, he'd have him. Then he was gone in another clap of thunder. The judge warned Ebenezer that the Devil would be after him if he forgot anything, and sure enough, said Zeke, "De nex' day when Ebenezer wuz sittin alone in de office, de devil he comes wid a clap o' thunder an' say: 'Boy, how does yo' like yo' eggs cooked?'" But he didn't wait for an answer. And he didn't come back. And so much time went by that the judge died, "de buggies went out and de ottomobiles cum in," and Ebenezer became a lawyer himself. Then, "one day 22 years atter he fust cum, de devil he cum back in a clap o' thunder an' he say loud-like, he say: 'How?'" And Ebenezer answered him—"Widout a moment's hesitation Ebenezer say loud an' firm: 'Scrambled.'" The Devil was defeated. He just "groaned 'loud and disappear'd wid a clap o' thunder."[17]

Several things about this tale are odd. First, in a tale deriving from Europe the Devil would be bargaining with Ebenezer, offering him youth or wealth, in this case maybe freedom, in exchange for his soul. In this story there's no bargaining between them, or even between the Devil and the judge. The Devil asks for Ebenezer as a favor, and the judge seems to feel free to turn the Devil down flat. Next, in a tale drawing on Christianity the Devil would be able to seize Ebenezer only if he were to sin. Here, though, the Devil tests not Ebenezer's virtue but his memory. Finally, in a Christian tale the Devil would be God's antagonist, torturing lost souls because torture is his pleasure, not because it is God's will. Here, however, the Devil sees himself as an officer of some high court: he has a judgment to carry out. Ebenezer, if caught by the Devil, would not become one of the damned but a recording secretary. So here we have a Devil who can hope to be given Ebenezer, who values him for his memory, and who would use him to help carry out duties assigned from on high.

This is plainly not the European, or Christian, devil. He comes to the cotton belt of Alabama from a different culture's system of beliefs and values. Indeed, this Devil combines Shango, the Yoruba lord of thunder and lightning, with the Yoruba deity Eshu the trickster. Several characteristics in the story give the tip-off. Claps of thunder coincide with the Devil's coming and going, and he is domineering. Shango, his presence announced by thunder, is forceful and aggressive. Eshu, also called Elegba, is unpredictable and disappears and reappears unexpectedly; he tricks people into making mistakes which outrage the gods and lead to death.[18] Here he hopes to trick Ebenezer into forgetfulness.

But there are more subtle characteristics that point to a complex transmission of values. Christianity opposes good against bad, God against the Devil. The qualities are separated, embodied in separate entities. Yoruba gods embody gradations of good and bad in each entity. Thus, Shango's lightning and thunder can bring fire and destruction. In Nigeria and in Cuba drums are used in the worship of Shango; the sound of the drums mimics

the roll and flash of thunder and lightning. Thompson has said that Shango's drums "resonated with the secrets of turning clear skies into tempest." His power conquers enemies and makes things happen. But Shango requires intelligence and wisdom. He wants people to use their abilities morally to good purpose.[19] By becoming a lawyer, Ebenezer conquers white southerners who during Reconstruction felt both jealousy and malice toward African Americans and in the time of the automobile worked to block their way by depriving them of the right to vote and denying them schooling. By becoming a lawyer, Ebenezer works for justice, using his ability to uphold morality through law. He exemplifies Shango's best ideals.

Shango combines traits with other deities. He particularly works with Eshu. Eshu is the messenger deity, the god of the crossroad where the worlds of the living and the dead come together. In his impudence he challenges society's rules and limits, taking on rulers and commoners alike. Here in Zeke's tale is an African god throwing down the gauntlet before the Big White Judge. Eshu also comes when society is experiencing upheaval.[20] Here he appears in a threatening, unsettled time. Ebenezer has become a lawyer in Randolph County, Alabama—something no slave could have done; nor would white society there suffer him kindly in the time when automobiles have come along. Eshu brings the message from Shango to Ebenezer: be careful; be wary; don't be lulled into forgetfulness even if twenty-two years go by. In Uncle Zeke's Alabama, Shango and Eshu have become one in the Devil.

These tales give a glimpse into the beliefs and values that formed Bill Traylor's world in central Alabama and that would have been all but invisible to white people from the time of slavery far into the twentieth century. From their European cultural background white people typically saw these elements as simple-minded superstitions and applied epithets like "hoodoo" and "witchcraft" to such beliefs and rituals. Even well-intentioned folklorists did not understand what they were seeing and hearing and were apt to refer to the customs as Susan Showers did when recording folk remedies: "weird and gruesome." At Hampton Institute the Folk Lore Society in 1894 ascribed psychological origins to the many versions of the "hag" story, concluding that it resulted from "the mental and physical surroundings of the Negroes in the South."[21] At that time even African American scholars had no way to understand that the hag survived from a Kongo initiation rite. When describing their communities of spirits in the 1930s, Alfred Jones and Pete Williams could not know that they were describing African concepts of life after death from complex philosophies of cosmological systems.

The cultural backgrounds that began to weave themselves into an American tapestry in the inland South derived from principles held in common by

most of the peoples brought from Africa. Most believed in one creator God. Most believed in ancestral spirits. Sometimes details overlapped. For example, the Ejagham nsibidi sign for sky and earth resembles the Kongo circle with cross.[22] The fundamental similarity of these symbols led African Americans to believe in the importance of the crossroad. Many people, including the Igbo and Yoruba, believed that a group of deities served the interests of the creator God. Shango and Eshu were merely two of these in the Yoruba pantheon. We have seen that death was no more final for Igbo than for Kongo peoples. Ancestors of other peoples had similar relationships with their living relatives, participating in the concerns of daily living. Ancestors and deities could promote either good or bad fortune. A minister's widow, born and raised in Orangeburg, South Carolina, articulated this belief:

> A good spirit, it leaves the body, that is why the body becomes helpless. It cannot exist any longer. It goes to decomposition because the spirit is gone. The life is gone out of it. But still the spirit never dies. It goes to its immediate loved ones on earth, it overlooks them. . . . In my belief . . . we are continually being enveloped and surrounded by the spirits of our loved ones who have gone before. . . . That is the good spirit.
>
> The evil spirit, it is abroad in the world . . . and still doing work they were engaged in, either frightening or bringing about disorder, just like they was when in the body.[23]

Living people needed to keep the spirits "on their side," working for their good fortune. To do this, all groupings developed media for communicating with the spirit world. We have examined the Kongo minkisi medium and its translation into hands with the same purpose in the United States. The Brunswick Confessor spoke at length of the significance of the dirt dauber's nest. A root doctor in Florida illustrated the necessity for fee payment to the spirits. Sam Doyle told the story of the chewing-stick hand that Doctor Buzzard made to keep Doyle's friend out of jail. Doctor Jones composed a little man figure that changed color in a bottle of liquid—a hand for healing. We have seen a number of hands made for the seemingly mundane—for good luck at cards and in love—and for the less mundane—protection of home and family. And several root doctors have spoken of the crossroads as a place to meet the spirits: the woman doctor in Louisiana emphasized that "when yo' git in touch wit de fo'k of de road, yo' gittin' in touch wit a whole lot." Doctor Watson in Charleston explained the crossroad's analogy to the cemetery: it was the site of initiation, where one came into contact with the spirit world. As the grave was nkisi, so was the crossroad for the inheritors of Kongo traditions.

Other African peoples used systems of divination as a medium to reach the spirits. A Yoruba divining system, Ifá, may be the most familiar to Western students; but the religious structures of Igbo, Fon, Ewe, Edo—all groups that had members sold into New World slavery—also included divination.

Igbo, like Yoruba, traditionally consult diviners about any situation that seems to cause disorder or anxiety. They can identify evil spirits and give advice on placating them, tell fortunes, prescribe sacrifices, make charms. They are the specialists who sort out the myriad origins of difficulties that come from the complex world of spirits or from the human community. Divination precedes any important decision or activity.

A primary method of divination uses shells, seeds, or nuts that have a concave and a convex side. In Ifá divination the Yoruba link eight of these to a metal or string chain so that four are in each half of the chain. The diviner tosses the chain; it falls in a pattern; he interprets the pattern. Igbo may simply cast four sections of a kola nut on the ground or may go to the diviner, who keeps divination seeds and bones in his secret bag of supplies. Other methods include staring into mirrors or water. Yoruba also use a divining tray covered by a fine powder in which the diviner traces lines according to how he is able to pick up sacred palm nuts.[24]

Vestiges of these divination systems have been seen in the southern United States. One of Hyatt's informants in Alabama gave the basic African reason for going to the diviner:

> She used to could look in a glass of water and she could concentrate with the spirits in this glass of water and she have tole some things out of that. She'd knock on de table and she would hold her head down and she would look in that glass of water and she could jest tell you most anything. . . . Ah went to her whenevah ah'd git worryin' or vexed.[25]

Another gave Hyatt a description of a divining tool that was like the Yoruba chain but used the Igbo's basic number, four. The instruction was to boil a black cat and take five bones from it. Put four of them together in a pattern. Hyatt asked how they could be held together, and the answer described the chain: "Well, dey takes a little fine wire—wire 'em togethah." The fifth bone was to be worn as a charm. Hyatt also was told of a ritual to find out who had caused a beautiful girl to "go crazy." About 1890 in Isle of Wight County, Virginia, a root doctor drew a circle around the girl's house. Then he gave powder to the girl's father to sprinkle on the line. The order in which the powder was used and the line drawn is reversed here from the use on the Yoruba divining tray, but the ingredients are the same. The ritual produced the perpetrator, who appeared and was unable to cross the line.[26]

In the Igbo Ozo association, as we have seen, title-taking required money. This value came to the United States as an emphasis on the value of holding jobs. Accordingly, Hyatt was given many descriptions of hands composed for getting work. Thus, when Will Bidgood found himself being dunned for all his money by a white man in Blacksburg, South Carolina, he pursued a classic Igbo course to find a solution. Bidgood was a successful farmer. He made three or four bales of cotton one year and harvested a good wheat crop as well. But the white man he rented land from claimed it all. Upset,

Bidgood consulted a root doctor from Blacksburg who had become established in Charleston. Bidgood took one look and knew the man was authentic—"his eyes was red as flame," and his beard was so long it "hung on his stomach" like "he had nevah shaved." The doctor advised Bidgood to offer to trade his pigs to the man. The white man accepted. Bidgood hung onto his money and his status in Blacksburg and ultimately was able to move to Cincinnati—away from the greedy white man's land.[27] The root doctor had functioned as a classic Igbo or Yoruba diviner.

Although the divining system for finding answers to problems appears illogical and haphazard, the anthropologist Philip Peek argues that it is not. To begin with, he points out that diviners have "an intense need to know the true reasons for events." They are both "highly skeptical" and "pragmatic" about any information they receive. They wish to help their clients adjust as necessary. The intensity of the need to know, he says, points to a cultural value that searches for reality beyond what merely appears to be true and that accepts the principle that the "suprahuman realm" both causes the problems and contains the knowledge of true reality. Peek's observation is also true of African American culture in the southern United States, where we have seen the search for reality in the "suprahuman realm" operating throughout the structure of cunjuring. He emphasizes that extreme care surrounds the entire process. Tools are tested repeatedly; procedure is matched to both client and problem; conditions are tested for consistency by holding several sessions; and in the final session client and diviner together discuss how the message received applies to the problem so that they can find the best solution. There is, he says, no coin-tossing; the matter is too serious. Peek asserts that divination, wherever it is practiced among African peoples, "is a dynamic reassessment of customs and values in the face of an ever-changing world." His analysis helps us to understand that the trait which may seem trivial or frivolous is actually grounded in a philosophical system and contains order within its apparent chaos. This awareness is necessary to our understanding African American culture as well.[28]

The appearance of chaos also characterizes a third African medium for communicating with the spirit world. This is the custom of conducting rituals through masks. Although a mask usually is thought of as a facial covering, Africanists use the term "mask" as a shortened term for "masquerade." When the mask is worn, most or all of the body is covered by a costume, as in the Ekpe and Lemba rituals. Masking is a warp thread in the African American cultural tapestry, so we must look at it more closely. We met it in the Efik Ekpe society, which had palaver houses for meetings and rituals and kept costumes there. The messenger of the spirit Ekpe wore a knitted suit patterned with horizontal bands of stripes or triangles and with a hood over the head. When Lemba initiates met the ancestors, the priests

wore masks. Initiates were terrorized by a superhumanly tall figure in white, black, and red costume. A mask brings the spirit it portrays into the community both visibly and tangibly. It may have ideographic carvings which teach the community's system of values as it performs.[29] For many West and Central African peoples masking was an intense, dominant component of their rituals. It was also a focal point in their societies for the use of art.

In his study of the Igbo of Afikpo, Simon Ottenberg described characteristics of masquerade rituals. The masquerade will be associated with a secret society. Those who are masked must be members of the society; they have learned how to perform the mask during their initiation. There will be bodily movement. Often it is dance, as in the Yoruba ancestral spirit Egungun, which arrives covered in strips of exquisite colored cloth, whirling the strips outward and around with a god-driven force of wind to chase away pestilence and bring wisdom to the living world. But a mask's movement may also be in the form of threatening or mocking gestures. Thompson describes a Dan mask called kao gle. Athlete-musicians follow kao gle as it dances. It throws a sharp hook at its them, and they must leap over it. The facial mask is ugly with fang-like teeth that seem to "bite into space."[30]

As the mask represents one or more spirits, behavior associated with those spirits is incorporated into the movements. Symbols also refer to those spirits. Villagers who are observing probably know who the performer is, but they immerse themselves in the spirit represented and the emotion generated by the masquerade. The masquerade can be simple—as a spirit's appearance, a procession, or a dance would be—or it can be so complex that it requires a production manager and becomes a play with several stages. Senufo funeral ritual, for example, is structured through such a complex system of masquerade that it appears chaotic to a stranger, while in reality it brings the arts of sculpture, music, and dance together with ritual to measure the loss of the one person "against the larger perspective of community, continuity, and communion."[31]

The mask conceals. It engenders secrecy, a value permeating African American culture. We have examined attitudes toward keeping names secret. On Edisto we met Bella Brown and her sister, whose African names "Beuw" and "Baw" were never known to white people. In 1900 Bill Traylor and his wife Louisa gave no name to the census-taker for their new son. Instances like this abound in the census records. In African tradition the baby's name must not be told, we learned, lest the stranger gain power over the infant. Other examples demonstrate the value in secrecy on both sides of the Atlantic. In Nigeria, Efik members of the Ekpe society executed fellow members for revealing secrets and nonmembers for discovering them. In Haiti the Bizango society required its membership and rituals to remain secret. In coastal South Carolina the Brunswick Confessor emphasized that Hyatt must not reveal his cunjuring secrets, and Doctor Jones taught cunjuring to his grandson while insisting that the boy never reveal the

secrets even if he didn't use them. In Ozo and in the Independent Order of St. Luke, in Lemba and in St. Helena's prayer house/church structure we have seen that secrecy is paramount. Its functions within initiation rites reveal why secrecy is a dominant value first in African, then in African American culture.

African initiation rites merge art, masking, and secrecy into a method for imparting knowledge to those being initiated. An exhibit in New York explored this relationship, its title tantalizingly descriptive: "Secrecy: African Art That Conceals and Reveals." Its curator, Mary Nooter, quoted the comments of a Baga elder who explained that knowledge cannot be gained all at once. It has to come in stages through a lifetime. It comes through all media, all senses. It is subjective, and therefore each person's knowledge is different. So it isn't possible simply to tell the secrets. But the power of secrets, Nooter found, did not lie in their content so much as in their "strategies of concealment." Possessing secrets—revealing them or withholding them—granted the power to include in or exclude from the group. Thus, secrecy serves a society's objective by organizing it into controllable groups—such as title associations or fraternal orders. The Yoruba also view the progressive stages of initiation—the acquisition of knowledge—as a journey in life.[32] Thus, in initiation each stage is a metaphor, its own secret journey into knowledge.

The art of masking, adding the visual to the philosophical, creates an emotional impact that produces unforgettable knowledge.[33] The masquerade creates seeming disorder which conceals order. It is both a cloak and a clue to secrets, those vital elements of knowledge which must be learned through experience in order to be truly known. Chaos conceals order: this is an African value, not a European one.

Within African American initiation rites the use of secrecy is more obvious than the use of aesthetic media. Much of the visual culture that might have come from Africa was suppressed during slavery. However, vestiges survived. Thompson has pointed to the link between Vili feather masks in the Kongo and the feathered costumes of the African American "Indians" who march in Mardi Gras parades in New Orleans. These groups certainly had African derivations: they were associations which provided mutual aid benefits, and at one time at least one of the groups observed burial rituals. They also masked on other occasions and sometimes, like African societies, wore headdress constructions so heavy they were borne on the shoulders. Thompson has also noted the relationship between Kongo sculpture and pottery face jugs, especially those made in Edgefield, South Carolina, by slave potters. He makes the telling point that the kaolin inserts which form and color the eyes and mouths of these faces link the jugs with the spirit world.[34] Although not made to be used as masks, face jugs are an African American manifestation of the mask idiom. Their spiritual essence performs

for their potters just as the mask's performance brings its spirit into its community.

Among the Senufo people, the Poro society constructed aesthetic displays for initiation ceremonies. In the Independent Order of St. Luke in Richmond there was a comparable aesthetic construction for the sixth-degree initiation when the council chamber was decorated to represent Jerusalem. Curtains or veils in the room were to be painted black or green. Boxes were planted with evergreens, and a cross stood in them. Boards or some other medium were to represent the road "to and around the hills about Jerusalem." In all degrees the colorful regalia worn by members resembles abbreviated mask costumes; but at this stage, besides the purple collars with yellow trim and a white or gold cross that members wore, the Degree Chief wore a robe trimmed with red and yellow and a crown.[35] The construction, the regalia, the robe and crown covering, like the masquerade, used the visual to create the emotional impact to make knowledge unforgettable.

The crown is a subtle clue to African origins of custom. Because we are familiar with crowns worn by European royalty, we pay little attention to this trait. But the fact that it is worn by the Degree *Chief,* not *king* or *queen,* is telling. We glimpsed the supreme importance of the mind of humans in African philosophy when we looked at the importance the Dogon ascribe to speech. A root doctor in Louisiana revealed the same concept in African American thought. Hyatt asked if he used an altar. "I don't need no altar," he declared, "because my altar, which is myself, is in my brain—you see, because I was gifted for that."[36]

The Yoruba, who had some degree of hierarchical organization, used a crown as a symbol of leadership. The head contains the mind, and Thompson quotes a Yoruba diviner who said that traditional Yoruba philosophy held that God's spirit was in each person's head. It is, Thompson explains, the "source of his character and destiny." With that power one can control one's behavior—especially "evil impulses." The head is the most important part of the body, and the crown was referred to as "the House of the Head." The crown was the apex of the entire Yoruba costume in which the face was veiled if not masked.[37] In the African American community the crown survived, "housing" the head as the seat of the "altar in the brain," while the facial veil may not have survived. In the African context the crown symbolized the leader's responsibility for the whole community, for being its link with its ancestral leaders, for preserving knowledge of its traditions, for maintaining balance in all spheres within it. The crown of the Independent Order of St. Luke symbolized those values. The Degree Chief, thus attired, visually expressed the power of the society to achieve its moral and its social goals in its community.

These aesthetic values and these elements from African masquerade ritual came together in the sixth, intensely secret, degree of the St. Luke initiation.

Within the Jerusalem setting and in the presence of members in regalia and their fully gowned Degree Chief the initiation began with a confrontation. The initiates were charged with being strangers who had no right to be in the room. The Degree Chief ordered the stranger to be brought forward. Members lined up, forming a channel through which the initiates had to pass. While they passed, they were seized, "some [members] charging them with intrusion, some with being an enemy, some with being a traitor," while some members called out punishments they should receive. Then the Degree Ritual specifies: "*It must be made to appear* that it is with great difficulty the candidates are brought out of this confusion."[38] There must be *apparent* chaos. But we know, because we have minutely examined the details of the initiation, that this chaos concealed highly structured order. And the requirement to appear chaotic derives from the African masquerade tradition.

Dress, bodily movement, ceremonies of secret initiation ritual, association with spirits, and use of the spirits' symbols reveal that vestiges of the tradition abounded in the New Orleans region. Hyatt received many descriptions of root doctors in elaborate gowns leading ceremonies of procession and dance. One woman wore a blue robe and, on her head, "a white piece of cloth . . . made like a crown." Several informants had consulted Madam Helen, known for her ability to summon spirits. She was garbed in yellow with a black silk headdress, three or four skirts, "and a lot of beads around her neck." An informant who had worked for her reported that if her client was coming about a love affair "she'd be all in blue," but if her client was coming with a serious affliction, she'd be wearing a black gown "just like there something in danger." A man who consulted her because his wife left found her dressed in a silk cap and a "big robe, a purple robe."[39]

All the necessary elements of masking appeared in the practices of Julius Pete Caesar. Born in Richmond, Virginia, he moved to New Orleans where, according to his younger cousin, he was "King of the Hoodoos for thirty years." The cousin lived with Caesar for fifteen years and so had intimate knowledge. Caesar led a classic example of the African masquerade form. His ceremony was associated with a secret society. There were thirteen in his group, which always initiated seven at a time. When seven of the thirteen left to go to a different city, seven more would be initiated in New Orleans. Stages, called "keys," were based on the fee charged. The group's activities were kept secret, and initiates took an oath to secrecy. There was performance with dancing or processional walking. The cousin described it: "And the night they going to have the performance, that is, to make some of the co-workers, then he dresses all in red, from head to feet. Then everybody barefeeted." Six or seven "dead-folk skulls out of the graveyard" were placed in a circle, and the thirteen members "walk around there thirteen

times." And while they walked "everybody's setting their mind direct on one thing. . . . And in doing that there will be a light will appear in there [in one of the skulls]."[40]

The ceremony was elaborated during Mardi Gras when they believed the city police would not be paying attention to them. At that time they lit the space with "maybe about 250 candle" and had as many as twenty-five skulls "scattered all around the floor . . . and they'd have their hoodoo dinner and singing an old song." And while Caesar was singing the song, he "walked" around the room: Hyatt indicates that the cousin demonstrated dancing rather than walking. Then he said, "Everybody be dancing, you know, dancing around. Then after while when we'd sing, the whole building would shake—she'll vibrate, she'd shake." Again, the chaos of the performance conceals the order of the organization within.

Caesar kept an inner room where he performed initiations, and when there he was gowned in black with a green head-wrap. During initiation the candidate might be asked whether he or she wanted to work with "the good side or the bad side." The cousin commented: "There's two sides to everything." Then he described what happened when they "wanted to do the devil's work." They march around circling and call the spirit, Lucifer, expecting him to materialize in their midst. In African America communication with the spirit world continued, and leaders such as Madam Helen and Caesar continued ceremonies for calling the spirits into the presence of the participants. Next, the cousin continued, "Whensomever [Lucifer] comes, he come with a chain. You can hear that chain—look like he's coming—I don't know where he's coming but you hear that chain." The chain as a symbol for Lucifer probably derived from the Yoruba belief that the deity that created the earth came down from the sky on a chain. The chain's appearance in Caesar's ceremony brought the ceremony to a final phase: "When that chain come, well, then they all sit right down there and eat and drink and have a good time, sing these different hoodoo songs."[41]

These practices in New Orleans often blended North American concepts with others brought in from the Caribbean and South America which were already mixtures of customs. In the Caribbean and South America they had gained titles of respect as bona fide religious beliefs—Santería in Cuba, Vodou in Haiti, Candomblé in Brazil.[42] But in North America the only titles were epithets: the Haitian title "Vodou," derived from the Fon word "vodu," which referred to spirits of the ancestors, gave way to "voodoo" and "hoodoo."

Nevertheless, the structural principles survived. A little east of Montgomery, traces of a masking custom were revealed to Charles Johnson well into the twentieth century. He was studying how African Americans lived out in the country in Macon County during the Depression in the 1930s.

People told him about parties their elders had held. They called them "tackie parties": "The folks all dress up and looks ugly, puts moss all on they heads and paint they faces, and then charge five cents for you to come up and lookd." His informant bragged that he had made three dollars for his church, saying, "I put on the concert all by myself."[43] This old tradition was dying out because the elders felt the celebration had become too secular.

Although Johnson could not know it, this was what remained of masquerades that used grotesque masks. Kao gle of the Dan was one example. Another was the Igbo Mgbedike spirit, which exhibited grotesque facial features roughly constructed from seeds, hides, twigs, and such.[44] The link between these masks and the spirit world had been translated in the New World into using masking for the church. Then as the celebrations became more secular—evolved into "tackie parties"—the elders felt the association with the spirit world had been eroded and profaned. So they ended the performance custom.

The elders of Macon County, like others throughout the South, did not forget either their forebears' spirits or the depth of reverence shown through their customs. All observed a need for regeneration, a need to become "pure" enough to enter the spirit world—to "die good," *not* to "die bad." They would achieve this standing through initiation ceremonies of regeneration and through learning belief systems that would bring them, like Na Kunka and his wife, into contact with their living community and with their spiritual, ancestral community.

We have seen how African Americans established formal institutions to achieve regeneration. The Igbo exemplified an African custom of initiating in well-defined stages; the Independent Order of St. Luke has shown how the system translated formally into beneficial societies in the United States. We have seen how the structure of initiation into the Sea Island prayer house/church system derived from Bakongo rites of initiation into a society for healing afflictions with its use of the minkisi concept. Through these and through Hyatt's interviews we have seen how this value in regeneration by means of initiation permeated all geographic areas and all levels of African American communities through the whole span of their existence in North America. With these structures came multitudinous details of multitudinous rituals. The entire panoply informs Bill Traylor's work; although he lived in cotton-farming Alabama, the details of African American culture came to him from both east and west, converging to form a tapestry of cultural origins, developments, migrations. His work reveals these multitudinous survivals of details. We have but to recognize them.

Understanding Traylor's so-called Black Dandy as Baron Samedi was merely a glimpse. If we move from that portrait to a complex drawing identified as *Yellow and Blue House with Figures and Dog* (Plate 14), we find

Baron Samedi again—but now we can place him in the rich interpretive context that we have developed. He seems to stand on the housetop. But does he? One foot appears to penetrate the roof, because the roofline crosses the foot at the ankle while the rest of the foot is inside the blue triangle of what would be attic space. The other foot touches the tip of the toes to the roof, while the rest of the foot seems to stand on air.

Wearing the same dark clothes as the first Baron Samedi we saw, with the same open front and three "buttons," this figure both hovers above and penetrates the house as he stands free. He is balanced so that the bulk of his weight bears on the straight leg which has no support other than air. And unlike a human who would have to crawl up there, grabbing onto something to avoid falling, Samedi's hands hold onto nothing on the roof for support. He stands there erect and large, appearing almost twice as tall as each of the other two figures in the picture, almost as tall as the house itself. Samedi's stance declares that he is indestructible; it conveys his power to control. The Lord of the Crossroads, Guardian of the Cemetery, can do as he wishes. He penetrates the house while hovering over the whole composition. His size proclaims his dominance.

Some distance beneath him a ladder seems to stand against the house. Although a viewer might assume that the man climbed it to get to the roof, testimonies from Sea Island people who had been seeking in the wilderness hint at other interpretations for this ladder, for in their visions a golden ladder appeared. Inland, at Grovetown, Georgia, on the route to Benton, Alabama, an African American preacher, Sol Lockheart, described how he started on his journey into the ministry. He was out plowing one day, he said, and "there came a west wind as a fire" which raised him up where he saw "a ladder from the northwest." The ladder went past him, and a voice told him to follow it. One end of it was at a church where it was "light and bright," and the other end "ran up into the sky and was dark." And he explained, "If it had a been bright I would have seen into heaven." Soon he was baptized, and a year later he began traveling long distances on foot to preach. Each year after that the vision of the ladder returned, and Lockheart traveled in whichever direction it pointed.[45]

This ladder of Traylor's might not seem to be related to these visionary ladders except for his use of the ladder in many other pictures. In one of them (Plate 15) the ladder floats horizontally above the house, propped against nothing, apparently having, like Sol Lockheart's ladders, the ability to move through the air. The odd appearance suggests a symbolic significance. Moreover, just as Maude Wahlman's detection of the nsibidi leopard-society symbol in a Traylor picture proved not only possible but even likely, the ladder deserves probing. Traylor's mother, Sally, might point the way. Since she had Igbo culture in her background, let's search there.

In Nigeria the Ekpe society was also an institution among Igbo peoples. Ekpe was started in the Cross River area by the Ejagham, who may have

developed nsibidi, the secret ideographic writing system which was inscribed on Ekpe's drums and printed on the ukara cloth that screened the leopard-noise mechanism in Ekpe's lodge. An Igbo historian has found nsibidi prevalent among Igbo people in the eastern area and in the Cross River basin. Igbo also were well known for their cloth-making. Ekpe members who reached the highest stage had the privilege of using ukara and might wear it as a wrapper. The cloths were used as hangings around an Ekpe lodge, shrine, or funerary construction. In their work on Igbo arts and beliefs Cole and Aniakor reproduce several examples of ukara cloths. One of them presents two ladder symbols (Illus. 5.1).[46]

Although meanings of most nsibidi symbols still remain known only to members of secret societies, many outsiders did know it. When a missionary told a class of Igbo children that their people had no writing, one child piped up to argue that they had nsibidi. It was used to record court cases. A special group of older women taught it to newly initiated society members. The missionary noted that many Igbo craftsmen knew nsibidi, traveled widely, and took the knowledge everywhere they went. Nsibidi signs told stories. One sign depicted a deceased chief on a bier raised high in the air; another depicted the ladder on which to reach him. On the Cross River an association of Mbembe men performed this ritual for a dead member in utmost secrecy: members, led by their priest, marched slowly around a high bier on which the body lay; and the priest climbed a ladder to reach the body to perform a ritual.[47] In both nsibidi signs and in this ritual the ladder is used metaphorically to reach the spirit world.

Across the Niger River the Edo also used the ladder symbol in their cosmology. Living between the Igbo and Yoruba groups, the Edo shared traits with both. With the Yoruba they shared worship of the same family of deities; and they placed miniature ladders on their altars to Olokun, the god of the oceans. One must cross the waters of the ocean, they believed, before one could reach the spirit world. Consequently, Olokun held the power of life after death. The ladder symbolized the path of communication between the worshipper and the worshipped: the prayer of the devotee was sent upward, and the spirit of the god descended to meet the devotee. Herbert M. Cole contributes a proverb from the Akan: "Everyone climbs the ladder of death." He emphasizes the connection between the verbal and the visual in Akan concepts and illustrates the point with a ritual pot on which the ladder symbol appears.[48]

From the Kongo, Robert Farris Thompson traces another route of the ladder into Cuba and Brazil through the spirit Tempo. Tempo's name, he says, comes from "tembo," a Kongo word meaning "a violent wind, a storm, a hurricane." The ladder is one of Tempo's symbols.[49] Igboland, Edoland, Yorubaland, Ghana, and the Kongo—all are regions from which multitudes of slaves were taken to the New World. These African peoples took their symbols with them and continued to use them in ritual observances. In the

5.1. *Ukara* cloth, Ekpe society. Cotton with indigo dye. *Fowler Museum of Cultural History, Gift of Herbert M. Cole. Photograph courtesy of Herbert M. Cole.*

Caribbean and in South America they appear in the flags—like the Vodou flag in Plate 2—that open ceremonies, and they appear in the chalked ground-drawings that are danced away as spirits are called to earth. In North America the evidence may be more difficult to read, but consider again the golden ladder of Sea Island visions. Consider again how Sol Lockheart's ladder first came to him—a vision brought by "a west wind as a fire"—just as it went to Brazil with the wind spirit Tempo. The ladder in the New World becomes an ideogram for the principle of rising through stages to regeneration, to being worthy to live with the spirits in their world.

Ground-drawings containing symbols are another clue to cultural information that Traylor has depicted. Nsibidi symbols might be drawn in any direction—horizontally, vertically, and even askew. They might be drawn on walls or on the ground as well as sewn onto cloth, carved into drums or gourds, or molded into pots. They thus could be seen from any direction. In the picture with Baron Samedi and the ladder Traylor has drawn two other symbols that may be nsibidi or other ideographic references to beliefs. These the viewer might read as the alphabet letters "A" and "B"—but only if one reads sideways. In relation to the bottom of the card they are written on and the way it is held by the man who might be reading it, the "A" is tipped over, and the "B" lies on its back. (Traylor's own signature testifies that he knew how to write a "B" right-side-up.) A ground-drawing from St. Vincent Island combined these three symbols with others. There the "A" was askew as in Diagram 5-1. The "B" was in the same position that Traylor draws it (Diag. 5-2). And the ladder was on its side, as it is in Traylor's drawing in Plate 15.[50] Ground-drawings would of course be seen from all sides as a dancer moved around and onto them. But Traylor repeated the skewed position of "A" and "B" in other pictures. His positioning is West African, and it is intentional, but what does it signify?

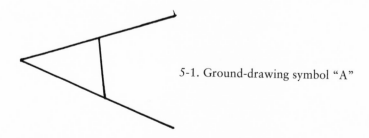

5-1. Ground-drawing symbol "A"

George E. Simpson, studying the structure and beliefs of Spiritual Baptists in Trinidad, found drawings bearing similar symbols including "A,"

5-2. Ground-drawing symbol "B"

"B," and the ladder. He found that the Spiritual Baptists observed stages of ritual initiation, purification, and regeneration. The symbols signified the stages of progress up the "ladder" to regeneration. He also found evidence that similar sects existed in the United States in the late nineteenth century. These included locations in Alabama—Mobile and, still closer to Benton, Selma.[51]

The Trinidad sect also inscribed its designs with white chalk on the bench where initiates sat, on the floor or ground where they lay during initiation, and on cloth bands placed over their eyes during the rituals of each stage of advancement. The sect might make inscriptions on the walls of the church as well. Vertical positioning of symbols therefore existed along with ground positioning. Thompson illustrates an African comparison in an initiation fan from Nigeria. Symbols on this fan, he says, communicate difficulty in the community. These symbols would be seen straight up when the fan was held by the handle and used. Among the symbols are two "B" shapes, one tipped forward and one lying on its back. Traylor's symbols on the card, as on the fan, signify trouble. In another drawing he goes further. The "B" symbol virtually shouts difficulty: it is huge and weighs down the figure trying to carry it on its head (Diag. 5-3).[52] Traylor might be making a conscious pun here between the symbol for difficulty and the "B" initial of his name to illustrate that he has caused his own trouble. We shall come back to this idea further along.

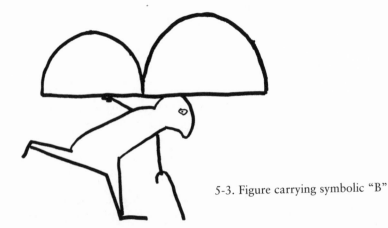

5-3. Figure carrying symbolic "B"

There's more evidence of a link between Traylor's letter symbols and spirituality. Bakongo believed in receiving messages from the spirit world in writing. The messages are referred to both as "spirit-writing" and as "letters," even though the "letters" may only vaguely resemble alphabet letters or might not be identifiable at all. The concept traveled to the Caribbean and to the United States, where it has especially been practiced by J. B. Murray, an African American artist from Georgia. Throughout the South, African Americans decorated their mantels, especially on important religious holidays, with fringed sections of newsprint, thus combining the custom of "letters" with the concept of meeting the spirit world through the movement of air as the fringed sections caught drafts and moved. The use of writing permeated cunjuring practices. In Alabama an informant told Hyatt that when a black candle is lit, letters will appear in the tallow at the bottom. A "seal" [a hand] is made by folding reflective paper around the letters. To activate protection, the seal must contact the spirit world: it must be buried on a grave.[53]

In Plate 14 the colors combined on the house—blue and yellow—also mean trouble afoot. Bright light blue, we know, is used to protect houses and property from misfortune, from spirits performing harmful deeds. It still outlines doors and windows of homes of African Americans in the deep South; sometimes it also colors the eaves. Lavinia Doyle Fields' house on St. Helena had a post painted blue and driven into the ground at the front edge of her property. In Traylor's house the doors, eaves, and entire attic space are colored spirit-protecting blue. But it is combined with the yellow of the walls. Yellow signifies disorder. It is sometimes used with black and white as colors of Eshu, the Yoruba trickster who causes disorder in all directions and can lead humans to their death. Talbot found trees and rocks painted yellow and red for protection in Ekoi land when the people feared dangers from white people. Bakongo use the same word for both red and yellow, implying some disturbance with the spirits. The entrance gate to a Bakongo lodge was painted yellow with red and blue. We saw Doctor Jones composing a hand with words from Psalms written with a yellow pencil. Blue added to yellow openly signifies a spiritual matter needing protection. Something chaotic is happening. A South Carolina yard post bearing one broad yellow vertical stripe and one broad blue vertical stripe communicates turmoil and a need for protection, while the post's rootedness sends the message downward beneath the kalunga line into the spirit world.[54]

Unlike the Baron Samedi figure that hovers in air, both of the smaller figures in Plate 14 appear grounded. Both sit in chairs, one in the dog-trot space between rooms and the other in the yard. Since we learned through Uncle Remus in Sam Doyle's yard that chairs signify communication with the spirit world, we must look at these figures carefully. Both wear black

clothes and top hats. As George Young of Livingston, Alabama, and Liza White of Lee County have already told us, Alabamians saw spirits dressed in black and wearing hats.

The figure that sits in the house holding the "letter" card sits with one foot raised. When we examined Doyle's presentation of Doctor Buzzard, we learned that the raised-foot gesture among Kongo people signaled killing. Thompson's explanation of that gesture puts it into a wider context which will shed more light on Traylor's presentation here. Thompson discusses the symbols and significance of a form of Kongo funerary pottery, called diboondo (plural: maboondo) which was made to honor prominent members of society. Pieces were shaped as columns, were hollow, and were placed at the gravesite. We need a full explanation, because we shall see more maboondo characteristics in other Traylor pieces:

> They are generally cylindrical or quadrangular in shape, frequently sectioned in horizontal registers bearing rich incised patterning. Maboondo are symbolically perforated with openwork diamonds, triangles, or squares. They are thus made, not to hold grain or liquid, but to suggest to the initiated an exquisite shell of honor around the void of death, a shell around the presence of an unseen spirit.[55]

One diboondo presented a figure that both thrust a foot up and pointed a rifle toward an animal. The combination, Thompson explains, referred to hunting and meant "kill by all means possible." Traylor also presents the idea of hunting by situating the second figure outside the house holding a rifle and accompanied by a dog that the viewer would logically read as a hunting dog. But this figure is not hunting: he is sitting in a chair smoking a pipe. Again the chair signals a relationship with the spirit world. The stem of the pipe, Thompson explains, signifies a bridge to the spirit world, and the smoke that goes through the pipestem signifies the dead spirit itself. Another diboondo that Thompson studied was interpreted as representing the concept of house.[56] With the gestures of the two figures added to the presence of Baron Samedi and the trouble-colored house, Traylor thus presents a combination of Kongo elements symbolizing a path of interchange between worlds along with trouble, killing, and death.

Baron Samedi, the death spirit, blatantly displays death. One arm is bent at the elbow to hold a black bird aloft: a *dead* one, its feet sticking stiffly upward. The Lord of the Cemetery has crushed it. Another black bird is perched on the peak of the roof: the Baron stretches his other arm out to grab it around its neck. It is about to die. From the Thunderbolt community of oyster fishermen in Savannah, Georgia, came the explanation that dreaming of "any kind of black bird" signaled death. African Americans in Gloucester, Virginia—a point of entry for Africans from the Bight of Biafra—reported that the hoot of an owl or howl of a dog near a house was a sign of death and that black birds are the Devil's birds and help him do his work.

And the belief went inland to central Alabama, where informants repeated it and added, "The owl is old-time folks. You mustn't hurt him."[57] "Old-time folks" meant that the owl signified ancestral spirits. Another informant near Calhoun told how a little wren announced a baby's death:

> De day dat baby was bo'n dere came a little bird an' he sat right on dat cornder of de cabin. He hadn't never come befo', but dat day I noticed him whistlin' an' singin' like close by de baid. . . . He sat dar an' he sang every day for three years, an' de night de baby died I heerd him singin' dar for half an hour or mo'. But when de baby died dat little bird lef' an' went away an' he hasn't never sung dere no mo'.[58]

Since many African peoples hold that birds, like dogs, are messengers from the gods, and since birds—especially black ones—are so prevalent in Traylor's pictures, it would be wise to look further into their roles in the African pantheon.

Birds are associated with the head, the "house" of knowledge, and often appear in conjunction with the head—as on the peak and sides of conical beaded crowns of Yoruba kings, as on the tops of Igbo masks, or as black feathers tied to a mask of the Bambara Komo society in Mali. Birds are messengers, carrying the concept of wisdom and knowledge of the gods and spirits. Some Igbo groups danced a mask with a bird on the head of a figure honoring women's fertility. Igbo decorated roofs in a shrine compound with bird cutouts. An Igbo masquerade honoring spirit maidens uses birds as metaphors in song.[59]

Among the western Yoruba birds are at the core of a major masquerade. Called Gelede, the masquerade paid homage to elderly women, who were referred to as "our mothers." It acknowledged them as the givers of life and of gentle care, in that respect even more powerful than the gods or the ancestors. It acknowledged that women could live to be very old and tended to live longer than men and so were in that respect more powerful than men. The old women of the communities had a secret society in which they were believed to have the power to transform themselves into night animals—bats or rats—but most especially into birds. With their great power they could make things happen—good things or, if they were angered, the worst things. The masquerade was always performed by men, but they took roles as women, their costumes referring openly to women's power to transform themselves into birds.[60]

Evidence of the concept, if not the actual masquerade, was given to Hyatt. A slave in Halifax, Virginia, ran into the woods to escape a whipping. Even bloodhounds couldn't find him. Much later, in about 1886, he told the story to Hyatt's informant. He said he escaped by changing into a bird. He perched on a fence and watched the people who were chasing him pass right by. From Albany, Georgia, came a tale that combined the bird association with the concept of woman's extreme power. A woman owned birds that obeyed

her commands. A mother came to plead with her to save her son from being hanged. The woman sent an owl down in the creek "wit de voice," and at the same time sent a hawk way up in the air out of sight where it was commanded to say, "If dey kill dat man, Ah destroy de worl'!" From the creek the owl was to add: "De Lawd." And the informant reported, "An' all of dem heah de voice, an' jes' as dey fixin' tuh kill de man dey all stop, an' jes' he say 'Lord' again fo' three times, an' dey thought sho' 'nuff it was somepin up in de air—de good Lord or somepin. Den ever'body to' [tore] out 'way from dere an' dey nevah did hang dis fellah."⁶¹

Sally Traylor exemplifies mothers honored in the Yoruba Gelede masquerade. She had the power to make things happen: she gave life and nourished growth. On March 26, 1845, her owner noted in his diary: "Sally had a chile at night." This was probably her son Henry, listed in John Getson Traylor's will, which was probated in 1850. The will listed three other children born to Sally and Bill: Liza, Frank, and Jim. Once he became a free man, Jim, like Evelina Fludd in coastal South Carolina, gave the census-taker his formal name, James.⁶²

A Thomas Traylor, born in 1839, may also have been one of Sally's sons—perhaps her oldest. His birth was recorded in one of the Bibles belonging to the slave-owning Traylor family. As a grown man he lived near Sally, so his three daughters also felt her influence. Two of Sally's daughters, Mary and Susan, were with her in 1870. But they, like Liza and any others she may have had, disappeared from records once they were married: the census did not record "maiden" names. But daughters don't disappear from their mothers as a rule, and we may assume that Sally's influence spread to their children also. James had at least eight children and raised them near his mother's house. Even after he was divorced, his children stayed with him and so were close to Sally.⁶³

Through her son Bill, Sally had many more grandchildren. Traylor's great-granddaughter said he had thirteen children. He and his first wife Louisa had Pauline, George, Sally, and one whose name confused the census-taker so that it appears to be "Nutel." Then they had Reubin, Easter, Alline, Lillie, and the baby unnamed in the census. With his second wife Larcey he had Clement, William, Mock, John—all named Traylor—and Nellie Williams, who may have been his stepdaughter, as this was Larcey's second marriage. At the end of his life he lived in Montgomery with his daughter Sally, who now used the formal name Sarah. There may have been other children that did not live or that are not recorded, as he did not marry for the first time until he was 37 years old.⁶⁴ His mother Sally, then, had at least two dozen grandchildren, probably more. Certainly, she gave life.

And she had the power to make other things happen as well. Although documents don't reveal just when she came into John Traylor's possession,

his diary provides insight into what her life was like. John Traylor worked as an overseer while he acquired property of his own to make a farm. While an overseer, he noted that he "whiped too negros for harlern. one run away." "Harlern" was hollering. In the nineteenth century Frederick Law Olmsted described it as "such a sound as I never heard before, a long, loud, musical shout, rising, and falling, and breaking into falsetto . . . ringing through the woods . . . like a bugle call." Slaves sent messages to each other by hollering, giving vent to feelings, locating themselves, passing along news, or giving plans to run away. A holler from Alabama begins:

> Ay-oh-hoh!
> I'm goin' up the river!
> Oh, couldn't stay here!
> For I'm goin' home!

The slave who ran away from John Traylor may well have been communicating his plan to the other when he got caught hollering, but words in a holler weren't intelligible to most whites. Hollering "spells" were common enough for Hyatt to glean a cure for them from a root doctor in eastern Virginia.[65]

In the thirteen years that John Traylor kept his diary this is the only time he wrote of whipping slaves. One gets the impression that he was not happy to do it. A year after this incident he stopped overseeing for good. For the next five years he added onto his house and built a stable, a wagon shed, and a cow pen. He did this work with two men, George and Bill Traylor's father, Bill, hiring others as needed. Besides Sally he owned two other women, Drusiter and Silvy, who did field work. Five weeks before her baby was due in 1845, Sally was "knocking" down cotton stalks. She also did plowing; and while Bill hauled cotton seed for manure, Sally and Silvy bedded the cotton.[66]

John G. Traylor died of malaria in 1850. He left three minor children, and his will made elaborate provisions for their care. While they were to live with his brother George, he specified that his plantation be kept as a working farm with his slaves staying there together to work it just as they had always done until his children reached their majority. Thus, Sally's subsequent children, including Bill in 1854, were born on John Getson Traylor's farm. By 1860 John's only son, Thomas Getson Traylor, just 18, was managing his own farm. Presumably he took over his father's farm from his Uncle George's management. The 1860 census slave schedule shows that he had fifteen slaves and three houses for them. Although this schedule lists slaves only by age and gender, not by name, it does list slaves of age and gender that fit Sally and Bill's family. The slave schedule list for George H. Traylor does not.[67] Thus, Sally continued in the same lifestyle and same place after her owner's death. There she made a livelihood for a large number of people. And like the Yoruba women in the secret society of elderly

women she lived to be an old woman. When the 1880 census was taken, she had reached 60, a very old age in the nineteenth century. Since the 1890 census was lost in a fire, we cannot know whether she lived to 70. Since she is not listed in the 1900 census, she apparently did not live to 80.

Two of Traylor's works appear to honor his mother. The clue to one comes from St. Helena. When Victoria Polite talked with African American students, she described spirits she'd seen, saying "And the woman have a black dress and a white face on." Traylor painted such a figure (Plate 16). Both Polite and her companion Rosa Johnson said their mothers talked to them after they died. Polite saw her mother: "My mama, ee coming from Beaufort." Johnson asks, "Walkin'?" Polite replies, "Hands together walking on down—comin'—comin'. . . . Then my mama did see me." And Johnson says, "Too worrisome?" Polite wants to get rid of the spirit: "Well, let em go walk by [and not] walk for me."[68] Traylor's woman, with one foot before the other, appears to be walking, walking. Her shoes—electric blue—shout that she walks in the spirit world. She carries an electric-blue minkisi bag. Like Uncle Remus's reflective glasses, her eyes, surrounded by large circles of white, peer into mpemba.

The second work that appears to honor Sally (Plate 17) also bears a white spirit-face. It has no mouth or nose, only eyes. As in the foregoing figure, the head of this woman is circled by a covering, a head-wrap. On top of the head is a construction which has been labeled as a basket. It appears to be of woven material. On top of this a platform supports a plant shape, and on top of that shape a small black bird lights. This woman's figure reads as a spirit figure in Gelede masquerade costume. The head-wrap is a principal detail of Gelede costume, as is the whitened face. Nose and mouth are absent, as they are in mask coverings. Strong black eyes stare outward, seeing all; and, like Ralph Griffin's roots that had their eyes painted first, these eyes of the mother communicate vision. The head-coverings of masks were constructed to conceal performers' heads, often with woven raffia material that allowed the eyes to see out. A person who heard a description of this covering without being able to see the actual artifact could easily translate woven raffia into basketry. Baskets were more than practical artifacts in the New World; they were containers for revered objects. Hence, the African woven-raffia face-covering that has a connection with the spirit world is rendered here as a basket shape on top of the face mask. But the relationship could be still more tangible: some Gelede masks have woven basketry carved on top of the head of the mask.[69] Also, Igbo "maiden spirit" masks honored motherhood as well as feminine beauty and delicacy. Both mother masks and maiden masks performed at funerals for women of high standing in the community. Associated with the spirit world, both had white faces with facial features outlined in black. And on Traylor's figures the faces are white, the eyes outlined with black circles.

Many Yoruba and Igbo masks top the head with platforms that support heavy carved representations of almost anything—people, animals, plants, even motorcycles and airplanes in modern times. Traylor drew many pictures with shapes on similar platforms. Since the shapes have branches and seem to grow out of whatever medium they are placed on, they are usually interpreted as plants. This one, which resembles a tree with somewhat drooping branches, recalls the Gelede masquerade. The mothers who have changed into birds light in trees to rest—as has the bird shape Traylor has placed on top of this headdress. Spirits of trees are believed to be closely associated with the mothers. Plant shapes, such as plantain stalks or trees, rise out of Gelede masks to state this reference to the spirit world.[70] They also closely resemble Traylor's representation. The bird resting on Traylor's tree shape we also know as a messenger from the spirit world.

The color red as Traylor uses it here appears to have both Gelede and Kongo derivations. Gathering the wood for carving a Gelede mask is a sacrificial ritual involving prayer and divination before the first cut can be made in the tree. The sap of the tree that is ordinarily used is red and is seen as symbolic blood, for the tree is a living being as well as the home of spirits. Using red in the masquerade costume pays homage to the tree "killed" to serve the mothers.[71] Traylor has woven strips of red into the basketry of the mask and has colored the masker's shirt red. The masker supplies a link with the Kongo: the arms make the classic Kongo gesture that we first saw in Doyle's painting of Doctor Buzzard; one hand is on the hip and the other arm raised to indicate that where the community's balance has been upset, another leader will show the way back to balance. Restoring balance and harmony in the community is the mothers' essential function. The mass of red here asserts that communication across kalunga is happening: the mothers see—or Sally sees—the problem and will act.

The "mother mask" that appears at the climax of the Gelede masquerade is outsized as a way of showing its importance. Likewise, the woven form carried atop Traylor's figure is outsized, seeming to dwarf the figure that nevertheless holds it up in perfect balance without laboring under the weight. It symbolizes the positive purpose served by Gelede in its culture: the power which elder women—those who have given life and who have acquired great knowledge—bring to bear on producing and preserving harmony and balance within the community.

Gelede is associated with witchcraft. The Yoruba word for women with the powers of Gelede has been translated "witch," but it is too loose a translation, and the English language offers nothing more precise. The English word normally implies evil, whereas in Gelede it refers to the mothers' extreme power. They wish to uphold morality, but their power is so great, and their anger so vengeful, that awful things can happen if they are

offended. Gelede confronts moral issues. It literally exposes them to the light of day: part of the ritual is performed during daytime. Gelede directs the community toward correct behavior so that the mothers will be pleased and will use their extreme power to bring good fortune.[72]

Dance pleases the mothers. Gelede, therefore, is danced. It requires years of specialized training to reach its great degree of intricacy. Yoruba believe that all living things have àshe, vital force. Henry and Margaret Drewal, scholars of Gelede, describe the masquerade itself as having àshe.[73] Another of Bill Traylor's pictures conveys several essential characteristics of this climactic Gelede performance (Plate 18). Gelede dancers perform as identical pairs. The platform across the shoulder and chest area of Traylor's figure bears two identical figures, one on each side of the head. Some Gelede masks bear platforms on either side of the head of the mask, and the platforms hold figures engaged in whatever activity the masker is making a point about, for Gelede produces a host of maskers and can encompass any subject. Many maskers comment on moral issues. The Drewals conclude that "doubling seems to imply increased spiritual force and transcendency."[74]

Traylor's paired figures multiply the spiritual force. One figure leans out to clasp the bottle: Charles Shannon reported that Traylor commented to him, "What little sense I did have whiskey took away." A root doctor, describing a recipe from Alabama, specified, "You gets a *black* bottle," which was to hold roots and iron nails in order to influence a court decision.[75] Traylor blended colors in every item in this picture except the bottle, which he carefully *blacked* in with pencil. Thus, the bottle also specifies the spirit world as context and hints that Traylor has a problem with the spirit world as well as with whiskey. The other figure confirms it, for it makes the familiar Kongo gesture indicating that a problem here needs leadership and resolution. All three figures wear the top hats of African American spirit clothing, showing that Traylor's frame of reference is the spirit world. The dog and the bird, messengers of the gods, reinforce that message.

At the top of this picture there are two sets of marks. The upper group contains four straight parallel marks. Near Calhoun, in Lowndes County, Alabama, two teachers from the Calhoun School, a school for African Americans, went to visit people in their homes to collect stories. A woman welcomed them to her house and said she knew they were coming because, she said, "I dreamed las' night dat Miss Dillin'ham came to see me and she stood befo' de do' an made four little marks on de ground wid her parasol." She thought the dream meant death because Miss Dillingham was wearing black in the dream, but she was relieved to see that it merely was the color Miss Dillingham wore to visit her. And she repeated: "Her parasol was black too an she made four straight marks." Among Nigerian peoples, diviners drew four parallel lines on the ground with chalk to open conference with the spirit world. The lines meant "purity of heart": the diviners' intentions were honest. Marks on their eyes with the same chalk meant they

should see hidden truths clearly.[76] For the Calhoun woman dreaming was equivalent to divining; it was communication with the spirits, the marks indicating clear and truthful revelation. Traylor's marks address his spirit world. They validate the message of the top hats, dog, and bird, announcing that what is on this paper reveals truth.

In the Gelede dance the maskers perform short segments called eka. Eka meld verbal and drum rhythms: an adage or poem referring to behavior is drummed and danced. Thompson describes eka as "short bursts of creative brilliance before the senior drum." The masker has trained for years to accomplish eka. They are difficult and fast and must be perfect. The Drewals describe body positioning: "As with much West African dance, the line of the back appears fairly rigid, straight, and inclined forward from the hips." Traylor's figure likewise appears with his back straight, seemingly rigid, and slightly inclined forward. The dancer's knees are "slightly flexed" to stabilize the body and allow "the dancer to maintain close contact with the earth, while freeing his body from the waist down for speed, force, and agility in the transferral of weight . . . [while maintaining] a very wide stance."[77] Traylor's figure likewise exhibits a very wide stance while it appears to move quickly and lightly, landing securely on the toes of one foot while the other kicks out gracefully in the air.

In his work on Gelede, Lawal describes a photograph of a dancer wearing a headdress of twin figures standing on a platform, one figure on each side of the dancer's head. The dancer, with knees bent and feet lifted, resembles Traylor's figure. Lawal's description of the Gelede dancer's face could also apply to Traylor's figure: "Its eyes fleetingly appear to be 'seeing' the environment; yet the face looks uncannily dignified and tranquil, as if sensing the presence of supernatural beings among the audience who have come to judge the performance and thereby assess the community's sense of purpose."[78]

The bird in Traylor's work, while placed directly over the dancer's head, flies in a position that communicates speed, agility, power, and purpose. It appears to tie the analogy between mothers and bird to this "dancing" figure. The contrast between movement of the feet and stability of the torso is emphasized by the arm position, with hands firmly held at the waist. Thompson filmed a demonstration of eka dancing without costume. The dancer can be seen holding his arms in angular position—akimbo—exactly as Traylor's figure holds them. The akimbo gesture may indicate that the dancer accepts a challenge here.[79]

The Drewals explain that Gelede spread quickly and came to the New World—to Cuba and Brazil—with Yoruba people; they say its "fame is proverbial." Gelede penetrated still further in the New World. Hyatt received evidence that an eka type of dance ability also came to the United States. An informant told him of a man who kept a skull relic through which he called for extraordinary power. To call forth the spirit's power, he talked, sang, and danced to the skull:

Now, he would go to work, he had five lamps, he placed one in the center of each hand, he placed one on each shoulder and one on his head, and buck danced. He—I mean danced—he wasn't trying to dance, he danced! And danced jist as about as fast as any that choo would find in any theatre.[80]

Objects on head and shoulders, speed, balance, a facility to inspire awe, and relationship with the spirit world—all qualities of the Gelede dance—are here. Then the informant described the man's ability to become invisible—to transform himself like the mothers, although he doesn't mention birds—and travel anywhere.

The costume for Gelede does not look like what Traylor's figure wears. The Gelede costume is bulky with layering of cloth. Under the layers, however, the Gelede masker often wears a red jacket with long sleeves.[81] Traylor's dancer may actually have begun the costume, but the poverty of central Alabama would not allow adding layers of cloth even if the trait were remembered. The mass of red of the "jacket" and platform—and perhaps also the red of the dog—functions just as it does in Traylor's "mother" mask of Plate 17 above. Communication across kalunga is happening: the mothers see a problem and will act. In Plates 16, 17, and 18—as with Baron Samedi on the yellow-and-blue house in Plate 14—Traylor blends traits from the African progenitors of African Americans in central Alabama to state the essence of facets of their philosophy. Gestures, symbols, body positioning, facial renditions—all combine, giving evidence that he confronts a moral issue as it confronts him, that he feels himself answerable to the "mothers," to the spirit world. Powerful in their simplicity, his works, like masquerades, reveal as they conceal.

Hyatt's dancer also kept a lamp perpetually lit in his room. The informant reported, "He said when that lamp should go out he'll have to go out, he can't stay in that room."[82] Traylor, too, depicted the central importance of the lamp. In Plate 19 it centers an inside view of a house. In another version he placed it, outsized and dominant, in the center of a platform between a man and a woman who are dwarfed by it while it absorbs their attention.[83] Observers commented on the centrality of light from candles and from fire in prayer house services on St. Helena.

A glance into William Faulkner's Yoknapatawpha County in the Mississippi delta further clarifies the depth of the light's significance. On the day Lucas Beauchamp married Molly, he began a fire in the hearth of their home. It burned, never to be allowed to go out no matter what troubles arose in the complex culture around it. It burned until the hearth held "a slow, deep solidity of heat, . . . a condensation not of fire but of time, as though not the fire's dying and not even water would cool it but only time would." Firelight—"the ancient symbol of human coherence and solidarity"[84]—and lamplight centered the lives of African American families. Na Kunka illus-

trated the depth of the "human coherence and solidarity" in families among the Kongo people. And Sally Traylor's children stayed close to her, her family equally coherent and solid.

Those families passed down cultural values through teaching. Stories were told, moral lessons were embedded in them, mythologies were remembered or changed as the environment or the occurrence of the moment demanded: Edward Jones's brother told his siblings about the ghosts he saw, and his siblings learned that it was dangerous to be out at night; Pete Williams was taught that the dead come back after they die, and he learned the cosmology of the spirit world. We have begun to see that Bill Traylor's work gives evidence of the tales told and religious beliefs he learned as a child. There is more.

A house in the neighborhood was believed to be haunted, one Alabama story began. No one would go there even though all the family had died and their possessions remained in the house. Finally, a sign appeared saying that anyone who stayed all night in the house could have it and everything in it. A boy who was poor "came along," read the sign, and said he would do that. He went in and cooked his supper. Then just when he sat down to eat it, he heard a voice coming from the top of the chimney. Looking up, he saw a leg. It said, "I am going to drop."

"I don't keer," was the boy's response, "jes' so's you don' drap in my soup."

That leg came down and jumped on a chair, and another leg appeared in the chimney. It, too, said, "I am going to drop." And again the boy replied, "I don't keer, so you don' drap in my soup."

The boy then said, "Will you have some supper? Will you have some supper?"

The legs didn't answer.

"Oh," said the boy. "I save my supper and manners too." He ate his supper, then made up his bed. "Will you have some bed room? Will you have some bed room?"

No answer.

"Oh, I save my bed room and my manners too."

He went on to bed, but shortly after he was comfortably tucked in, the legs roused him up, pulled him under the house and showed him a chest of money. The little boy became rich.[85]

Bill Traylor produced several versions of disembodied legs (Illus. 5.2).[86] In the vast body of Ifá divination literature there is a being whose name translates as "Legs." Legs represents helping oneself, struggling or working hard to bring one's natural abilities to fruition. A verse tells of a time when all the Ori—the spiritual or inner self of people—tried to hold a conference without inviting Legs. The unhappy result was that the Ori only quarreled and accomplished nothing. Then they asked Legs to come and consulted him, and after that they were successful and never again failed to consult

Legs. Igbo diviners carried small carvings representing concepts, and one of these was a figure of Legs, which symbolized travel. These carvings were set up at a divination, a Yoruba scholar described, "as if to watch over it and help it to a satisfactory conclusion."[87] The Alabama story clearly teaches children good manners. But it also emphasizes self-help through struggle: the poor boy determined to make himself endure the ordeal of fear in the haunted house to improve his position in life. The story may also imply travel, as it specifies that the boy "came along" and does not identify him as a member of the community.

Traylor's portrayal of "Legs" in this version has the legs curl around so that they seem to form eyes—thus watching over the "divination"—while they support an elevated platform on which rests an inverted cone out of which something seems to grow. The elevated platform, or pedestal, is one manifestation of a concept that permeates Traylor's work and is prevalent among many peoples of West and Central Africa. Many groups expressed the concept in the form of stools. Among the Igbo, Ozo titled men had stools as one of the symbols of their status as elders and priests in the community. In early times the carving on each stool indicated the stage that the owner had reached in the association. Kalabari Ijo stools had religious affiliation and might be carved with a spirit's "likeness" and kept at a shrine for a priest to sit on. Stools belonged to society initiates among Lobi, Birifor, Bamana, Senufo, and Baoule groups. Elaborately carved stools or chairs elevated kings in Cameroon and in Angola. All of these are associated with the relationship between the one who uses the stool and the spirit world, whether it refers to direct worship or to the powers of leadership and responsibility for the welfare of the group. Likewise, Yoruba worshippers of Shango and of Eshu carried batons which were formed like a stool above the handle shaft. Figures were elevated, carved on top of the "stool" or platform in standing or other positions.[88]

Many masks worn as spirit costumes surmount the head with one or more platforms bearing figures which point to a relationship between the matter at hand in the community's masquerade and the spirit present in the costume. Among Kongo peoples a raised platform would be placed over a grave, and objects belonging to the deceased would be placed on it. Thompson has established a relationship between this custom and an early nineteenth-century gravesite in northern Florida over which loomed a high platform. The site was marked with many emblems of communication with the spirit world.[89] Since elevated platforms are spiritually significant, when Bill Traylor presents them to us, we must look closely.

The cone on the platform is the central object in the version of disembodied legs in Illustration 5.2. Among Igbo groups inverted cones were important in worship. The Igbo worshipper required only a locus through which to reach the deity, and the worshipper could choose the locus. It might be a living tree, stakes in the earth, a cone of earth or clay, or an object that

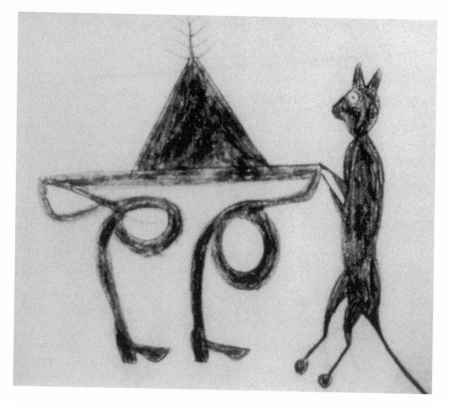

5.2. Bill Traylor, Untitled, exhibited as *Anthropomorphic Figure and Cat.*
*Private Collection.*

could be carried along. Mud cones were made from a special mud from termite hills. This mud could be shaped and covered with a more liquid mud that could be polished. Traylor's cone is colored—polished—the "deep, deep black" he particularly preferred. Igbo cones were made in any size from small to very large ones described as pyramids. The scholar of Igbo culture G. I. Jones describes the largest known example as a mound of earth piled up to the branches of a large rain forest tree, maybe as high as fifty feet, so that the tree appears to be growing out of the mound. Traylor presents this form in miniature. The growth emerging from the point of Traylor's mound is the nsibidi character for "tree."[90] Among the Igbo, when the locus of worship was placed inside a house, there was a raised platform associated with it. Traylor presents this conjunction.

Jones notes that ethnographers tend to conclude that the Igbo cones are phallic symbols; but, he says, no evidence supports this conclusion. When Igbo wanted to indicate phallic representation, he adds, they were perfectly clear about it.[91] Traylor's attitude toward phallic representation is Igbo: the

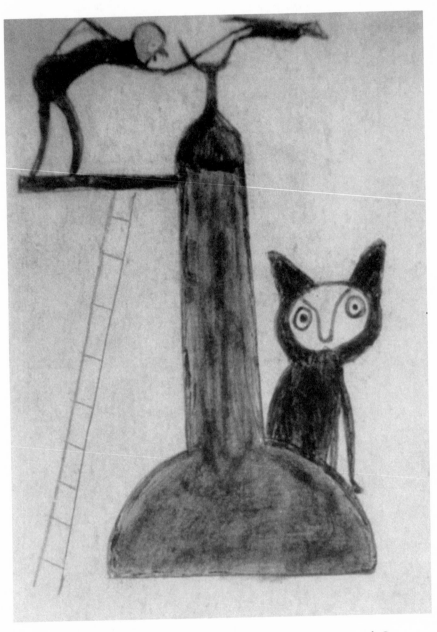

5.3. Bill Traylor, Untitled, exhibited as *Figure, Construction with Cat.*
Poster paint and pencil on cardboard; 13¼" x 7¼".
*Private Collection.*

bird in the upper left corner of Plate 15 is blatantly pecking at the penis of the figure facing it. The central construction in Illustration 5.3 is quite clearly phallic. Traylor is not obsessed with sexuality; but when he's ready to comment on it, he does so. The question is: What is he saying? The answer to this question may be surprising.

On a gray wintry day the parlor of the Ross-Clayton funeral home in Montgomery, Alabama, was set up for a service. The body of an elderly man awaited mourners. The quiet was spiritual though not sad.

In the office behind the parlor Dutch Kuyk and I sat with David Ross Jr., the senior executive in charge of Ross-Clayton, and with his father. Ross said, "Daddy, these people have come to ask if you know anything about a man named Bill Traylor. They say he slept in our funeral home during the Depression."

The elder Mr. Ross, pale with age and illness, put his hand to his face and looked down.

"Bill Traylor," he said, ". . . Bill Traylor." Then his voice came strong. "I never thought to hear that name again in *this* world."

We explained to Mr. Ross that Bill Traylor had drawn pictures with colored pencils on show cards, the cardboard covers that protected produce during shipping and were set up on sidewalk stands to illustrate what was for sale. We told him that Bill Traylor had become famous. And Mr. Ross said, "I saw him with papers and things. He always carried a bag with him. He was a good sitter. He could sit quiet and say nothing. So I didn't quiz him. I figured he didn't want to hear that noise."

He told us that in Traylor's time Ross-Clayton was open all night. Because they kept a fire going, the police asked them to let people like Traylor come in to sleep where it was warm. "It was hard times—the Depression." Bill Traylor was poor but independent. Mr. Ross remembered that Traylor had daughters, perhaps in Detroit and Philadelphia, who came to see him. He would meet them in town and take walks with them. But he didn't go to live with his daughter Sarah Howard in Montgomery until the welfare people said he couldn't stay on the street anymore.[92]

Ross-Clayton was downtown in the neighborhood of Monroe and Lawrence Streets in the 1940s, and that was where African Americans went in Montgomery then. Dr. Richard Bailey described it as a "mecca" for them and said that was why Traylor went there: "He'd be comfortable there."[93]

The elder Mr. Ross said there was another man there from Lowndes County. His name was Uncle Jesse Jackson, and he and Bill Traylor stayed together a lot. Then Mr. Ross said that Traylor "used to yell in his sleep. I heard him hollering in his sleep, so I asked Uncle Jesse Jackson if he knew what was happening. And he said Traylor had murdered a guy long ago, and it came down heavier on him every year."[94]

This was Traylor's problem with the spirit world. The death suggested by Baron Samedi on the yellow-and-blue house now comes clear. Traylor shows us the murder (Illus. 5.4). On a platform base a T-support holds the two men. It is a solid foundation, its solidity and its "T" initial implying a sense of responsibility. The victim leans forward as if to run away, while the man behind points toward him and raises the weapon to bash in his head.

The gesture and the position are repeated in a strong version which has been exhibited as *The Chase*.[95] There the victim's face is contorted, his eyes run together in terror. The pursuer kicks his foot up, actually reaching the fleeing man with it. He will kill: death is at hand. He stretches one arm out toward the fleeing man as if to accuse him. The victim's arm reaches up in the Kongo gesture communicating that he needs help; something dreadful is happening to him. He does not have his other hand on his hip. This evil cannot be put down, suppressed. This picture holds no hope that he will be saved; the issue will not cool down. Traylor repeatedly drew this image—the one man about to bash in the head of the other—frequently depicted as small figures among many other people and animals.

What happened to bring Bill Traylor to this state of violence?

Bill and Louisa Traylor were married in 1891 when he was 37 and she was about 19. However, they had a daughter born when Louisa was 12 years old, not an uncommon occurrence in that time. In the next year they had a son and, in 1887, two more children. In 1888 Traylor helped with a survey on the John Bryant Traylor farm. Then there was a five-year gap in births before Reubin was born in 1892, followed by the other four children in that decade. Louisa reported in 1900 that she had had nine births and had nine living children.[96] Therefore she and Bill appear to have been separated from each other for at least four years, if not five. The reason is unknown.

Some time between 1900 and 1910 Traylor left Benton, Alabama, and apparently never lived there again. During the same period he lost his first wife Louisa. In 1909 he married his second wife Laura, called Larcey, and ultimately established their home, renting farm land on the Will Sellers plantation on the Selma Road near Montgomery. By then his older children were grown, but since he took Louisa's younger children—Reubin, Easter, Alline, and Lillie—we might assume that Louisa had died. In 1910 he and Larcey had quite a large family in Montgomery, having added five more children to the household with Louisa's four. The 1920 census listed one more son, Plonk, then 10 years old. Their sons Clement and Will had moved into their own houses near Bill and Larcey, and each house included a young boy listed as a brother. Arthur, who was with Clement, was also 10.[97] But by 1930 the settlement was dispersed; Bill was alone, the rest of his family gone. Traylor's family was important to him. The "good sitter who sat

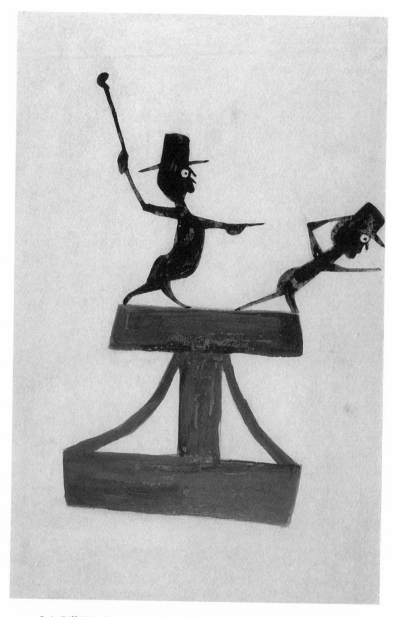

5.4. Bill Traylor, Untitled, exhibited as *Figures, Construction.*
Watercolor and pencil on cardboard; 14¼" x 8¾".

*Montgomery Museum of Fine Arts, Montgomery, Alabama.*
*Gift of Charles and Eugenia Shannon.*

quietly and said nothing" talked about his children in his old age and traveled far—to Detroit four times, to Chicago, New York, Philadelphia, and Washington—to visit them.[98]

He disappeared from public records, however, and the next time we see him is in 1939 when Charles Shannon photographed him sitting on a box in a deep, brick doorway beside a Coca-Cola cooler on Monroe Street, drawing. The murderous episode had happened "long ago," Mr. Ross said. Perhaps it happened before he was married the first time. All of his youth had passed by the time he married at 37. Perhaps it happened in Benton in or soon after 1888, and he had left town—and so had been separated from Louisa for four or five years. Perhaps it happened between 1900 and 1909 and had something to do with why he lost Louisa. His pictures indicate the "what" and "how," but they don't define the "when." What about the "why"? There seems to be an explanation in his work.

The picture entitled *Kitchen Scene, Yellow House* (Plate 19) summarizes the situation. The picture has two levels. The upper level dominates: the items drawn there are larger than in the level below. A man and a woman focus on the table with the lamp prominently at its center as the woman adjusts the lamp. The man is dipping something from a bucket. Behind her is a stove with pots apparently set to cook. The couple seems serenely at home. Below them, however, is turmoil. The house here duplicates the yellow-and-blue coloration of the house in Plate 14 that bore messages of death.

Beside this house a man wearing a top hat swings a weapon toward the back of the head of a man in front of him, who grabs at the leg of a bird. We saw the concept of bird as metaphor for woman elaborated in the Gelede masquerade. Here the bird metaphor also refers to sexual relations between man and woman. The same metaphor was written in nsibidi: a bird figure was drawn to show a pregnant wife. A courtship verse from central Alabama in 1895 repeats it: a young man courted his lady with the lines, "I hears dat you is a dove flyin' from lim' to lim' wid no where to res' your weary wing."[99] Another of Traylor's pictures blatantly shows that bird means woman (Illus. 5.5). This work was exhibited with the euphemistic title *Man Riding Bird.*

Against the serenity of the home *Kitchen Scene, Yellow House* juxtaposes the turmoil caused in the home by another man "messing around" with Traylor's woman and Traylor's desire for retribution. But his portrayal is more subtle yet, for the lamp in African American observance lit the way to the spirit world. At funerals in central Alabama it stood at the head of the coffin. Later it might be affixed to the grave.[100] By centering the lamp in the dominant level of this picture, Traylor connects the entire summation with the spirit world.

We have seen the deep and complex value in the marriage relationship manifested in Lemba rituals, in Sam Doyle's *He/She* figure, in the significance of Adam-and-Eve root, in Doctor Jones's rituals to produce

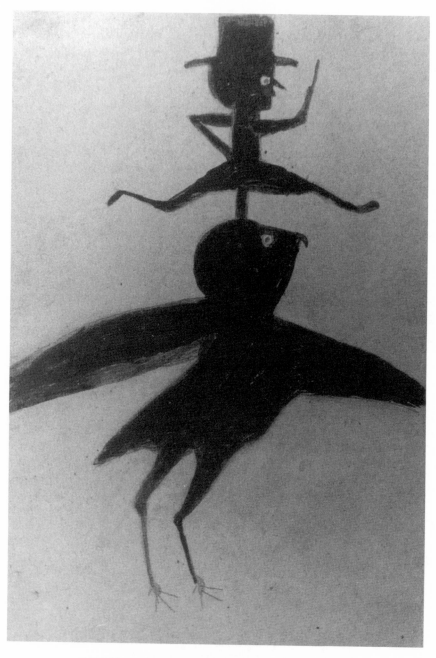

5.5. Bill Traylor, Untitled, exhibited as *Man and Bird*.
Pencil and tempera on cardboard; 17¼" x 11".
*Sharp-Curtis Collection.*

faithfulness in spouses. Churches even performed trials for the unfaithful. African American folklore from the South demonstrates how the African American community dealt with "two-timing." Portia Smiley, who taught at the Calhoun School in Lowndes County, Alabama, reported this example:

> Husband worked at night. Woman wasn' true to him, anoder man came in. Havin' a good time. Anoder man stop in. Put fir' man under de bed. . . . Den de husban' came. . . . She made de secon' man get up in de loft. Husban' came in, looked 'round, didn' see anybody, went to bed. Began to talk; said, "Somebody's been tellin' me dat you hasn' been true to me. Dat's why I came back here to-night. . . . Now, de fir' nigger dat I fin' in dis house I gwine to kill."[101]

In Virginia an informant told Hyatt that in 1918 a woman became angry with him "because I was going to see another woman and wouldn't look after her." She threatened to get even with him, and he said, "I told 'er . . . if she was to monk [monkey] with me I would shoot 'er." An original meaning of the nsibidi symbol that we have read as a "B" in Traylor's work addresses this issue. The "B" symbol in nsibidi signified handcuffs and meant that a man told a woman he loved her so much that if she slept with another man he would handcuff her.[102] In Diagram 5-3 the giant horizontal "B" bent Traylor's figure of a man down.

In *Kitchen Scene, Yellow House* there is another figure that appears repeatedly in Traylor's work. At the bottom of the picture a small figure in top hat runs, apparently fast: he is bent down with his legs spread in a huge stride. Often in Traylor's work a similar creature pokes at another figure with a long object—what appears as a long switch or an elongated index finger. Visually, the small figure resembles a description by G. I. Jones of a figure in an Igbo Ekpe masquerade. Jones notes that examples of the figure survived from a very old observance. The mask that he saw had four heads, one atop the other, and on top of them there was a small figure wearing a hat and smoking a pipe.[103]

Conceptually, the figure seems to derive from the same Kongo idea of the duality of the human's nature that produced the Kongo mythological figure Mahungu, which we examined in connection with Sam Doyle's *He/She* paintings. As Fu-Kiau describes it, this concept speaks of the person's "double," which also is translated as "shadow" or "shade" and sometimes "ghost." In Kongo thought the concept refers to strength versus weakness in the person. Fu-Kiau notes that the elderly use the plural to greet another of their own age with respect even though the person to whom they speak is alone.[104]

In African American belief the dual-nature concept was translated into having two spirits. In the coastal areas around Beaufort, South Carolina,

Lawton found widespread definition of the two spirits as "heaven-going" and "traveling." An elderly Sea Island woman described these in 1934. Her belief was rooted in African influences current during the time of slavery:

> Yo' see, suh, everybody got two kinds ob speerits. One is der hebben-goin' speerit. Dat is de speerit what goes right on to hebben or hell. Den dere is de trabblin' speerit. . . . [These] trabbel about all ober de world 'tween de hours ob sunset and de second cock crow in de mornin'. . . . De hebben-goin' speerit don't gib you no trouble, but de trabblin' speerit, 'e be de one dat gib you worrimint. 'E come back to de t'ings 'e like. 'E try fur come right back in de same house.[105]

In the South the two spirits evolved into the duality of good versus evil. Thus, in New Orleans, Doctor Caesar asked his candidates for initiation whether they wanted to work with "the good side or the bad side"; and his cousin noted that "there's two sides to everything." The minister's widow in Orangeburg, South Carolina, elaborated on her theories of the good and evil spirits; and Sol Lockheart explained that "The good spirit may say, 'Go in the swamp to pray'. . . . If you follow the good one, you will receive good; if the bad one, you will get nothing."[106]

Visual and conceptual ideas of good and of evil became personified. One man told Hyatt of his initiation experience while learning to play a guitar. The guitar was the devil's instrument, and this man had been meeting the devil at the crossroads to get his lessons. He explained to Hyatt that when it was time for the last lesson, "A lil' ole funny boy will come out . . . an' ah got tuh playin' an' fust thing ah knows he had two lil' ole sticks . . . an' ah didn't have tuh go no mo' . . . 'cause ah got playin' so's ah could play anything ah want." Rose Austin, the wife of a root doctor in Florida, explained learning how to "'complish somethin' dat's good": you must go to the crossroads alone, and "dere'll be a white man come to yo'—dat's a good spirit." Then if you want to accomplish something other than good, "It's a little dark-skinned man, he'll come. Well, dat's de evil spirit."[107]

The *Southern Workman* reported a little black creature that was a spirit: an old man named Sam went to spend a night in a house known to be frequented by spirits, but he wasn't afraid. He put a pan of meat on the fire to cook and sat back to smoke his pipe while he waited.

> Suddenly a small, black, formless being about the size of a common hare ran out on the hearth, spat across the frying pan into the fire beyond, then turned to Uncle Sam, and said,

> "There is nobody here but you and me tonight."

Sam ignored the creature until it spat close to the meat again, when he became furious and "rushed at the little imp." The creature retaliated, and Sam gave in to it and left. In Traylor's *Kitchen Scene* the little man that seems to run is accompanied by a dog. They resemble the description of the

spirit seen by the guitar-player who kept on going to the crossroads. After eight more Sunday mornings the creature he described as a "lil' ole funny boy" came "out lak a dog": "He be runnin' jes' lak a dog."[108]

In another work Traylor has placed two little black men wearing hats. This work centers on a large pedestal with two large figures—a man and a woman—standing on it. Both little men focus on the large man. One stands above and behind the large man, pointing at him with a weapon raised in its other hand; the other pokes him with the long object from below. The man and woman on the pedestal gesture toward each other. Between them looms a large perfectly circular hole in the card (Illus. 5.6). Pointing out that the Bakongo communicate through a very large "symbolic universe," Thompson reads the gestures and symbols carved on a Kongo scepter-slate. "Scepter-slates," he explains, "are highly specialized objects by which elders 'discover' the hidden issues of the past and bring them into the light of the present." Their tips are pointed; they probe history.[109] In Traylor's picture the spirit figure under the man on the pedestal probes the man with his long pointed object. The man is Traylor himself. The spirit figure wishes to bring to light an issue from the past.

In the carvings on the Kongo scepter-slate a man stands on a pedestal. For the Bakongo he represents an ideal, an attempt to shut out evil in a situation of conflict and restore—regenerate—the community. Traylor has put two people on his pedestal. The imbalance at issue here is an individual, not a community, matter. Raising the people on the pedestal represents the desire to close out the evil in the matter—to regenerate. The two people point at each other—a Kongo gesture which Thompson translates as meaning mutual criticism, accusation.[110] What are they accusing each other of? The hole in the card—the circular void—is like an empty disk on the scepter-slate which says there is death at issue. While the woman's pointing hand completes its gesture, the man's pointing hand, his accusation, is cut off by the void, the death. It is no accident that Traylor has chosen to use this card for this picture. He has carefully designed the layout so that the void occurs between the faces—between the mouths that speak to accuse.

With Traylor's symbolic use of the ladder, bird, elevated platform, and the small figure with "pointer" explained, we now are prepared to answer the question of what he was saying in Illustration 5.3, his picture that is clearly phallic. The phallus dominates; the bird, though it might fly away, remains attached to the phallus: the woman represented by the bird "belongs" to the man represented by the phallus. The cat, African American folklore reveals, is an animal that stays near death;[111] and the cat's white face and large size reinforce the presence of death. The ladder and elevated platform combine to indicate involvement with the spirit world. The figure on the platform has a whitened face: raised on the platform atop the ladder, the figure is a spirit. It reaches across the bird's attachment to the dominant phallus to probe the bird in her private parts. The spirit is the man whom

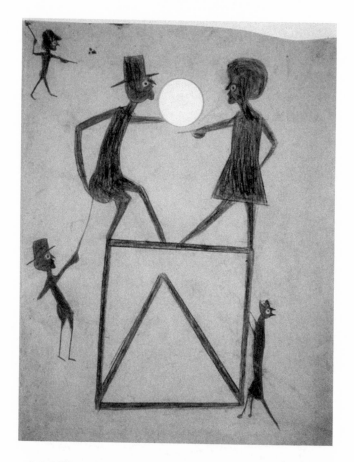

5.6. Bill Traylor, Untitled, exhibited as *Construction with Figures, Hole*. Colored pencil on paper; 16" x 12".
*Private Collection.*

Traylor has killed. He killed the man for having sex with his woman. This picture, like the scepter-slate in the Kongo, uncovers the "hidden issue" of Bill Traylor's past and brings it "into the light of the present."

Looking again at the pedestal of accusations in Illustration 5.6, we can see that although the figure of the little man holding a weapon in the upper left corner points to the man on the pedestal, the figure is not about to kill anyone. It is merely there. Almost inconspicuous, it simply states that the man caused death. The man's other hand, the one that does not point, grabs his behind: he feels the probe. Raised on the pedestal, he wants resolution. Likewise, the woman's other hand is on her hip in the Bakongo gesture to put down the evil matter. The messenger dog is focused on the hand on her hip; in African American folklore the dog tries to chase death away to

protect its owner from death.[112] All wish for resolution of the issue. Many of Traylor's pictures show his inner feelings at work, illustrating the extent of turmoil that caused the yells heard by Mr. Ross. This picture is somewhat more peaceful, stating his desire to resolve it.

By the time Traylor began to draw and paint in Montgomery about 1939, he had lost the three most important people in his life, and they were all women: his mother Sally and his two wives, Louisa and Laura. That he thought of them frequently is clearly evident from the large number of women appearing in his pictures. Two works particularly stand out as memorials: one has been titled *Woman with Green Blouse and Umbrella* and the other, *Woman in Blue Blouse* (Plate 20). The skirts of both women are cross-hatched, giving them patterns of connected diamonds.

Each diamond on the skirt of the woman wearing the green blouse is marked with one or two dots (Diag. 5-4). Thompson describes the same patterning in Kongo funerary design. "It must be ancient in Angola," he says. It survives in caves of the Bakongo; it was still in use there in the mid-seventeenth century; and it was demonstrated by Tu-Chokwe people in the twentieth. He shows maboondo with horizontal bands patterned with the same design of nucleated diamonds.[113] Such longevity and its continuing use on important objects demonstrates the trait's importance.

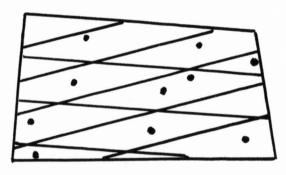

5-4. Cross-hatch pattern, skirt of woman in green blouse

Fu-Kiau interpreted the meaning of the pattern for Thompson: the diamond pattern signifies the meeting of the living world with the spirit world: it is the cemetery. Each dot is a "pulsing spirit." The spirits are the members of the clan who have gone to mpemba. But as the diamonds represent mpemba, the dots also may represent the darkness in the other world. Thompson cautions that meanings in Kongo thought might have many interpretations which may even contradict one another—and in that complexity lies richness.[114]

Each diamond on the skirt of the woman wearing the blue blouse is marked with a cross. It is a Kongo cross: the horizontal bar crosses at the midpoint of the vertical. It is the cross made by the kalunga line crossing the vertical link between two worlds in the Kongo cosmogram. Like the cross of Baron Samedi on the Vodou flag it is the crossroad where the living meet the dead, where man and woman meet God. We have seen that the diamond shape that it centers is frequently used by the Bakongo instead of the circle and that they also use squares and rectangles in the same way. Western thinking would deny that analogies could exist between curved and straight lines. Thompson counters that "the curving power of the sign of cosmos is so overpowering that it can even be sensed in hard-edged and straight-lined geometries of expression."[115]

These skirts exemplify the Kongo cosmogram still further. By cross-hatching with red diagonal lines, Traylor has emphasized the meeting between living and spirit worlds in his patterning; for red is the color of communication between those worlds. Communication is the point—the boundary—where the two worlds contact each other. Hyatt found, too, that the diagonal line had particular—sacred—significance to African Americans. They often placed their personal altars on the diagonal in the room. This arrangement, he noted, formed a "tau cross" design (which resembles an arrow tip) with the corners of the room (Diag. 5-5). The arrangement seemed odd, but he saw that those who used it believed it carried extraordinary power.[116]

5-5. Diagonal altar; "tau" cross-tip corners

Here we are seeing the transmission of a concept. Scholars of Afro-Caribbean practices have examined the same concept in the practice of ground-drawings such as the one we examined in connection with Traylor's use of the letters "A" and "B." Thompson refers to it as "drawing a 'point.'" He shows the design as it was rendered in a Kongo cross in Cuba, and the design of the bars of the cross are identical to Hyatt's design (Diag. 5-6). Both Thompson and Hyatt noted the relationship between the four cross tips and the "four winds of the universe."[117] Although one manifestation is

in altar and walls and the other manifestation is in chalk, the basic concept is common to both: on this point the power of the spirit world will come into the living world. Traylor's cross-hatching in diagonal lines carries the same potent message.

5-6. Hyatt's crossed "tau" crosses

Furthermore, a real woman's skirt would go all the way around the body. The figured diamonds would then travel around the body in a circle just as horizontal bands of diamonds travel around maboondo. It is the continuing circle of the physical and spiritual life of man and woman as conceived in Kongo cosmology. It speaks of renaissance, regeneration. And it circles here around woman, the giver of life. These portraits are like maboondo: just as the funerary pots communicate with the spirit they are made for, so do Traylor's portraits. His use of human figures and cloth as memorials lies within still broader Kongo traditions of funerary art, where some peoples wrapped bodies in large cloth packages and others preserved bones in cloth mannequins like the muzidi we studied with Sam Doyle's *Uncle Remus*.

Gestures of the two women reinforce their connection with the spirit world. The woman in green stands with her head leaning way back, supported by her uplifted right arm. Her left arm stretches out, bends at the elbow, and then drops down to hold an umbrella. If seen from the front, her arm positions form the classic Kongo pose signifying the cosmos, the "four moments of the sun": the right hand is raised, the left hand points down; the line roughly from elbow to elbow is horizontal, signifying the line of kalunga. However, the woman's head leans and needs support, a need inherent in Kongo gestures of grief as depicted in figures on maboondo. The umbrella suggests that this is a person respected for her sound judgment. In West Africa kings were shielded by umbrellas to "cool" their decisions, to keep them wise and fair. In the United States the value in "cool" decision-making was articulated as peace-making, and the umbrella continued as its

symbol, a direct transmission of an African trait. An important root doctor in Waycross, Georgia, explained it to Hyatt. "Yo' kin use a umbrella to make peace," she said. "Yo' set chure umbrella down dere. Well, ah'm goin' make peace between me an' yo' because yo' hates me without a cause. . . . Yo' come in an' yo' done sit down wit yore umbrella." Then she would perform a ritual: "Ah throw it open a little an' ah blow mah breath in dere three times, an' ah ask de, 'Father, Son an' Holy Spirit. . . . Dat's yore voice dat's in dis umbrella. . . . Jes' speak wit chure voice into dat parasol.'"[118] Her breath is like the breath of the elders in Lemba ritual, joining spirit with "cooling" the situation to make peace. Traylor's woman in green has the ability to do likewise.

The woman in blue also stands with her head leaning back, although not so far, and it is not supported. On the contrary, one can feel the tension in this woman's arms as they stretch straight down with all the fingers on both hands also stretched out as far as they can go. Her feet do not move. Her stance is one of abrupt, even startled, arrest, her head indicating her desire to keep away from the issue or to halt it. In yet another approach to woman in the spirit world Traylor presents a woman in silhouette all in black and seated on a stool (Illus. 5.7). The black color and the seating are clues that she is a spirit. In her study of African American yard art Grey Gundaker notes that while such seating may seem ordinary, it may have some characteristic, such as an odd tilt or height, that marks it as related to having spiritual power.[119] This woman's seat is too high: her feet don't reach the ground—or perhaps there is no ground. She perches on the stool with arms akimbo, challenging . . . what?

Rose Austin, in St. Petersburg, Florida, also knew the "little dark-skinned man" spirit and described a challenge that came to her from the world of spirits: "One night ah remember dat I were laying in de bed an' mah mothah—jes' lak she was ridin' me." Hyatt asked why her mother would do this, and she answered, "Ah don't know—jes' can't undahstand jes' why, prob'bly doin' somethin' ah jes' had no business doin' an' she didn't like it."[120]

Is Sally challenging her son Bill from the spirit world to get himself prepared to enter her world?

Traylor depicted the challenge in one masterwork that brought African uses of the colors red and white to inform his devices of gesture. He made this piece large, nineteen inches high and two feet wide. In the left half a man stands in the white color of mpemba: even his shoes are white. Whiteness also refers to acquiring learning and insight, the knowledge that one properly acquires before entering the spirit world. In the right half a woman stands in red. Red, the color associated with women in Lemba initiation, can also refer to the watery world of mpemba. Fu-Kiau says that red refers to dynamism and vigilance but also to what he describes as sexual or maidenly modesty and to maturity.[121] Both man and woman have spirit-faces.

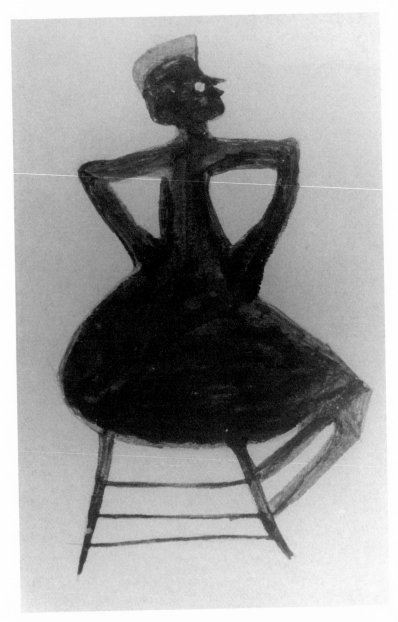

5.7. Bill Traylor, Untitled black seated figure.
Show card: poster paint and pencil on cardboard; 14½" x 8".
*Luise Ross Gallery, New York.*

Both man and woman are strong. They stand upright, their feet firmly planted. Both wear shirts with a dotted pattern. This pattern in conjunction with the white/red duality in color scheme speaks of symbols of Shango worship as photographed by Thompson in Ibadan, Nigeria, and by Phyllis Galembo in Benin City, Nigeria. The dots refer to the leopard, revered for its strength. In a major study of color symbolism among the Bakongo, Anita Jacobson-Widding notes that when a nkisi is composed, white items precede red. White will then influence red, directing the nkisi to act for the good of its recipient.[122] In Traylor's piece, just as we read sentences from left to right, viewers read the colors from left to right, placing white first before red in the order that minkisi are composed. This nkisi—this painting—is to be used for the good of its composer. The woman's strength is in her vigilance: she knows what the man has done. Force flows from her redness through her arm, which is raised and reaches into his whiteness, pointing toward his head, challenging him.

The man's strength is in his willingness to accept the challenge. He must climb the ladder: initiation that will result in rebirth is necessary for him to "mature," to proceed to full acceptance in the spirit world. He smokes a pipe: it is a "bridge" for messages between worlds.[123] It reinforces the whiteness to show his growing insight. Both man and woman hold umbrellas: their judgment at this time is sound and has the sanction of the spirit world; both value peace and work to bring it to this situation.

The woman makes the Kongo cosmos gesture, her left arm positioned with umbrella in hand, her right arm pointing. Behind the man there are lightly penciled lines. If the painting is turned clockwise 90 degrees, the lines reveal another statement of Traylor's thesis: ladder beside platform or house, man wearing top hat, bird, figure running away from them. They are faint, receding; the spirit that is the man superimposed on them is leaving them behind. The woman is pointing to the issue behind the man as well as to the man: her upraised hand, in Thompson's phrase, "vibrates the future"—that is, she lends her power to bring good fortune to the matter at hand.[124] With insight and strength the man will ascend the ladder to death. Stepping up each rung, he will pass each stage to find purification worthy of the spirit world. This is his goal.

Bill Traylor, the "good sitter" who would "sit quiet and say nothing," picked up a piece of paper blown in by the wind and, with a pencil, began to create figures. All day every day and into the nights he stayed in his little outdoor niche working, concentrating. Charles Shannon watched him across three years. Later he noted that Traylor was "calm and right with himself, beautiful to see."[125]

Traylor's drawings, however, belie Shannon's interpretation. They, along with his crying out in his sleep, testify that he was far from "calm and right

with himself." What Shannon was observing was the African American's "mask of the cool," as Thompson has defined it. Those who are "cool" have complete self-control, an "immaculate concentration of mind." Their faces do not disclose emotion. They do not talk unnecessarily so that they can focus completely on their thought. Within this concept of "the cool" lies a principle of purity, Thompson says. Coolness produces pureness. It is pureness in the African sense—the Igbo sense, as the Ozo titled man became pure to enter the spirit world: "The cooler a person becomes, the more ancestral he becomes."[126]

Throughout this work I have been discussing belief systems in the United States which have African roots. At their onset they are God-oriented, but they are not Christ-oriented. Christian doctrine is based on a concept of "original sin." African belief is not. These African-rooted belief systems are, instead, based on what Thompson terms "the divine spark of equilibrium in the soul." This spark is a gift from the gods when one is born, and should one deny that equilibrium—should one fall out of balance—then one loses one's soul. It can only be restored, he finds, through what the Gã people call "extraordinary aesthetic persuasion."[127]

Bill Traylor had fallen out of balance. When a serious crime is committed, the Yoruba say, "Sinners will not go unpunished." In the nighttime portion of the Gelede masquerade the masker-spirit, Oro Efe, sings songs that are about current issues but that enunciate "ancient formulas." One song repeats the line, "The wickedness you seek to forget will find you." Teachings like these haunted Bill Traylor, causing him to "yell in his sleep," for he believed what other African Americans believed. One man reported: "Dey say if a person dies, if he die cruel to yo' or something lak dat, say his spirit will come back." Another described what could happen: "If a man a ole sinner, a ole drunkard, ole gambler an' he die, he die a bad spirit." And we know that the person who "dies bad" cannot rest.[128] Traylor needed to find and restore his own "divine spark of equilibrium."

In their study of the Yoruba Gelede masquerade Henry and Margaret Drewal found that the Yoruba word which referred to it—irọn: spectacle— also was used to refer to "mystical vision" and to "the power of visions" and to "mental recollection." These attributes are temporary. They are brought into existence in this world only for the time they are performed, seen, spoken of. Their permanence is metaphysical, otherworldly. Something must bring any of these manifestations from their metaphysical world into this world. In Yoruba philosophy that something is àshe. Àshe refers to life force or energy—that which activates. Yoruba end prayers with the form "áàshe," which may be translated "let it happen" or "so be it." This concept is basic and ancient in Yoruba thought.[129] Consequently it went wherever Yoruba went; and so when African Americans sang a prayer to their God asking for a closer relationship—"Just a closer walk with Thee"—the natural refrain was, "Let it be, dear Lord, let it be."

Words, the philosophy holds, have the power to make things happen. Words have àshe. In the Yoruba language, the Drewals explain, some words have sounds which call pictures to mind, and so the very act of saying them brings what they depict into existence. This is what happens when Oro Efe sings stories and moral principles such as "The wickedness you seek to forget will find you." The song is a performance of words. In ritual, when a person makes sacrifice, àshe is released to nourish the spirit that the person is calling on for help. Performance can be sacrifice: Gelede is a sacrifice, performed to nourish "the mothers" for the community's benefit. Therefore, the Drewals conclude, "Art is sacrifice, and artistic displays carry the sacred power to bring things into existence."[130]

Art, in all its manifestations, has àshe. When Bill Traylor put pencil to paper, he performed through the medium of drawing. He performed from a rationale that came to him from his own broadly African-derived cosmos, and his performance was his sacrifice. He put pencil to paper to call on his gods to find rebirth. Charles Shannon said that Traylor "regarded his pictures as if he had not been the creator."[131] That is because his gods guided his hand. His art had àshe: it was his initiation, his journey to mpemba.

The paper blown in by the wind would be his medium—the wind, which brought ritual resurrection to Mayombe initiates in the Kongo; the wind, from which the Cuban spirit Tempo derived his name; the wind, which raised Sol Lockheart up to find regeneration through the vision of his ladder. And when Shannon took Traylor "nice clean" poster boards to use, he rejected them in favor of his found materials. He would only use Shannon's materials after they too had lived in the air for a while—Shannon called them "ripened off" when Traylor used them.[132]

The first marks that Shannon says he saw Traylor make on his first paper were several "clean straight lines." And the very next day, he said, "the ruled lines had given way to objects: rats, cats, cups, tea kettles, and other silhouetted shapes neatly distributed across the rectangle." As we have learned, the custom in Alabama of making straight marks on the ground derives from the equivalent set of marks in divination; and making them is a ritual to begin a conference with the spirits. The Drewals note that every type of Yoruba spectacle has a "clearly demarcated opening." The opening functions to introduce the current visit of the spectacle, to establish that it has left the metaphysical world for the time being to exist in this world.[133] The opening ritual thus functions like the diviner's set of marks: it begins a communication in this world with the spirit world. This is what Bill Traylor was doing when making "clean straight lines."

Then, each picture finished, Traylor hung it on the fence behind him. He did not fix it tightly to the fence with tacks or pins; he hung it with string so that it would swing in the breezes, letting its message flow into the spirit-communicating air. This act, too, was grounded in his African heritage. It was like the wind bringing Sol Lockheart's ladder, like the breezes blowing

the flag on the march to St. Helena's cemetery to open the door to mpemba, and like the spirit that traveled through the air "all ober de world 'tween de hours of sunset and de second cock crow." It was like a custom practiced by Bakongo priests who sent messages to the spirit world in symbols carved on live turtles' shells, on fish, or on ducks' bills, releasing the animals into water and air to be the carriers.[134]

The concept went to Haiti where it opens Vodou rituals with flags waving to salute the gods. Here we are reminded that the spirit is *in* the flag.[135] And this principle—that the spirit's presence is within the object that honors it—also informs masquerade performances. So where Bill Traylor draws spirit figures and hangs them in the air, he is both putting them out there to travel about and telling us that they are present within his pictures. Now we are able to see them. It remains to see whether he found regeneration.

In one Bakongo initiation rite the candidates go to their climactic meeting with mpemba blindfolded. They reach a string that trips them so that they fall. The string forms a circle, the boundary where the worlds of living and dead meet. It is the symbol of the circularity of life, of the four moments of the sun. Fu-Kiau shows that in Bakongo belief the human being is a microcosm of the universe. Standing in the circle, the human personifies Bakongo belief in life as circular movement. Death is only a mutation of the body, a change of place, he says, and the person continues to live in this circle.[136]

Through Higginson's journal we saw the ritualized performance of this belief in the Sea Islands. Outside a palm-leaf enclosure like the lodge of the Kamba group of Bakongo, men danced in a circle around one man in the center. We have seen the Lemba initiate standing in a circle of members to swear the oath that validated his initiation. And in the Sea Islands we also saw that one person would kneel in the center of a circle to go "down to the mire."

Teaching the circling concept of life was so central to Kongo initiations, the image of the universal man standing alone in the circle so powerful, that in the United States facets of the structure were taken into both the initiations of the more formally structured societies and initiations into cunjuring practices. Ida Bates was taught by her African-born grandfather Ned Brown, "a old, old ancient cunjure." She described part of the initiation into her society in New Orleans: "They would circle around there, out of the hall or the house. . . . They'll make a drill [circle] round and round. . . . Then they'd pass the main candle and get a light—just keep adrilling around there."[137]

Doctor Watson, of Charleston, cautioned that one must be initiated— "you gotta stand de test"—to be a qualified root doctor; and Rose Austin's root-doctor husband described the circle in the work that used candles of the red-white-black triad. "It's a certain hour that chure to burn each candle,

but yo're to make a circle around de candle an' yo' git on de inside of de circle. . . . You must make your vow an' speak de word." An informant in Washington, D.C., told Hyatt that you must go to the graveyard at midnight and circle the grave two or three times. Then you must "fortify" the circle by leaving a gift of money, vinegar, or whiskey, and "you have to make crosses" in it. Then "you sit there quiet" inside the circle. You "pray and [the spirits will] come. . . . They scare yuh to death," but if the circle is properly fortified, "they can't harm you."[138] Just as for the Bakongo, the rite in the circle where initiates meet the ancestors and make their "vow an' speak de word" validates the initiation for African Americans.

Traylor recorded the circle rite of initiation. In Illustration 5.8 he renders the circle as a thick red line. The line is comparable to the red diagonal lines on the skirts of the women in blue and green shirts. Drawn on the earth, the color red becomes red earth signifying the dead.[139] Like red nkisi ingredients Traylor's red mediates between living and spirit worlds. But the thickness of Traylor's line makes this passage appear difficult. In Illustration 5.9 the circle is a simple pencil line. Two men dominate this version: they are of equal size and equal depth of coloration. The arm of the hatless figure has penetrated the circle, crossed the boundary. The other has gotten completely inside the circle and wears the top hat and black clothes of a spirit, but his face is not white as many of Traylor's spirit-faces are.

Inside this penciled circle the man with top hat stands in the classic Bakongo pose—one hand on hip, the other raised. The hand on the hip swears to eliminate the evil at issue; the other, raised to "release positive powers," says more. The arm is stretched to its fullest extent, all five fingers also outstretched. The man looks upward toward the hand. All of these gestures emphasize the releasing of positive powers. The arm with fingers outstretched makes a gesture—usually made with both arms—of "ecstatically" calling on God; it is a gesture that symbolizes a desire to "climb up."[140] But the evil at issue is so great that it must be dealt with, put down; and only one arm can be freed to make supplication. Both circle drawings reveal in subtle ways that the issue is connected with sexuality. Although it doesn't show up clearly in reproduction, the pencil-drawn circle is surrounded by a faint line that, at the bottom of the drawing, shapes a penis and testicles. The penis meets or penetrates the circle. The figure in the red circle bears a dark red smear at the genital area. The sexual is not shameful in traditional African or African American thought. Sexuality creates life, the primary gift of God. Yet the devices are faint in these drawings: sexuality is receding here, as Traylor's life is receding. But firmness of purpose grows.

Traylor produced at least one other version of the circle with the man in the center, arms uplifted. In each of these three versions the circle is almost surrounded by a line of small, diagrammatic people. In Lemba initiation Father and Child enter a circle representing the cosmogram to swear their oath of purity. Like the circle described by Hyatt's Washington informant

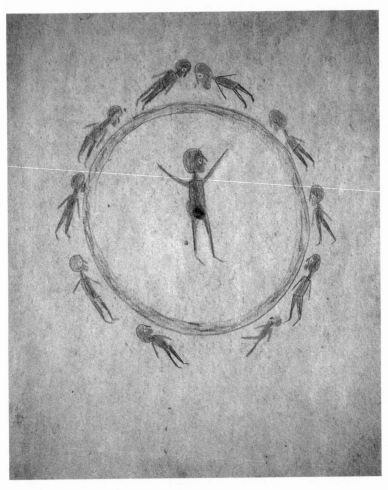

5.8. Bill Traylor, Untitled man in red circle; exhibited as
*Preaching in Circle.* Colored pencil on cardboard; 16" x 13¼".
*Private Collection.*

this Lemba circle is "fortified" with the central cross-shaped trench and
white and red nkisi ingredients. When Father and Child enter the circle, all
other members surround the circle. Now, Janzen says, the initiates learn
"how to relate ceremonially to the abstract reality of power and the be-
yond." Traylor continues Kongo tradition, placing the person in the center
of the circle, the point of greatest strength in meeting his God. In the pencil-
drawn circle supplication dominates. In the red circle the man stands with
feet firmly planted and both arms raised upward. Fu-Kiau says that this
gesture means "I testify that what I say, standing between the living and the

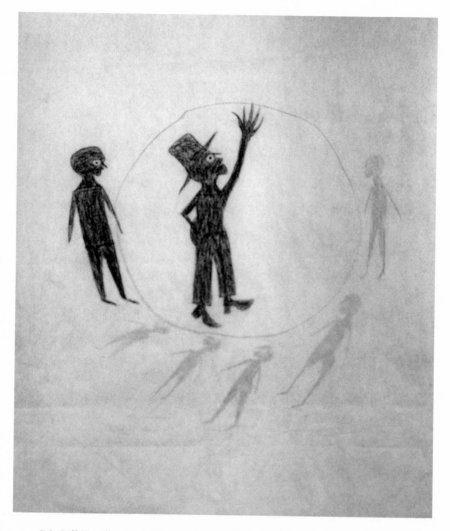

5.9. Bill Traylor, Untitled man in pencil circle; exhibited as *Preacher and Congregation*. Pencil and colored pencil on paper; 15¼" x 13¼".
*Collection of Judy Saslow.*

dead, is true" and "Here I am, arms uplifted, ready to say anything, but what I say will be true."[141] Traylor's circle works are portrayals of confession, the figure standing between the living—those outside the circle—and the spirit world within.

Traylor needed to reveal himself here, but he also meant to keep the secret. Initiation and oath-taking must be kept secret. In Illustration 5.9 the pair of men indicate progression from being outside the circle to being within

it. The man inside, through placing his hand on his hip, refers to the evil—the murder—which he repents and wishes to counterbalance. The raised arm emphasizes his desire to "die good," to enter the spirit world in a re-generated state. In Illustration 5.8 the man emphasizes that he speaks truth. He confesses. In these statements Traylor links the theological and structural systems governing African initiation and African American initiation with himself.

The crossing of the vertical with the horizontal kalunga line in the Kongo cosmogram was translated by African Americans into the crossroads, where one must go, usually at midnight, to meet the spirits. That is where one "stands the test." Hyatt learned from a woman in Memphis that "diff'rent things will come befo' yo'" at the crossroads. The test came in stages, as rungs on the ladder. If you stood one, you went on to the next: "De furst thing dat come to yo' would be a cow dat night. Yo' stand out dere . . . an' de second thing would be a dog. . . . He'd be a funny dog—he be a small dog when he furst git to yo', an' aftah he gittin' to yo' he'd be large as a cow. If yo' could stand dat, well, den next would be de form of a man dat would come to yo' wit no haid on."[142]

In Richmond, Hyatt heard about "imps" that "come an' dance up to you" in the graveyard. You are supposed to be out there for nine consecutive nights, and each night more "imps" appear until on the ninth "a whole bunch of 'em" come. Rose Austin reported "all kinda things will come to yo'—mens wit no heads, cows wit no heads, mens wit red eyes, an' diff'rent things. . . . Dey'll come an' dey'll push yo' ovah—dey'll shove yo'—dey'll slap yo'—dey'll always do somethin' to yo' to try tuh make yo' pay 'em attention so yo' git scared an' run. . . . Yo' jes' continue to set right dere."[143]

Bill Traylor stood the test. He drew the things that came to him during his ordeal. Nsibidi symbols draw a snake in sinusoid shape. It signifies guilt and sinful acts. The sinusoid snake reappears throughout Traylor's work. Like the one in Plate 15 his snakes are often ready to bite. One nsibidi symbol shows two such snakes and means that a snake will kill any society member who wants to kill another. Traylor's well-known coiled blacksnake—illustrated on the cover of Black Folk Art in America and in other works on Traylor—is centered by the circle of the Kongo cosmogram and spirals from there to head and tail, unmistakably communicating àshe—in an amazing statement of the blend of African backgrounds, at once simple and complex—as the snake bares fangs to strike. In the upper left corner—insignificant enough to overlook—there is an inscription of parallel lines like the lines in Plate 18. Norma Rosen, scholar of the Edo people of Benin, finds parallel lines used "as a direct salutation" to the gods during initiation rituals.[144] Traylor uses the lines ritually, addressing the snake as a member of the spirit world. He meets it at the crossroads of life and death: beneath the snake in Plate 15 he lies, apparently dead.

By the very act of painting, Traylor was preparing himself to enter the spirit world by undergoing his own initiatory ordeal. At this stage of his ordeal he, too, saw a cow. He painted it as black, and on its cardboard there were circles as if water drops had fallen on it. Traylor used the circles, coloring their centers chalky white. One of the cow's back feet is placed solidly in the largest circle. All of the circles except one very small one are below the cow as if on the ground. Root doctors all through the South drew circles on the ground as part of their ritual communication with the spirit world. Traylor's circles here are whitened to make the reference to the spirit world within the circle. The black cow, with one back foot in the whitened circle, is coming to him from mpemba.[145]

And into his ordeal came the dog that got to be "as large as a cow." He drew it in several versions. In one of them a man faced the snarling dog and walked into its chest. This man is clothed all in black and wears the black top hat of the spirit.[146] From Traylor's ordeal came myriad dogs, ferocious with teeth bared, fighting, biting, chasing people. From his ordeal came a red-eyed man smoking (Plate 21): red eyes, we learned from Will Bidgood, identified root doctors, those who already had been initiated into cunjuring and who would initiate others; and smoke communicates with the spirit world. And in Traylor's ordeal the "imps" repeatedly prodded. They poked women under their skirts, men in the crotch, dogs in the anus. Certainly they would "make yo' pay 'em attention." But Traylor didn't run; he "jes' continue to set right dere."

Shannon visited Traylor intermittently during three years, until World War II interrupted. During his visits he found Traylor working in what Shannon called his "basket period." The basket is an important artifact among all the African peoples we've seen. Traylor produced so many that it obviously was important to him. Fu-Kiau spoke of the maboondo as baskets "made of terra cotta." Their crosshatch patterning had funerary meaning. Basket weave is comparable to crosshatch: it, too, signifies the cemetery. Maboondo held the clan's medicines and its souls; and when placed on an individual's grave, they symbolized that person's extraordinary contributions to maintaining peaceful relations in the community. Baskets themselves were often placed on individual graves, where they stayed until they rotted away. As the Kongo kingdom disintegrated into chieftaincies in the seventeenth century, each chief held a "sacred basket" which validated his claim to authority.[147]

Deeper into Zaire the Bwami society of the Lega people stored initiation tools in a basket that was passed from one member to another during the initiation ceremony. These were the teaching tools: they included items from nature—skulls of chimpanzees and crocodiles, shells of turtles and snails, snake skins, seeds and pods—as well as carvings and masks. Initiates kept

shoulder bags to hold their secret initiation items. With these items the elders taught initiates how to live in their rain forest environment. Igbo members of the Odo society accompanied its spirit by carrying a basket of sacrificial items as the spirit left their village, and the headpiece of the costume was made of basketry. Even where baskets seem to have only mundane use, they hold pieces of votive sculpture, foods to be given to the gods, or other things used in worship. The chorus of a Yoruba song for the deity Olokun, for example, is translated as "We always greet hunger with a basket."[148]

Among the Bakongo, when a basket held consecrated objects, it became a nkisi; it had power. If it had no "medication," it was considered empty. Bags, too, were used to carry items of power. Both kings and priests carried such bags. Philosophically, these are links between the living kings and priests and those who have preceded them.[149] The items connect the living with the spirit world; therefore their containers are important. I emphasize this because the importance of the container continues as a value in central Alabama. When David Ross Sr. described Bill Traylor, he emphasized the bag that Traylor carried. Mr. Ross's son called an elderly woman they knew who lived in the neighborhood where Traylor had lived with his daughter to ask whether by any chance the woman remembered Traylor. While they were on the telephone, Mr. Ross repeatedly told his son to tell her about the bag because he was sure that would remind her of Traylor if she knew him at all. Like the African diviners, priests, and secret society members before him, Traylor carried the tools of his art in his bag: they were the tools of his sacrifice and initiation.

When he did baskets of more complex design, he incorporated symbols we have seen as related to the spirit world. A man done all in black strides along with one hand on his hip and a cane in the other, preceded by a black dog. On his head he balances an enormous basket with the ubiquitous black bird perched on its top. Another has the dog carrying the basket on its back, and again the black bird perches on top of the basket. One basket with heavy black shell and red-and-black weaving rests on a flat platform. Out of a bottle on its top rises a spirit figure reaching for another bottle. Again Traylor puns on the duality of spirits as deities and spirits as alcohol. And African American folklore contains many references to the belief that the spirits are attracted to alcohol. These renditions, as well as the mother figure detailed with the Gelede masquerade, present the basket and its support—whether man, woman, dog, or platform—as altars. "Anchoring men and women at life's deepest moments," as Thompson says, "they back up crisis or transition with the immortal presence of the divine." Anything—whether grave or pot, whether crossroad or flag—will be an altar so long as it acts as a "hieroglyph of the spirit," a "threshold for communication with the other world." He quotes a passage from Herskovits's work in Suriname in which a pot is analogous to Traylor's basket on the head of a man: "I talk to my god. If I have something to beg of him for myself, or for someone else,

then I put the pot which belongs to him on my head and the drum calls him."[150]

Plate 22 shows one of Traylor's simplest baskets, just a dark gray, rectilinear network surrounded by a frame of rich blue. But Traylor is performing art in the African mode: the basket conceals and reveals. The drawing is on the drab back of a show card, but the card Traylor chose has a remarkable image on its front (Plate 23). It advertises Baby Ruth candy bars. A young man sits cross-legged atop the upper part of the globe—the cosmic circle. Beneath the globe is the phrase "Sitting on Top of the World." The young man's arms are raised in the Kongo gesture of ecstatic worship of the gods. He holds up an outsized candy bar in offering while rays as of the sun at its brightest moment rise up around him. Concealed behind the basket, then, is a "hieroglyph of the spirit" as it makes an offering to the gods. Traylor has linked the basket with the spirit world, making the humble show card an altar complete with sacrificial food: he has something to beg of his god.

<p style="text-align: center;">❀</p>

"A grave," MacGaffey says, was "known formerly as . . . house of n'kisi" because the grave was "a collection of physical materials arranged in a prescribed way and supposed to contain a sentient being." In the Bembe group of Kongo people he found that when a diviner revealed that a person's ailments were caused by an ancestor, it meant that the ancestor consented to lend its power to protect the person. The person then would procure a statue with human shape which might be a carving but could be made of basketry. The priest then "caught" the ancestor's spirit and "fixed" it in the statue, and its power of protection began.[151]

The grave, the basket, and the statue all share the attribute of being an enclosure that houses the spirit of one who has died. The enclosure protects the spirit of the dead within it; and it protects the living outside it from the spirit's extreme power. "The concept of the enclosure," Thompson notes, has been "always metaphorically strong in Kongo." The Vodou flag in Plate 2 shows its transmission into Haiti. Symbols of the Lord of the Cemetery—the cross, the bottles of spirits, the god with his cane—are enclosed in a border of semicircles. In Sam Gadsden's family cemetery on Edisto the slab covering of a grave encloses a Christian cross in a similar border of semicircles. Thompson has seen the form produced by old tires sunk to their mid-line in earth to enclose southern yards. He defines the device as Kongo-derived, meaning "suns moving along." The circling sun encloses life. The concept extends to other devices of enclosure—a grave outlined with shells or plastic flowers. In Lemba initiations ritual objects were enclosed in miniature coffins, and Hyatt found this type of enclosure used in rituals throughout the southern United States. Shed-like enclosures were built both by the Anang in eastern Nigeria and by Bakongo. The Anang represented

the spirits in their "houses" with frescoes and appliquéd cloth; the Bakongo, with carved ancestor figures. The figures in both cases were visible from outside the "house."[152]

Traylor, too, has rendered many enclosures. Illustration 5.10 shows one enclosure within another. Inside a blue frame, a platform becomes an altar, a "threshold for communication with the other world." It bears an enclosure with a small figure inside. This figure is drawn as a spirit—all black with white face that has only eyes. Other spirit figures surround it. Above this enclosure of the dead, however, plant-like shapes reach out, and a man's figure rests on them with bent knees. Among the Bakongo this gesture, or position, indicates that this figure is alive.[153] This figure has risen above the dead and is reaching out. The outsized bird and dog stand ready to serve their purpose—to communicate with the spirit world. The dog stands on the border of spirit-protection blue, and the bird's wing spreads through it.

Themes in this enclosure appear repeatedly in the body of Traylor's work. Often the base of a so-called construction serves as an altar supporting a T-shape. Using the initial of one's name in art forms is a common practice at least among older southern African Americans. It is especially noticeable in quilts, where whole pieces may be designed from one initial. Traylor's frequent use of the forms "B" and "T" reveal his intimate personal relation to his work. The live person in this enclosure reaches out to communicate but needs the protection of the spirit world. We've seen the visions that appeared as Traylor "stood the test" in his search for regeneration, or self-purification. This enclosure is a statement of his traveling the route alone.

This value in individual achievement, including self-purification, manifests itself in Bill Traylor especially as an Igbo trait. Initiation into the Ozo society revealed that the Igbo valued developing one's ability. The intensity of Traylor's expression of his value in self-purification shows that he has reached a level toward regeneration. At this level his conception of truth is as Igbo conceive it. Richard Henderson, scholar of the Onitsha Igbo, has described this truth as "the ultimate order of things in their relation to the past." Self-purification, he says, "transforms one's general identity to bring a man close to the divine order of things."[154]

And this is precisely Bill Traylor's goal: by enduring initiation, by entering the spirit world through his art, he hopes to achieve self-purification in order to join the ancestral past, to take his place in "the divine order of things." One magnificent narrative work outlines his journey (Plate 24). The narrative begins in the center of the picture and, in Kongo fashion, his journey moves in a spiral. Black colors the evil acts: inside the leaning enclosure, a man snatches a bird—read "woman"—off her balance; outside the enclosure, a man swings the mallet to kill the man snatching her. Like the outline of his basket above, rich blue colors the enclosure and all of the

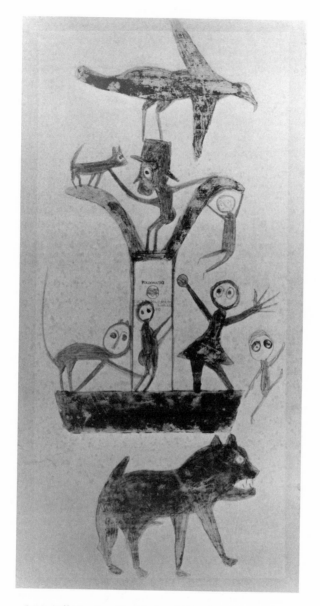

5.10. Bill Traylor, Untitled, exhibited as *Figures and Construction with Blue Border.* Poster paint on cardboard; 15½" x 8".

*Collection of the American Folk Art Museum, New York, 1991.34.01. Gift of Charles and Eugenia Shannon.*

action leading to the spirit world. The spirit dog runs away from death and toward the ladder which leads to the spirit world.

On the bottom of the ladder, at the first stage, a man climbs hatless; just above him the next figure has a hat. For the rest of the spiral, figures continue in pairs, one with hat, one without. To further understand Traylor's pairing, we can recall an explanation from a St. Helena woman: "Yo' see, suh, everybody got two kinds ob speerits." And among the Bakongo, we know, the elderly use the plural to greet one another. Their duality referred to the opposing qualities of strength and weakness in every person. Here, each hatted figure is strong; and each figure without hat follows behind him, seeming weaker. At the top of the ladder the platform is long: the journey here is difficult, an ordeal to endure before continuing to climb. The pair of figures at the beginning of this ordeal has turned toward those coming up the ladder, apparently to urge them upward. The two at the top are a complementary pair; the weaker, standing with hand on hip, still indicates evil to be suppressed while the hatted figure tries to draw the others toward regeneration. The tension in this figure shows his strength.

From the top of the ladder the figures turn to make their way across the long space. At the end of it the hatless figure bends over. His legs spread out as he lowers himself. His arms reach the surface below him. His face bends down. Symbolically, he goes down to the mire. But he endures it. Regaining strength—hatted once more—he stretches to climb to the last stage. His one leg still in the mire, almost touching the arm of the hatless self behind him, he stretches the other leg as far as he can. It reaches almost as high as his arms, which stretch out in long parallel lines. His head looks up.

And there above him he sees the figure backed out in a sitting position but almost completely into the air, its feet barely touching the top of the ladder, its two strong arms reaching out as long as possible and raised as high as possible, to the top edge of the paper. It is the ancestral deity, its arms extended in a Kongo gesture of generosity, a value which for the Bakongo is intensely moral.[155] The arms of the hatted figure reach out to receive the blessing of the deity. The deity gestures that it will generously share forgiveness: it restores Traylor's balance; it restores his soul.

In Central Africa, beyond where the Zaire River divides into its Lomami and Lualaba branches and south onto the banks of the Lualaba River, live the Lengola people. Like all of their neighbors, they have a secret association which has political, legal, economic, and religious powers. Called Bukota among the Lengola, it is responsible for rituals of healing, circumcision, and burial. It, too, reveres the leopard. Its organizational structure has three stages, each subdivided into several levels. It requires kinship, teaching, fee payment, gift-giving, and moral responsibility of those who would be members. The society cuts across lineages to increase harmony among the people.

All these things they have in common with the Bwami society of their better-known neighbors, the Lega,[156] and with the Ozo and Ekpe societies of the Igbo and Efik in faraway Nigeria.

Little else is known of the Lengola but that they revered their ancestors. Among them is Suway. He is represented by a figure called ubanga nyama (Illus. 5.11). When an elder of the village died and had been buried, ubanga nyama was mounted, standing over seven feet tall, in the heart of the village. There the men of the village could make their supplications, calling on their founding spirit and the spirit of their new ancestor for help.[157]

Bill Traylor, too, left such a figure (Plate 25). The similarities are striking: head and chest triangulated, body a thin column, legs spread in balance, and arms uplifted. Traylor's figure includes a tripod device for making it stand upright. The messenger birds and dog, belonging to the figure in their connectedness to it, stand ready to go to work, while the "little man" who will prod them to action does not yet connect. The ancestor figure must first receive the invocation from humankind.

Traveling through African American cemeteries in the southern United States, Thompson found graves holding an array of twentieth-century vehicles—bicycle parts, ship, airplane. From the Kongo he found evidence of identical grave adornment. In 1965 MacGaffey photographed an airplane modeled to dominate the top of a Kongo grave.[158] Vehicles of the twentieth century have in common the ability to go fast. For the Bakongo and for African Americans they promise the quick journey desired both by the deceased, who would reach the spirit world quickly, and by the survivors, who would be able to call on the help of this spirit sooner.

In 1997 the *New York Times* illustrated a story about Bill Traylor with his drawing showing an airplane flying above while two figures and a dog ran along under it. It was called *Airplane Sighting* (Illus. 5.12). But now we can read the picture more closely and realize that it is not a mere "sighting." The position of the airplane is odd: drawn as if seen from above, Traylor's airplane joins the style of the reptiles carved on the now-famous walking sticks made by Henry Gudgell, James "Stick Daddy" Cooper, and William Rogers. Thompson related these, although not definitively, to a carved staff belonging to a Woyo chief in Congo-Kinshasa and to other African art forms. Traylor has also portrayed reptiles the same way.[159]

In discussing attitudes toward animals among the Bakongo, MacGaffey notes that "reptiles are most closely associated with the passage between the worlds and the relation between life and death." In modern times the reptiles have given way to vehicles. Dreaming of a vehicle warns, he says, that a "soul will be traveling." Moving fast and on wheels, vehicles circle as the sun circles through its four moments or as humankind circles through life. Airplanes' circling propellers power them through the air, creating

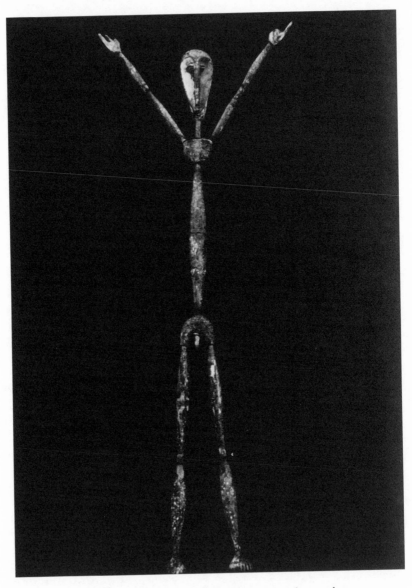

5.11. *Ubanga nyama.* Wood; 85" h. Lengola people,
Democratic Republic of Congo.
*Courtesy of The Africa-America Institute.*

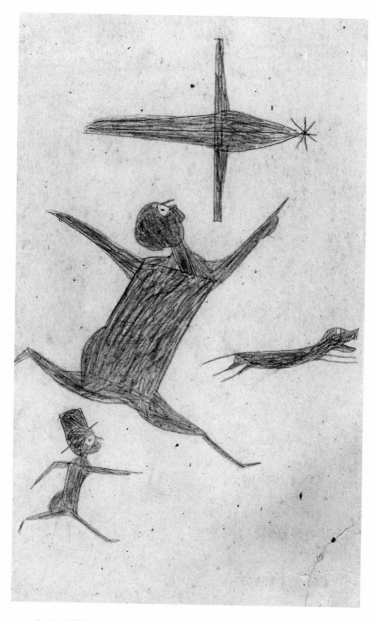

5.12. Bill Traylor, Untitled, exhibited as *Airplane Sighting*.
Pencil on cardboard; 14¼" x 8¾".
*Collection of Judy Saslow.*

currents that open the door to mpemba.[160] The airplane becomes a symbol for getting to the spirit world quickly. Thus, in Traylor's picture the man is running toward the spirit world, toward death. He is followed closely by his second spirit, the little man in top hat, who runs with his arms making the gesture of the Kongo cosmogram, the symbol of Baron Samedi, Lord of the Crossroads and Guardian of the Cemetery. The dog precedes them, open-mouthed with fangs bared: he carries a message. Every figure in the picture communicates speed. Speed is desirable.

When Bill Traylor lay ill in the Fraternal Hospital in 1947, he asked to see Charles Shannon. Shannon had held $25 for him for quite some time, but he did not ask for it at this visit. Only later, after he died, did his daughter call Shannon for the money.[161] Traylor had told her about it. In this way he had saved the money, just as African Americans before him had paid money to their fraternal organizations, in order to have it for his burial. For African Americans as for Africans the journey into the spirit world is a major rite of passage and must be done properly. Zora Neale Hurston taught it in *Their Eyes Were Watching God* when her Janie buried her love, Tea Cake:

> Tea Cake was the son of Evening Sun, and nothing was too good. . . . Tea Cake slept royally on his white silken couch among the roses she had bought. . . . Janie bought him a brand new guitar and put it in his hands. He would be thinking up new songs to play to her when she got there.[162]

Bill Traylor was prepared for this journey. Speed was indeed desirable; he was eager for it.

After 1942 Bill Traylor's "burst of creativity" ended.[163]

On January 5, 1944, Father Joseph Jacobi baptized Bill Traylor in St. Jude's Roman Catholic Church in Montgomery. Fully cognizant, Traylor used his formal name—William Traylor—for his ritual initiation.

On January 6, 1944, he received his first communion from Father Jacobi at St. Jude's Church. Like Nicodemus, like priests initiated into Ozo, like members initiated into Lemba, and like Sea Islanders received into prayer house and church, William Traylor was reborn through water and spirit.

Five years later, on October 23, 1949, William Traylor died in Oak Street Hospital in Montgomery. He received burial through the Roman Catholic Church.[164]

Bill Traylor had "climbed the ladder of death" to pass into the spirit world regenerated, a spiritually purified Christian African American.

# Epilogue
## *To Build a Nation*

Sam Gadsden said his forebears in the Sea Islands were separated by being taken to different islands to work, but they raised "a whole lot of children" and "they were a family, were sisters and brothers right on, because they could row across the river . . . and could row back. . . ."

In July 1863 Thomas Gadsden, liberated slave husband of Kwibo Tom's daughter Rebecca and grandfather of Sam Gadsden, enlisted in the Union army. He was assigned to Company C of the First South Carolina Volunteers. This African American regiment had been forming during the fall of 1862, and in November Thomas Wentworth Higginson had been asked to take command. Before Thomas Gadsden's enlistment the regiment had already faced enemy fire.[1]

The regiment's first expedition took the troops from Beaufort south into the St. Mary's River near Fernandina, Florida, where they hoped to capture lumber and save Union forces from having to bring it from the North. Higginson went ashore with about 100 soldiers. About two miles from their base they met their "first stand-up fight." They won it, although with casualties. And what Higginson had seen of their determination caused him to comment, "An officer may be pardoned some enthusiasm for such men as these." Among them a soldier who had captured two muskets had walked two miles back to camp with two bullet holes in his neck and shoulder, "and not a murmur escaped his lips." Another who was shot in the shoulder stood guard duty all night, not telling anyone about his wound lest he be taken off duty. And yet another with a potentially fatal head wound had to be compelled by his officers to give up duty and go to the medics.[2]

In the spring of 1863 the First South Carolina Volunteers returned to Beaufort and went on picket duty on the Coosa River. By that time Harriet Tubman, called "Moses" by her fellow African Americans, was a nurse on Port Royal Island near Beaufort. She tended wounded soldiers and islanders made ill by deprivations brought on by war. Gaining their confidence, she was able to travel inconspicuously around those islands and pick up information about Confederate defenses. A group of islanders helped her and in effect created a spy network that enabled Union officers to plan attacks. In the night of June 2, 1863, with a Union commander and about 300 African

American soldiers, she led a raid up the Combahee River, which flows between St. Helena and Edisto. That raid liberated over 700 slaves, who escaped to Beaufort on the Union boats; and it strengthened a growing argument to allow former slaves to join the Union army.[3]

A month after Tubman's raid, Higginson and Captain Charles Trowbridge led an expedition up the South Edisto. They hoped to liberate many slaves still working rice plantations for Confederate owners and to burn a railroad bridge connecting Savannah and Charleston. Confederate artillery frustrated their efforts to burn the bridge but could not stop the liberation of slaves. About 200 streamed to the river balancing belongings in bundles on their heads, old women kneeling down frequently to give prayers of thanks, women and older children carrying smaller children. Years later Higginson reflected, "When I think of the morning sunlight, those emerald fields, those thronging numbers, the old women with their prayers, and the little boys with their living burdens, I know that the day was worth all it cost, and more."[4]

The men who were liberated that day went into the army and on to fight. Their families went to camp out as refugees on St. Helena. During this time Thomas Gadsden's Company C was stationed on Hilton Head Island, but in October the whole regiment assembled in Beaufort. These men, when tested under fire, drew only complimentary reports from their commanding officers. Brigadier General Rufus Saxton reported to the Secretary of War that the African American troops "fought with a coolness and bravery that would have done credit to veteran soldiers. There was no excitement, no flinching, no attempt at cruelty when successful. They seemed like men who were fighting to vindicate their manhood and they did it well."[5]

Saxton recognized their superior knowledge of how to navigate the inlets and land in the marshes and woods. They understood the tides and currents as no white Union soldier ever could. Saxton requested special equipment and detailing to let these men lead where they had superiority. Lieutenant Colonel Oliver Beard, in command of an expedition on the Georgia and Florida coast, wrote:

> The colored men fought with astonishing coolness and bravery. For alacrity in effecting landings, for determination, and for bush fighting I found them all I could desire—more than I had hoped. They behaved bravely, gloriously, and deserve all praise.

Having set out with sixty-two African American troops, he returned to Beaufort with 156. And he commented, "As soon as we took a slave from his claimant we placed a musket in his hand and he began to fight for the freedom of others."[6]

Late in 1863 the First South Carolina was stationed at the new Camp Shaw, named for the heroic commander of the 54th Massachusetts who had recently been killed in the assault on Battery Wagner. Hoping to join an expedition to Florida early in 1864, the troops were frustrated by an out-

break of smallpox in their regiment. In July, however, Charles Trowbridge led the unit, now renamed the 33rd United States Colored Troops, on an invasion of James Island. Still a Confederate stronghold, James Island stood between the Union forces and the city of Charleston.[7]

On James Island there were people from the slave community of Thomas and Rebecca Gadsden, for Lydia Clark Murray's half-brother, Ephraim, had married Susan Bailey of James Island. The couple had settled there, and Ephraim Clark had become a successful cotton planter. When his mother died in 1823, he inherited Billy, Caty, and Charlotte, valued as a group at $1,300; African John, Maria, Emily, and Caroline, valued as a group at $900; and Little John, valued alone at $600. The grouping of valuations in all likelihood indicate families. These slaves, except for Emily and Caroline who probably were born after 1819, had come to Ephraim's mother from James Clark, Lydia's father, when he died in 1819. The Clark family remained closely connected to their relatives on Edisto through intermarriage and frequent visits.[8] When the 33rd United States Colored Troops invaded James Island, Thomas Gadsden had to know that his 33rd was fighting to free members of his wife's family.

That invasion began with the 103rd New York regiment leading, followed by the 33rd led by Trowbridge and then the 55th Massachusetts, also composed of African Americans. They advanced quietly in the wee hours of July 2nd, hoping to make a surprise attack. But when they had gotten deep into a marsh, the Confederates opened fire on them, and the lead regiment broke into disarray. The brigade commander ordered all to retreat. But his order was misunderstood, and both Trowbridge and the commanders of the other two regiments ordered a charge. In the confusion the order of the regiments was reversed so that the African American troops led the attack. They stormed and took the battery, the color-bearers of the 33rd and the 55th at the end racing each other to be the first in with the flag.[9]

Thomas Gadsden was restoring the freedom that Kwibo Tom and Wali and their families had lost when they had been smuggled into Bohicket Creek more than forty years before. Gadsden was a Union soldier for two years and four months, until he was discharged in November of 1865 because, like the soldier who was one of Higginson's "such men as these," he had been shot in the neck and shoulder in the service of his country. His name is inscribed in the National Archives of the United States in the records of Union veterans.

"They kept together," Sam Gadsden said, "and that way they founded a whole nation."

And so they did.

Áàshe.

# NOTES

## Abbreviations

*HCWR*    Harry Middleton Hyatt. *Hoodoo—Conjuration—Witchcraft—Rootwork*
PCOHP    Penn Community Services Oral History Project. Individual interviews are
listed alphabetically under this citation in the bibliography.

## Preface

1. John Mason, "Transformation," in Edwards and Mason, *Black Gods*, vii.
2. Cole and Aniakor, *Igbo Arts*, 9–10.
3. Morrin, "Bill Traylor," 31.
4. Armstrong, *The Affecting Presence*, xiv.
5. Rawley, *The Transatlantic Slave Trade*, 334–335, 18.
6. Thompson and Cornet, *The Four Moments of the Sun*, 45.
7. Neyt, *Traditional Arts*, 80.
8. Bentor, "Life as an Artistic Process," 66–71, 94. Bentor paraphrases and agrees
with a thesis given by Paul Riesman at the African Studies Association's annual
meeting in New Orleans, 1985.
9. Zahan, *The Religion, Spirituality, and Thought of Traditional Africa*, 2–7.
10. Vansina, *Paths in the Rainforests*, 19–21, passim.
11. Hyatt, *HCWR*, 1: 667.
12. Janzen, *Lemba*, 101.

## 1. Crossing the Middle Passage

1. Emory Campbell, director, Penn Community Services, interview by author, St.
Helena Island, S.C., 21 March 1983.
2. PCOHP, Gadsden; and Lindsay, *An Oral History of Edisto Island: Sam Gadsden
Tells the Story* (hereafter cited as *Sam Gadsden*).
3. Curtin, *The Atlantic Slave Trade*, 73–75.
4. U.S. Bureau of the Census, *Ninth Census*, 1870, Alabama, Lowndes County,
Benton Post Office; and U.S. Bureau of the Census, *Tenth Census*, 1880, Alabama,
Lowndes County, Benton Post Office. Census references are to "Population Sched-
ules" unless otherwise noted.
5. Vansina, *Oral Tradition as History*; and Vansina, *Art History*.
6. Vansina, *Oral Tradition as History*, xii, 111.
7. Vansina, *Oral Tradition as History*, 8; Lindsay, *An Oral History of Edisto
Island: The Life and Times of Bubberson Brown* (hereafter cited as *Bubberson
Brown*), 75; U.S. Bureau of the Census, *Twelfth Census*, 1900, South Carolina,
Charleston County, Edisto Island; and Lindsay, *Sam Gadsden*, 46–49, 11. Sam
Gadsden is listed as Emanuel. Census-takers who did not know the Gullah lan-
guage made many mistakes.
8. Lindsay, *Sam Gadsden*, 67; PCOHP, Gadsden; and Lindsay, *Bubberson Brown*,
54.

9. Vansina, *Oral Tradition as History*, 110; Nick Lindsay, interview by author, Edisto Island, S.C., 30 December 1989; and Lindsay, *Sam Gadsden*, 34. Gadsden's reference is to Chalmers Murray, *Here Come Joe Mungin*.

10. Lindsay, *Sam Gadsden*, 14–15; and PCOHP, Gadsden.

11. Vansina, *Oral Tradition as History*, 107, 17.

12. Morgan, "Black Society," 129–132; Lindsay, *Sam Gadsden*, 23; and Vansina, *Oral Tradition as History*, 111. Lindsay explores the Nigerian origin in *And I'm Glad*.

13. Herskovits, *The Myth of the Negro Past*, 33.

14. Vansina, *Art History*, 211.

15. *New York Times*, 2 September 1893, 2; 3 September 1893, 5.

16. Ibid.

17. *New York Times*, 30 August 1893, 1; 29 August 1893, 1.

18. *New York Times*, 3 September 1893, 5; 2 September 1893, 1; E. Mikell Whaley to *New York Times*, 25 September 1893; *New York Times*, 2 September 1893, 2; and 4 September 1893, 1.

19. PCOHP, Bradley; PCOHP, Rachel Holmes; PCOHP, Mack; PCOHP, Milton; and Glen, *Life on St. Helena*, 40–41.

20. Lindsay, "Stories from Edisto Island," 27–32.

21. Sam Doyle, interview by author, Wallace plantation, St. Helena Island, S.C., 21 March 1983.

22. Vansina, *Art History*, 41, 44.

23. Henderson, *The King in Every Man*, 120–121, 346–348, 376–377, 505–507; Cole and Aniakor, *Igbo Arts*, 24–34; Jeffreys, "Ikenga," 28–34; and Boston, *Ikenga Figures*, 13–14, 76–78, 110–120. Boston includes many illustrations of ikenga figures.

24. Livingston and Beardsley, *Black Folk Art in America*, 6, Catalog no. 90.

25. Maude S. Wahlman, lecture at University of Connecticut, Storrs, Conn., 19 March 1984.

26. Louis Armstrong, "New Orleans Function."

27. Hirschl & Adler Modern, *Bill Traylor*, 1985, Catalog no. 9; Margaret Ausfeld, Curator, Museum of Fine Arts, interview by author, Montgomery, Ala., 7 January 1987; Livingston and Beardsley, *Black Folk Art*, 140; and David Calloway Ross Sr., interview by author, Montgomery, Ala., 7 January 1987.

28. Métraux, *Voodoo in Haiti*, Plate III. For further introduction to Haitian lwa, see Deren, *Divine Horsemen*; Desmangles, *The Faces of the Gods*; and Rodman and Cleaver, *Spirits of the Night*.

29. Dewhurst, MacDowell, and MacDowell, *Religious Folk Art*, 77, Catalog no. 106.

30. Thompson and Cornet, *The Four Moments of the Sun*, 35.

31. Williams, *Voodoo and the Art of Haiti*, 102; Laguerre, *Voodoo Heritage*, 96; Helfenstein and Kurzmeyer, *Bill Traylor*, 70, Catalog no. 32; Maresca and Ricco, *Bill Traylor*, 54; and Jahn, *Muntu*, 46. Jahn specifies that Baron's leaves are withered; those with Traylor's figure are black.

32. Federal Writers' Project, *Alabama*, vol. 1 of *Slave Narratives*, microfiche, Card 10, 1F9, p. 432; Rawick, *Alabama Narratives*, vol. 1 of *American Slave*, Supplement, Series I, 444–445; Ibid., *Mississippi Narratives, Part 2*, vol. 7, 598; and Hyatt, *HCWR*, 2: 1067.

33. *Stitched from the Soul,* exhibition at the Museum of American Folk Art, New York, September 1989.

34. Ruel, *Leopards and Leaders,* 216; Talbot, *The Peoples of Southern Nigeria,* vol. 3, *Ethnology,* 779–780; Latham, *Old Calabar,* Maps 1 and 3 on pages 2 and 4, 35–37; and Jones, *The Art of Eastern Nigeria,* 6–13, 72–75, 194.

35. Udo Ema, "The Ekpe Society," 314–316; and Jones, "Political Organization," 135–148.

36. N'Idu, "Ekpe—Cross River Cult," 747–749; Simmons, "Ethnographic Sketch," 16–17; Jones, "Political Organization," 140; Thompson, *Art in Motion,* 182; and Ottenberg and Knudsen, "Leopard Society Masquerades," 38–40. See Leib and Romano, "Reign of the Leopard," 48–57, 94, especially for spectacular photographs.

37. Jones, "Political Organization," 140–141; Simmons, "Ethnographic Sketch," 17–20; and Duke, "Diary of Antera Duke," 14 and 15 October 1786, 48–49.

38. Simmons, "Ethnographic Sketch," 18; Simmons, "Notes on the Diary," 74 n. 64; and Duke, "Diary of Antera Duke," 29 August 1785, 37. All in Forde, *Efik Traders.*

39. Duke, "Diary of Antera Duke," 10 May 1785, 31; and Simmons, "Notes on the Diary." Both in Forde, *Efik Traders,* 71–72 n. 43.

40. Talbot, *Peoples of Southern Nigeria,* 932.

41. Laguerre, "Bizango," 149–157.

42. Davis, *Passage of Darkness,* 243.

43. Bastide, *The African Religions of Brazil,* 128; Murphy, *Santería,* 26–31; Hurston, *Tell My Horse;* and Leacock and Leacock, *Spirits of the Deep.*

## 2. Into the American Community

1. PCOHP, Gadsden.

2. Graydon, *Tales of Edisto,* 95.

3. PCOHP, Gadsden; Lindsay, *Sam Gadsden,* 11; Brockman, "The Clarks of Edisto," 8–9; *Charleston Courier,* 29 October 1819; and South Carolina, "Appraisement of the Goods and Chattels of the Late James Clark of Edisto Island," South Carolina Department of Archives and History.

4. Gerhard Speiler, "Island Count Matter of Dispute," *Beaufort Gazette,* 9 October 1984.

5. Hughson, *Carolina Pirates,* 329; and Graydon, *Tales of Edisto,* 12.

6. Paul Hamilton, Secretary of the Navy, to H. G. Campbell, 22 January 1811, in U.S. House, *Report of Mr. Kennedy,* H.R. 283, 27th Cong., 3rd sess., 230–231.

7. Dodd, "The Schooner *Emperor,*" 121–126.

8. Ibid., 126–128.

9. Quoted in Stafford, "Illegal Importations," 133; and DuBois, *The Suppression of the African Slave Trade,* 155–158.

10. Drake, *Revelations of a Slave Smuggler,* 49. Although some historians apparently accept this source as fact, it is highly suspect. Drake's editor hoped the journal would help abolitionist goals. Flamboyant coincidences run rampant. Yet some of the material is provable, and reading in the sources on piracy in the eighteenth and nineteenth centuries shows how true Drake's portrayals of butchery could be.

11. "Extract of a Letter from Captain John D. Henley to the Secretary of the Navy, 17 March 1818," in U.S. House, *Report of Mr. Kennedy,* H.R. 283, 27th Cong., 3rd Sess., 258.

12. A. S. Bullock, Collector at the Port of Savannah, Ga., to William H. Crawford, Secretary of the Treasury, 25 November 1817, in U.S. House, *Report of Mr. Kennedy,* H.R. 283, 27th Cong., 3rd Sess., 253–254; Judge William Johnson, Charleston, S.C., to the Secretary of State, 12 June 1821, in Society of Friends, *A View of the Present State of the African Slave Trade,* 44; and R. W. Habersham, District Attorney, Savannah, Ga., to the Secretary of State, 18 July 1821, in ibid., 46–47.

13. W. I. McIntosh, Collector at the Port of Darien, Ga., to William H. Crawford, Secretary of the Treasury, 14 March 1818, 252–253, and 5 July 1818, 251–252, in U.S. House, *Report of Mr. Kennedy,* H.R. 283, 27th Cong., 3rd sess.

14. Rev. Samuel Sitgreaves Jr., Baltimore, Md., to Rev. Jackson Kemper, Philadelphia, Pa., 16 May 1822, in Staudenraus, "Victims of the African Slave Trade," 149.

15. Quoted in Society of Friends, *A View of the Present State of the African Slave Trade,* 42–43.

16. Secretary of the Navy to M. M'Ilwain Jr., Marshal of South Carolina, 1 April 1820, in Society of Friends, *A View of the Present State of the African Slave Trade,* 43.

17. Thomas Parker, District Attorney, Charleston, S. C., to M. M'Ilwain Jr., Marshal of South Carolina, 13 May 1820, in Society of Friends, *A View of the Present State of the African Slave Trade,* 43.

18. For background regarding Dutch involvement in the slave trade in the seventeenth and eighteenth centuries, see Postma, "The Dimension of the Dutch Slave Trade," 237–248; Postma, "The Dutch Slave Trade," 234, 237; Postma, *The Dutch in the Atlantic Slave Trade;* and Unger, "Essay on the History of the Dutch Slave Trade," 46–98.

19. Emmer, "Surinam and the Decline of the Dutch Slave Trade," 248.

20. Postma, "The Dutch Slave Trade," 236–240; Treasure, *The Making of Modern Europe,* 489–490; and Boxer, *The Dutch Seaborne Empire,* 244–245, 281–283.

21. U.K., Foreign Office 84/19, "Memorandum respecting the Slave Trade by Zachary Macaulay, of 5th September 1822," quoted in Fyfe, *Sierra Leone Inheritance,* 156–157; "Queries proposed by Viscount Castlereagh to, and answers of, the African Society, in London, December, 1816," in U.S. House, *Report of Mr. Kennedy,* H.R. 283, 27th Cong., 3rd sess., 308–311; Ward, *The Royal Navy and the Slavers,* 58; and U. K., Colonial Office 267/29 fol. 152–153, "Report of the Commission of Inquiry, 1811," in Fyfe, *Sierra Leone Inheritance,* 155–156.

22. USS *Cyane* to the Secretary of the Navy, 10 April 1820, in U.S. House, *Report of Mr. Kennedy,* H.R. 283, 27th Cong., 3rd sess., 297; and Ward, *The Royal Navy and the Slavers,* 81, 70.

23. Society of Friends, *A View of the Present State of the African Slave Trade,* 35–39.

24. *Charleston (S.C.) Carolina Gazette,* 27 April 1822, quoting the *Royal Gazette and Sierra Leone Advertiser,* 16 February 1822.

25. Ward, *The Royal Navy and the Slavers,* 91–93; and "Extracts from the Royal Gazette and Sierra Leone Advertiser, January 6, 1822," in Society of Friends, *A View of the Present State of the African Slave Trade,* 16. Italics mine.

26. David Murray, *Odious Commerce,* 1–91; Klein, *The Middle Passage,* 209–211; DuBois, *The Suppression of the African Slave Trade,* 110–111; and Bradlee, *Piracy in the West Indies and Its Suppression,* 21.

27. Secretary of the Navy to Capt. Daniel T. Patterson, 17 December 1817, in U.S. House, *Report of Mr. Kennedy,* H.R. 283, 27th Cong., 3rd sess., 232; and Bradlee, *Piracy in the West Indies and Its Suppression,* 21.

28. Bradlee, *Piracy in the West Indies and Its Suppression,* 22, 41–42.

29. U.S. Department of the Navy, *Dictionary of Fighting Ships,* 6: 574; Cornelius Bennett, Sailing Master, USS *Spark,* to the Hon. Smith Thompson, Secretary of the Navy, 18 February 1822, in Naval Records Collection, National Archives and Records Administration.

30. *Charleston (S.C.) Southern Patriot and Commercial Advertiser,* 23 and 27 February 1822; *Charleston Mercury,* 23 February 1822; and *Charleston (S.C.) Carolina Gazette,* 2 March 1822.

31. PCOHP, Gadsden. Italics denote Gadsden's emphasis.

32. Lindsay, *Sam Gadsden,* 23–24.

33. Martin, "The Trade of Loango," 144–152; and Martin, *The External Trade of the Loango Coast,* 42–88.

34. Murdock, *Africa,* 292; Vansina, "Notes," 37; and Martin, *The External Trade of the Loango Coast,* Chapter 1.

35. Martin, *The External Trade of the Loango Coast,* 19–27.

36. Ibid., 96–100.

37. U.S. Bureau of the Census, *Twelfth Census,* 1900, South Carolina, Charleston County, Mt. Pleasant Township; and Eberson Murray, "Memoirs," 6.

38. Lindsay, *Sam Gadsden,* 25–26.

39. Ibid., 26–27.

40. Martin, *The External Trade of the Loango Coast,* 171–172.

41. Ibid., 29–132; Robertson, *Notes on Africa,* 364, 322; and Adams, *Remarks on the Country Extending from Cape Palmas to the River Congo,* 154.

42. Martin, *The External Trade of the Loango Coast,* 93–117; Vansina, *The Tio Kingdom,* 248–255.

43. Vansina, *The Tio Kingdom,* 250–253.

44. Perkins, *To the Ends of the Earth,* 62.

45. Quoted in Martin, *The External Trade of the Loango Coast,* 118–119. Koubedika was a Vili porter in 1891. Martin quoted from an interview by Elie Gandziami, "De Loango à Tandala par la Piste de Caravanes," *Liaison* XLIX–L (1955): 26–30.

46. Martin, *The External Trade of the Loango Coast,* 119–126.

47. Weeks, *Among the Primitive Bakongo,* 204–205.

48. Ibid., 205.

49. Martin, *The External Trade of the Loango Coast,* 120–121; Monteiro, *Angola and the River Congo,* 1: 203–204.

50. Monteiro, *Angola and the River Congo,* 1: 202–203.

51. Vansina, *The Tio Kingdom,* 253.

52. Harms, *River of Wealth,* 81–82.

53. Martin, *The External Trade of the Loango Coast,* 120; Vansina, *The Tio Kingdom,* 257, 253; Harms, *River of Wealth,* 81; and Vansina, *Paths in the Rainforests,* 202, 360 n. 9.

54. PCOHP, Gadsden.

55. Martin, *The External Trade of the Loango Coast,* 159; and Adams, *Remarks on the Country Extending from Cape Palmas to the River Congo,* 265.

56. Tams, *Visit to the Portuguese Possessions in South-Western Africa,* 2: 173 and 1: 226.

57. Tuckey, *Narrative of an Expedition to Explore the River Zaire,* 214.

58. Harms, *River of Wealth,* 63; Martin, "Power, Cloth and Currency," 4; and Monteiro, *Angola and the River Congo,* 1: 21.

59. Martin, *The External Trade of the Loango Coast,* 106; and Tuckey, *Narrative of an Expedition to Explore the River Zaire,* 199, 212.

60. Martin, "Power, Cloth and Currency," 1–12.

61. Bentley, *Pioneering on the Congo,* 1: 174–175.

62. Martin, *The External Trade of the Loango Coast,* 109.

63. Owen, *Narrative of Voyages to Explore the Shores of Africa, Arabia, and Madagascar,* 2: 171.

64. Adams, *Remarks on the Country Extending from Cape Palmas to the River Congo,* 253–259; and Vogel and N'Diaye, *African Masterpieces,* 94 and 150, Catalog no. 70.

65. Martin, *The External Trade of the Loango Coast,* 70, 130–132.

66. Martin, *The External Trade of the Loango Coast,* 132; and Vansina, *Paths in the Rainforests,* 94.

67. Tuckey, *Narrative of an Expedition to Explore the River Zaire,* 126, 283.

68. Rinchon, *Pierre-Ignace-Liévin van Alstein,* 156; Tuckey, *Narrative of an Expedition to Explore the River Zaire,* 153; and Dennett, *Seven Years among the Fjort,* 147–149.

### 3. Voices of Survival

1. South Carolina, "Appraisement of the Goods and Chattels of the Late James Clark of Edisto Island," South Carolina Department of Archives and History; Bentley, *Pioneering on the Congo,* 1: 385–386; and MacGaffey, *Custom and Government in the Lower Congo,* 3.

2. South Carolina, "Appraisement of the Goods and Chattels of the Late James Clark."

3. Vansina, *The Tio Kingdom,* 11; MacGaffey, *Custom and Government in the Lower Congo,* 19; and Lindsay, *Sam Gadsden,* 12–13.

4. Vansina, *The Tio Kingdom,* 9–11.

5. Martin, *The External Trade of the Loango Coast,* 10–11, 144.

6. Griaule, *Conversations with Ogotemmêli,* 27; and Dieterlin, "Parenté et mariage chez les Dogon," 109.

7. MacGaffey, *Custom and Government in the Lower Congo,* 96–98; and Munday, "Spirit Names," 39–44.

8. MacGaffey, *Religion and Society,* 109–111.

9. Horton, "African Traditional Thought," 157.

10. MacGaffey, *Custom and Government in the Lower Congo,* 96–97; Herskovits, *The Myth of the Negro Past,* 190; Towne, *Letters and Diary of Laura M. Towne,* 84; and Botume, *First Days amongst the Contrabands,* 45–49. Baltimore Chaplin rose to the rank of sergeant in the U.S. Army.

11. Louise Mason McDaniels, interview by author, Hollywood, S.C., 16 August 1990; and Mrs. Evelina Fludd, interview by author, Hollywood, S.C., 16 August 1990.

12. Cooley, *School Acres,* 156.

13. Lavinia Fields, interview by author, St. Helena Island, S.C., 25 October 1985; and Lorenzo Turner, *Africanisms in the Gullah Dialect,* 40–43, 148.

14. Lindsay, *Bubberson Brown*, 27–29; Vansina, *The Tio Kingdom*, 8–12; and U.S. Bureau of the Census, *Ninth Census*, 1870, South Carolina, Charleston County, Edisto Island.

15. Dabbs, *Sea Island Diary*, following 51.

16. MacGaffey, *Custom and Government in the Lower Congo*, Chapter 9, 182, 203.

17. Soret, "La propriété foncière," 281–296; and Bohannon, "'Land,' 'Tenure,' and Land-Tenure," 105–107.

18. PCOHP, Gadsden; U.S. Bureau of the Census, *Fifth Census*, 1830, "Slave Schedule," South Carolina, Charleston District–St. John's Colleton Parish and Beaufort District–St. Helena Parish; Rosengarten, *Tombee*, 588; and Deacon Tom Brown, interview by author, St. Helena Island, S.C., 7 July 1983.

19. MacGaffey, *Custom and Government in the Lower Congo*, 17–22.

20. Ibid.

21. Ibid., 25; and Fu-Kiau, *Le MuKongo*, 106–107.

22. Lindsay, *Sam Gadsden*, 24–25.

23. MacGaffey, *Custom and Government in the Lower Congo*, 82; and Evelina Fludd, interview by author, Hollywood, S.C., 16 August 1990.

24. Lindsay, *Sam Gadsden*, 29.

25. PCOHP, Gadsden; and Lindsay, *Bubberson Brown*, 29.

26. Lindsay, *Sam Gadsden*, 1–5.

27. MacGaffey, *Custom and Government in the Lower Congo*, 19; and PCOHP, Gadsden.

28. Quoted in Lindsay, *Bubberson Brown*, 53. The U.S. Census of 1870 for Edisto Island lists Caesar Knight, age 55, with Eliza Knight, age 40, and four children. Census-takers usually listed all birthplaces of African Americans as "South Carolina," so most of these lists are not reliable sources for birthplaces of parents or elderly people of foreign birth.

29. MacGaffey, *Custom and Government in the Lower Congo*, 19–21; and Lindsay, *Sam Gadsden*, 25.

30. Lindsay, *Sam Gadsden*, 25, 60–62.

31. Ibid., 60–62.

32. PCOHP, Grant; PCOHP, Milton; and PCOHP, Bradley. Walterboro, South Carolina, is about 45 miles inland.

33. Doyle painted several versions of his subjects. A large version of the freedom painting is in the collection of Penn Center.

34. Cooley, "Homes of the Freed," 36–39; Sam Doyle, interview by Vertamae Grosvenor, "Horizons," National Public Radio, 25 July 1984; portraits illustrated in LaRoche, *Sam Doyle*; and U.S. Bureau of the Census, *Twelfth Census*, 1900, South Carolina, Beaufort County, St. Helena Island. Doyle said that Cinda Ladson learned midwifery from "Dr. White." Thomas Grimké White owned Woodstock plantation, next to Frogmore. He did practice medicine early on but switched to practicing law. T. B. Chaplin called him "fickle" (see Rosengarten, *Tombee*, 694). Rossa Cooley was headmistress of Penn School, older than Doyle, and knew Adelaide well, as Penn students helped care for Adelaide when she was old. Doyle was incorrect in saying that Adelaide was Cinda's sister. Susan Doyle Myers confirmed that Adelaide was Cinda's daughter.

35. Sam Doyle, Tom Brown, and Dirk Kuyk, conversation with author, St. Helena Island, S.C., 21 December 1984.

36. MacGaffey, *Custom and Government in the Lower Congo*, 21; and Sam Doyle, interview by author, St. Helena Island, S.C., 23 March 1983.

37. Tindall, *South Carolina Negroes*, 284; Asa Gordon, *Sketches of Negro Life and History in South Carolina*, 84; Walton, "The Negro in Richmond," 51; and Burrell, "The Negro in Insurance," 13–14.

38. Trent, "Development of Negro Life Insurance Enterprises," 20; and DuBois, "Some Efforts of American Negroes," 13. Trent added that secret orders became "legion" in a short time but gave no source for his information. Carter Woodson stated that African American fraternal orders originated in Richmond. He, too, gave no source. See Carter Woodson, "Insurance Business among Negroes," 205–206. These are examples of many indications that much of African American history has been transmitted orally.

39. Klein, "Slaves and Shipping," 383–412; and Curtin, *The Atlantic Slave Trade*, 150. Although figures showing total numbers of slaves exported from Africa have been revised, the trend still shows that the high volume of Biafra export coincided with Virginia's import. Klein has done a thorough exposition of slave trade literature, including revisions of figures, in the "Bibliographic Essay" in his *The Atlantic Slave Trade*.

40. Klein, "Slaves and Shipping," 396; Kulikoff, "The Origins of Afro-American Society," 231–233; Curtin, *The Atlantic Slave Trade*, 144, 156–158; and Wax, "Preferences for Slaves in Colonial America," 394–398.

41. N'Idu, "Ekpe," 749; and Udo Ema, "The Ekpe Society," 314.

42. "Stick" is a word from pidgin English referring to a length of wood: Ottenberg, *Masked Rituals of Afikpo*, 11. Here the "sticks" are carved symbols. The degree of carving may vary.

43. Nzekwu, "Initiation into the Agbalanze Society," 173; and Forrester, *Degree Ritual* (1894), 11.

44. Nzekwu, "Initiation into the Agbalanze Society," 174–175; Henderson, *The King in Every Man*, 251; Janzen, "The Tradition of Renewal," 90; Forrester, *Degree Ritual* (1894), 47, 41; and Victor Turner, "Colour Classification," 47–83, 79.

45. A tantalizing coincidence with this Igbo use of "rubbing" to mean gaining knowledge appeared in a speech by one W. L. Taylor of Richmond: "I heard an elder say, 'I have never rubbed my head on a college wall'; but he knew more than some of the boys that had rubbed their heads against the wall." Burrell, *Twenty-five Years History of the Grand Fountain of the United Order of True Reformers*, 129.

46. Forrester, *Degree Ritual* (1894), 30.

47. Henderson, *The King in Every Man*, 259–260; and Nzekwu, "Initiation into the Agbalanze Society," 183.

48. Forrester, *Degree Ritual* (1894), 27, 36, 45–47.

49. Forrester, *Degree Ritual* (1894), 37–39; Henderson, *The King in Every Man*, 259–260.

50. "Knights of Pythias: Another New Lodge in Richmond," *Richmond Planet*, 28 October 1905.

51. Forde and Jones, *The Ibo and Ibibio-Speaking Peoples*, 20, 32, 37; and Nzimiro, *Studies in Ibo Political Systems*, 46–50.

52. Latham, *Old Calabar*, 24–40; Udo Ema, "The Ekpe Society," 314; Duke, "Diary of Antera Duke," 27–65; and Simmons, "Ethnographic Sketch," 18.

53. Forrester, *Ritual* (1877), 39, 15. Both 1877 and 1894 editions contain governing rules.

54. Forrester, *Degree Ritual* (1894), 10, 16–18, 32–33.

55. Ibid., 32–33, 36–37, 42–44.

56. Ibid., 42–44.

57. Ibid., 38.

58. Nzekwu, "Initiation into the Agbalanze Society," 173; and Henderson, *The King in Every Man,* 315, 267. Nzekwu refers to ancestral spirits rather than "personal god." Henderson (111–125) clarifies distinctions between gods, ghosts, and spirits; and I have used his term, "personal god."

59. Forrester, *Ritual* (1877), 35–36; and Dorothy V. Turner, interview by author, Richmond, Va., 16 December 1977.

60. Forrester, *Degree Ritual* (1894), 41, 47–48.

61. F. A. Onwuemelie of Awka recorded by Isichei in *Igbo Worlds,* 67; and Dorothy V. Turner, interview by author, Richmond, Va., 16 December 1977.

62. Mbiti, *African Religions,* 157–163; Tempels, *Bantu Philosophy,* 44–65, 100–101; Henderson, *The King in Every Man,* 109–112; and Uchendu, *The Igbo of Southeast Nigeria,* 12.

63. Burrell, "The Negro in Insurance," 13–14; and Simmons, "Ethnographic Sketch," 18.

64. Forrester, *Ritual* (1877), 46; Meek, *Law and Authority in a Nigerian Tribe,* 180; and Thomas, "Ibo Burial," 176.

65. Forrester, *Ritual* (1877), 47; and Thomas, "Ibo Burial," 204, 180, Plate V(I).

66. Forrester, *Ritual* (1877), 43; Thomas, "Ibo Burial," 198–199, 182, 160–212; and Meek, *Law and Authority in a Nigerian Tribe,* 304.

67. Forrester, *Ritual* (1877), 43, 48; Thomas, "Ibo Burial," 165–180, 185; and Meek, *Law and Authority in a Nigerian Tribe,* 179.

68. Forrester, *Ritual* (1877), 49.

69. Mulago, "Vital Participation," 138–139; and Arazu, "Prayer of Titled Men," in Isichei, *Igbo Worlds,* 168.

70. Meek, *Law and Authority in a Nigerian Tribe,* 174–175; Jones, "Political Organization," 140; Jones, *The Trading States of the Oil Rivers,* 96; and Offodile, "Title Taking in Awka," 16.

71. DuBois, *Economic Cooperation,* 138; Abram Harris, *The Negro as Capitalist,* 62–63; Burrell, "The True Reformers," 267–269; Burrell, *Twenty-Five Years History of the Grand Fountain of the United Order of True Reformers,* 83–84, 108, 147–158, 194, 267–268, 295–296; and "In the Sanctum," *The Voice of the Negro,* 723. The National Negro Business League also held such prayer meetings. *The Voice of the Negro* called them "peculiar" and commented, "This . . . is purely and originally Negro."

72. Dr. Bessie B. Tharps, "Rewards for Service," in Dabney, *Maggie L. Walker,* 102; Walker, "Address," 20 August 1901; Dabney, *Maggie L. Walker,* 38–40; Trent, "Development of Negro Life Insurance Enterprises," 23; and Clairmont Williams, "The Afro-American People of Greenville," 429.

73. "Here and There," *Colored American Magazine,* 387–389; and Fleming, "A History of the Consolidated Bank and Trust Company," 17.

74. Howard Turner, *Turner's History of the Independent Order of Good Samaritans,* 96–97, 147–148; Ross, *Black Heritage,* 146; and Tindall, *South Carolina Negroes,* 284.

75. Gannett and Hale, "The Freedmen at Port Royal," 11.

## 4. Sea Islands Voices

1. Lawton, "The Religious Life of South Carolina Coastal and Sea Island Negroes," 186–187.
2. U.S. Bureau of the Census, *Thirteenth Census*, 1910, South Carolina, Beaufort County, St. Helena Township; Daise, *Reminiscences of Sea Island Heritage*, 87; and Sam Doyle, interview by author, St. Helena Island, S.C., 8 December 1983.
3. Hyatt, *HCWR*, 2: 1325–1334.
4. MacGaffey, *Art and Healing of the Bakongo*, 4–5.
5. Ibid., 5.
6. Janzen, *Lemba*, 101.
7. Fu-Kiau, *Le MuKongo*, 119.
8. Positions of the sun are clarified by Janzen in his introduction to Fu-Kiau. The system is explained in detail by MacGaffey in *Religion and Society* and by Thompson and Cornet in *The Four Moments of the Sun*. Many variations of the cosmogram are illustrated by Thompson in *The Four Moments of the Sun; Flash of the Spirit;* and *Face of the Gods*.
9. MacGaffey, *Religion and Society*, 96–97; and Fu-Kiau, *Le MuKongo*, 107–109 and Diagram T.4.
10. MacGaffey, *Religion and Society*, 99–102.
11. Thompson and Cornet, *The Four Moments of the Sun*, 41.
12. Ibid., 67.
13. PCOHP, Robert Grant; PCOHP, Franklin Holmes; and PCOHP, Mattis.
14. PCOHP, Franklin Holmes; PCOHP, Perry; and Sam Doyle, interview by author, St. Helena Island, S.C., 21 March 1983.
15. Susan Doyle Myers and Lavinia Doyle Fields, interview by author, St. Helena Island, S.C., 25 October 1985; and Sam Doyle, interview by author, St. Helena Island, S.C., 21 March 1983.
16. PCOHP, Johnson and Polite.
17. Jacobson-Widding, "Death Rituals," 141–145; and PCOHP, Perry.
18. MacGaffey, *Religion and Society*, 110; Knappert, *Myths and Legends of the Congo*, 158–161; and Sam Doyle, interview by author, St. Helena Island, S.C., 21 March 1983.
19. Sam Doyle, interview by author, St. Helena Island, S.C., 21 March 1983.
20. Weeks, *Among the Primitive Bakongo*, 241.
21. Thompson and Cornet, *The Four Moments of the Sun*, 90, 122–123.
22. McTeer, *High Sheriff*, 19–20.
23. Ibid., 35; McTeer, *Fifty Years*, 25; U.S. Bureau of the Census, *Tenth Census*, 1880, South Carolina, Beaufort County, St. Helena Island; U.S. Bureau of the Census, *Thirteenth Census*, 1910, South Carolina, Beaufort County, St. Helena Island Township; and Janzen, *Lemba*, 297. "Toom" was also transliterated to "Thomas."
24. Samuel Hopkins Adams and John Berendt are among those who have written about Doctor Buzzard.
25. Hyatt, *HCWR*, 2: 1738–1747. Hyatt did not believe this informant was telling the truth, but the coincidence of detail is too strong for disbelief.
26. PCOHP, Loundes; and Lawton, "The Religious Life of South Carolina Coastal and Sea Island Negroes," 143.

27. Peterkin, *Roll, Jordan, Roll,* 179.

28. Ibid.; and PCOHP, Jeremiah Alston.

29. Lawton, "The Religious Life of South Carolina Coastal and Sea Island Negroes," 148.

30. PCOHP, Chaplin; PCOHP, David Grant; PCOHP, Doyle; PCOHP, Milton; Parsons, *Folk-Lore of the Sea Islands, South Carolina,* 204; Lawton, "The Religious Life of South Carolina Coastal and Sea Island Negroes," 150–153, 144; and Sam Doyle, interview by author, St. Helena Island, S.C., 21 March 1983.

31. PCOHP, Loundes; PCOHP, Chaplin; PCOHP, Gertrude Green; PCOHP, Robert Grant; and Lawton, "The Religious Life of South Carolina Coastal and Sea Island Negroes," 143.

32. Lawton, "The Religious Life of South Carolina Coastal and Sea Island Negroes," 139; and PCOHP, Perry.

33. PCOHP, Jenkins.

34. PCOHP, Rivers.

35. PCOHP, Loundes; PCOHP, Doyle; PCOHP, Gertrude Green; U.S. Bureau of the Census, *Tenth Census,* 1880, South Carolina, Beaufort County, St. Helena Island; and U.S. Bureau of the Census, "Veterans and Widows Schedule," *Eleventh Census,* 1890, South Carolina, Beaufort County, Frogmore Post Office–St. Helena Township.

36. U.S. Bureau of the Census, *Fourteenth Census,* 1920, South Carolina, Beaufort County, St. Helena Island; PCOHP, Loundes; PCOHP, Chaplin; and PCOHP, Smalls.

37. Lawton, "The Religious Life of South Carolina Coastal and Sea Island Negroes," 150–162.

38. PCOHP, Ezekiel Green.

39. PCOHP, Rivers.

40. PCOHP, Josephine Green; PCOHP, Smalls; and PCOHP, Milton.

41. Lawton, "The Religious Life of South Carolina Coastal and Sea Island Negroes," 71; and PCOHP, Emanuel Alston.

42. Lawton, "The Religious Life of South Carolina Coastal and Sea Island Negroes," 72; Ames, *New England Woman's Diary,* 81–82.

43. Lawton, "The Religious Life of South Carolina Coastal and Sea Island Negroes," 15.

44. PCOHP, Emanuel Alston.

45. Lawton, "The Religious Life of South Carolina Coastal and Sea Island Negroes," 16.

46. PCOHP, Emanuel Alston.

47. Lawton, "The Religious Life of South Carolina Coastal and Sea Island Negroes," 172–179.

48. Ibid.; and PCOHP, Bradley.

49. PCOHP, Jenkins; PCOHP, Anderson; Pearson, *Letters from Port Royal,* 146; and Pinky Murray in Parsons, *Folk-Lore of the Sea Islands, South Carolina,* 205.

50. PCOHP, Bradley; Lawton, "The Religious Life of South Carolina Coastal and Sea Island Negroes," 28–30; and Parsons, *Folk-Lore of the Sea Islands, South Carolina,* 205.

51. Lawton, "The Religious Life of South Carolina Coastal and Sea Island Negroes," 36–38; and Parsons, *Folk-Lore of the Sea Islands, South Carolina,* 205.

52. Lawton, "The Religious Life of South Carolina Coastal and Sea Island Negroes," 77–79.

53. Lindsay, *Sam Gadsden*, 34; and Chalmers Murray, *Here Come Joe Mungin*, 59–61.

54. Pearson, *Letters from Port Royal*, 26–28, 44.

55. Forten, "Life on the Sea Islands," 82; *New York Nation*, 30 May 1867, in Allen, Ware, and Garrison, *Slave Songs of the United States*, xiii; Pearson, *Letters from Port Royal*, 26; and Schwartz, *A Woman Doctor's Civil War*, 39–40.

56. Excerpt from Robert Gordon, "Negro Spiritual," in Botkin, *A Treasury of Southern Folklore*, 657–659.

57. Ibid., 659; Works Progress Administration, *Drums and Shadows*, 141; and Parrish, *Slave Songs of the Georgia Sea Islands*, 71–72.

58. Janzen, *Lemba*, 3.

59. Weeks, *Among the Primitive Bakongo*, 79; and Cooley, *School Acres*, 116.

60. Thompson and Cornet, *The Four Moments of the Sun*, 83, 38.

61. Janzen, *Lemba*, 3.

62. Federal Writers' Project, "Lizzie Davis," in *South Carolina*, Part I, vol. XIV of *Slave Narratives*, microfiche, Card 131, 2F8, p. 293.

63. Forten, "Life on the Sea Islands," 82; Glen, *Life on St. Helena Island*, 37; PCOHP, Mattis; and PCOHP, Cohen, Part I.

64. Parrish, *Slave Songs of the Georgia Sea Islands*, 106–107; and Allen, Ware, and Garrison, *Slave Songs of the United States*, 14.

65. Cooley, "Homes of the Freed," 65; Nick Lindsay, interview by author, Edisto Island, S.C., 16 August 1990; and Vass, *Bantu Speaking Heritage*, 52, 57.

66. PCOHP, Emanuel Alston; and Deacon Tom Brown, interview by author, St. Helena Island, S.C., 6 and 7 July 1983.

67. Deacon Tom Brown, interview by author, St. Helena Island, S.C., 6 and 7 July 1983; Glen, *Life on St. Helena Island*, 39–40; and Janzen, *Lemba*, 321.

68. Janzen, *Lemba*, Plate 3.

69. Hyatt, *HCWR*, 2: 1416–1418; and Ibid., 1: 730.

70. Janzen, *Lemba*, passim, 256–257; and Works Progress Administration, *Drums and Shadows*, 3, 190–191, 20–21.

71. Sam Doyle, interview by author, St. Helena Island, S.C., 5 December 1983; U.S. Bureau of the Census, *Twelfth Census*, 1900, South Carolina, Beaufort County, St. Helena Island; PCOHP, Johnson and Polite; and Hyatt, *HCWR*, 2: 1742–1745.

72. PCOHP, Jim and Julia Horton; PCOHP, Jim Horton, Part I; and PCOHP, Ezekiel Green.

73. Janzen, 179–182; and PCOHP, Jim Horton, Part I.

74. PCOHP, Jim Horton, Part I.

75. Fu-Kiau, *Le MuKongo*, 112, T.12.

76. Ibid., 111–114.

77. Fu-Kiau, *Le MuKongo*, 111; Sam Doyle, interview by Vertamae Grosvenor, "Horizons," National Public Radio, 25 July 1984; U.S. Bureau of the Census, *Twelfth Census*, 1900, South Carolina, Beaufort County, St. Helena Island; Susan Doyle Myers, interview by author, St. Helena Island, S.C., 25 October 1985; and Emory Campbell, interview by author, St. Helena Island, S.C., 3 November 1986. Some have suggested that Doyle's *He/She* figures represent homosexuality. When Doyle

wanted to paint homosexual subjects, he painted two people of the same sex, as in *Two Ladies*, or he gave the painting an indicative title, as in *Miss Boy*. These are illustrated in LaRoche, *Sam Doyle*.

78. Cooley, "Homes of the Freed," 57; Robert Gordon, "Negro 'Shouts' from Georgia," 451; Gutman, *The Black Family in Slavery and Freedom*; and Clarke, *Wrestlin' Jacob*, 123–124. See also Kuyk, "Seeking Family Relationships."

79. Janzen, *Lemba*, 161–162; and Peterkin, *Black April*, 74–75.

80. Hyatt, *HCWR*, 2: 1025.

81. Federal Writers' Project, "Eliza Hasty," in *South Carolina*, Part II, vol. XIV of *Slave Narratives*, microfiche, Card 136, 3F8, pp. 254–255; Janzen, *Lemba*, 121–123, 139; and PCOHP, Cohen, Part II.

82. Janzen, *Lemba*, 116–123; and Lorenzo Turner, *Africanisms in the Gullah Dialect*, 271–273.

83. Janzen, *Lemba*, 140–143, 172–174.

84. Ibid., 122.

85. Hyatt, *HCWR*, 2: 1751.

86. Ibid., 1752; and Janzen, *Lemba*, 142.

87. Hyatt, *HCWR*, 2: 1420–1421.

88. Ibid., 1746–1747.

89. Hyatt, *HCWR*, 1: 33; Parsons, *Folk-Lore of the Sea Islands, South Carolina*, 208; and Deacon Tom Brown, interview by author, St. Helena Island, S.C., 6 July 1983.

90. Janzen, *Lemba*, 234–243; and Lawton, "The Religious Life of South Carolina Coastal and Sea Island Negroes," 51–52.

91. Janzen, *Lemba*, 210–214; see 220–222 for a structural analysis of the bell as mediating instrument.

92. Ibid., 105–107, 197.

93. Ibid., 151, 196.

94. Ibid., 277; and Steiner, "Seeking Jesus," 172.

95. Lawton, "The Religious Life of South Carolina Coastal and Sea Island Negroes," 71; and Janzen, *Lemba*, 189.

96. Janzen, *Lemba*, 130, 291–292.

97. Ibid., 172–173, 141, 197, 146–147.

98. Ibid., 189, 200, 255–256.

99. PCOHP, David Grant; and Janzen, *Lemba*, Plates 18 and 19, p. 255.

100. Janzen, *Lemba*, 211–212, 108.

101. Ibid., 234, 236.

102. PCOHP, Ezekiel Green.

103. Hyatt, *HCWR*, 1: 512, 135.

104. Sam Doyle, interview by author, St. Helena Island, S.C., 21 March 1983; and MacGaffey, *Religion and Society*, 50.

105. Janzen, *Lemba*, 113–114, 133; PCOHP, Milton; PCOHP, David Grant; and Lawton, "The Religious Life of South Carolina Coastal and Sea Island Negroes," 28–29.

106. Janzen, *Lemba*, 193–194.

107. MacGaffey, *Religion and Society*, 154; MacGaffey, *Art and Healing of the Bakongo*, 141; MacGaffey, "Fetishism Revisited," 172–183; Nooter, *Secrecy*, 107; and Janzen, *Lemba*, 194.

108. Higginson, *Army Life in a Black Regiment*, 135–136; and Janzen, *Lemba*, 290–291.

109. Janzen, *Lemba*, 117, 162; and Higginson, *Army Life in a Black Regiment*, 41, 33.

110. Janzen, *Lemba*, 190–192.

111. Somé, *Of Water and the Spirit*, 214, 243–244, 226.

112. Parrish, *Slave Songs of the Georgia Sea Islands*, 146; Allen, Ware, and Garrison, *Slave Songs of the United States*, 53; PCOHP, David Grant; and PCOHP, Cohen, Part I.

113. MacGaffey, *Religion and Society*, 52; Janzen, *Lemba*, 190–192; and Hyatt, *HCWR*, 2: 1742–1743.

114. Works Progress Administration, *Drums and Shadows*, 125, 131; and Janzen, *Lemba*, 108, 52.

115. Janzen, *Lemba*, 117.

116. Ibid., 163, 170, 249–250.

117. Ibid., 193; and Higginson, *Army Life in a Black Regiment*, 197–198.

118. Janzen, *Lemba*, 193; Higginson, *Army Life in a Black Regiment*, 194; and Allen, Ware, and Garrison, *Slave Songs of the United States*, 4.

119. Glen, *Life on St. Helena Island*, 48–52; and Janzen, *Lemba*, 194, 199–200, 184.

120. Allen, "Diary and Letters, 1863–1865," 20 March 1864, 154.

121. Janzen, *Lemba*, 161; and Parrish, *Slave Songs of the Georgia Sea Islands*, 85.

122. Parrish, *Slave Songs of the Georgia Sea Islands*, 86; Allen, "Diary and Letters, 1863–1865," 25 December 1863, 70; and Janzen, *Lemba*, 184.

123. Chalmers Murray, *Here Come Joe Mungin*, 60–61.

124. Luke 2:22–32 New English Bible; and Cooley, "Homes of the Freed," 58.

125. Allen, Ware, and Garrison, *Slave Songs of the United States*, 10–11; and Lawton, "The Religious Life of South Carolina Coastal and Sea Island Negroes," 186–188.

126. Fu-Kiau in Thompson and Cornet, *The Four Moments of the Sun*, 74–75; and MacGaffey, *Religion and Society*, 155.

127. Lawton, "The Religious Life of South Carolina Coastal and Sea Island Negroes," 187–188; Thompson and Cornet, *The Four Moments of the Sun*, 74–75; PCOHP, Glover; and PCOHP, Reynolds.

128. PCOHP, Doyle; PCOHP, Chaplin; PCOHP, Glover; PCOHP, Clarence Johnson; and Thompson and Cornet, *The Four Moments of the Sun*, 52.

129. Author's observation; photo by William A. McNulty of Lady's Island; photo by Bob Sofaly in "Sam Doyle Works Exhibited on Hilton Head," *Beaufort Gazette*, 5 February 1988, 12A; photo in Spriggs, *Local Heroes*, 33; and Thompson and Cornet, *The Four Moments of the Sun*, 52–58.

130. Sam Doyle, interview by Vertamae Grosvenor, "Horizons," National Public Radio, 25 July 1984; and Thompson and Cornet, *The Four Moments of the Sun*, 52–58.

131. Thompson and Cornet, *The Four Moments of the Sun*, 54–55, 61–68.

132. Ibid., passim; Thompson, *Flash of the Spirit*, 125; and Gundaker, "Tradition and Innovation in African-American Yards," 58–71, 94.

133. PCOHP, Doyle; and Thompson, *Flash of the Spirit*, 185.

134. Lawton, "The Religious Life of South Carolina Coastal and Sea Island Negroes," 213, 188; and PCOHP, Loundes.

135. Parsons, *Folk-Lore of the Sea Islands, South Carolina*, 215; and Weeks, *Among the Primitive Bakongo*, 158–167.

136. Hyatt, *HCWR*, 2: 1607–1608, 1773–1774; MacGaffey, *Religion and Society*, 56; and Lawton, "The Religious Life of South Carolina Coastal and Sea Island Negroes," 202.

137. Janzen, *Lemba*, 43–44; MacGaffey, *Religion and Society*, 72–73; author's observation and interview with Nick and DuBose Lindsay, Edisto Island, S.C., 9 July 1988.

138. MacGaffey, *Religion and Society*, 56; PCOHP, Loundes; Lawton, "The Religious Life of South Carolina Coastal and Sea Island Negroes," 196; and conversations with Agnes Sherman at Penn Center, St. Helena Island, S.C., July 1983.

139. Translated from Kikongo into English by Thompson in *The Four Moments of the Sun*, 95; PCOHP, Franklin Holmes; and PCOHP, Cohen, Part I.

### 5. African Resonance

1. Ralph Griffin, interview by author, Girard, Ga., 10 August 1990.

2. Ibid.; and Thompson, "The Circle and the Branch," 47.

3. Thompson, *Flash of the Spirit*, 131.

4. Ralph Griffin, interview by author, Girard, Ga., 10 August 1990.

5. Ibid.; and Kecskési, *African Masterpieces*, 290.

6. Communication from Fu-Kiau to Thompson quoted in *Flash of the Spirit*, 121; MacGaffey, *Religion and Society*, 132; and Janzen, *Lemba*, 109, 150.

7. Ralph Griffin, interview by author, Girard, Ga., 10 August 1990; and communication from Fu-Kiau to Thompson quoted in "The Circle and the Branch," 27.

8. Janzen, *Lemba*, 299–304.

9. PCOHP, Gadsden.

10. Janzen, *Lemba*, 303.

11. Rawick, ed., *Georgia Narratives, Part 2*, 357, 364, 626; Rawick, ed., *Alabama Narratives*, 464; Federal Writers' Project, "Benny Dillard," in *Georgia, Part I*, vol. IV of *Slave Narratives*, microfiche, Card 63, 3F9–10, pp. 287–288; and ibid., "Sarah Byrd," microfiche, 168, Card 61, 3F7, p. 168.

12. Alabama, "Lowndes County Tract Book," 35–36, 81; John Getson Traylor, Diary, 25 February 1843–12 March 1847, 95–132, and 5 March 1840, 68: probably the fort he called "Rascil" [Rascal]; John Getson Traylor, "John G. Traylor's Will," probated 14 February 1850, Dallas County, Alabama; Mrs. J. Bryant Traylor, Family Papers; and U.S. Bureau of the Census, *Ninth Census*, 1870, Alabama, Lowndes County, Benton Post Office. Getson is also spelled "Getzen"; I use the spelling from John's diary. For sources of other family wills, see Bibliography under Traylor and Weisiger.

13. U.S. Bureau of the Census, *Ninth Census*, 1870, Alabama, Lowndes County, Benton Post Office; U.S. Bureau of the Census, *Tenth Census*, 1880, Alabama, Lowndes County, Benton Post Office; and Rawick, ed., *Alabama Narratives*, 407–412.

14. Russell, *My Diary*, 73–75; and Federal Writers' Project, *South Carolina*, vol. XIV of *Slave Narratives*, microfiche, Card 139, R1F10–12, pp. 63–66.

15. Johnson, *Shadow of the Plantation*, 90; and MacGaffey, *Religion and Society*, 97.

16. Rawick, ed., *Alabama Narratives*, 223, 461–462; Rawick, ed., *Mississippi Narratives, Part 3*, 1203–1207; Rawick, ed., *Mississippi Narratives, Part 2*, 750; and Doyle, interview by author, St. Helena Island, S.C., 21 March 1983.

17. Rawick, ed., *Alabama Narratives*, 130–134.

18. Thompson, *Flash of the Spirit*, 18–33, 84–93; and Edwards and Mason, *Black Gods*, 9–10.

19. Thompson, *Face of the Gods*, 169; Edwards and Mason, *Black Gods*, 42–46; and Idowu, *Olódùmarè*, 89–95.

20. Margaret Drewal, "Dancing for Ogun," 210; and Wescott, "Sculpture and Myths," 337, 345.

21. Showers, "Alabama Folklore," 443; and "Folklore and Ethnology: Hags and Their Ways," 27.

22. Thompson, *African Art in Motion*, 181.

23. Hyatt, *HCWR*, 1: 20.

24. Thompson, *Flash of the Spirit*, 33–42; Metuh, *God and Man*, 79–80; and Arinze, *Sacrifice in Ibo Religion*, 65.

25. Hyatt, *HCWR*, 1: 215.

26. Ibid., 85, 332.

27. Ibid., 294–295.

28. Peek, "African Divination Systems," 193–195.

29. For example see Anderson and Kreamer, *Wild Spirits*, 116–117, Catalog nos. 69–71.

30. Ottenberg, *Masked Rituals of Afikpo*, 87–106; and Thompson, *African Art in Motion*, 219–226, 163–165.

31. Ottenberg, *Masked Rituals of Afikpo*, 87–106; and Glaze, *Art and Death*, xii.

32. Nooter, ed., *Secrecy*, 19–20; and Margaret Drewal, *Yoruba Ritual*, 28–38. See also William Murphy, "Secret Knowledge," 193–207, and his references.

33. See Babatunde Lawal's elegant description of this concept in *Gèlèdé Spectacle*, 98–99.

34. Thompson, *Face of the Gods*, 28–29; Draper, "The Mardi Gras Indians," 22–23, 35–38; and Thompson and Cornet, *The Four Moments of the Sun*, 157–161.

35. Glaze, *Art and Death*, 197–198; Forrester, *Degree Ritual* (1894), 19, 40–41.

36. Hyatt, *HCWR*, 1: 775.

37. Thompson, *African Art in Motion*, 101, 62–63; and Thompson's description of bronze Yoruba crown in *For Spirits and Kings*, ed. Vogel, 108–110.

38. Forrester, *Degree Ritual* (1894), 42: italics mine.

39. Hyatt, *HCWR*, 1: 773–781.

40. Hyatt, *HCWR*, 2: 1641–1646; compare this description of Caesar dressed in red with the photo in Anderson and Kreamer, *Wild Spirits*, 34: Doctor J. E. Uhurebor, the chief priest of a shrine to Osun in Nigeria, is barefooted and wears red cap, red gown which reaches to his ankles, and red cape.

41. Hyatt, *HCWR*, 2: 1641–1645; and Bascom, *Yoruba*, 9–11.

42. For a thorough exposition of these strains, see Robert Farris Thompson, *Face of the Gods*; for African origins of Vodou, see Blier, *African Vodun*.

43. Johnson, *Shadow of the Plantation*, 181.

44. Anderson and Kreamer, *Wild Spirits*, 74, and 94, Catalog no. 23.

45. Lawton, "The Religious Life of South Carolina Coastal and Sea Island Negroes," 152; and Steiner, "Sol Lockheart's Call," 67–68.

46. Afigbo, *Ropes of Sand,* 172, 365; and Cole and Aniakor, *Igbo Arts,* 58–61. The Ejagham are also called Ekoi.

47. Afigbo, *Ropes of Sand,* 374–375; MacGregor, "Nsibidi," 209; Dayrell, "Further Notes," 529, Plate 46 (fig. 87); and Rosemary Harris, "Mbembe Men's Associations," 61–63, 96.

48. Ben-Amos, *The Art of Benin,* 64–71; Nevadomsky, "Religious Symbolism," 22–25; Rosen, "The Art of Èdó Ritual," 33–38; Galembo, "Photographs from Benin City," in *Divine Inspiration,* 85; Herbert M. Cole, e-mail communication to author, 21 October 1999; and Cole and Ross, *The Arts of Ghana,* 8–12, fig. 9. The Edo are also called Bini.

49. Thompson, *Face of the Gods,* 60–74. Ladder symbols on flags and shrines and in ground-drawings are illustrated in this passage and in *Flash of the Spirit,* 112.

50. MacGregor, "Nsibidi," 212; and Thompson, *Flash of the Spirit,* 112.

51. Simpson, "Baptismal, 'Mourning,' and 'Building' Ceremonies," 537–549.

52. Ibid.; and Thompson, *Flash of the Spirit,* Plate 152, page 240. The diagrammatic sketch is from a detail in a Traylor work exhibited at Vanderwoude Tananbaum Gallery in 1982; its whereabouts are now unknown.

53. McWillie, *Another Face,* 10–11, 65; Thompson, "The Song That Named the Land," 100–104; Thompson, *Face of the Gods,* 296; and Hyatt, *HCWR,* 1: 804–805.

54. Thompson, "An Aesthetic of the Cool," 43; Edwards and Mason, *Black Gods,* 9–13; Talbot, "The Land of Ekoi," 650; Jacobson-Widding, *Red-White-Black,* 198, 263; Wahlman, "African Symbolism in Afro-American Quilts," 75; and observation by author, Rt. 905 near Hickory Grove, S.C., 1 August 1991.

55. Thompson, *The Four Moments of the Sun,* 76–77.

56. Ibid., 90–91, 103–104, and 193–194.

57. Work, "Some Geechee Folk-Lore," 635; "Beliefs and Customs Connected with Death and Burial," 18; and "Alabama Folk-Lore," 51.

58. Bacon, "A Trip Through the South," 81.

59. Thompson, "The Sign of the Divine King," 8–17, 74–80; McNaughton, *Secret Sculptures of Komo,* 33 and illus. 5; Jones, *The Art of Eastern Nigeria,* 200–202; and Cole and Aniakor, *Igbo Arts,* 89, 121–128.

60. Drewal and Drewal, *Gẹlẹdẹ,* xv, 8–9, 73–74, 203–209.

61. Hyatt, *HCWR,* 1: 56, 58–59. Hyatt mistakenly translated "to' out" as "took out."

62. John Getson Traylor, "John G. Traylor's Will," probated 14 February 1850, Dallas County, Alabama; and U.S. Bureau of the Census, *Ninth Census,* 1870, Alabama, Lowndes County, Benton Post Office.

63. Mrs. J. Bryant Traylor, Family Papers; U.S. Bureau of the Census, *Ninth Census,* 1870, Alabama, Lowndes County, Benton Post Office; and U.S. Bureau of the Census, *Tenth Census,* 1880, Alabama, Lowndes County, Benton Post Office.

64. Pérez-Peña, "Link to Past," 9 December 1992; U.S. Bureau of the Census, *Tenth Census,* 1880, Alabama, Lowndes County, Benton Post Office; U.S. Bureau of the Census, *Twelfth Census,* 1900, Alabama, Lowndes County, Benton Precinct; U.S. Bureau of the Census, *Thirteenth Census,* 1910, Alabama, Montgomery County; U.S. Bureau of the Census, *Fourteenth Census,* 1920, Alabama, Montgomery County;

and *Montgomery* [Alabama] *City Directory 1947–1948.* A somewhat different list of Traylor's children, though undocumented, is given in Helfenstein and Kurzmeyer, *Bill Traylor, 1854–1949,* 171–172.

65. John Getson Traylor, Diary, passim and 15 July 1841, 80, Alabama Department of Archives and History; Olmsted in Courlander, *A Treasury of Afro-American Folklore,* 507; and Hyatt, *HCWR,* 1: 447.

66. John Getson Traylor, Diary, 9 July 1842, 89 and passim; 13 February 1845, 114; 26–27 February 1847 and 12 March 1847, 132. Drusiter was called "Drusella" in John G. Traylor's will.

67. Albaugh, *Collerine,* 20; John Getson Traylor, "John G. Traylor's Will"; and U.S. Bureau of the Census, "Population" and "Slave" Schedules, *Eighth Census,* 1860, Alabama, Dallas County, Old Town Beat, Thomas G. Traylor, and Alabama, Lowndes County, Northern Division, George H. Traylor.

68. PCOHP, Johnson and Polite.

69. Lawal, *Gèlèdé Spectacle,* 184; and Drewal and Drewal, *Gẹlẹdẹ,* 79–84, Plate 97 on page 172 and Plate 143 on page 212. Lawal has many illustrations of masks with white face and Traylor-like eyes.

70. Drewal and Drewal, *Gẹlẹdẹ,* 212, and Plates 144 and 145 on page 213.

71. Ibid., 262.

72. Ibid., 74, 11–16, 214–229; and Lawal, *Gèlèdé Spectacle,* xiii–xiv, 36.

73. Drewal and Drewal, *Gẹlẹdẹ,* 105.

74. Lawal, *Gèlèdé Spectacle,* 261–262; Thompson, *African Art in Motion,* 202–204; Drewal and Drewal, *Gẹlẹdẹ,* 152–155, 161–162, 170, 136.

75. Shannon, "Bill Traylor's Triumph," 61; and Hyatt, *HCWR,* 2: 1391: italics mine. This root doctor was taught by an old man in Alabama who died in 1918.

76. Bacon, "A Trip Through the South," 81; Cole and Aniakor, *Igbo Arts,* 73; and Rosen, "Chalk Iconography," 46.

77. Thompson, *African Art in Motion,* 203; and Drewal and Drewal, *Gẹlẹdẹ,* 111–116, 138.

78. Lawal, *Gèlèdé Spectacle,* fig. 5.19 on 160, 159.

79. Thompson, still photos in *African Art in Motion,* 205, plate 249; and Thompson, "Kongo Influences," 159–160.

80. Drewal and Drewal, *Gẹlẹdẹ,* xv; and Hyatt, *HCWR,* 1: 283.

81. Drewal and Drewal, *Gẹlẹdẹ,* 123.

82. Hyatt, *HCWR,* 1: 283.

83. Reproduced in Maresca and Ricco, *Bill Traylor,* 77. Whereabouts unknown.

84. Faulkner, *Go Down, Moses,* 50–51, 361.

85. "Folklore and Ethnology: The Boy and the Ghost," 57.

86. Other versions are reproduced in Hirschl & Adler Modern, *Bill Traylor,* 1985, Catalog no. 34; and in Maresca and Ricco, *Bill Traylor,* 123 [duplicate in Chicago Office of Fine Arts, *Bill Traylor Drawings,* 1988, Catalog no. 3 but printed upside down], 153 [duplicate in Hirschl & Adler Modern, *Bill Traylor,* 1988, 17, Catalog no. 2.], and 157.

87. Abímbólá, "Ifá: A West African Cosmological System," 112; Cole and Aniakor, *Igbo Arts,* 73–74.

88. Jones, *The Art of Eastern Nigeria,* 117–118. Stools are illustrated in Thompson, *African Art in Motion,* 86–90; batons in Armstrong, *Powers of Presence,* plates 10–14 and 17–18.

89. Thompson and Cornet, *The Four Moments of the Sun*, 190–193.

90. Jones, *The Art of Eastern Nigeria*, 51–53, 78–82; Rankin, "Rankin File," 31 March 1948; and Cole and Aniakor, *Igbo Arts*, 61, fig. "i" in illus. 100.

91. Jones, *The Art of Eastern Nigeria*, 79–80.

92. David Ross Sr. and David Ross Jr., interview by author, Montgomery, Ala., 7 January 1987.

93. Dr. Richard Bailey, historian, Maxwell Air Force Base, interview by author, Montgomery, Ala., 7 January 1987.

94. David Ross Sr., interview by author, Montgomery, Ala., 7 January 1987.

95. Reproduced in Maresca and Ricco, *Bill Traylor*, 149. Another startling version is reproduced on 104.

96. U.S. Bureau of the Census, *Twelfth Census*, 1900, Alabama, Lowndes County, Benton Precinct; and Mrs. J. Bryant Traylor, Family Papers.

97. U.S. Bureau of the Census, *Thirteenth Census*, 1910, Alabama, Montgomery County; and U.S. Bureau of the Census, *Fourteenth Census*, 1920, Alabama, Montgomery County. The census-taker of 1910 misspelled Traylor's name as "Taylor," thus making his location in that census obscure.

98. *Montgomery City Directory 1928*; U.S. Bureau of the Census, *Fifteenth Census*, 1930, Alabama, Montgomery County; Helfenstein and Kurzmeyer, *Bill Traylor*, 172; and letter from an unidentified Traylor daughter in Detroit to Charles Shannon, quoted in Maresca and Ricco, *Bill Traylor*, 20–22.

99. MacGregor, "Nsibidi," 213, 215 (fig. 14); and "Folklore and Ethnology: Notes from Alabama," 78.

100. Sisk, "Funeral Customs in the Alabama Black Belt," 170; and Thompson and Cornet, *The Four Moments of the Sun*, 198–200.

101. Smiley, "Folk-lore from Virginia, South Carolina, Georgia, Alabama, and Florida," 372.

102. Hyatt, *HCWR*, 1: 136; and Dayrell, "Further Notes on 'Nsibidi' Signs," 530, Plate 46 (fig. 100).

103. Jones, *The Art of Eastern Nigeria*, 199–200.

104. Fu-Kiau, *Le MuKongo*, 112 and n. 5.

105. Lawton, "The Religious Life of South Carolina Coastal and Sea Island Negroes," 212–213.

106. Steiner, "Sol Lockheart's Call," 68.

107. Hyatt, *HCWR*, 1: 100–102, and 2: 1612.

108. "Folklore and Ethnology: A Negro Ghost Story," 449; and Hyatt, *HCWR*, 1: 100–102.

109. Thompson and Cornet, *The Four Moments of the Sun*, 49.

110. Ibid., 51–52.

111. Ruth Bass, "The Little Man," 391–392.

112. Ibid.

113. Thompson and Cornet, *The Four Moments of the Sun*, 46–48. Traylor's portrayal of the woman wearing a green blouse was sold out of the United States: its whereabouts are unknown. It is reproduced in Maresca and Ricco, *Bill Traylor*, 113.

114. Thompson and Cornet, *The Four Moments of the Sun*, 48, 91, 78.

115. Ibid., 44.

116. Hyatt, *HCWR*, 1: 827–828.

117. Thompson, *Flash of the Spirit*, 110.

118. Thompson and Cornet, *The Four Moments of the Sun*, 87–90; and Hyatt, *HCWR*, 2: 1500.

119. Gundaker, "Tradition and Innovation in African-American Yards," 68.

120. Hyatt, *HCWR*, 2: 1620.

121. Jacobson-Widding, *Red-White-Black*, 197, 294, and passim; and Fu-Kiau, *Le MuKongo*, 130. Traylor's piece is reproduced in Hirschl & Adler Modern, "Bill Traylor," December 1, 1985–January 11, 1986, Catalog no. 37, and Maresca and Ricco, *Bill Traylor*, 100; whereabouts unknown.

122. Thompson, *Face of the Gods*, 238–239; Galembo, *Divine Inspiration*, 72, 75, 90–91; and Jacobson-Widding, *Red-White-Black*, 265.

123. Thompson and Cornet, *The Four Moments of the Sun*, 193. Pipe-smoking is also associated with Igbo ikenga figures: Jones, *The Art of Eastern Nigeria*, 143, illus. 50.

124. Thompson and Cornet, *The Four Moments of the Sun*, 172.

125. Shannon, "Bill Traylor's Triumph," 62.

126. Thompson, "An Aesthetic of the Cool," 41.

127. Ibid., 42.

128. Idowu, *Olódùmarè*, 146; Drewal and Drewal, *Gẹlẹdẹ*, 40, 51; and Hyatt, *HCWR*, 1: 512, and 2: 979.

129. Drewal and Drewal, *Gẹlẹdẹ*, 1–5; and Lawal, *Gèlèdé Spectacle*, 126–128.

130. Drewal and Drewal, *Gẹlẹdẹ*, 6.

131. Charles Shannon, telephone conversation with author, Montgomery, Ala., 9 January 1986.

132. Maresca and Ricco, *Bill Traylor*, 11.

133. Shannon, "Bill Traylor's Triumph," 61; and Drewal and Drewal, *Gẹlẹdẹ*, 5–7.

134. Thompson and Cornet, *The Four Moments of the Sun*, 151.

135. Thompson, *Flash of the Spirit*, 184–186.

136. Jacobson-Widding, *Red-White-Black*, 293–294; and Fu-Kiau, *Le MuKongo*, 121 and its Introduction by John Janzen, 5.

137. Hyatt, *HCWR*, 2: 1667–1669.

138. Ibid., 1774–1775, 1238, and 1: 125.

139. MacGaffey, *Religion and Society*, 140.

140. Thompson and Cornet, *The Four Moments of the Sun*, 87, 122–123.

141. Janzen, *Lemba*, 193–194; Thompson, *Flash of the Spirit*, 110–111; and Thompson and Cornet, *The Four Moments of the Sun*, 91.

142. Hyatt, *HCWR*, 2: 1581–1582.

143. Hyatt, *HCWR*, 1: 78, and 2: 1619.

144. Battestini, "Reading Signs," 101; Dayrell, "Further Notes," 530, Plate 46 (fig. 102); Livingston and Beardsley, *Black Folk Art in America*, cover; and Rosen, "Chalk Iconography," 46. The coiled snake is also reproduced in Maresca and Ricco, *Bill Traylor*, 64.

145. Hirschl & Adler Modern, "Pictures from the Bill Traylor Family Trust and Others," December 10, 1994–January 14, 1995, Exhibit No. 1.

146. Hirschl & Adler Modern, *Bill Traylor, 1854–1947*, December 2, 1985–January 11, 1986, Catalog no. 15; also in Maresca and Ricco, *Bill Traylor*, 28.

147. Maresca and Ricco, *Bill Traylor*, 29; Thompson and Cornet, *The Four Moments of the Sun*, 78–80; and Neyt, *Traditional Arts*, 83.

148. Anderson and Kreamer, *Wild Spirits*, 99; Biebuyck, *The Arts of Zaire*, 2: 24–27, 138; Meek, *Law and Authority in a Nigerian Tribe*, 77–78; Cole and Aniakor, *Igbo Arts*, 135–138; and Edwards and Mason, *Black Gods*, 64.

149. MacGaffey, *Religion and Society*, 139–145.

150. Hirschl & Adler Modern, *Bill Traylor: High Singing Blue*, 20, 38, 39; Thompson, *Face of the Gods*, 20–21, 30, 127–128: quotation is from *Rebel Destiny*.

151. *Religion and Society*, 145–148.

152. Conversation with author, Hanover, N.H., 13 April 1996; Thompson and Cornet, *The Four Moments of the Sun*, 96 (fig.63), 194–197 (figs. 186, 187); and Jones, *The Art of Eastern Nigeria*, 103–108.

153. MacGaffey, *Religion and Society*, 142.

154. Henderson, *The King in Every Man*, 522, 266.

155. Thompson and Cornet, *The Four Moments of the Sun*, 116–120.

156. Biebuyck, *The Arts of Zaire*, 2: 238–240.

157. Cornet, *Art from Zaire*, 124–126; see Neyt, *Traditional Arts*, 42 (fig. II.12) for another ubanga nyama figure.

158. Thompson and Cornet, *The Four Moments of the Sun*, 201–203; and *Flash of the Spirit*, 139–141.

159. Thompson, "African Influence on the Art of the United States," 31–33, 43–46. See works identified as *Brown Lizard* in Hirschl & Adler Modern, *Bill Traylor: High-Singing Blue*, 51; and *Turtle* in Maresca and Ricco, *Bill Traylor*, 43.

160. MacGaffey, *Religion and Society*, 133, 50. For further elaboration of the philosophy of the circling wheel in African America, see Thompson's amazing exposition of the life and art of Henry Dorsey in *Flash of the Spirit*, 147–158.

161. Maresca and Ricco, *Bill Traylor*, 8, 22.

162. Hurston, *Their Eyes Were Watching God*, 189.

163. Shannon, "Bill Traylor's Triumph," 64.

164. Mary Stanford, Records Office, St. Jude's Roman Catholic Church, Montgomery, Ala., telephone interview by author, 5 November 1999.

### Epilogue

1. National Archives and Records Administration, *Records of the Veterans Administration: Schedules Enumerating Union Veterans*, 1890, microfilm roll M123–93; Higginson, *Army Life in a Black Regiment*, 28–33.

2. Higginson, *Army Life in a Black Regiment*, 79–90.

3. Ibid., 133–134; Rose, *Rehearsal for Reconstruction*, 243–244.

4. Higginson, *Army Life in a Black Regiment*, 163–176.

5. "Troops in the Department of the South, Maj. Gen. Quincy A. Gillmore, U.S. Army, Commanding, December 31, 1863," in Scott, ed., *The War of the Rebellion*, Series I, 28, part 2: 137–138; "Abstract from Return of the Department of the South, Maj. Gen. Q. A. Gillmore, U.S. Army, Commanding, for September, 1863; Headquarters Folly Island," ibid., 102, 116; and Brig. Gen. Rufus Saxton to the Hon. E. M. Stanton, Secretary of War, 12 November 1862, ibid., Series I, 14, 189–190.

6. Lt. Col. Oliver T. Beard to Brig. Gen. Rufus Saxton, 10 November 1862, ibid., 191–192.

7. Higginson, *Army Life in a Black Regiment*, 223–226, 271–272.

8. Brockman, *The Clarks of Edisto*, 8–10; and Works Progress Administration, "Will of Sarah Clark," 885.

9. Higginson, *Army Life in a Black Regiment*, 272.

# BIBLIOGRAPHY

Abímbólá, Wande. "Ifá: A West African Cosmological System." In *Religion in Africa: Experience and Expression*, edited by Thomas D. Blakely, Walter E. A. van Beek, and Dennis L. Thomson. Portsmouth, N.H.: Heinemann, 1994.

Adams, Capt. John. *Remarks on the Country Extending from Cape Palmas to the River Congo*. 1823. Reprint, London: Frank Cass, 1966.

Afigbo, Adiele Eberechukwu. *Ropes of Sand: Studies in Igbo History and Culture*. Ibadan, Nigeria: Published for University Press in association with Oxford University Press, 1981.

Alabama. "Lowndes County Tract Book." Deeds, 1828–1833. In Alabama Department of Archives and History, Montgomery, Ala.

"Alabama Folk-Lore." *Southern Workman* 33, no. 1 (January 1904): 51.

Albaugh, June M. *Collerine: The Queen Hill*. Montgomery, Ala.: Paragon Press, 1977.

Allen, William Francis. "Diary and Letters, 1863–1865." Manuscript and Typescript. Family Papers, 1775–1937. State Historical Society of Wisconsin. Madison, Wis., 1967. Microfilm.

Allen, William Francis, Charles P. Ware, and Lucy McKim Garrison, eds. *Slave Songs of the United States*. 1867. Reprint, New York: Books for Libraries Press, 1971.

Ames, Mary. *From a New England Woman's Diary in Dixie*. Springfield, Mass.: The Plimpton Press, 1906.

Amugbanite, Tony. "Iboland's Sleeping Customs." *West African Review* 30 (October 1959): 649–651.

Anderson, Martha G., and Christine Mullen Kreamer. *Wild Spirits, Strong Medicine: African Art and the Wilderness*. Edited by Enid Schildkrout. New York: Center for African Art, 1989.

Arinze, Francis A. *Sacrifice in Ibo Religion*. Edited by J. S. Boston. Ibadan, Nigeria: Ibadan University Press, 1970.

Armstrong, Louis. "New Orleans Function." On Side One, *Louis Armstrong and the All Stars. Vol. I: New Orleans Days*. Decca DL5279, 1950, Long Play recording 33⅓ RPM.

Armstrong, Robert Plant. *The Affecting Presence: An Essay in Humanistic Anthropology*. Urbana: University of Illinois Press, 1971.

———. *Powers of Presence: Consciousness, Myth, and Affecting Presence*. Philadelphia: University of Pennsylvania Press, 1981.

Bacon, Alice M. "A Trip through the South." *Southern Workman* 23, no. 5 (May 1894): 81.

Bascom, William. *The Yoruba of Southwestern Nigeria*. New York: Holt, Rinehart and Winston, 1969.

Bass, Ruth. "The Little Man." In *Mother Wit from the Laughing Barrel*, edited by Alan Dundes. Jackson: University Press of Mississippi, 1990. First published in *Scribner's Magazine* 97 (1935): 120–123.

Bastide, Roger. *The African Religions of Brazil: Toward a Sociology of the Interpenetration of Civilizations*. Translated by Helen Sebba. Baltimore: Johns Hopkins University Press, 1978.

Battestini, Simon P. X. "Reading Signs of Identity and Alterity: History, Semiotics and a Nigerian Case." *African Studies Review* 34, no. 1 (April 1991): 99–116.

*Beaufort (S.C.) Gazette,* 9 October 1984 and 5 February 1988.

"Beliefs and Customs Connected with Death and Burial," *Southern Workman* 26, no. 1 (January 1897): 18–19.

Ben-Amos, Paula Girshick. *The Art of Benin.* Washington, D.C.: Smithsonian Institution Press, 1995.

Bennett, Cornelius. Cornelius Bennett, Sailing Master, USS *Spark,* to the Hon. Smith Thompson, Secretary of the Navy, 18 February 1822. Letter ref. 111 in "Letters Received by the Secretary of the Navy from Commissioned Officers below the Rank of Commander and from Warrant Officers: (Officers Letters) 1802–1884." Naval Records Collection. RG45. National Archives and Records Administration, Washington, D.C.

Bentley, William Holman. *Pioneering on the Congo.* London: The Religious Tract Society, 1900.

Bentor, Eli. "Life as an Artistic Process: Igbo Ikenga and Ofo." *African Arts* 21, no. 2 (February 1988): 66–71, 94.

Biebuyck, Daniel. *The Arts of Zaire.* Vol. 2, *Eastern Zaire, the Ritual and Artistic Context of Voluntary Associations.* Berkeley: University of California Press, 1986.

Blier, Suzanne Preston. *African Vodun: Art, Psychology, and Power.* Chicago: University of Chicago Press, 1995.

Bohannon, Paul. "'Land,' 'Tenure' and Land-Tenure." In *African Agrarian Systems,* edited by Daniel Biebuyck. London: Published for the International African Institute by Oxford University Press, 1963.

Boston, John S. *Ikenga Figures Among the North-west Igbo and the Igala.* London: Ethnographica, 1977.

Botkin, B. A., ed. *A Treasury of Southern Folklore: Stories, Ballads, Traditions, and Folkways of the People of the South.* New York: Crown Publishers, 1949.

Botume, Elizabeth Hyde. *First Days amongst the Contrabands.* 1893. Reprint, New York: Arno Press, 1968.

Boxer, C. R. *The Dutch Seaborne Empire,1600–1800.* New York: Knopf, 1965.

Bradlee, Francis B. C. *Piracy in the West Indies and Its Suppression.* 1923. Reprint, Salem, Mass.: Essex Institute, 1980.

Brockman, Mary Clark. "The Clarks of Edisto Island, South Carolina." Typescript. South Caroliniana Library, University of South Carolina, Columbia, S.C., n.d.

Burrell, W. P. "The Negro in Insurance: Early History—Failures and Reorganization." *Proceedings of the Hampton Negro Conference* 8 (July 1904): 13–16.

———. "The True Reformers." *Colored American Magazine* 7 (April 1904): 267–269.

———. *Twenty-five Years History of the Grand Fountain of the United Order of True Reformers, 1881–1905.* Richmond, 1909.

*Charleston (S.C.) Carolina Gazette,* 2 March 1822 and 27 April 1822.

*Charleston (S.C.) Courier,* 29 October 1819.

*Charleston (S.C.) Mercury,* 23 February 1822.

*Charleston (S.C.) Southern Patriot and Commercial Advertiser,* 23 February 1822 and 27 February 1822.

Chicago Office of Fine Arts. *Bill Traylor Drawings.* Chicago, 1988.

Clarke, Erskine. *Wrestlin' Jacob: A Portrait of Religion in the Old South.* Atlanta: John Knox Press, 1979.

Cole, Herbert M., and Chike C. Aniakor. *Igbo Arts: Community and Cosmos.* Los Angeles: Museum of Cultural History, University of California, 1984.

Cole, Herbert M., and Doran H. Ross. *The Arts of Ghana.* Los Angeles: Museum of Cultural History, University of California, 1977.

Cooley, Rossa B. "Homes of the Freed." Typescript. Penn Center Historical Collection, Penn Community Services, Frogmore, S.C., 1926.

————. *School Acres.* New Haven, Conn.: Yale University Press, 1930.

Cornet, Joseph. *Art from Zaire: 100 Masterworks from the National Collection.* New York: African-American Institute, 1975.

Courlander, Harold. *A Treasury of Afro-American Folklore: The Oral Literature, Traditions, Recollections, Legends, Tales, Songs, Religious Beliefs, Customs, Sayings, and Humor of Peoples of African Descent in the Americas.* New York: Crown Publishers, 1976.

Curtin, Philip D. *The Atlantic Slave Trade: A Census.* Madison: University of Wisconsin Press, 1969.

Dabbs, Edith M. *Sea Island Diary.* Spartanburg, S.C.: The Reprint Company, 1983.

Dabney, Wendell P. *Maggie L. Walker and the I. O. of St. Luke.* Cincinnati: The Dabney Publishing Company, 1927.

Daise, Ronald. *Reminiscences of Sea Island Heritage.* Orangeburg, S.C.: Sandlapper Publishing, 1986.

Davidson, Grace Gillam. *Early Records of Georgia: Wilkes County.* Vol. 1. Macon, Ga.: J. W. Burke Co., 1933.

Davis, Wade. *Passage of Darkness.* Chapel Hill: University of North Carolina Press, 1988.

Dayrell, Elphinstone. "Further Notes on 'Nsibidi' Signs with Their Meanings from the Ikon District, Southern Nigeria." *Journal of the Royal Anthropological Institute* 41 (1911): 521–540.

Dennett, Richard E. *Seven Years among the Fjort.* London: S. Low, Marston, Searle, and Rivington, 1887.

Deren, Maya. *Divine Horsemen: The Living Gods of Haiti.* 1953. Reprint, Kingston, N.Y.: McPherson and Company, 1991.

Desmangles, Leslie G. *The Faces of the Gods: Vodou and Roman Catholicism in Haiti.* Chapel Hill: University of North Carolina Press, 1992.

Dewhurst, C. Kurt, Betty MacDowell, and Marsha MacDowell. *Religious Folk Art in America: Reflections of Faith.* New York: E. P. Dutton in association with the Museum of American Folk Art, 1983.

Dieterlin, Germaine. "Parenté et mariage chez les Dogon (Soudan français)." *Africa* 26, no. 2 (April 1956): 107–148.

Dodd, Dorothy. "The Schooner *Emperor.*" *Florida Historical Quarterly* 13, no. 3 (1935): 117–128.

Drake, Philip. *Revelations of a Slave Smuggler: Being the Autobiography of Capt. Rich'd* [i.e., Philip] *Drake, an African Trader for Fifty Years from 1807 to 1857.* 1860. Reprint, Northbrook, Ill.: Metro Books, 1972.

Draper, David E. "The Mardi Gras Indians." Ph.D. diss., Tulane University, 1973.

Drewal, Henry John, and Margaret Thompson Drewal. *Gẹlẹdẹ: Art and Female Power among the Yoruba.* Bloomington: Indiana University Press, 1990.

Drewal, Margaret Thompson. "Dancing for Ogun in Yorubaland and in Brazil." In *Africa's Ogun: Old World and New*, edited by Sandra T. Barnes. Bloomington: Indiana University Press, 1989.

———. *Yoruba Ritual: Performers, Play, Agency.* Bloomington: Indiana University Press, 1992.

DuBois, W. E. B. *Economic Cooperation among Negro Americans.* Atlanta University Publication no. 12. Atlanta: Atlanta University Press, 1907.

———. *Some Efforts of American Negroes for Their Own Social Betterment.* Vol. 1 of *Atlanta University Publications.* 1898. Reprint, New York: Octagon Books, 1968.

———. *The Suppression of the African Slave Trade to the United States of America.* 1896. Reprint, Baton Rouge: Louisiana State University Press, 1965.

Duke, Antera. "The Diary of Antera Duke, an Efik Slave-Trading Chief of the Eighteenth Century." In *Efik Traders of Old Calabar*, edited by Daryll Forde. 1956. Reprint, London: Dawsons of Pall Mall for the International African Institute, 1968.

Dundes, Alan, ed. *Mother Wit from the Laughing Barrel: Readings in the Interpretation of Afro-American Folklore.* Jackson: University Press of Mississippi, 1990.

Edwards, Gary, and John Mason. *Black Gods: Orisa Studies in the New World.* Brooklyn: Yoruba Theological Archministry, 1985.

Emmer, Pieter C. "Surinam and the Decline of the Dutch Slave Trade." *Révue française d'histoire d'outre-mer* 62, nos. 226–227 (1975): 245–251.

Faulkner, William. *Go Down, Moses.* New York: Vintage Books, 1990.

Federal Writers' Project. *Alabama.* Vol. 1 of *Slave Narratives: A Folk History of Slavery in the United States from Interviews with Former Slaves.* Washington, D.C., 1941. Microfiche.

———. *Georgia.* Part 1 in Vol. 4 of *Slave Narratives: A Folk History of Slavery in the United States from Interviews with Former Slaves.* Washington, D.C., 1941. Microfiche.

———. *South Carolina.* Parts 1 and 2 in Vol. 14 of *Slave Narratives: A Folk History of Slavery in the United States from Interviews with Former Slaves.* Washington, D.C., 1941. Microfiche.

Fleming, Jesse B. "A History of the Consolidated Bank and Trust Company: A Minority Bank." M.B.A. thesis, Rutgers University, 1972.

"Folklore and Ethnology: The Boy and the Ghost." *Southern Workman* 27, no. 3 (March 1898): 57.

"Folklore and Ethnology: Hags and Their Ways." *Southern Workman* 23, no. 2 (February 1894): 26–27.

"Folklore and Ethnology: A Negro Ghost Story." *Southern Workman* 28, no. 11 (November 1899): 449–450.

"Folklore and Ethnology: Notes from Alabama." *Southern Workman* 24, no. 5 (May 1895): 78.

Forde, Cyril Daryll, ed. *Efik Traders of Old Calabar.* 1956. Reprint, London: Dawsons of Pall Mall for the International African Institute, 1968.

Forde, Cyril Daryll, and G. I. Jones. *The Ibo and Ibibio-Speaking Peoples of South-Eastern Nigeria.* 1950. Reprint, London: International African Institute, 1967.

Forrester, William M. T., comp. *Degree Ritual of the Independent Order of Saint Luke.* Richmond, Va.: Richmond Dispatch Printing House, 1894.

————. *Ritual of the Independent Order of Saint Luke.* Richmond, Va.: Richmond Dispatch Printing House, 1877.

Forten, Charlotte. "Life on the Sea Islands." In *Two Black Teachers during the Civil War,* edited by Lewis C. Lockwood. New York: Arno Press, 1969. First published in *Atlantic Monthly* in May and June, 1864.

Fu-Kiau kia Bunseki-Lumanisa, A. *Le MuKongo et Le Monde Qui L'Entourait: Cosmogonie-Kôngo.* Translated from Kikongo into French by C. Zamenga-Batukezanga. Kinshasa, [Democratic Republic of Congo]: Office National de la Recherche et du Développement, 1969.

Fyfe, Christopher. *Sierra Leone Inheritance.* London: Oxford University Press, 1964.

Galembo, Phyllis. *Divine Inspiration: From Benin to Bahia.* Albuquerque: University of New Mexico Press, 1993.

Gannett, William C., and Edward E. Hale. "The Freedmen at Port Royal." *North American Review* 101 (July 1865): 1–28.

Glaze, Anita J. *Art and Death in a Senufo Village.* Bloomington: Indiana University Press, 1981.

Glen, Isabella C. *Life on St. Helena Island.* New York: Carlton Press, 1980.

Gordon, Asa H. *Sketches of Negro Life and History in South Carolina.* 2nd ed. Columbia: University of South Carolina Press, 1971.

Gordon, Robert W. "Negro 'Shouts' from Georgia." In *Mother Wit from the Laughing Barrel,* edited by Alan Dundes. Jackson: University Press of Mississippi, 1990. First published in *The New York Times Magazine,* 24 April 1927.

Graydon, Nell S. *Tales of Edisto.* Orangeburg, S.C.: Sandlapper Publishing, 1955.

Griaule, Marcel. *Conversations with Ogotemmêli: An Introduction to Dogon Religious Ideas.* London: Oxford University Press, 1965.

Grosvenor, Vertamae. "Interview with Sam Doyle." *Horizons.* National Public Radio, 25 July 1984.

Gundaker, Grey. "Tradition and Innovation in African-American Yards." *African Arts* 26, no. 2 (April 1993): 58–71, 94.

Gutman, Herbert G. *The Black Family in Slavery and Freedom, 1750–1925.* New York: Pantheon Books, 1976.

Harms, Robert W. *River of Wealth, River of Sorrow.* New Haven, Conn.: Yale University Press, 1981.

Harris, Abram L. *The Negro as Capitalist: A Study of Banking and Business among American Negroes.* 1936. Reprint, Gloucester, Mass.: P. Smith, 1968.

Harris, Rosemary. "Mbembe Men's Associations." *African Arts* 18, no. 1 (November 1984): 61–63, 96.

Helfenstein, Josef, and Roman Kurzmeyer. *Bill Traylor, 1854–1949: Deep Blues.* New Haven, Conn.: Yale University Press, 1999.

Henderson, Richard N. *The King in Every Man.* New Haven, Conn.: Yale University Press, 1972.

"Here and There." *Colored American Magazine* 4 (April 1902): 387–389.

Herskovits, Melville J. *The Myth of the Negro Past.* 1941. Reprint, Boston: Beacon Press, 1958.

Higginson, Thomas Wentworth. *Army Life in a Black Regiment.* 1869. Reprint, New York: W. W. Norton, 1984.

Hirschl & Adler Modern. *Bill Traylor: 1854–1947.* New York: Hirschl & Adler Modern, 1985.

———. *Bill Traylor.* New York: Hirschl & Adler Modern, 1988.

———. *Bill Traylor: High Singing Blue.* New York: Hirschl & Adler Modern, 1997.

———. "Pictures from the Bill Traylor Family Trust and Others." Typescript. Exhibition list. New York, December 10, 1994–January 14, 1995.

Horton, Robin. "African Traditional Thought and Western Science, Part II." *Africa* 37, no. 2 (April 1967): 155–187.

Hughson, Shirley C. *The Carolina Pirates and Colonial Commerce, 1670–1740.* Baltimore: Johns Hopkins University Press, 1894.

Hurston, Zora Neale. *Tell My Horse.* 1938. Reprint, Berkeley, Calif.: Turtle Island, 1981.

———. *Their Eyes Were Watching God.* 1937. Reprint, New York: HarperCollins, 1998.

Hyatt, Harry Middleton. *Hoodoo—Conjuration—Witchcraft—Rootwork.* 2 vols. Hannibal, Mo.: Western Publishers, 1970.

Idowu, E. Bolaji. *Olódùmarè: God in Yoruba Belief.* New York: Praeger, 1963.

"In the Sanctum: The National Negro Business League." *The Voice of the Negro* 2, no. 10 (October 1905): 723–724.

Isichei, Elizabeth. *Igbo Worlds: An Anthology of Oral Histories and Historical Descriptions.* Philadelphia: Institute for the Study of Human Issues, 1978.

Jackson, Luther Porter. *Free Negro Labor and Property Holding in Virginia, 1830–1860.* New York: Atheneum, 1969.

Jacobson-Widding, Anita. "Death Rituals as Inversions of Life Structures." In *On the Meaning of Death: Essays on Mortuary Rituals and Eschatological Beliefs,* edited by Sven Cederroth, Claes Corlin, and Jan Lindstrom. Uppsala: Ubsaliensis Academiae, 1988.

———. *Red-White-Black as a Mode of Thought.* Uppsala: Almqvist and Wiksell International, 1979.

Jahn, Janheinz. *Muntu: An Outline of the New African Culture.* 1958. Reprint, New York: Grove Press, 1961.

Janzen, John M. *Lemba, 1650–1930: A Drum of Affliction in Africa and the New World.* New York: Garland Publisher, 1982.

———. "The Tradition of Renewal in Kongo Religion." In *African Religions: A Symposium,* edited by Newell S. Booth Jr. New York: NOK Publishers, 1977.

Jeffreys, M. D. W. "Ikenga: The Ibo Ram-headed God." *African Studies* 13, no. 1 (1954): 25–40.

Johnson, Charles S. *Shadow of the Plantation.* Chicago: University of Chicago Press, 1934.

Jones, G. I. *The Art of Eastern Nigeria.* Cambridge: Cambridge University Press, 1984.

———. "Native and Trade Currencies in Southern Nigeria during the Eighteenth and Nineteenth Centuries." *Africa* 28, no. 1 (1958): 43–54.

———. "The Political Organization of Old Calabar." In *Efik Traders of Old Calabar,* edited by Daryll Forde. 1956. Reprint, London: Dawsons of Pall Mall for the International African Institute, 1968.

———. *The Trading States of the Oil Rivers.* London: Published for the International African Institute by Oxford University Press, 1963.

Kecskési, Maria. *African Masterpieces and Selected Works from Munich: The Staatliches Museum für Völkerkunde.* New York: Center for African Art, 1987.

Klein, Herbert S. *The Atlantic Slave Trade.* New York: Cambridge University Press, 1999.

———. *The Middle Passage: Comparative Studies in the Atlantic Slave Trade.* Princeton, N.J.: Princeton University Press, 1978.

———. "Slaves and Shipping in Eighteenth-Century Virginia." *Journal of Interdisciplinary History* 5, no. 3 (winter 1975): 383–412.

Knappert, Jan. *Myths and Legends of the Congo.* Nairobi, Kenya: Heinemann Educational Books, 1971.

Kulikoff, Allan. "The Origins of Afro-American Society in Tidewater Maryland and Virginia, 1700 to 1790." *William and Mary Quarterly* 35, no. 2 (1978): 226–259.

Kuyk, Betty M. "The African Derivation of Black Fraternal Orders in the United States." *Comparative Studies in Society and History* 25, no. 4 (October 1983): 559–592.

———. "Seeking Family Relationships." *Negro History Bulletin* 42, no. 3 (July–September 1979): 60.

Laguerre, Michel S. "Bizango: A Voodoo Secret Society in Haiti." In *Secrecy: A Cross-Cultural Perspective,* edited by Stanton K. Tefft. New York: Human Sciences Press, 1980.

———. *Voodoo Heritage.* Beverly Hills, Calif.: Sage Publications, 1980.

LaRoche, Louanne, ed. *Sam Doyle.* Kyoto, Japan: Kyoto Shoin, 1989.

Latham, A. J. H. *Old Calabar, 1600–1891.* Oxford: Clarendon Press, 1973.

Lawal, Babatunde. *The Gè̩lè̩dé̩ Spectacle: Art, Gender, and Social Harmony in an African Culture.* Seattle: University of Washington Press, 1996.

Lawton, Samuel Miller. "The Religious Life of South Carolina Coastal and Sea Island Negroes." Ph.D. diss., George Peabody College for Teachers, Nashville, Tenn., 1939.

Leacock, Seth, and Ruth Leacock. *Spirits of the Deep: A Study of an Afro-Brazilian Cult.* New York: Doubleday Natural History Press, 1972.

Leib, Elliot, and Renee Romano. "Reign of the Leopard: Ngbe Ritual." *African Arts* 18, no. 1 (November 1984): 48–57, 94.

Lindsay, Nick. *And I'm Glad: An Oral History of Edisto Island.* Charleston, S.C.: Tempus Publishing, 2000.

———. "Stories from Edisto Island." *Southern Exposure* 10, no. 3 (May–June 1982): 27–32.

Lindsay, Nick, ed. *An Oral History of Edisto Island: The Life and Times of Bubberson Brown.* Goshen, Ind.: Pinchpenny Press, 1977.

———. ed. *An Oral History of Edisto Island: Sam Gadsden Tells the Story.* Goshen, Ind.: Pinchpenny Press, 1974.

Livingston, Jane, and John Beardsley, eds. *Black Folk Art in America, 1930–1980.* Jackson: University Press of Mississippi, 1982.

MacGaffey, Wyatt. *Art and Healing of the Bakongo Commented by Themselves.* Stockholm: Folkens Museum—Etnografiska, 1991.

———. *Custom and Government in the Lower Kongo.* Berkeley: University of California Press, 1970.

———. "Fetishism Revisited: Kongo Nkisi in Sociological Perspective." *Africa* 47, no. 2 (1977): 172–184.

———. *Religion and Society in Central Africa: The BaKongo of Lower Zaire.* Chicago: University of Chicago Press, 1986.

MacGregor, Rev. J. K. "Some Notes on Nsibidi." *Journal of the Royal Anthropological Institute* 39 (1909): 209–219.

Maresca, Frank, and Roger Ricco. *Bill Traylor: His Art—His Life.* New York: Knopf, 1991.

Martin, Phyllis M. *The External Trade of the Loango Coast, 1576–1870.* Oxford: Clarendon Press, 1972.

———. "Power, Cloth and Currency on the Loango Coast." *African Economic History* 15 (1986): 1–12.

———. "The Trade of Loango in the Seventeenth and Eighteenth Centuries." In *Pre-Colonial African Trade: Essays on Trade in Central and Eastern Africa before 1900,* edited by Richard Gray and David Birmingham. London: Oxford University Press, 1970.

Mbiti, John. *African Religions and Philosophy.* New York: Doubleday Anchor, 1969.

McNaughton, Patrick R. *Secret Sculptures of Komo: Art and Power in Bamana (Bambara) Initiation Associations.* Philadelphia: Institute for the Study of Human Issues, 1979.

McTeer, J. E. *Fifty Years as a Low Country Witch Doctor.* Beaufort, S.C.: Beaufort Book Company, 1976.

———. *High Sheriff of the Low Country.* Beaufort, S.C.: Beaufort Book Company, 1970.

McWillie, Judith, ed. *Another Face of the Diamond: Pathways through the Black Atlantic South.* New York: INTAR, Hispanic Arts Center, 1989.

Meek, C. K. *Law and Authority in a Nigerian Tribe: A Study in Indirect Rule.* 1937. Reprint, New York: Barnes and Noble, 1970.

Métraux, Alfred. *Voodoo in Haiti.* 1959. 2nd English ed. Translated by Hugo Charteris. Reprint, New York: Schocken Books, 1972.

Metuh, Emefie Ikenga. *God and Man in African Religion: A Case Study of the Igbo of Nigeria.* London: Geoffrey Chapman, 1981.

———. "The Religious Dimension of African Cosmogonies: A Case Study of the Igbo of Nigeria." *West African Review* 17, no. 2 (1978): 9–21.

Monteiro, Joachim J. *Angola and the River Congo.* Vol. 1. 1875. Reprint, London: Frank Cass, 1968.

*Montgomery [Alabama] City Directory 1928.* Richmond, Va.: R. L. Polk, 1928.

*Montgomery [Alabama] City Directory 1947–1948.* Richmond, Va.: R. L. Polk, 1947–1948.

Morgan, Philip D. "Black Society in the Low Country, 1760–1810." In *Slavery and Freedom in the Age of the American Revolution,* edited by Ira Berlin and Ronald Hoffman. Charlottesville: University Press of Virginia, 1983.

Morrin, Peter. "Bill Traylor: Artist-Bricoleur." In *Bill Traylor, 1854–1949: Deep Blues,* edited by Josef Helfenstein and Roman Kurzmeyer. New Haven, Conn.: Yale University Press, 1999.

Mulago, Vincent. "Vital Participation." In *Biblical Revelation and African Beliefs,* edited by Kwesi A. Dickson and Paul Ellingworth. Maryknoll, N.Y.: Orbis Books, 1969.

Munday, J. T. "Spirit Names among the Central Bantu." *African Studies* 7, no. 1 (March 1948): 39–44.

Murdock, George P. *Africa: Its Peoples and Their Culture History.* New York: McGraw-Hill, 1959.

Murphy, William P. "Secret Knowledge as Property and Power in Kpelle Society: Elders versus Youth." *Africa* 50, no. 2 (1980): 193–207.

Murray, Chalmers S. *Here Come Joe Mungin.* New York: Putnam, 1942.

Murray, David R. *Odious Commerce: Britain, Spain and the Abolition of the Cuban Slave Trade.* Cambridge: Cambridge University Press, 1980.

Murray, Eberson. "Memoirs." Typescript in Murray Family Papers, South Carolina Historical Society. Charleston, S.C., 1939.

Museum of American Folk Art. *Stitched from the Soul.* Exhibition. New York, 1989.

National Archives and Records Administration. *Schedules Enumerating Union Veterans and Widows of the Civil War, 1890.* Records of the Veterans Administration. RG 015. Microfilm roll M123–93.

Nevadomsky, Joseph. "Religious Symbolism in the Benin Kingdom." In *Divine Inspiration: From Benin to Bahia,* edited by Phyllis Galembo. Albuquerque: University of New Mexico Press, 1993.

*New York Times,* 29 August–15 September 1893.

Neyt, François. *Traditional Arts and History of Zaire: Forest Cultures and Kingdoms of the Savannah.* Translated by Scott Bryson. Brussels: Société d'arts primitifs, 1981.

N'Idu, Ado. "Ekpe—Cross River Cult." *West African Review* 30 (November 1959): 747–749.

Nooter, Mary H., ed. *Secrecy: African Art that Conceals and Reveals.* New York: Museum for African Art, 1992.

Nzekwu, Onuora. "Initiation into the Agbalanze Society." *Nigeria Magazine* 82 (September 1964): 173–187.

Nzimiro, Ikenna. *Studies in Ibo Political Systems.* Berkeley: University of California Press, 1972.

Offodile, E. P. Oyeoka. "Title Taking in Awka." *West African Review* 18, no. 232 (January 1947): 16.

Ottenberg, Simon. *Masked Rituals of Afikpo.* Seattle: University of Washington Press, 1975.

Ottenberg, Simon, and Linda Knudsen. "Leopard Society Masquerades: Symbolism and Diffusion." *African Arts* 18, no. 2 (February 1985): 37–44, 93–95, 103–104.

Owen, William F. W. *Narrative of Voyages to Explore the Shores of Africa, Arabia, and Madagascar.* Vol. 2. New York: J. and J. Harper, 1833.

Parrish, Lydia. *Slave Songs of the Georgia Sea Islands.* 1942. Reprint, Hatboro, Pa.: Folklore Associates, 1965.

Parsons, Elsie Clews. *Folk-Lore of the Sea Islands, South Carolina.* 1923. Reprint, Chicago: Afro-Am Press, 1969.

Pearson, Elizabeth Ware, ed. *Letters from Port Royal, 1862–1868.* 1906. Reprint, New York: Arno Press, 1969.

Peek, Philip M. "African Divination Systems: Non-Normal Modes of Cognition." In *African Divination Systems: Ways of Knowing,* edited by Philip M. Peek. Bloomington: Indiana University Press, 1991.

Penn Community Services. Oral History Project. Penn Center Historical Collection, Frogmore, S.C., 1971–1974. Reel tapes.

Alston, Emanuel. 8 January 1974.

Alston, Jeremiah (Jerry). 24 May 1972.

Anderson, Virginia. 26 October 1973.

Bradley, Amanda. 23 September 1971.

Chaplin, Fred. 14 May 1974.

Cohen, Ezekiel. Part I, 10 September 1971; Part II, n.d.

Doyle, Sam. April 1974.

Gadsden, Sam. 27 July 1972.

Glover, Evelena. 9 July 1974.

Grant, Reverend David. 2 March 1972.

Grant, Robert. 22 February 1972.

Green, Ezekiel. 21 October 1971.

Green, Gertrude. April 1974.

Holmes, Franklin. 16 August 1972.

Holmes, Rachel. 15 August 1972.

Horton, Jim. 3 November 1971, Part I.

Horton, Jim and Julia. 20 July 1972.

Jenkins, Minnie. 23 July 1974.

Johnson, Clarence. 1 February 1974.

Johnson, Rosa, and Victoria Polite. July 1972.

Loundes, Harold and Richard. 31 January 1974.

Mack, Ben. 22 September 1971.

Mattis, Rebecca. 2 July 1974.

Milton, Edward and Annie. 8 August 1972.

Perry, Mariah. 17 October 1972.

Polite, Victoria, and Rosa Johnson. July 1972.

Reynolds, Carrie. 24 July 1974.

Rivers, Florence. 20 January 1972.

Smalls, Ellic. 18 October 1972.

Pérez-Peña, Richard. "Link to Past." *New York Times,* 9 December 1992.

Perkins, John. *To the Ends of the Earth.* New York: Pantheon Books, 1981.

Peterkin, Julia. *Black April.* Indianapolis, Ind.: Bobbs-Merrill Company, 1927.

———. *Roll, Jordan, Roll.* New York: R. O. Ballou, 1933.

Postma, Johannes. "The Dimension of the Dutch Slave Trade from Western Africa." *Journal of African History* 13, no. 2 (1972): 237–248.

———. *The Dutch in the Atlantic Slave Trade, 1600–1815.* New York, 1990.

———. "The Dutch Slave Trade: A Quantitative Assessment." *Révue française d'histoire d'outre-mer* 62, nos. 226–227 (1975): 232–244.

Rankin, Allen. "Rankin File." *Montgomery Alabama Journal,* 31 March 1948.

Rawick, George P., ed. *Alabama Narratives.* Vol. 1 of *The American Slave: A Composite Autobiography,* Supplement, Series I. Westport, Conn.: Greenwood Publishing Company, 1977.

———. *Georgia Narratives, Part 2.* Vol. 4 of *The American Slave: A Composite Autobiography,* Supplement, Series I. Westport, Conn.: Greenwood Publishing Company, 1977.

———. *Mississippi Narratives, Part 2.* Vol. 7 of *The American Slave: A Composite Autobiography,* Supplement, Series I. Westport, Conn.: Greenwood Publishing Company, 1977.

———. *Mississippi Narratives, Part 3.* Vol. 8 of *The American Slave: A Composite Autobiography,* Supplement, Series I. Westport, Conn.: Greenwood Publishing Company, 1977.

Rawley, James A. *The Transatlantic Slave Trade*. New York: W. W. Norton and Co., 1981.

*Richmond Planet*, 18 March 1899, 12 August and 28 October 1905, and 23 June 1906.

Rinchon, P. Dieudonné. *Pierre-Ignace-Liévin van Alstein: Capitaine Négrier*. Dakar: IFAN, 1964.

Robertson, G. A. *Notes on Africa, Particularly Those Parts Which Are Situated between Cape Verde and the River Congo*. London: Sherwood, Neely, and Jones, 1819.

Rodman, Selden, and Carole Cleaver. *Spirits of the Night: The Vaudun Gods of Haiti*. Dallas, Tex.: Spring Publications, 1992.

Rose, Willie Lee. *Rehearsal for Reconstruction: The Port Royal Experiment*. New York: Oxford University Press, 1964.

Rosen, Norma. "The Art of Èdó Ritual." In *Divine Inspiration: From Benin to Bahia*, edited by Phyllis Galembo. Albuquerque: University of New Mexico Press, 1993.

———. "Chalk Iconography in Olokun Worship." *African Arts* 22, no.3 (May 1989): 44–53, 88.

Rosengarten, Theodore, ed. *Tombee: Portrait of a Cotton Planter with the Journal of Thomas B. Chaplin (1822–1890)*. New York: Morrow, 1986.

Ross, Edyth L. *Black Heritage in Social Welfare, 1860–1930*. Metuchen, N.J.: Scarecrow Press, 1978.

Ruel, Malcolm. *Leopards and Leaders: Constitutional Politics among a Cross River People*. London: Tavistock Publications, 1969.

Russell, William H. *My Diary North and South*. New York: T. O. H. P. Burnham, 1863.

Schwartz, Gerald, ed. *A Woman Doctor's Civil War: Esther Hill Hawks' Diary*. Columbia: University of South Carolina Press, 1984.

Scott, Robert N., ed. *The War of the Rebellion: A Compilation of the Official Records of the Union and Confederate Armies*. Series I. Washington, D.C.: Government Printing Office, 1890.

Shannon, Charles. "Bill Traylor." In catalog of exhibition, Hirschl & Adler Modern. New York, December 2, 1985–January 11, 1986.

———. "Bill Traylor's Triumph." *Art and Antiques* (February 1988): 61–64, 88.

Showers, Susan H. "Alabama Folklore." *Southern Workman* 29, no. 7 (July 1900): 443.

Simmons, Donald C. "An Ethnographic Sketch and Notes." In *Efik Traders of Old Calabar*, edited by Daryll Forde. 1956. Reprint, London: Dawsons of Pall Mall for the International African Institute, 1968.

Simpson, George E. "Baptismal, 'Mourning,' and 'Building' Ceremonies of the Shouters in Trinidad." *Journal of American Folklore* 79 (1966): 537–550.

Sisk, Glenn. "Funeral Customs in the Alabama Black Belt, 1870–1910." *Southern Folklore Quarterly* 23 (1959): 169–171.

Smiley, Portia. "Folk-lore from Virginia, South Carolina, Georgia, Alabama, and Florida." *Journal of American Folklore* 32, no. 125 (July–September 1919): 357–405.

Society of Friends. *A View of the Present State of the African Slave Trade.* Philadelphia: William Brown, 1824.

Somé, Malidoma Patrice. *Of Water and the Spirit.* New York: Penguin, 1994.

Soret, Marcel. "La propriété foncière chez les Kongo du Nord-Ouest." In *African Agrarian Systems,* edited by Daniel Biebuyck. London: Published for the International African Institute by Oxford University Press, 1963.

South Carolina. "Appraisement of the Goods and Chattels of the Late James Clark of Edisto Island." *Charleston Inventory, 1813–1824,* Book F, 175–177. Department of Archives and History, Columbia, S.C. Photocopy.

Spriggs, Lynne E. *Local Heroes: Paintings and Sculpture by Sam Doyle.* Atlanta: High Museum of Art, 2000.

Stafford, Frances J. "Illegal Importations: Enforcement of the Slave Trade Laws along the Florida Coast, 1810–1828." *Florida Historical Quarterly* 46 (1967): 124–133.

Staudenraus, P.J. "Victims of the African Slave Trade, A Document." *Journal of Negro History* 41, no. 2 (1956): 148–151.

Steiner, Roland. "Seeking Jesus." *Journal of American Folklore* 14 (1901): 172.

———. "Sol Lockheart's Call." *Journal of American Folklore* 13 (1900): 67–70.

Talbot, P. Amaury. "The Land of the Ekoi, Southern Nigeria." *The Geographical Journal* 36, no. 6 (December 1910): 637–657.

———. *The Peoples of Southern Nigeria.* Vol. 3, *Ethnology.* London: Oxford University Press, 1926.

Tams, Georg. *Visit to the Portuguese Possessions in South-Western Africa.* 1845. Translated by H. Evans Lloyd. Reprint, New York: Negro Universities Press, 1969.

Tempels, Placide. *Bantu Philosophy.* Paris: Présence africaine, 1959.

Tepowa, Adebiyi. "The Titles of Ozor and Ndichie at Onitsha." *Journal of the African Society* 9, no. 34 (January 1910): 189–192.

Thomas, Northcote. "Some Ibo Burial Customs." *Journal of the Royal Anthropological Institute* 47 (1917): 160–213.

Thompson, Robert Farris. "An Aesthetic of the Cool." *African Arts* 7, no. 1 (autumn 1973): 41–67, 89–91.

———. *African Art in Motion: Icon and Act.* Los Angeles: University of California Press, 1974.

———. "African Influence on the Art of the United States." In *Afro-American Folk Art and Crafts,* edited by William Ferris. Boston: G. K. Hall, 1983.

———. "The Circle and the Branch: Renascent Kongo-American Art." In *Another Face of the Diamond: Pathways through the Black Atlantic South,* edited by Judith McWillie. New York: INTAR, Hispanic Arts Center, 1989.

———. *Face of the Gods: Art and Altars of Africa and the African Americas.* New York: Museum for African Art, 1993.

———. *Flash of the Spirit: African and Afro-American Art and Philosophy.* New York: Random House, 1983.

———. "Kongo Influences on African-American Artistic Culture." In *Africanisms in American Culture,* edited by Joseph E. Holloway. Bloomington: Indiana University Press, 1990.

———. "The Sign of the Divine King: An Essay on Yoruba Bead-Embroidered Crowns with Veil and Bird Decoration." *African Arts* 3, no. 3 (spring 1970): 8–17, 74–80.

———. "The Song That Named the Land: The Visionary Presence of African-American Art." In *Black Art: Ancestral Legacy*, edited by Robert V. Rozelle, Alvia Wardlaw, and Maureen A. McKenna. Dallas, Tex. Dallas Museum of Art, 1989.

Thompson, Robert Farris, and Joseph Cornet. *The Four Moments of the Sun: Kongo Art in Two Worlds*. Washington, D.C.: National Gallery of Art, 1981.

Tindall, George Brown. *South Carolina Negroes, 1877–1900*. Columbia: University of South Carolina Press, 1952.

Towne, Laura M. *Letters and Diary of Laura M. Towne*. Edited by Rupert S. Holland. 1912. Reprint, New York: Negro Universities Press, 1969.

Traylor, Humphrey, Jr. "Will of Humphrey Traylor, Jr." Dinwiddie Co., Va. Made 16 September 1802, proved 21 February 1803. In Hines Genealogy Collection, Library of Virginia, Richmond, Va. Photocopy.

Traylor, Mrs. John Bryant. Family Papers. Private collection, Tyler, Alabama.

Traylor, John Getson. Diary, 1834–1847. Typescript. Alabama Department of Archives and History, Montgomery, Ala.

———. "John G. Traylor's Will." Executed 3 December 1849, probated 14 February 1850. Dallas County, Alabama, Will Book B, 1850–1871, p. 1. In Alabama Department of Archives and History, Montgomery, Ala.

Treasure, Geoffrey R. R. *The Making of Modern Europe, 1648–1780*. New York: Methuen, 1985.

Trent, W. J. Jr. "Development of Negro Life Insurance Enterprises." M.B.A. thesis, University of Pennsylvania, 1932.

Tuckey, Capt. James H. *Narrative of an Expedition to Explore the River Zaire, Usually Called the Congo*. New York: W. B. Gilley, 1818.

Turner, Howard H. *Turner's History of the Independent Order of Good Samaritans and Daughters of Samaria*. Washington, D.C.: R. A. Waters, 1881.

Turner, Lorenzo Dow. *Africanisms in the Gullah Dialect*. 1949. Reprint, Ann Arbor: University of Michigan Press, 1974.

Turner, Victor W. "Colour Classification in Ndembu Ritual." In *Anthropological Approaches to the Study of Religion*, edited by Michael Banton. New York: F. A. Praeger, 1966.

Uchendu, Victor Chikezie. *The Igbo of Southeast Nigeria*. New York: Holt, Rinehart, and Winston, 1965.

———. "The Status Implications of Igbo Religious Beliefs." *Nigerian Field* 29, no. 1 (1964): 27–37.

Udo Ema, A. J. "The Ekpe Society." *Nigeria* 16 (1938): 314–316.

Unger, Willem S. "Essay on the History of the Dutch Slave Trade." In *Dutch Authors on West Indian History*, edited by M. A. P. Meilink-Roelofsz. The Hague: M. Nijhoff, 1982.

U.S. Bureau of the Census. "Population Schedule." *Eighth Census of the United States*. Washington, D.C., 1860, in National Archives and Records Administration.

———. "Population Schedule." *Ninth Census of the United States*. Washington, D.C., 1870, in National Archives and Records Administration.

———. "Population Schedule." *Tenth Census of the United States*. Washington, D.C., 1880, in National Archives and Records Administration.

———. "Population Schedule." *Twelfth Census of the United States*. Washington, D.C., 1900, in National Archives and Records Administration.

———. "Population Schedule." *Thirteenth Census of the United States.* Washington, D.C., 1910, in National Archives and Records Administration.

———. "Population Schedule." *Fourteenth Census of the United States.* Washington, D.C., 1920, in National Archives and Records Administration.

———. "Population Schedule." *Fifteenth Census of the United States.* Washington, D.C., 1930, in National Archives and Records Administration.

———. "Slave Schedule." *Fifth Census of the United States.* Washington, D.C., 1830, in National Archives and Records Administration.

———. "Slave Schedule." *Eighth Census of the United States.* Washington, D.C., 1860, in National Archives and Records Administration.

———. "Veterans and Widows Schedule." *Eleventh Census of the United States.* Washington, D.C., 1890, in National Archives and Records Administration.

U.S. Department of the Navy. *Dictionary of American Naval Fighting Ships.* Vol. 6. Washington, D.C.: Government Printing Office, 1976.

U.S. House. *Report of Mr. Kennedy of Maryland from the Commerce Committee on the Conference of the African Colonization Society of May 1842, including Miscellaneous Papers and Diplomatic Correspondence concerning the African Slave Trade.* H. R. 283, 27th Cong., 3rd sess., 28 February 1843.

Vansina, Jan. *Art History in Africa: An Introduction to Method.* London: Longman, 1984.

———. "Notes sur l'origine du royaume de Kongo." *Journal of African History* 4, no. 1 (1963): 33–38.

———. *Oral Tradition as History.* Madison: University of Wisconsin Press, 1985.

———. *Paths in the Rainforests.* Madison: University of Wisconsin Press, 1990.

———. *The Tio Kingdom of the Middle Congo, 1880–1892.* London: Oxford University Press for the International African Institute, 1973.

Vass, Winifred K. *The Bantu Speaking Heritage of the United States.* Los Angeles: University of California Press, 1979.

Vogel, Susan, ed. *For Spirits and Kings: African Art from the Paul and Ruth Tishman Collection.* New York: Metropolitan Museum of Art, 1981.

Vogel, Susan, and Francine N'Diaye. *African Masterpieces from the Musée de l'Homme.* New York: Center for African Art, 1985.

Wahlman, Maude S. "African Symbolism in Afro-American Quilts." *African Arts* 20, no. 1 (November 1986): 68–76, 99.

Walker, Maggie L. "An Address to the 34th Annual Session of the R. W. G. Council of Virginia, I. O. of St. Luke." Presented at the Third Street African Methodist Episcopal Church, Richmond, Virginia. Typescript in archive of Independent Order of St. Luke, Richmond, Va., 20 August 1901.

Walton, Thomas E. "The Negro in Richmond, 1880–1890." M.A. thesis, Howard University, 1950.

Ward, William E. F. *The Royal Navy and the Slavers.* London: George Allen and Unwin, 1969.

Wardlaw, Alvia. "Catalogue." In *Black Art: Ancestral Legacy,* edited by Robert V. Rozelle, Alvia Wardlaw, and Maureen A. McKenna. Dallas, Tex.: Dallas Museum of Art, 1989.

Wax, Darold D. "Preferences for Slaves in Colonial America." *Journal of Negro History* 58, no. 4 (1973): 371–401.

Weeks, John H. *Among the Primitive Bakongo: A Record of Thirty Years' Close Intercourse with the Bakongo and Other Tribes of Equatorial Africa, with a Description of Their Habits, Customs and Religious Beliefs.* 1914. Reprint, New York: Negro Universities Press, 1969.

Weisiger, Benjamin B., III, comp. *Chesterfield County, Virginia, Wills, 1774–1802.* Athens, Ga.: B. B. Weisiger, 1986.

———. *Colonial Wills of Henrico County, Virginia: Part Two, 1737–1781,* Richmond, B. B. Weisiger, 1977.

Wescott, Joan. "The Sculpture and Myths of Eshu-Elegba, the Yoruba Trickster." *Africa* 32, no. 4 (October 1962): 336–354.

Williams, Clairmont A. "The Afro-American People of Greenville," *Colored American Magazine* 10, no. 6 (June 1906): 428–429.

Williams, Sheldon. *Voodoo and the Art of Haiti.* Nottingham, England: Morland Lee, 1969.

Woodson, Carter. "Insurance Business among Negroes." *Journal of Negro History* 14, no. 2 (1929): 202–226.

Work, Monroe N. "Some Geechee Folk-Lore." *Southern Workman* 34, no. 11 (November 1905): 633–635.

Works Progress Administration. *Drums and Shadows: Survival Studies among the Georgia Coastal Negroes.* 1940. Reprint, Westport, Conn.: Greenwood Press, 1973.

———. "Will of Sarah Clark." Typescript in Vol. 36 of *Charleston Wills,* 885–886. South Carolina Department of Archives and History, Columbia, S.C. Microfilm, Roll #23485.

Zahan, Dominique. *The Religion, Spirituality, and Thought of Traditional Africa.* Chicago: University of Chicago Press, 1979.

# PHOTOGRAPHIC CREDITS

# INDEX

BETTY M. KUYK is an independent historian. Born to a Southern family with roots in both Georgia and Virginia, Kuyk now lives in Massachusetts with her husband and dog family and in Virginia with her extended Southern family.